THE VANISHING MAN

BY THE SAME AUTHOR

A Face to the World: On Self-Portraits

THE VANISHING MAN

IN PURSUIT OF VELÁZQUEZ

Laura Cumming

Chatto & Windus LONDON

13579108642

Chatto & Windus, an imprint of Vintage, 20 Vauxhall Bridge Road, London swiv 28A

Chatto & Windus is part of the Penguin Random House group of companies whose addresses can be found at global.penguinrandomhouse.com.

Copyright © Laura Cumming 2016

Laura Cumming has asserted her right to be identified as the author of this Work in accordance with the Copyright,

Designs and Patents Act 1988

First published by Chatto & Windus in 2016

www.vintage-books.co.uk

A CIP catalogue record for this book is available from the British Library

HB ISBN 978070II88443 TPB ISBN 978070II88450

Every effort has been made to trace or contact copyright holders. The publishers will be pleased to make good any omissions or rectify any mistakes brought to their attention, at the earliest opportunity.

Penguin Random House is committed to a sustainable future for our business, our readers and our planet. This book is made from Forest Stewardship Council® certified paper.

Typeset in Dante MT Std by Palimpsest Book Production Limited, Falkirk, Stirlingshire Printed and bound by Clays Ltd, St Ives plc For Hilla, Thea, Elizabeth and Dennis with all my heart And in memory of the painter James Cumming a de la composição de la composiç

Contents

1	A Discovery	1
2	The Painting	13
3	The Painter	23
4	Minster Street	37
5	Man in Black	51
6	The Talk of London	65
7	A Man in Full	81
8	The Attack	91
9	The Theatre of Life	107
10	Seizure and Theft	125
11	The Trial	137
12	The Escape	157
13	Velázquez on Broadway	173
14	The Escape Artist	187
15	The Vanishing	205
16	Seeing Is Believing	219
17	The Ghost of a Picture	227
18	An Infinite Number of Charleses	237
19	Lost and Found	249
20	Saved	261

Acknowledgements	271
List of Illustrations	273
Notes on Sources	275
Select Bibliography	281
Index	289

A Discovery

My father died quite suddenly when I was in my late twenties. He was a painter. The fatal illness attacked his brain, then his eyes. In my raging grief, I could not bear to look at any paintings but his, as a way of holding the memory of him as close and tight as possible, I suppose, and in blind protest against the blighting of his life and art.

Several months passed. I went to Madrid in a bitter midwinter, a city chosen because neither he nor I had ever been there and I couldn't speak the language. There would be no old associations and no new conversations; time could stand still while I thought about nothing and no one but him. Every day I would leave my hotel room and walk round and round the streets, spiralling out to the freezing suburbs and the snow-capped hills beyond. I did not know what else to do.

But Madrid is not large; I would pass the Prado Museum time and again, sometimes twice in one day, steeling myself not to go in. Eventually the effort to avoid the place became a distraction in itself and it was there, in that crowded city within a city, that I had the luckiest of strikes. On a hunt for El Greco, one of my father's favourite painters, I was passing the opening to a large gallery when a strange frisson of light caught the edge of my eye. As I turned to look, all the people standing at the other end of the gallery suddenly moved aside as one, clearing an open view to the source of that light: Velázquez's monumental *Las Meninas*. I had

no thought of it, no idea it would be there or how vast it would be – an image the size of life, and fully as profound. The living people revealed the painted people behind them like actors in the same performance, and flashing up before me was the mirror-bright vision of a little princess, her young maidservants and the artist himself, all gathered in a pool of sunlight at the bottom of a great volume of shadow, an impending darkness that instantly sets the tenor of the scene. The moment you set eyes on them, you know that these beautiful children will die, that they are already dead and gone, and yet they live in the here and now of this moment, brief and bright as fireflies beneath the sepulchral gloom. And what keeps them here, what keeps them alive, or so the artist implies, is not just the painting but you.

You are here, you have appeared: that is the split-second revelation in their eyes, all these people looking back at you from their side of the room. The princess in her shimmering dress, the maids in their ribbons and bows, the tiny page and the tall, dark painter, the nun whose murmur is just fading away and the chamberlain silhouetted in the glowing doorway at the back: everyone registers your presence. They were here like guests at a surprise party waiting for your arrival and now you have entered the room – *their* room, not the real one around you – or so it mysteriously seems. The whole scene twinkles with expectation. That is the first sensation on the threshold of that gallery in the Prado where *Las Meninas* hangs: that you have walked into their world and become suddenly as present to them as they are to you.

The image holds you there, stopped in surprise, motionless as the moment it represents in which all these people pause too, except the little page nudging the stoic dog. Everything is still except for the circumambient air and the light fluttering across the white-blonde hair of the princess, who stares at you with the candid curiosity of a child at the centre of a painting that is itself so completely attentive. The dwarf gives you her frank consideration, hand on heart, the maids kneel or curtsey, the servants observe

you, all the way to the man in black hovering on the threshold of this room, waiting to usher you into the next. And from behind the back of the great canvas on which he is working, the size of this one, steps the painter himself, taciturn, watchful, the magician momentarily revealed.

But take a few steps towards this painting in all its astounding veracity and the vision swithers. The princess's lustrous hair begins to look like a mirage, or a heatwave scintillating above a summer road that vanishes at your approach. The face of the lady dwarf dissolves into illegible brushstrokes. The figures in the background become inchoate at point-blank range and you can no longer see where a hand stops and the tray it is holding begins. The nearer you get to the painting, the more these semblances of reality start to disappear, to the point where it is impossible to fathom how the image could have been made in the first place. Everything is on the verge of dissolution and yet so vividly present that the sunshine in the painting seems to float free and drift out into the gallery. It is the most spellbinding vision in art.

Las Meninas – The Maidservants – was most likely painted in 1656, four years before Velázquez's own sudden death (Plate A). It shows a chamber of the royal Alcázar palace in Madrid that is also long gone, destroyed in two days by a fire. This was the very room in which the picture was first shown: only imagine how perfectly the illusion must have merged with the reality when it hung there, the two sides of the chamber, real and depicted, presumably appearing seamlessly connected. To walk in and find these people waiting there must have been astonishing - like entering a dream, or a flickering projection of life quite unimaginable before the invention of cinema - for it still amazes today. Velázquez keeps this vanished circle before us like the moment's reflection in a mirror, and his painting has the characteristics of a mirror, too: look into it and you are seen in return. Many paintings have the scene-shifting power to take us to another time and place but this one goes further, creating the illusion that the people you see are equally aware of your presence, that their scene is fulfilled by you. Velázquez invents a new kind of art: the painting as living theatre, a performance that extends out into our world and gives a part to each and every one of us, embracing every single viewer. For anyone who stands before Las Meninas now, held fast by the eyes of these lost children and servants, is positioned exactly where the people of the past once stood. This is part of the picture's content. It elects you to the company of all who have ever seen it, from the little princess and her maids, who must have rushed round to see themselves the moment Velázquez finished, to the king and queen who appear in miniature in that glimmering mirror at the back. We stand where they once stood, the mirror implies (and the servants' eyes), looking into this scene, this moment held intact down the centuries. The picture turns the world upside down, so that citizens may take the place of kings, and kings may be tiny compared to children. We stand together in history and Las Meninas gathers us all into its boundless democracy.

The painting I saw that day seems to hold death back from the brink even as it acknowledges our shared human fate. It shows the past in all its mortal beauty, but it also looks forward into the flowing future. Because of Velázquez, these long-lost people will always be there at the heart of the Prado, always waiting for us to arrive; they will never go away, as long as we are there to hold them in sight. Las Meninas is like a chamber of the mind, a place where the dead will never die. The gratitude I feel to Velázquez for this greatest of paintings is untold; he gave me the consolation to return to my own life.

We see paintings in time and place (no picture makes this clearer, putting us on the spot and in the moment) and always in the context of our own lives. We cannot see them otherwise, no matter how objective we might hope to be. Novelists long ago recognised this truth; literature is full of characters falling in love with the people in paintings, obsessing over enigmatic figures or shapes,

feeling intimidated – or intensely disappointed, in the case of Madame Bovary – by their first sighting of a tarry Old Master. Fictional people are allowed to have feelings about art entirely unconnected with the analysis of formal attributes, still less any knowledge of art history. But this is not how the rest of us are encouraged to view art by specialists and historians, for whom feelings may be dubious, unstable or irrelevant. If one should happen to experience an involuntary personal response, an eminent art historian once advised me, as if mentioning some embarrassing arousal, one should always keep it firmly to oneself.

Over time, many scholars have written about the mysteries of Las Meninas: who or what Velázquez might be painting on that huge canvas – is it the king and queen, is it this very painting – who the painter is looking at, what the mirror reflects, what is happening in the picture, how it was constructed. Architects have made scale models of the room in an attempt to 'solve' these puzzles through perspective, although the painting does not itself abide by those laws. Physicists have experimented with mirrors and light to comprehend the paradoxes. Art historians have attempted to deduce, stroke by stroke, how on earth the illusion was achieved. The philosopher Michel Foucault, in an essay in Les mots et les choses, with its famous conclusion that Las Meninas is nothing less (and perhaps nothing more, for him) than 'the representation of Classical representation', inaugurated whole schools of theoretical interpretation.

But the compelling humanity of Velázquez's vision is ignored. Some historians actually believe he was only talking to himself or his employer, Philip IV, the little king in the mirror, so that all the beautiful open-ended complexities that have enthralled viewers down the centuries are either our mistaken fantasy or a closed conversation between two Spanish men. Yet *Las Meninas* is living proof of the opposite, that when painters make images they do not do so in some kind of austere isolation or without hope of an audience beyond the studio. For this painting accepts as many

interpretations as there are viewers, and part of its grace lies in allowing all these different responses to coexist, no matter how contradictory, by being such a precise vision of reality and yet so open a mystery. Velázquez is able to make you, and all before and after you, feel as alive to these people as they are to you; everyone sees, everyone is seen. The knowledge that this is all achieved by brushstrokes, that these are only painted figments, does not weaken the illusion so much as deepen the enchantment. The whole surface of *Las Meninas* feels alive to our presence.

This is at least as central to the technical feat of the painting as it is to our personal response, and still it goes unmentioned. There seems to be some collective recoil from the idea that art might actually overwhelm, distress or enchant us, might inspire wonder, anger, compassion or tears, that it might raise us up as a Shakespeare tragedy raises its audience. Even quite fundamental emotions are not in the language of scholarship, let alone museums, which rarely speak of the heart in connection with art. Yet so many people have loved *Las Meninas*.

I believe this response is too often overlooked, even though it is clear that painters do not make pictures without some hope of reaching more than our eyes. Since art history does not concern itself much with the power of images to move or affect us, I went looking for other people's reactions to art down the years in the literature of our daily existence. And it was here, among the memoirs, diaries and letters that tell of our encounters with art, that I came upon the strange case of this lucky – or unlucky – provincial tradesman, as he describes himself, and his love for a long-lost Velázquez.

Or rather, in the drowsy shadows of a library in winter, I came upon a curious Victorian pamphlet stitched into a leather-bound miscellany between a quaint history of the Hawaiian Islands and a collection of short stories ominously titled *Fact and Fiction*. If the owner of this particular volume, a London lawyer with an elaborate *Ex Libris* plate, hadn't underlined the words 'A Brief Description

of the Portrait of Prince Charles, afterwards Charles the First, painted at Madrid in 1623 by Velasquez' in heavy ink on the contents page, I might not have noticed it. By such accidents are the traces of people, and pictures, preserved. The pamphlet was anonymous, but someone, presumably the lawyer had hazarded a name: J Snare? John Snare? The guess turned out to be right.

John Snare was a bookseller from the market town of Reading in Berkshire. His shop was at 16 Minster Street, the same address as the printer of the pamphlet, which he had evidently written and published himself. Snare describes the portrait quite clearly: it shows the young prince with his large liquid eyes and pale complexion, painted without rigidity or outline in an airy three-quarter view. Although the language is occasionally florid – he speaks of manliness and silken locks – for a moment, in the fug of the library at dusk, I seemed to think I had some inkling of this painting, which is commonly mentioned by historians as the one good thing to come out of Charles's visit to Madrid to court the Spanish princess in 1623. In my mind I saw the young Charles, who had entirely failed to charm the disdainful infanta, given a better face by Velázquez, his dignity restored to the point of grace.

Overnight, however, I began to doubt the description so much that I returned next day to see if I had misread the pamphlet and dreamed fiction into fact. But John Snare and his story turned out to be real.

The pamphlet was in fact a miniature catalogue for a one-picture show held in London to high acclaim in the spring of 1847. But how did Snare come to be its curator, and how did he discover the lost painting in the first place? It wasn't hard to find answers to these obvious questions to begin with; but then the case turned into a deeper mystery.

Snare's feeling for Velázquez touched me. He did not see the painting as a thing apart, remote from his own existence; it filled his mind as if it were a living being. He wrote another pamphlet, and then another, in the hope that others would feel for it too. His

obsession with discovering a past for the portrait eventually turned him into a detective and sent me on a search of my own.

At first I was following the painting, like Snare, but soon I was following the fortunes of the bookseller too. The trail took me to Edinburgh and a shocking court battle over the picture in 1851. The trial was a crossfire of rage, persecution and snobbery involving outraged aristocrats and awestruck engravers, experts from Soho and dealers from France, servants who had dusted the picture in an earl's London mansion and frame-makers who claimed to have seen it in quite other places. Every class of society was represented, from the Scottish nobility to the typesetters who worked alongside Snare in Reading and remembered his life-or-death passion for the portrait. I had never encountered a case where the voices of the past were so clearly heard speaking about art in an age before it became densely familiar through museums, exhibitions and reproductions. Scarcely a single witness had seen more than one Velázquez and many testified to the extraordinary surprise of this one, the face of the long-dead prince flashing up into a timeless present.

For the art of Velázquez was rare, unfamiliar, obscure. He left so few paintings – not more than 120 over a forty-year career – it is rightly said that he measured out his genius in thimblefuls. Almost all of his work was painted for the Spanish king and court and stayed exactly where it was made, long after his death, immured in the royal palaces. Even when the Prado first opened to the public in 1819, with the revelation of more than forty paintings by Velázquez, only the well-heeled traveller could have the slightest sense of his work that is so freely available to us today. Photography did not yet exist, prints were precious few and could scarcely convey his mysterious and diaphanous style, so that the only way a Velázquez could be kept in mind was through the fantastic vagaries of memory.

No two Victorians would remember the portrait at the heart of this case in quite the same way. This was a time before paintings tended to have titles by which their subjects could be identified, and were often wildly misunderstood as a consequence; when it was hard to tell one anonymous sitter from another beneath the filth of old canvases; when paintings were easily mislabelled and signatures misread or slyly added by dealers, when genuine masterpieces could languish overlooked while pathetic imitations were exorbitantly prized.

It was a time of grand houses full of dirt-blackened pictures, auctioneers hovering eagerly in the wings; of visitors paying to see a travelling stunner in the Egyptian Hall in London or the Pantheon in New York; when middlemen worked their way through the villas and courts of Europe sending back masterpieces sight unseen, while restorers primped up, or simply copied, old canvases, when a picture might be 'identified' as a Velázquez just because it included a dark-eyed man with a Spanish goatee beard or an especially expressive mongrel.

Some people knew Velázquez chiefly as a painter of dogs.

By the early nineteenth century some of the paintings that had been locked away in Spain began to appear across Europe in the wake of the Peninsular War of 1808–14, in which British troops helped free Spain and Portugal from Napoleonic occupation. Works by Velázquez turned up on battlefields, in soldiers' baggage and in the hands of go-betweens engaging in suspect acts of diplomacy, like a hoard of bright treasures suddenly emerging out of ploughed soil. They did not pass straight into the hands of specialists as they would now, to be examined for every iota of evidence, but cropped up at auctions and post-mortem picture sales, in people's private houses and bequests, often quite randomly and without fanfare, occasionally disappearing straight back into the darkness. Every new discovery fanned the growing craze for Velázquez.

In all this flux and confusion, people did not always know what they were looking at, still less what they were buying or selling. In England, Earl Spencer of Althorp had a painting of a bagpipe player that he thought was by Velázquez. In Scotland, the Earl of Elgin had a white poodle sniffing a bone. In rural Dorset, an English politician believed he had nothing less than the original version of Las Meninas, rather smaller and admittedly lacking some of the crucial details, but nonetheless the pride of his collection, if not England itself. Even today, some scholars believe he was right.

For two centuries and more it has been confidently predicted that the small sum of Velázquez's art would never increase, that no more paintings by him would now be found, that any lost paintings were permanently lost. But this has never been true. His pictures really have turned up again, tumbled in the tide of history, one by one, discovered in the most unlikely places: in Latin America; in an English seaside town; hiding in plain view on the walls of New York's Metropolitan Museum in the twenty-first century.

For Velázquez's portraits, so miraculously empathetic and precise, so unmistakeable and inimitable, as it seems, keep on being mistaken and overlooked. Perhaps something in his exceptionally enigmatic way of painting has veiled these works; something in their mystery and modesty – from the self-effacing brushwork to the absence of a signature – has obscured them. They depend upon the kindness of strangers to an unusual degree; they need people to find and to save them.

Las Meninas presents the most famous piece of canvas in art: the blank back of the enormous picture on which the artist is working; it is the obverse of a painting, literally, but such a beautiful depiction of that vast stretch of cloth tacked to the stretcher. What Velázquez shows is the curious double nature of paintings: that they are objects as well as images; objects that are propped up and lugged about and screwed to high walls, that suffer calamity and misadventure, shipwreck and fire, that may be arbitrarily sacrificed to disaster or rescued by providence, bought and sold, crated up and transported, lost and found and sometimes even lost again.

We say that works of art can change our lives, an optimistic piety that generally refers to the moral or spiritual uplift of a

painting, and the way it may improve its audience. But art has other powers to alter our existence. The moment he bought the portrait of Prince Charles, Snare's life changed direction. It was a lost work, disregarded, on its way to the oblivion from which he saved it in 1845. It was an object that he would be forced to defend from danger and theft, that took him from small-town provincial life to the most fashionable streets of London and New York, and from obscurity to newspaper fame; a painting he would take with him wherever he went, that came to mean more to him than anything in the world, more than his family, his home and himself, that would lead to exile, a lonely death in a cold-water tenement and an unmarked grave in New York: the painting that would ruin his life.

Whatever one may come to think of John Snare in this book – and I came to question his motives, at times – his sincerity is never in doubt. He loved the art of Velázquez, at least the precious little he was ever able to see of it during his lifetime. He and I have stood in the same few places in England, amazed in front of the same few paintings in different centuries. If only he had lived in another era, he too might have been able to see *Las Meninas*.

This is a book of praise for Velázquez, greatest of painters, a man whose life is almost as elusive as his art; and it is the portrait of an obscure Victorian who loved that art, in so far as I can bring Snare back out of the darkness. For he is to me like one of the figures in *Las Meninas* – the servant on the far edge by the window, the *only* person in that masterpiece about whom nothing is known, whose story is never told and who is all but a painted blur, vanishing into the shadows.

The control of the co

Accompany to the control of the flee shaper are made by accompany to the control of the control

The Painting

IT BEGAN WITH two inches of dense black print in the long columns of the *Reading Mercury* in October 1845. The fateful notice announced a forthcoming auction at Radley Hall near Oxford, home to Benjamin Kent's Academy for Boys. The boarding school was closing down, the pupils were already gone and everything was up for sale. The *Mercury* mentioned bolsters and iron bedsteads, dictionaries and Latin grammars, but there was something else too. Mr Kent was selling his art.

The notice was buried among advertisements for top hats and patent tonics for overburdened mothers, but it did not escape John Snare. The bookseller felt a sudden excitement on seeing it. He had once been to Radley Hall with a friend who knew the headmaster, and had seen the paintings now mentioned in the *Mercury*: Dutch landscapes, portraits of medieval bishops, a very ancient picture of an abbess and a pope. But the one that had most intrigued him, too poorly lit and high on the wall to be properly visible, was also the one identified in the advertisement as something special: 'A Half-Length of Charles the First (supposed Van-dyke)'.

Auctions were a blessing for a provincial tradesman like Snare. There were no art galleries in Reading and this was still the dawn of the museum age, when most people saw paintings, if they saw any at all, in travelling shows or at church on Sunday. The private

collections of country houses were generally closed to anyone without superior social connections, whereas auctions, no matter how valuable the paintings, were open to all. Even the hastiest of bankruptcy sales might have several public previews when visitors could linger over the art in the guise of potential customers, a tradition that reached right back through the ages. This was how Rembrandt saw, and sketched, Raphael's famed portrait of Baldassare Castiglione when it surfaced at an auction in Amsterdam in 1639, giving it a somewhat bulbous Dutch nose, more like his own; this was the only way most people would see Rembrandt's own paintings for centuries.

The Reading Mercury was on sale in Snare's Minster Street shop, a handsome double-fronted emporium with large bow windows, elaborate cornices and enough shelves to take the burden of an immense and ever-expanding miscellany of publications, from The Lancet and Punch to the latest novels of Dickens and Thackeray, guides to beekeeping, taxidermy and the far-flung islands of the South Pacific. Advertisements in the Mercury itself reveal the proud diversity of his stock. At Snare's, customers could buy anything from Paradise Lost to the Bible and Shakespeare, along with quaint picture books, oil paints and India rubbers, blotting paper and coloured ink. Snare even sold prints of famous paintings; that same autumn of 1845 he was offering Jacques-Louis David's devastating portrait of Marat stabbed to death in his bath. For art was his passion; Snare was 'an amateur of pictures', as they were known: a lover of paintings.

How old he was then is unclear, for his early life has slipped from the records. He was probably born in 1808, but the birth certificate has gone and in later life Snare was inconsistent about his age. His father was an ironmonger at 21 Minster Street, selling hammers, screws and iron pails; his uncle was the founder of the shop at number 16, which originally specialised in selling hymn books and pious poetry for Sunday consumption. If Snare had

any education beyond the age of ten, in those days the school-leaving age in Reading, there is no documentary proof of it, but the documents are in any case less illuminating than the town's local newspapers – three of them, for a population of scarcely 20,000 people – in which one catches sight of the bookseller in his shop and about town, moving through the momentous events of his life as if through a magnifying glass.

'Snare and Nephew' is the new sign above the door when he is apprenticed to his uncle, who has now diversified into printing. The young John learns how to set the finicky rows of metal type in their wooden frames, ink the plates and gold-stamp the leather bindings of books. One day he will become known for the aesthetic beauty of his printing, and for experimenting with early photogravure engravings; but in the meantime the two Snares turn out visiting cards, election posters and theatre handbills in the back room behind the shop as the book business develops in the front. At night, when the presses are silent, Snare reads his way steadily through the stock to develop a writing style of his own, first evident in the lyrical passages he contributes to an illustrated Berkshire guide printed on the Minster Street presses. In 1838 he inherits the shop and in the same year, by now a rather mature bachelor for the times, he marries Isabella Williams, whose family has some involvement in the local bank. A man of buoyant aspirations, he starts a small lending library and begins to compile a local postal directory for Reading, setting his neighbours' names in elegant fonts. His own name appears in the 1847 edition, living with Isabella and their three small children above the shop at number 16, which is where he read the advertisement in the Mercury with its promise of the supposed Van Dyck. There were to be three viewings before the sale. He would be just in time for the last.

Victorian auctions were arranged like exhibitions, with advance tickets and printed catalogues, though these were generally crude

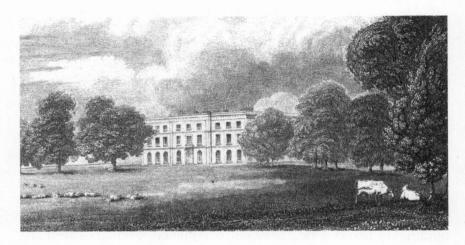

and unhelpful. What they declared, on the whole, was that a painting of an unknown gentleman was for sale, or a fish, or two cows drinking by a river. Possibly Dutch. So it was at Radley Hall, a Georgian mansion in grounds landscaped by Capability Brown where one could expect to see kings as well as cows, according to the terse catalogue issued by the auctioneers, Belcher and Harris. 'The whole assemblage consists of 180 lots, the particulars whereof it would be difficult to describe,' they shrug, making no attempt to talk up the art beyond the occasional stab at a painter or country of origin; not that there was any great risk in these guesses, which were often absurdly awry, for the unspoken rule of the auction was, and remains, *caveat emptor*: buyer beware.

Snare was no buyer, at least not at this stage; he was going to see a historic image of a famous king while the opportunity was briefly open to all. Yet he seems to have had a sixth sense about the painting, for he took along a fellow amateur, a Mr Keavin, for a second opinion of the portrait of Charles and the teasing mention of Van Dyck, greatest of all his court painters; who knows, perhaps the picture would be worth a king's ransom.

The journey on one of the new steam trains out of Reading, stopping at every little station, was so laborious that the light was already failing when they reached Radley Hall. But this time Snare

was prepared. He waited until the other visitors had gone and then dragged a ladder from the library into the salon where the large painting hung high on the wall, so darkened by time that they could hardly make out the features. Clambering up until he was eye to eye with Charles, Snare wet a finger and rubbed the surface like a window cleaner. 'I never can forget the impression,' he wrote, 'as the tones came alive like magic'. Materialising before him was the face of a young man, bearded, dark-eyed, solitary, a faint dew on his brow, looming pale and close in the gloom, a monarch destined to die on the scaffold.

The more he stared at the painting, amazed, the more John Snare began to feel that the catalogue, such as it was, must somehow be wrong. The portrait certainly showed Charles, wearing armour, but he was too young to be king; so this must be Charles as a prince. But if it was a portrait of *Prince* Charles, then it couldn't possibly be by Van Dyck, for the Flemish painter only arrived in England in 1632, eight years after Charles had become king, and by which time he looked considerably older. It did not seem that 'Charles the First (supposed Van-dyke)' could be entirely right.

Snare the autodidact, haunter of auctions, close student of engraved reproductions, and of all the prints of kings that he had managed to collect or discover in the many books in his shop, recognised the young Charles immediately. But he could not recall a single image that looked anything like this portrait, so fluid and enigmatic, not even in the prolific works of Van Dyck. This was surely by an artist of equal stature, if not higher still – he was thinking of the Spaniard Velázquez.

On the way home, Mr Keavin urged his friend to return and bid, convinced that they really had seen a genuine Van Dyck. Snare had already resolved to do so, but managed to keep quiet.

'The lovers of Art are well acquainted with the fact that no productions are more rare in England than the works of Velázquez.' The opening line of Snare's 'Brief Description of the Portrait of Prince

Charles' acknowledges the glaring impossibility straight away. No matter how thrilling it might be to come upon a Van Dyck, the Flemish painter's portraits of Charles with languid eyes and flowing hair were practically ubiquitous compared to the art of Velázquez. Not only was Velázquez one of the least productive painters of all time but his works were still very rarely seen outside Madrid, still less in some defunct boarding school in rural Oxfordshire. Snare knew that the chances were infinitesimal, yet he could not help taking a whisper of hope from one of the books on the shelves of the Minster Street shop, Richard Ford's recently published A Handbook for Travellers in Spain.

Based on a four-year tour of a country that still seemed as remote as the South Pacific to most readers back home, Ford's vigorous guide is an early masterpiece of travel writing. It runs all the way from awe at the sublime sierras to disgust at the worst hotels, is deeply versed in history and culture and at the same time bristling with useful tips on mosquito nets, drinkable water and Spanish cheese, where to send a telegram and how to discuss politics with a quick-tempered Madrileño.

Ford looks at paintings wherever he goes and writes superbly about them. He is amazed, above all, by the truth and beauty of the art of Velázquez in the Prado. 'No man,' he observes with piercing acuity, 'could draw the *minds* of men, or paint the air we breathe better than he.' His close praise of each painting in the museum, in a land so far beyond the comfortable circuit of the Grand Tour, was at least partly responsible for the rising passion for Velázquez in Britain; and it is in this book that Ford speaks in passing of a portrait of Prince Charles painted by Velázquez in 1623. The author laments the fact that he cannot see the painting, mentioned in an early Spanish biography; as far as he knows, it has not survived.

If the much-travelled Ford thought it was lost, then how could Snare possibly have found it? The mention only made the bookseller more hopeful. Though he was leery of confessing his dream to Mr Keavin – 'I was half ashamed of my own thoughts, and afraid lest I should be mocked' – Snare could not help reasoning that if it once existed, then the portrait might still exist somewhere in the world even now, and why not, perhaps, in Radley Hall?

The day of the auction arrived, along with dealers up from London and rich country squires with empty walls to fill. Perhaps the painting would be snatched by a higher bidder, whisked away at the eleventh hour by someone who knew its true worth far better than Snare, someone with deeper pockets, more experience, a connection with the London market. Or then again perhaps the opposite would happen, and the picture would be comprehensively scorned as scarcely a Van Dyck, let alone an actual Velázquez. Which would be worse for the hopeful amateur: to be trumped, or to bid for what might be nothing at all, thus making a fool of oneself before the cognoscenti? Two London dealers, Mr Blaker of Covent Garden and Mr Street of Soho, were already circling on Snare's arrival at Radley Hall. His courage instantly faltered. Indeed he was so fearful of drawing attention to the Velázquez by staring too fixedly at it that he stood directly below, where he could not see it.

As the auction began, Snare seems to have become so afraid of showing his hand, or perhaps of making some hapless gesture mistaken for a bid, that he actually asked Street to represent him. Taking pity on this provincial bookseller, the metropolitan dealer condescended. Lot 72 was announced towards midday. The bidding started at five pounds; the hammer soon came down at eight.

In that winning moment two opposing waves of emotion overcame poor Snare – swiftly departing joy, followed by listless deflation. Perhaps he had bought nothing, a pig in a poke; after all, he could scarcely see what he had in that blackened rectangle. The price was low, not much more than the cost of a horse in Victorian England, a fact that worried Snare (who had nerved himself to bid all the way up to a ruinous £200 if necessary) and a figure that would arouse some suspicion in years to come.

But the market price of a painting is no proof of its authenticity or value, and it never has been. The history of the art trade is full of ridiculous misattributions and preposterously low bids, up to and beyond Leonardo's Salvator Mundi, which changed hands for a mere £45 in 1958. Two years after Radley Hall, Richard Ford himself bought one of Velázquez's royal portraits for only £13. Ten years later, as the mania for Velázquez was growing, another of his paintings went for a nugatory £15 at the height of the London season in a room dense with international dealers, and at the turn of the twentieth century Velázquez's Christ in the House of Mary and Martha, which still haunts visitors to the National Gallery in London with its strange double world, as if seen through a window, sold for not even £23. In fact, Snare would soon be offered one hundred times the price he paid that day at an obscure country-house sale, but for the moment he had to leave empty-handed, for he had given no thought to how he might ferry the picture home.

The following day he returned to the village of Radley and found a carpenter to knock up a big wooden box in double-quick time, which the two men lugged up to the Hall. But to Snare's dismay, they arrived too late. All the other bidders had long since retrieved their purchases, Radley Hall was locked and dusk was once more on its way.

It was the carpenter who suggested breaking into the building. They were just clambering in through the window that he managed to jemmy open when a neighbour caught them in flagrante and sent for a policeman to arrest them on the spot. The bookseller's good name was momentarily in doubt. But after a sensible discussion, helped along by tea, during which Snare must have been remarkably silver-tongued, the policeman offered his sympathies and even helped them acquire a front-door key. They got into the building, only to discover every door inside firmly locked.

'I began to wish I had never seen the Picture in the first place.

I felt almost ashamed to return again to Reading.' But home went Snare, empty-handed once more. It was the first of his troubles with the law.

The painting finally reached Minster Street a week later. What Snare now owned was an object in a box; a painting without a past, about which he knew nothing whatsoever. He had not seen it in a museum supported by some reassuring caption or catalogue. It had no signature, title or date. The painter was unknown and the whole modern apparatus of art history, critical writing, markets, prices, painstakingly researched provenance and all did not exist. The painting had no context, had just spoken to him out of the darkness. Snare had nothing to rely upon but his eyes and his instinct.

Radley Hall had at least lent a fine elevating grandeur to the portrait. At home, in the back shop, Snare could hardly bear to look at the thing in case it had reverted to the grimy rectangle of his first sighting. But he steeled himself, propped the picture on two chairs against the wall, and was instantly more despondent than ever. 'The paint was dry and husky . . . and there was a chalky aspect which very far from pleased me.' The masterpiece seemed to dwindle in its Minster Street surroundings and Snare could not tell whether the fault lay with the picture or its filthy condition. He fetched a sponge, dampened with a little turpentine, and proceeded to give the surface a half-hearted dab.

'I never can forget the impression which the sudden change induced. The drapery, as if by magic, came to light, the fair proportions of the figure and the brilliant tones in which it was depicted, all in an instant glowed before me. I saw the masterly treatment of a mighty artist and without time for reflection, I started from my chair and ran to fetch my wife and show her the treasure I possessed.' He could neither eat nor sleep and sat staring at the picture until three in the morning, rising early to sit before it once again. 'I was alive with exultation, and thought of nothing save only that I had found the long-lost Portrait.'

Later that morning, Mr Keavin called in to take a proper look at 'their' Van Dyck, enthusiastically repeating his opinion as if it were gospel. But still Snare kept his thoughts to himself. He was already a true believer – 'I could have vouched for the authenticity of the Portrait even as if I had seen it painted' – but he needed some kind of proof before he could reveal his conviction to anyone except Isabella. The difficulty was where to begin. Snare had no idea where to look for clues to the painting, its history or even that of the artist himself.

The Painter

Velázquez is sometimes said to be the most distant of artists, remote and inscrutable as a star in outer darkness. His life is unknowable, his mind unfathomable, his genius for creating illusions of living people almost beyond comprehension, as if he were not quite a real human being himself. Even in death he manages to escape. Some years ago, to mark the fourth centenary of Velázquez's birth, the Spanish government excavated not one but two churches in the hope of finding his corpse, digging cavernous holes and stopping traffic for months in the centre of Madrid. Still nobody knows where – if anywhere – his body now lies.

It is true that Velázquez remains strangely beyond the reach of documented fact. We know he was baptised in Seville on June 6th 1599, the eldest child of a church notary, Juan Rodríguez de Silva and his wife Jerónima Velázquez, though the date of his birth is not known. The family lived in a two-storey building in a maze of cramped streets. The house is still standing, but closed to the outside world; to go there now is to learn nothing of his boyhood four centuries ago except that the sky was visible in narrow blue bands above the alleys, that the fish market was close, that the cathedral bells were clankingly audible.

We could say he led a sheltered life. At eleven, Velázquez moved a few streets across town to become the star pupil in the studio of the artist and scholar Francisco de Pacheco – 'a gilded cage of art' an early biographer called it – qualifying as a master six years later.

At eighteen, he married Pacheco's daughter, which might seem convenient or prudent, but who knows what was in his heart. Nothing much is learned about his bride except that her name was Juana and she may (or may not) have been the model for a painting of the Virgin Mary. One early trip to Madrid in search of patrons was unsuccessful, but the next produced an immediate commission from the teenage Spanish king, Philip IV. Velázquez was hired as royal painter to the court, over the heads of more senior artists, in 1624. He now lived in a larger gilded cage. Many people thought his art was some kind of magic. Apart from two hard-won trips to Rome, from one of which he attempted not to return, he never left Spain and scarcely travelled outside the court, where he was eventually promoted to the rank of King's High Chamberlain. This is what the early documents tell us, at any rate, but they reduce a life at least as complex and profound as any other to a childish fable.

But pass through the looking glass into the world of his art and Velázquez becomes visible straight away, literally so in *Las Meninas*. Here the painter presides like a father figure over the bright party he has conjured, a man of intense tact and restraint who is clearly holding back, stepping into the shadows, not the spotlight. Nonetheless he is making an appearance, and in the full regalia of office too – tucked into his belt is the emblematic master key that opens every door of the Alcázar (freedom of the palace, highest honour); emblazoned on his doublet is the red cross of the Knights of Santiago, the noble order to which he was eventually elected. Around him are his colleagues and friends, as well as his royal employer in the person of the little princess. Here is Velázquez's life – and what the painting declares (among all its infinite nuances) is that this life, like the scene itself, was entirely made by his art.

It is beyond belief that people should say, as they frequently do, that the painter gives nothing away in this self-portrait. Look at the little dots of pigment on his palette: they echo the chain of faces in the room, as well as the colours needed to make the painting, repeating the central compositional truth that the artist is responsible

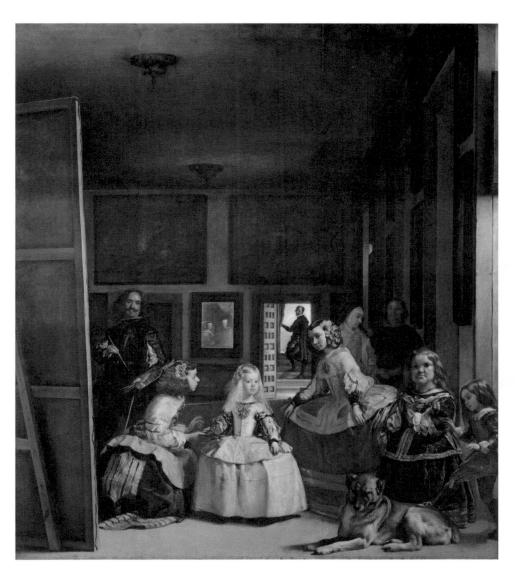

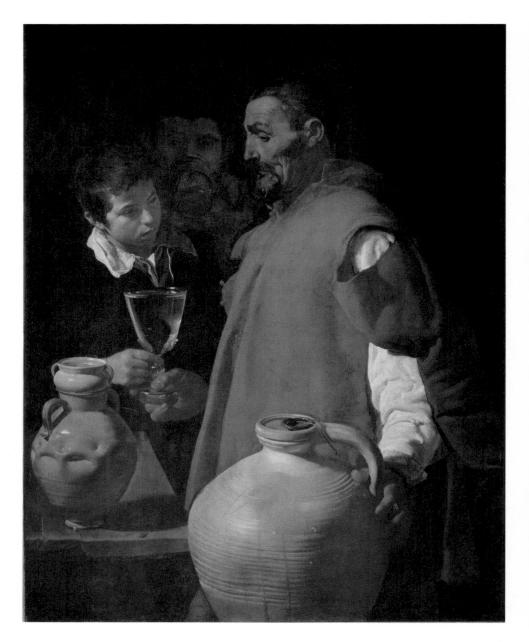

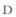

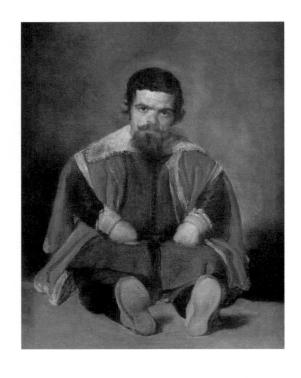

for everything you see. Look at the way Velázquez paints his tapering fingers as if they were brushes. Look at the actual brush; that it is no more than a darting streak of white, the one mark that is illegible at any distance and yet so sharply itself, feels like the subtlest of quips. The whole painting has been set in motion by its delicate tip – which effectively vanishes. No other artist before or since has made the paradox of painting so manifest, the strange idea that three dimensions can be persuasively portrayed on a flat sheet of cloth with paint colours and a brush; or, in his case, that fixed pictures can represent the mobile, ever-changing world around us to such a pitch and yet themselves dissolve into flux.

Given the existence of *Las Meninas*, it does not seem so bad that we have scarcely a single document that gives any sense of Velázquez's inner life.

About his professional career a great deal is known. One memoir was published during the artist's own lifetime, another written when people who knew him were still alive to give their recollections. Both are brief, just single chapters in longer books, and the second makes shameless use of the first. But they are the starting point of all our knowledge to this day, the vital biographical sources for anyone in search of Velázquez. John Snare, in 1845, had to search hard for them both.

The first memoir was a seventeenth-century fragment written in Spanish. But Snare was undaunted; he soon had the name of a reputable scholar (Mr Vizer: everyone who ever helps Snare is touchingly named in the pamphlets) who would translate it into English. The second was contained in an influential work much mentioned by Richard Ford and already published in English by 1739: Antonio Palomino's *Lives and Works of the Most Eminent Spanish Painters*. Palomino was an artist himself, had even been royal painter to the Spanish court some decades after Velázquez. He gives us almost the only surviving anecdotes about the painter and writes beautifully about the mysteries of his work. But the pure gold in his brief

biography – to Snare, as much as to us – is the description of actual paintings. Without Palomino, we would know even less about certain lost works; and for Snare, in the middle of the nineteenth century, the Spanish writer could give a vital impression – only an impression, but better than nothing – of how and what Velázquez painted, of paintings that Snare would never see. What he didn't know was just how close some of them were to him in Reading.

Richard Ford, in his Handbook for Travellers to Spain, urged his readers to make the journey from England to Madrid, no matter how gruelling - a week by ship to Cadiz, several more by carriage on roads rocky enough, he complains, to dislocate a hip - for the chance to see the art of Velázquez in the Prado. 'Here alone is he to be studied in all his protean power. Look therefore at every one of his pictures, for we ne'er shall see their like again.' But in fact several paintings had already made the journey in reverse, reaching England by even more circuitous routes from Spain. One of them came through seventeenth-century Belgium and eighteenth-century Paris to a London auction in 1813, where it was bought by a haberdasher named Samuel Peach in a temporary case of mistaken identity; the picture was unsigned and was listed as the work of a different Spaniard altogether, the ever-popular master of angels and urchins, Bartolomé Murillo. But there was a date on the canvas - 1618 - and what it reveals about this dazzling performance is an exceptional truth about Velázquez: that his genius was there from the very beginning.

The scene is a darkened tavern filled with objects, each gleaming in its own spotlight. A red onion, an egg, a white bowl balancing a silver knife, a brass vessel full of reflected glory: all appear as if laid out on an altar, singular, mysterious and sacramental. Velázquez pays the greatest respect to each humble item, and each is painted with mesmerising beauty. Even the strung melon cradled by the young boy on the left shines like some strange new gift to the world.

This boy and the old woman cooking eggs are not quite types, and not just models, but portraits of people in Seville, where Velázquez painted this masterpiece when he was not much more

than eighteen. They will reappear in other pictures, like the company of actors in the films of Ingmar Bergman. There is no interaction or dialogue in this early scene, however, and the stage directions are obviously minimal. Each person is simply to pose, lost in thought, for their role is very like that of the teenage prodigy who is painting them: to show off these objects – the eggs, the melon, the reflective glass flask – to hold them to the light and our contemplation.

The whole tableau was visibly made to bewitch, and so it does. But at the quick of it is a feat of staggering veracity: the starspangled pan of eggs coalescing from translucent fluid to opaque white flux, a moment in which liquid becomes solid, acquires visible form – just like the magical illusion of painting itself. It might be Velázquez's own emblem.

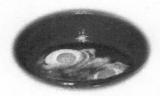

These early kitchen scenes show earthenware pots and jars, pitchers of water and wine, the heavy hands and faces of Spanish workers, with the same unsurpassed realism and respect that Velázquez will later extend to inbred Hapsburg kings. But they give us something of his way of thinking too. For even just to paint such subjects, no matter how superbly, was to defy everything his teacher represented. Francisco de Pacheco's career was in religious art; he was the censor of images for the Inquisition in Seville, and among his many friends were theologians who gathered to discuss religion and philosophy at salons in his house. A notorious dispute about the number of nails used to crucify Christ occurred at one such meeting; Pacheco thought four, not three, a conviction pedantically restated in his frigid altarpieces. Yet his pupil went right against the grain; Velázquez painted hardly any religious paintings in any case, but those that survive are on our side of life - deeply and radically human. The old woman from the tavern, for instance, reappears later that same year in the foreground of Christ in the House of Mary and Martha, no longer frying eggs but bossing a young maidservant in the kitchen. Their world of mortal, palpable reality is much larger than the little Bible story behind them, viewed as if through a frame in this split-screen picture.

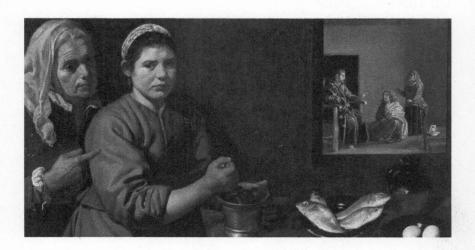

In the background Christ is in mid-parable in what might be a painting, a window or some peculiar hatch in the wall behind the old woman and the girl with the swollen eyelids, who has surely been crying only moments before we see her – and she sees us. For whatever else is going on in this haunting picture, with its silvery still life of garlic cloves, eggs, fish and chilli – another theatre of glinting objects – what strikes first and foremost is this potent relationship between the girl in the painting and the viewer outside. We look at her and she looks back, apparently conscious of our looking. The whole picture stages that connection. There is a premonition of *Las Meninas* here – of seeing and being seen, of the picture as an open-ended performance – when Velázquez was not yet twenty.

This painting was only a train journey away from Berkshire in Snare's day, but it was in social respects entirely out of reach. It belonged to Colonel Packe, who had led several campaigns during the Peninsular War and brought the painting home from Spain as a kind of souvenir to Twyford Hall in Norfolk. A carpenter's bill charges Packe twelve shillings in 1833 for restoring the picture by this strangely named foreigner, 'Valest'. The spelling is second-hand guesswork; naturally there was no signature on the canvas.

Palomino tells us that although the Seville paintings were revered throughout the city for their solid and breathtaking veracity, they were also criticised for being too low-life, with the implication that the rebellious young prodigy ought not to waste his talents on kitchens or crockery. Velázquez, in one of very few recorded remarks, apparently retorted: 'I would rather be first painter of coarse things than second in higher art.' But by the time he reached Madrid, where his subject was the court and his art would become astonishingly evanescent, he was first in both and did not have to choose.

Palomino takes the remark from Velázquez's first biographer, none other than Pacheco himself, whose mediocre gifts as a painter were so eclipsed by his pupil. Infuriatingly brief, given the little we know of Velázquez as a living man, this chapter in Pacheco's *Lives of the Painters*, published in 1649, is also effusively proud; not just because the pupil was so elevated at the royal court, but because he was also the author's own son-in-law.

Pacheco opens with unintended bathos by placing Velázquez up there with Titian and one Romulo Cincinato, of whom not a single painting is now highly regarded. He praises his pupil's virtue, chastity and so forth, and then offers an oleaginous thank-you to Philip for having Velázquez to stay all these years at the palace. Much boasting, name-dropping and talk of money ensues, until the reader could cry out for some mention of the art or the character of the man who made it. But sift the narrative and occasional gleanings emerge, the first of which is the story of how the young painter of low taverns came, with great rapidity, to become the high star of the palace.

In 1623 Velázquez travels to Madrid in hope of advancement, taking with him a painting known as *The Waterseller of Seville* (Plate B). There he meets a high-placed churchman from Pacheco's circle, Juan de Fonseca, who is now chaplain to Philip IV. Amazed by the painting, Fonseca buys it immediately; Velázquez then paints Fonseca, a feat evidently achieved in the space of one day, for that very evening a chamberlain rushes the portrait over to the Alcázar. 'Within the hour everyone in the palace saw it, the Infantes and the King himself, which is the greatest distinction it could receive. It was decided that the artist should paint his majesty.'

This is the classic Velázquez anecdote: a portrait made for a purpose, with extraordinary rapidity, which is then shown around town while the paint is still wet, to the amazement of all who see it. This will happen more than once. Pacheco, ever pedantic, concedes that His Majesty was too busy to be portrayed *straight* away – he had obligations to a visiting guest, the young Prince Charles of England – but that an opportunity arose a few days later and the sitting took place on August 30th 1623.

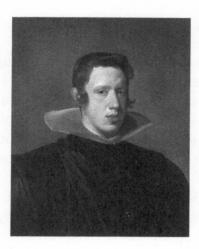

Philip IV was eighteen when he first posed for Velázquez. Puffy, adenoidal, so pale the blue veins are visible beneath the clammy white temples, with no sign yet of the famous upturned moustache that will attract attention away from the protuberant lips and long Hapsburg jaw: the early portraits are more truthful than flattering, which may be why the very first, painted that August day, has vanished beneath the surface of another version, one of three more painted that autumn. Still everyone was stunned; the gentlemen of the palace agreed that the king had never truly been portrayed until now, and the king decreed that nobody else should paint his person henceforth (a rule broken only by the infinitely more famous Rubens, visiting court a few years later).

The first portrait sets off a chain reaction. Velázquez is given a royal salary and payment for each separate work on top. A month later he paints an equestrian portrait of Philip so fine that poems are written in awe. A salary rise follows, and a pension granted by the Pope to the tune of 300 ducats a year. And then, the clincher, Velázquez wins a painting contest set by the king, beating all the established court painters who had worked for Philip's father before him, and whose rancour begins to leak into palace conversations.

The winning prize is the job of Usher of the Bedchamber; it is the first rung in Velázquez's ascent of the ladder.

Pacheco's biography is painfully limited in all the aspects that matter, but it does give a sense of the sudden surging miracle of Velázquez's early career; and the facts are borne out by evidence. Two anthologies of documents have been published in the last forty years, the latest containing more than four hundred details mined from financial and legal statements, state papers and court archives by some of the greatest of Spanish scholars, yet they scarcely give us the man. Velázquez slips away.

We know, for instance, that he had two daughters in his early twenties, Ignacia and Francisca. Death certificates show that both girls died before their father - one as a child, the other as an adult - so that it is possible to imagine the agonising grief, or the guilt, or the constant sorrow: but there is no evidence of how their deaths affected him (unless, perhaps, you look into his paintings). We know that a third child was born in Rome, when he was fiftyone, a son named Antonio. But Velázquez had already returned to Spain, and of this infant and his mother not another thing is heard. We know where he lived in the Alcázar at various times (East Wing, then West Wing, then in a two-floor apartment) because the palace records are meticulous, if sporadic; how much he was paid - or not paid - for specific offices and duties; which books were in the studio at his death - Herodotus, Pliny, Aristotle and Descartes, works of history, geometry, poetry and astronomy - perhaps revealing at least something of his intellectual interests. unless one considers that they were amassed during his early days with Pacheco. We know in fine-grained detail all about Velázquez's administrative roles, the taxes he owed, the pictures he purchased for Philip's collection, the Turkey carpets he possessed (or was given by the king, or bought as gifts for his wife: who knows?); and one of these exemplary scholars has even managed to unearth a literary fragment from Velázquez's wedding that promised to release some spirit of the occasion. Written by another of Pacheco's

friends, this dry skit plays on the name of one of Seville's patron saints (Diego). It is typical that it should offer a tiny background detail – a punning speech at a wedding – while giving us nothing whatsoever of the bridegroom.

Velázquez was born in the high summer of European painting. He was alive at the same time as Caravaggio, Rembrandt, Rubens and Poussin, all of whom were famous abroad in their own lifetime, as Velázquez was not, and about all of whom we know something comparatively intimate: Caravaggio's violent crimes; Rembrandt's bankruptcy, sorrow and destitution. Poussin's thoughts about art and life are conveyed in many personal letters. Rubens's full life is so abundantly documented that we even know what he thought of Philip IV (hesitant, under-confident, too easily led by his politicians) and of the young Velázquez (modest).

But Velázquez seems sunk in mystery still. It is unusually difficult to work out when his pictures were painted because they appear in job-lot payments in the court archives; they have no titles or inscriptions, and he rarely dated them. We don't truly know how many he made. He left no letters concerning his works and seems to have said nothing, or at least nothing that was ever recorded, about them. There are no personal writings and we scarcely even have a signature to scrutinise, in the hope of finding something expressive in its movement or shape.

It is clear that Velázquez had friendships with writers, sculptors and palace colleagues. At least three assistants were working with him at different stages: the Moorish slave Juan de Pareja, who stayed with him for years after he was given his freedom; the painters Juan Bautista Martínez del Mazo, who in turn became his son-in-law, and Juan de Alfaro, who made a most poignant drawing of the master on his deathbed and offered his recollections to Palomino. Velázquez made connections everywhere he went with fellow painters, and he never forgot a friend: the visual proof appears in the course of a lifetime's portraits. Yet among these friends, and at court, there is no sense of the living man. Nobody

leaves a record of their conversations with Velázquez; scarcely anyone mentions meeting him socially, or indeed his presence at royal occasions. It has become a cliché to compare his art with that of Shakespeare, but he is like the Bard in just this respect: a fine mystery, in the words of Charles Dickens. The sense of him is of a man in the corner of the gathering, watching and observing, saying nothing although he understands all.

But of course we do have deep knowledge of Velázquez as a man, of which we can be certain, what is more, and this is what his paintings give. We know where he went, who he met, how he felt, what he saw with his own eyes – we even have the revelation of how he wished to be seen and known, within and without, in *Las Meninas* – because the pictures show it. We have what Snare never had, the chance to know Velázquez through his work.

In one sense, our understanding has advanced very little since Snare's day in terms of hard facts. Those early biographies, particularly that of Palomino, have never been exceeded and they contain all the scant anecdotes that give us a sense of high Spanish pride. Velázquez must have hoped for a wider audience than the shuttered Alcázar or the gloomy Escorial outside Madrid, which was his only other home, for Palomino tells us that he went so far as to display some of his paintings in public. The equestrian portrait of Philip was set up outdoors in the open air by the Calle Mayor, buzzing epicentre of Madrid, where the citizens came to stare in reported amazement. Juan de Pareja carried his own magnificent portrait by Velázquez through the streets of the Eternal City so that the Romans could compare the reality with the painted illusion. The devastating portrait of Pope Innocent X, also painted around 1650, was exhibited under the porch of the Pantheon.

Artists were his best judges, never courtiers. When the equestrian portrait of Philip was presented at court in 1623 and actually *censured* 'for being done against the rules of art but with such contradictory judgments that it was impossible to reconcile them, Velázquez,

annoyed, wiped out the greater part of his painting'. Not in compliant acquiescence, but quite the reverse: to show that the same power that created this world could also destroy it.

On the canvas his superb reply was painted: 'Didacus Velázquius, Pictor Regis, *Expinxit*' – Diego Velázquez, Painter to the King, *Unpainted This*.

The picture, with its deleted horse, has itself now vanished – along with that first likeness of the king and the legendary portrait of the king's chaplain, Fonseca.

If his way of painting remains extraordinarily elusive – it was frequently described as a miracle in his day – the paintings give us so much of the man. We are able to see from them that Velázquez never copied anyone else, never struggled against aesthetic influence, always went his own way. Everything he did was original, and in every genre. His landscapes are unprecedented; his still lifes almost sacramental; his fables are real and human. He invented a new kind of pictorial space and a new kind of picture in which consciousness flows in both directions. His portraits are not just the living, breathing likeness, but the seeing, feeling being in the very moment of life and thought. Nobody has ever surpassed his way of making pictures that seem to represent the experience – the immediacy – of seeing in themselves. He is the taciturn revolutionary among them all.

Perhaps Velázquez had some deep sense of his own dramatic journey from provincial still-life painter to *Pictor Regis*. One small but crucial fact reveals a profound attachment to the painting that brought him from Seville to Madrid, which was effectively the origin of everything that followed: the old man selling water in Seville.

The picture shows a working man with a lifetime's experience, wizened and poor in his gaping garments, but with his sorrowful dignity intact. The boy (that same boy) lowers his gaze alongside, taking the water with respect; without this man, he might have been thirsty, without water who can survive? Their two hands

meet, holding this cheap but infinitely precious substance. Velázquez takes the most banal of transactions and gives it the significance of a parable.

The glass is an inordinately refined object containing a floating fig, perhaps there to flavour the water, but still a tremendously difficult illusion to paint. The immense terracotta jug, irregular in shape and discoloured by misfiring, changes colour and texture as a trickle of water leaves its trace down the surface. Velázquez was not twenty when he painted this scene and for all the many interpretations that have been put upon it – an allegory of age, prudence or Christian charity, a scene from a picaresque novel with the old man as a comedy beggar, a portrait of the Greek philosopher Diogenes, who was thought to have slept in a huge ceramic jug – it must at least be said to show a young artist selecting objects in order to display his ability to overcome the exceptional challenge of painting them. The glass is like the frying eggs. This mastery goes with the mysterious and sombre atmosphere of the picture: it dazzles in the same degree that it puzzles.

As for the idea that the waterseller – so stoic, so dignified, deeply respected by the painter as well as by the boy – was some low comic beggar, one wonders whether that commentator was looking at the same work of art.

When Fonseca died in 1627, Velázquez wrote an inventory of his art collection in which he gave the highest price to *The Waterseller*, and then he promptly bought it back. The chaplain's widow benefited, no doubt, but so did Velázquez. This early painting mattered so much to him that he never let it go again; this is what we know. He kept it with him until the end of his life.

Minster Street

Reading in 1845 was a close-knit town and John Snare was right at its heart. His business was at the very point where the main roads converged – King Street, Gun Street, Yield Hall Lane and Cheapside, redolent of Shakespeare's London – in a little nexus of cobbles and diamond-pane shop fronts. The streets were narrow and the lives tightly interwoven; nobody moved far from home. Snare's parents lived in the next street, where his sister married a grocer, and his brother ran the hardware business five doors up at number 21. His bookshop was opposite Simonds Bank and hard by the George Hotel, the market and the stables where the stage-coaches changed horses and many travellers came to buy the

papers, which Snare sold, with their dense columns of local news, moral urging and gossip. There can hardly have been a citizen of the town who did not pass through his shop at some stage to buy stationery or books, to have their funeral cards and wedding invitations rolled through the presses, or just to get paper and string. People often dropped in, it was said, for the conversation. At Snare's you could see the latest prints, hear the latest news.

Yet the portrait of Prince Charles entered this tight little world silently, to begin with. Snare somehow managed to keep it secret and out of sight in the back room, as he struggled to grasp precisely what he had bought. Although the bookseller spent his hard-won leisure looking at art wherever he could, all the knowledge in the world couldn't begin to help unless he could actually see what he was looking at.

All old pictures, and even quite young ones, are affected by the universal dirt of ages: log fires, tobacco smoke, the human sneeze, the slightest breath, oxidisation, pollution, copious use of bitumen in the priming that eventually drags them into blackness, excessive use of varnish that turns the surface bleary and yellow. Paintings fade, colours change, blue dwindles to grey, green blanches to white, leaving curious blanks on the canvas. Red underdrawing starts to show through, taking over the scene; blue skies become overcast. For a painting to show no signs of age or any other form of degradation over time would be quite abnormal. Snare had bought his portrait in 'country-house condition', as it is picturesquely known - that is to say, neither cleaned nor restored; even today auctioneers may not tamper very much with a picture in this state in case it removes some of the mystery and allure. In fact he had hit upon the most expedient of cleaning agents when he dragged his wet finger across the canvas, creating a short-lived window of transparent brilliance before the spittle dried. But in hindsight he was appalled to have done so, considering the fragility of the surface. Canvas reacts to pressure, quivering and bouncing ever so slightly like the skin of a drum, and if the paint is as thin and fine as a Velázquez, the warp and weft may be palpable beneath one's fingertips, an irresistible reminder that the image is transmitted on and through a piece of fabric and is as vulnerable as the material itself.

Of course we are not supposed to touch paintings any more. They have one barrier in the glass that protects them, and another in the alarm system that separates them from us in the gallery. Even quite small children know that they are not allowed to step over the enticing toy-fences that run at shin-height around the world's museums. The impulse to touch a picture is never mentioned, as if it did not exist, even though a painting may carry the movements of the brush as part of its content, and viewers may imagine tracing that motion with their own fingers in turn, fellow-travelling through the image.

There are passages of such mystery in Velázquez's paintings that one wonders how he could know exactly where to place those dots, dashes, flicks and spatters of paint so that they represent the sadness in an eye or the dazzle of sunlight on a silk dress; how he could catch the exact moment when heat turns to condensation on a glass of cool water. His brushstrokes are at times so sparse they can be counted, and presumably felt, one by one, giving an intimate sense of his hand at work.

One longs to run a finger over these marks, to read them like Braille in an effort to understand how he could invent such a miraculously persuasive language of painting. If even the smallest of specks were dislodged, it might alter precisely what was written there, as with few other painters. Take away a dot and the gold brocade no longer glints; remove even a scintilla of eyelash and a sitter's whole expression changes. Every pinprick of pigment counts.

Snare had not only touched the picture surface, he had dabbed it with turpentine, which is good for cleaning varnish, but can take the paint away with it. This was a mistake never to be repeated. Instead he tried muslin dampened with water and more of the portrait became visible.

There was the familiar face of Charles as a young prince, not

yet a king, with his long pale face and silky brown hair; there was the fledgling Spanish beard he first acquired in Madrid. That came as a relief, for at least it confirmed that the picture could not have been painted before Charles went to Spain, when he did not have a beard (though it did not of course prove that Velázquez was the painter). The prince was wearing armour and holding a baton; in the background was some kind of misty battle scene viewed in miniature as if through an aperture, window or frame. Snare proceeded with the utmost caution, inching over the dirtblackened canvas on the brink between hope and despair in case he found anything anomalous. But so far nothing ran against him. There were the greys, blacks and silvers that belonged to Velázquez's portraits, the tones blended wet-on-wet that seem to glow; the airy transitions, the characteristic lucidity and restraint praised by Palomino. The prince materialised before him, and Snare - like so many viewers before and since - was mystified by the illusion. 'The spectator,' he wrote, 'does not see how it has been done.'

And yet he did not confide his hopes to anyone but Isabella. The Velázquez was still a Van Dyck.

When we look at a picture we see its surface: that may seem a truth too obvious to mention; yet it is not quite the only truth today. Snare could see nothing more than the uppermost paint, whereas we can also see the ghosts below, witness the artist's changes, corrections and earlier versions, even the fundamental structures that exist within paintings like the skeletons inside our bodies, those pale surrogates that live within us all. And we can see them with the aid of exactly the same technology, the microscopes and X-rays that can give an image of the inner life of the corpus. In the case of Velázquez, modern X-rays have turned out to be vital – extraordinarily so – to the identification and understanding of his pictures. We know from X-rays that the artist was originally leaning towards the canvas in *Las Meninas*, but then repainted his own image so that he now faces the world, and his

king, altering the meaning of the picture. We know from X-rays that he returned to portraits that had been hanging on the palace walls for years to improve them, shifting a foot, removing a hat, adjusting an expression or pose as if he had been scrutinising his own works with a critical eye every time he passed in the corridor. We know that he painted over portraits, and even that other artists may have done so, too. In 2013 X-rays revealed the spectral likeness of one dark-eyed Spanish gentleman painted by Velázquez that had been hidden for almost four centuries beneath another by Rubens, from his eight-month visit to Spain in 1628.

We also know that there would come a time when Velázquez's technique was so perfect that there was no need of a first draft, there were no false starts or adjustments. The paint is so fine it arrives on the canvas like a veil. In such cases the X-rays give nothing away, reveal nothing whatsoever beneath the surface. The magic is all before your eyes.

By the early weeks of 1846 Snare had learned enough to realise that the mystery of Velázquez's art could be disturbed by too much cleaning, so he took the picture to a London restorer, who was just as wary of troubling the surface any further and would only agree to line the back with a second canvas for support. But this man did rather more for Snare than he could have imagined. When the bill arrived in Reading, it came with a letter of unqualified praise. 'Sir, Your Charles is a Superb Portrait, the finest I have ever seen. In my opinion, out of the Great Collections, it is the Most Important Picture of the Man.'

Snare was euphoric to receive this endorsement from an expert – his very first expert – though slightly dashed to notice that the portrait was itemised as a Van Dyck on the bill. Still, he comforted himself with the thought that the Flemish painter was so well known as Charles's royal image-maker that the king's face probably existed in the popular imagination entirely *as* a Van Dyck rather than a Velázquez, of whom so little was known. This was the first proof positive for Snare's case.

The restorer closed with an emphatic warning: 'I must by all means advise you not to let it slip through your fingers.' John Snare took heed.

People now began to call in at Minster Street on the pretext of shopping, but always with an eye to the picture, hoping they might be the first to see it. Reports of this marvel were beginning to leak out around the market town – perhaps Snare, or one of his employees, could no longer hold back. The shop began to buzz with conversation and sudden new custom; and one afternoon an important carriage was observed outside the door. It belonged to Colonel Blagrave, who owned half of Reading and more, and who had come to view this new sensation for himself. Snare was out, but the foreman of the print-works showed the visitor into the back room for a glimpse. The stunned Colonel offered an astounding £1,000 on the spot, convinced that the portrait before him was not just another Van Dyck.

If only Snare had accepted the Colonel's figure there and then – vastly more than anyone had ever paid for a Velázquez in England before – his life would not have turned towards the coming disaster. But the foreman, William Webb, politely refused the offer, explaining with prophetic regret that his employer was not inclined to sell the picture at any price. Webb would testify to the truth of that fact, and the events of that day, in Scotland some years later at the trial that would divide Snare's life.

Instead Snare had a room specially fitted out for his treasure, a miniature museum for a solo masterpiece. He now wanted everyone to see it. Notices of the picture on view at 16 Minster Street appeared in the Reading newspapers in the summer of 1846 and visitors began to pour into the shop. Fellow printers, fellow shopkeepers, school teachers, school children, the local MP, the local clergy, amateurs of every stripe: 'likely every citizen of Reading and hereabouts', as the foreman would later testify.

Everyone admired the painting; and almost everyone thought it was a Van Dyck. 'I would have given much to have heard one

person express a doubt leaning towards the supposition I had so long cherished . . . but I was silently prosecuting my inquiries.'

Portraiture is the art of living beings, of the live encounter between two people; the painting depicts the fact that they were both there in the same place at the same time, that they breathed the same air. That the artist was there with the subject is part of the amazement inherent in certain portraits: that David drew Marie-Antoinette in a mob cap on the tundril only moments before the guillotine; that Goya met and painted the Duke of Wellington in Spain; that Charles was ever in Madrid and that so unique a painter as Velázquez saw the young prince, before he too was executed, and depicted his living presence. This is one axis of portraiture, where the artist's presence is part of the picture's content, and the extent to which this is the case with Velázquez is apparent in all of his portraits. He sees the sitter, and the sitter looks back, responding to his penetrating intelligence. Stand before Las Meninas in the Prado, where Velázquez looks directly out at you from the shadows, and you may have exactly this experience today.

Snare was fascinated by this passing encounter between Velázquez and the future King of England, and almost overcome by the thought that he might have the visual evocation of that very day right there, crystallised for ever, in his Minster Street room. The colours of the Spanish flag might even be represented in a yellow and red curtain, draping over part of the globe, which had become apparent during the nerve-racking cleaning. But how could these two men have met, how could this portrait have come into existence? Snare needed more detail than Richard Ford's *Handbook* could supply, and he began by taking a train to Oxford and applying for a ticket to search in the Bodleian Library.

Charles, son of James VI and I of Scotland and England, was an impetuous and callow young prince of twenty-two in thrall to his father's favourite, George Villiers, Duke of Buckingham, in the year the portrait was painted. The two men dreamed up a secret

plan to end centuries of hostility between Britain and Spain by travelling in disguise under false names - John and Thomas Smith - across Europe to Madrid, where the Protestant Charles would somehow win the hand of the king's young sister, the Catholic Maria Anna. The two nations would thus be united by marriage. But the Spanish Match, as it is known, rapidly turned into one of the high farces of European history: Charles and Buckingham disguised as the Smiths in their wigs and false beards, nearly unmasked before they have even left England, violently sick at sea before they reach France, identified by German tourists outside Paris so that they have to reinforce their disguises with French periwigs, rustling goats for food and picking fights with the locals en route, arriving at the most rigidly formal court in Europe without invitation or warning. Their appearance, in March 1623, seems to have taken Philip so genuinely by surprise that everyone had to pretend the two Englishmen were more or less invisible for a week, until a sufficiently formal reception could be organised.

Snare came across a volume of letters known as *The Prince's Cabala; Or, Mysteries of State*, still regarded by historians today as one of the richest written portraits of James I's court. Among the correspondence is an anonymous tip-off to James concerning Buckingham's shocking behaviour in Madrid, in which the duke is depicted sitting when he should be standing, raucous when he should be quiet, putting his feet up on the royal chairs, wandering about half-naked, calling the prince by insultingly ridiculous names, dishonouring the Alcázar with prostitutes, threatening the apostolic nuncios and ranting about the pecking order at banquets, as well as about the entire culture of the Spanish court, behind Philip's back.

Buckingham undermined the mission at every turn with his gall, although modern scholars have been able to show that each side seems to have been equally duplications in the masquerade of diplomacy. The Spanish interpreted Charles's sudden arrival as a declaration that he intended to convert to Catholicism forthwith,

while Charles believed that a royal marriage - on the cards as far back as 1604, with his older brother Henry as prospective groom - was a virtual certainty, whatever he did. There were hideous misunderstandings from the start: Spain put on banquets, plays and concerts, produced bishops and nuncios for persuasive discussions of Catholicism; England sent out high-church Anglicans to convince the Spanish that it, too, had its incense. But Maria Anna had no intention of marrying a Protestant and the longer the prince lingered, failing to convert, the harder it was for the Spanish to eject him without delivering a lethal insult to the English. The Count-Duke Olivares, Prime Minister, puppet-master and favourite of Philip IV, engaged in some complex skulduggery to thwart the match, involving not one but two successive popes in devising conditions for the better treatment of English Catholics, which they knew James could never accept. The weeks turned into months

By late August the two sides were playing out the endgame, each still pretending the match might take place. The Spanish were exhausted by the charade, running out of money to pay for any more tournaments or feasts. The English were irritable, homesick and restless. One of Charles's pageboys had died of heatstroke, and fights between servants and soldiers were breaking out. These were the circumstances in which the English prince sat for Velázquez.

It is possible that the ingenious Olivares – Spain's true ruler, it was said – personally contrived the sitting as a sop to the unwelcome guest. Perhaps it was a way of passing time or a diplomatic gesture, flattering to Charles's refined tastes, for the prince had been buying, or trying to buy, works by Titian, Tintoretto and Leonardo from their reluctant owners all through the visit. Or perhaps it was a diplomatic gesture in reverse: Charles commissioning Philip's new painter as a sign of respect towards Spain. At the very least it seems that simple curiosity overwhelmed Charles, as it would over and again in the decades to come: the desire to see how he appeared – to see who he was – through the eyes of a painter.

Charles was attuned to art from childhood. His older brother, who would have become Henry IX had he not died of typhoid at eighteen, was compulsively interested in art. England's Lost Prince, as Henry became known, built a picture gallery for the portraits of Holbein and Hilliard, and was involved in designing the first bridge across the Thames at Westminster when he fell ill. His face, with its gleaming blue eyes and vivid smile beneath a tawny quiff, looks out from so many portraits by foreign artists at the English court that one has a sense of his appearance developing almost from birth. Charles was there when Henry died and so stricken with grief that he tried to resurrect his brother by commissioning a portrait from the Dutchman Daniel Mytens, which seems to conflate elements of both boys in a dreamy posthumous vision. Charles hung the painting on the wall opposite his bed, where he could see it on waking each day.

Sickly from birth, Charles suffered from rickets and could barely walk until the age of four. As an adult, he was barely five foot three, fragile and weak, constantly trying to build himself up with strenuous hours on horseback. The early portraits by Mytens show a wary rather than confident intelligence, a narrow-shouldered youth trying to grow into the role of future king. One may easily imagine the attraction for Charles of seeing himself differently, with a Spanish beard, as he looked to this exceptional Spanish painter. The trip may be doomed, but who cares when one considers the artist who will make him honest, human and true.

John Snare looked for any document that could give some sense of this occasion, how the sitting came about, where and when it took place. There were many accounts of the Spanish adventure in the Bodleian Library but almost nothing about this improbable encounter. In fact only two contemporary records survive, one written in English and the other in Spanish – the brief biography by Pacheco.

The Spanish translator had by now done his work and dispatched the English version to Snare. It came as a mixed blessing. Pacheco mentions the portrait of Prince Charles, to be sure, but he is so alive to the glory of his son-in-law's position at court that he gives no detail at all of the commission except to say, offhandedly, that Velázquez was painting the portrait of Philip IV at the time and 'while doing it, he also made a study of the Prince of Wales'.

'A study of the Prince': it sounds so succinct, and to modern eyes many, if not most, of Velázquez's portraits could be described as studies. But in those days there were different interpretations of the Spanish phrase – Hizo tambien de camino un bosquexo del principe de Gales – each of them turning on the translation of de camino to mean 'in passing'. These ranged from the juvenile idea that Velázquez just happened to see the prince passing in the street and made a quick study (un bosquexo was thus translated as 'sketch', which would hardly describe Snare's painting) to the long-held notion that the prince was en route to somewhere else and Velázquez tagged along, presumably cramming canvas, paints and all into the carriage to make a quick likeness in one day.

The English document is from the royal accounts for the Spanish journey. It simply records the amount the prince paid for the portrait and the date of September 8th when it was paid. Yet these numbers are vital. What this piece of parchment tells us is that Velázquez's portrait cannot have been a quick sketch made on the street or in some carriage on a rocky road, for the amount paid was an astonishing 1,100 reales. This was an enormous sum (Pacheco gives approximately this figure in escudos, too), as much as Charles had recently spent on a painting by Dürer and considerably more than Philip himself would pay his royal painter for a portrait the following month.

Even if the prince was only in the same room as the painter for a short time – Philip rarely gave more than an hour for the painting of his royal face – the portrait itself may have taken more than a week. Pacheco states that Velázquez was painting Philip on August 30th; the English party did not leave Spain until the day after the bill for the painting was paid in September.

Charles could only have seen one or two of Velázquez's paintings before - The Waterseller in Fonseca's collection, perhaps, or the likeness of Philip - and now the portrait of himself; but he must have recognised the painter's gifts immediately to reward them so highly. This is no small insight, given that Velázquez was still a newcomer to Madrid. His art had barely been seen outside Seville and he had yet to paint those images of the Hapsburg court that would win him the accolade 'king of painters and painter of kings'. It would be decades before these masterpieces were seen outside the Alcázar; generations before Velázquez's fame spread across Europe, before collectors began to vie for his work, before Joseph Bonaparte abandoned The Waterseller on a Spanish battlefield and the Duke of Wellington found it in the blood and mire; before Richard Ford endured weeks of bumping carriages, and before Manet made his famous pilgrimage during an outbreak of cholera to see Velázquez in the Prado.

It is not the least of John Snare's achievements, as his opponents would later concede, that he went to all the trouble of hiring a reputable scholar to translate Pacheco's biography. But Snare went further, for he made it available to his fellow readers by publishing it for the first time in English. It appears as an appendix to *The History and Pedigree of the Portrait of Prince Charles* in 1847. To Snare's relief, the translator did not come up with any nonsense about carriages or quickfire drawings in the street. He translated the vexed phrase un bosquexo (correctly) as 'a colour oil study or sketch'.

We know two central facts about Velázquez that Snare could not. Namely that he painted directly from his mind to the canvas without preliminary drawings; and that he left scarcely a single sheet of sketches. Some of his greatest paintings are made with astonishing freedom apparently on the wing. Las Meninas itself has been called the largest oil sketch ever painted.

Snare may not have known any of this, but his own account of the portrait describes it in just such terms. 'The handling is free in the extreme. The brush appears to have swept across the canvas and never to have paused or hesitated . . . Even when the colour is most solid it is always thin, and in many parts it looks as if it had been floated on.' How perfectly that puts the Velázquez effect.

In Minster Street, the painting hung in its special room, admired by one and all as a captivating image of Prince Charles. There was never any doubt about the sitter – as there would be with so many of Velázquez's other subjects, those men in black whose identities have yet to be discovered. But nor was there any documentary proof about the painter. There was no signature or date, no label on the back of the canvas. The only evidence of Velázquez was the painting itself.

Everything urged Snare towards Velázquez, but still he had to consider the possibility of Van Dyck, inventor of the cool Cavalier look of effortless authority, of stylish poses and languid expressions, coiner of the classic images of Charles. He must be methodic. Behind the prince was a curiously indeterminate space: this resembled nothing in Van Dyck. Next to him was a strange spherical object, a sort of spectral globe, but such things appeared in several other seventeenth-century portraits, so that was no proof one way or the other. The arm resting on what appeared to be the hilt of a sword - this looked like a Van Dyck; until Snare found other matches by much earlier painters at the court. The paint was too thin, the space too strange, the pose too natural, nothing like the suave attitudes of Van Dyck's Cavaliers. There was a freeness and honesty and disregard for effect that the Flemish painter was altogether incapable of showing. Snare could find nothing to support the view, voiced every second day at Minster Street, that this was a Van Dyck. So he tried saying the same thing himself.

'When I declared the painting was a Van-dyck these persons turned round and demanded that I should bring forward proofs. In short, I found that if I presumed to assert the Painting was by Van-dyck, there would be as great opposition offered as there ever was to its being the work of Velázquez.'

If it is not by Van Dyck, then how about van der Helst, a painter celebrated in his day but bypassed in ours? Van der Helst is airy, all right, but he conveys no sense of life or character. It cannot be the merry Dutchman Honthorst because he didn't arrive in England until long after Charles had been crowned (like Van Dyck). Perhaps it is the pensive and gracious Daniel Mytens, principal painter to King Charles until Van Dyck came to oust him; but Mytens never painted with such daring. Snare visits Hampton Court to look at Mytens, travels as far as Yorkshire for a portrait of Charles by Van Dyck. He goes from one painter to the next, but the slipper never fits. Everything returns him to Velázquez.

If science can give him no proof, and there is not a scrap of documentary evidence, he can only follow the principle of Occam's razor, which remains no less pertinent today. If nobody else could have painted this portrait as well as Velázquez, then the simplest possibility holds true: Velázquez must have painted this portrait. But the only way to confirm this is through the knowledge of one's eyes, so Snare must go to London and look more closely at the art of Velázquez.

Man in Black

THE PORTRAIT SHOWS a man in black staring straight back at you with a flash of electrifying intensity. He holds himself formidably still and correct. One eye is a pure black disc beneath the brow, the other a dark star glittering in the strange tawny light that flickers around him like St Elmo's fire.

The image startles every time, and so does the man – silent, vigilant, acutely handsome (Plate C). The painting puts him nowhere, in a no man's land of indeterminate space, surrounded by nothing but this atmospheric glow from which he looks with such penetrating directness that the past becomes the present in his glance. Only the archaic collar, stiff as a porcelain dish, returns the moment to some earlier century.

Who is this watchful stranger? There are no clues. He does not appear in any distinct period or location; his hands are not visible making any kind of telling gesture; he wears nothing to indicate his occupation, never mind his name; and the painting has no signature or date. There is no immediate clue to his identity – or that of the artist – in the form of a symbol, a prop or a painted word, nothing in the empty brightness around him to help anyone guess who he is. Before you is a man entirely outside time and space.

I stand where Snare once stood, on exactly the same spot, looking at the very same image. The bookseller was here in the 1840s, and so was the portrait. A period watercolour exists of the gallery with all the paintings in their exact positions, the Velázquez in tiny thumbnail

by the door where it still hangs today. Snare and I see the same portrait in the same place, centuries apart, but he has no idea who he is looking at, whereas I do. I have seen this person in *Las Meninas*.

The man in black hangs in the muffled warmth of the Waterloo Gallery in Apsley House in London. Snare was right to go there, for this grand Georgian building on the green verges of Hyde Park contained more genuine works by Velázquez than practically any other in England at that time. These paintings once belonged to the King of Spain, but now they belonged to the Duke of Wellington, who lived at Apsley House. How they got there is one of the most violent misadventures in art.

Wellington had no idea who or what he was looking at when they brought the portrait out into the hot Spanish light. He was as exhausted as his troops. They had been nearly a year pursuing Napoleon's elder brother, Joseph Bonaparte, out of Madrid – where he had usurped the Spanish king – through the country towards the French border. Clashing and regrouping, steadily losing men, weathering a long winter in the freezing sierra, the British had finally caught up with the fleeing French at the Basque town of Vitoria. On June 21st 1813 Wellington's soldiers battered away all day until the enemy lines finally broke apart and the surviving French ran away. Vitoria was the decisive battle of the Peninsular War, bringing an end to Napoleonic rule over Spain.

Somehow the portrait survived this terrible onslaught. The British found it in Bonaparte's own carriage in a long baggage train of wagons and carts abandoned by the fleeing French. It had been removed from the royal palace in Madrid, along with many other masterpieces thieved from Spanish collections. A chosen few, including five Raphaels and a Leonardo, were judged worthy of the risk to human life and made it all the way to Paris unscathed. The rest were abruptly jettisoned.

The paintings found in Bonaparte's baggage had been removed from their frames, wrapped flat or rolled up like scrolls. Some were in wooden crates, but others were unprotected and a few had even been used as protection themselves, laid like tarpaulins over pack-carrying mules. Among them was another work by Velázquez - a picture of an old man selling water.

Who painted the portrait of the man in black? Some people thought Caravaggio. But Wellington himself was sceptical. Dispatching the hoard of paintings for safekeeping to his brother in London, he wrote dismissively: 'They are not thought to be of any value.' In London, however, the President of the Royal Academy took the opposite view. Benjamin West was exultant in his praise of these spoils of war. 'The Correggio and the Giulio Romano ought to be framed in diamonds,' he gloated, imagining a triumphant display. 'It was worth fighting the battle just for them!'

Ten thousand men died in the bloodshed at Vitoria.

Among the paintings left behind in the Basque landscape was a small oak panel that Velázquez knew well, Jan Van Eyck's *The Arnolfini Portrait* of 1434: the rich couple with the dog, the oranges and the wooden shoes, touching hands in an expensive bedroom, a convex mirror shining on the wall behind them. Velázquez lived with this masterpiece for almost forty years, latterly as keeper of the royal collection. What ingenious use the Flemish painter made of his mirror, a way of introducing reflections of the outer world where we stand (and of the artist, minutely reflected) into the scene. Van Eyck's idea had its echo two centuries later in *Las Meninas*.

The Arnolfini Portrait vanished from Vitoria and was not glimpsed again until 1816, when a Scottish soldier named James Hay offered the picture to the future George IV, claiming to have fallen in love with it in the Brussels bedroom where he lay recuperating from wounds sustained at Waterloo. George foolishly turned it down. Hay, needless to say, was there at Vitoria.

A London dealer named William Seguier was hired to look after the paintings from Spain. The first Keeper of the National Gallery, as

he would shortly become, identified them in a catalogue written for Wellington's brother, who couldn't resist forwarding it to the duke with a jibe, pointing out just how wrong he had been. This was in fact 'a *most valuable* collection of pictures, one which you could not conceive'. The sum of £40,000 had already been mooted, although President West believed the value was simply unimaginable.

Wellington – who loathed looting – did not want to set a bad example himself and immediately instructed the English ambassador in Madrid to inform the Spanish king that his pictures could be collected. There was no reply. A year passed; then another. Wellington led the victory at Waterloo. And still there was no reply. Eventually he raised the question himself through the Spanish ambassador in London, who sent this discreet response: 'His Majesty, touched by your delicacy, does not wish to deprive you of that which has come into your possession by means as just as they are honourable. I believe you ought to let the matter rest where it stands and refer to it no longer.'

By such accidents of war, and such teasing diplomatic niceties, eighty-one of the paintings found in Bonaparte's baggage train came to reside at Apsley House, otherwise known as Number One London.

How to identify the man in black? William Seguier got closer to the truth than anyone before him. *Portrait of a Spanish Gentleman* was the modest but accurate title he gave the Velázquez (as he knew it to be). This might seem obvious now, but for centuries the painting had been misidentified in the very place where it hung: the Spanish royal palace.

Titles are a comparatively modern invention. Before the nine-teenth century few paintings were known by anything more precise or expressive than the bluntest description. *The Laughing Cavalier* was 'Portrait of a Man' (incontrovertible), *The Night Watch* was 'The Shooting Company of Frans Banning Cocq' (banal), *Las Meninas* was 'The Family of Philip IV' (bizarre) before it got its present title

on entering the Prado. It has also been referred to as 'The Artist's Studio' and 'Her Royal Highness the Empress'; each title shifts the emphasis, reflecting the priorities of those who confer it.

Until 1794 the portrait found at Vitoria was known as 'Gentleman in a Golilla', after the cardboard collar that was supposed to stay stiff for months and thus aid Spain's failing economy by saving on starch. Then, in an inventory signed by Goya, who ought to have known better, the picture is no longer by Velázquez and its subject is the notoriously cruel politician Antonio Pérez, who died when the painter was a child. What did Goya see in this beautiful portrait that could be construed as ruthlessness, or was he just signing off in haste? Inventories that ought to be meticulous often turn out to be random, slapdash and human – the same prejudices and errors compounded down the centuries.

After Pérez, the man in black was identified as the great Spanish playwright Pedro Calderón, Velázquez's colleague and contemporary, and a plausible identification, given the acute intelligence of the face; or perhaps he was Alonso Cano, a fellow painter known for his violent temper. From here it was a short step to Velázquez: for who could be making such intense eye contact with the viewer, if not the artist himself?

This claim has been bizarrely popular over the years, given that the man in black looks nothing like the only certain self-portrait we have. But Velázquez left several paintings of dark-eyed men with (and without) beards, all of which have been enthusiastically identified as self-portraits despite the evidence of that face looking back from *Las Meninas*.

In the past, before prints or photographs of the painting were widely available, there was little evidence to dispel such fantasies; and yet they linger. This reticent man who refused to impose himself upon history with wild anecdotes or outlandish behaviour, who does not step forward from behind the canvas, who does not make a show of his person except through his painting: for some people, this is not enough. There has to be another Velázquez, and surely he must

be disguised as one of these nameless men; though in the case of this portrait, the gentleman has a name. He is also called Velázquez.

José Nieto Velázquez was a lifelong colleague at the court. He arrived not long after the painter and they worked together until Velázquez's death. At one stage they had the same title: Nieto was chamberlain to the queen, Velázquez chamberlain to the king, the pinnacle of a courtier's career at the Alcázar.

When Velázquez came from Seville in 1623, the palace had 167 huntsmen to look after horses and sports, 300 guards and a corps de ballet of 350 servants to dance attendance on the monarchs and keep the Alcázar in perpetual motion. There were servants to dress and undress the king's person, to bring and remove his gloves and his dinner plates, to usher guests to and from his royal presence. A French visitor observed the frozen ritual: 'All his actions and all his occupations are always the same and move with such regularity that, day by day, he knows exactly what he will do for the rest of his life.'

As the performance, so too the performer: Philip's fixed and impassive deportment shocked dignitaries from abroad. The king was only to be approached through a succession of rooms, each more private than the last, and thus more exclusive, until visitors sufficiently important would come upon His Majesty standing by a table in the final chamber. He would raise his hat as they entered, place it upon the table and then remain motionless throughout the audience. His expression never changed. When he uttered, only his tongue moved; Philip was the statue that spoke.

This is exactly how Velázquez presents him in the early court portraits: stock-still and speechless, his authoritative hat upon the table. He is young and uncertain. Velázquez sees and paints him this way in fascination, without servility, and his fascination soon finds an unprecedented pictorial expression. It happens quite quickly, between one full-length portrait and the next. The line where the floor meets the wall disappears so that the king dominates the space, anchored only by his own shadow. The architecture becomes irrelevant. This is how we see people, after all, not as

dolls in boxes but as people alive and breathing in the same atmosphere as we. Velázquez's idea would change the history of painting.

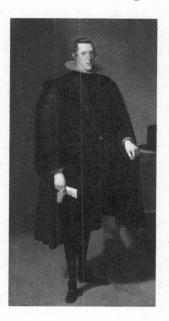

Velázquez's portraits of Philip are the most remarkable biography of a monarch in all art, spanning his life from the hesitance of youth to the melancholy disillusion of age. The lugubrious face thickens, the eyes sag, the dangling jaw takes on a foolish pathos. Only the moustache, whose upswept prongs were imitated by Salvador Dalí, remains forever vital. Philip grieves for his dead children; the ship of state runs aground; Velázquez understands. Even if one did not know it from the paintings, the bond between the king and the painter was so strong that it provoked envy.

Pacheco boasted that Philip would give his painter as many as three hours for a sitting – unheard of in the annals of the Alcázar – and that he had both a back route and a key to Velázquez's rooms. These sessions were a time out of time. The king is described as holding his power in abeyance when he posed. Even a child and a dog are reported to have held still for Velázquez, such

was his effect upon each and every sitter. And Velázquez finds the king no less ordinary, or extraordinary, than anyone else. His gaze is steady and consistent. He sees the intelligence, and the weakness, in Philip; the dignity in the waterseller; he paints Count-Duke Olivares as a great statesman who may also be a bully.

Olivares was Velázquez's first champion at the court (and Velázquez would be the last to paint him when he fell from grace). He too was from Seville and had brought many allies from home when he became Prime Minister in 1623. His control of Philip was absolute, from determining foreign policy to enforcing austerity measures, such as the golilla, as the economy foundered and there was no money for starched collars, let alone banquets. The people in these paintings are all surviving on credit.

Olivares is a formidable presence in the art of Velázquez, an imperious and choleric statesman erect in his stupendous girth, often mastering some defiant stallion that bears the brunt of his weight. Alone and in crowds, he is so familiar through these paintings — which hung alongside those of the king himself in the Alcázar — that one recognises those kiss-curls, mustachios and double chins even at a huge distance or on the tiniest of scales: overbearing at any size.

No matter that Spain was sinking into debt, its coffers at times so empty there was not enough money for firewood, the court still continued at its glacial pace, observing every hierarchical formality, every tortuous detail of etiquette. Spain was at war with Portugal, and fighting against its own citizens in the north, yet still there were standards to uphold and intense battles over court appointments. When one position came free – the undersecretary in charge of supervising the rituals for dinner, say – there might be twenty applicants fighting for the role, even in the knowledge that they might never see the salary rise. Palace wages were sometimes years in arrears (a surviving document shows Velázquez appealing for overdue payments early on in his career), but still the masque must continue. Calderón's latest play must be staged; the French ambassador must be

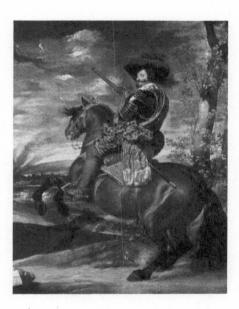

entertained with fireworks and music; courtiers must take part in elaborate dramas with complicated sets lit by thousands of candles. The number of courses at dinner might be reduced, to reflect the impoverished state of Spain, but only from seventeen to ten.

Velázquez, involved in these theatrical entertainments, in turn conceived new ways to theatricalise not just the pictures of his friends and colleagues, but more remarkably the portraits of the king, his wife and children. His painting of Philip's four-year-old heir, Baltasar Carlos in the Riding School, revolutionises the conventional equestrian portrait, not least by putting a little child upon a charger. Baltasar is shown in action, front of stage, one hand bravely at his hip while the other holds the reins, so close that he seems to rear into our space.

Dwarves and courtiers – including the tiny Olivares, who has one eye on the audience outside the painting while accepting a ceremonial lance from the prince's aide – observe from the heat and dust behind, while far in the distance, raised high on a balcony like a box at the opera, the king and queen preside over the whole

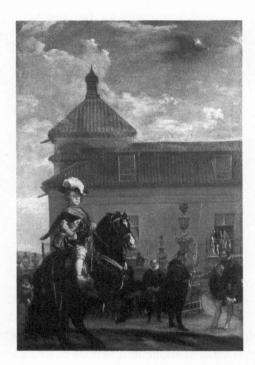

scenario. And behold! Everyone turns our way. A brilliant allegory of watching and looking, of society as spectacle, it seems to prefigure *Las Meninas* two decades in advance.

Velázquez accepted court positions that took him away from art all through his life. His industry as a royal servant is distressing to this day, since it speaks of all the pictures he never had time to paint. 'The diligence of a bee,' wrote Palomino. How can one not think of him as shackled by protocol, perpetually unfree as he ascends from Privy Chamber to Superintendent of Private Works and eventually to King's High Chamberlain, Holder of the Palace Key that one sees tucked into his belt in *Las Meninas*? 'Palaces are tombs,' wrote the contemporary playwright Lope de Vega, 'and if they had feelings, I would be sorry for the very figures in the palace tapestries.'

Yet the truth is that Velázquez aimed for social advancement just as much as his colleague Nieto, who never ceased to apply for these posts. He must have known he was a great painter, but he struggled to become a great courtier instead, angling year after year for the red cross, emblem of the high order of the Knights of Santiago, which finally appears painted on his tunic in *Las Meninas*.

But for all this scaling of the rungs, he scarcely surfaces in the royal archives as a person as opposed to a job title, and when he does it is often poignant: the one line he was given in the palace masque in 1638; the demeaning seat in the gods at the royal bullfight.

These archives are dense with material details: the number of logs needed, and the loan required to pay for them (Velázquez himself stumped up the money one winter); the cleaning of pearls; the bills for aubergines and mustard. One hundred pairs of gloves stitched in finest leather as a parting gift to the Prince of Wales in 1623, to wave him off (or away).

Yet it is also here that one sees the relationship between Velázquez and Nieto materialising through the minutiae. The two colleagues are involved in ceremonial dinners, in travel plans, in the arrangement of furniture and paintings. In 1627 Velázquez was working with Nieto's wife on that inventory of possessions belonging to Juan de Fonseca at his death. She valued the linen, he valued the paintings, which included *The Waterseller of Seville*.

Which John Snare also saw – marvelling at its depth of darkness and brilliant light – in the Waterloo Gallery.

Apsley House is an Olympian version of a gentleman's club. Here is Canova's three-metre statue of Napoleon standing naked in the stairwell, presented to the Duke of Wellington by the British public as a droll memento of his victory over tiny Boney at Waterloo. Here is the immense dining table with its solid-silver victory-girl statues, one for each medalled guest at military dinners. The rooms are hung floor to ceiling with portraits of the loyal officers, colonels and generals who fought alongside him, pre-eminently the pictures rescued in Spain. It is well said that Wellington's picture collection was founded on the fields of Vitoria.

Nieto and *The Waterseller* hang on either side of the entrance to the Waterloo Gallery, with its yellowing blinds and filtered light. They have been there for two centuries now, all the way through Wellington's time as Prime Minister and the downturn in his political career when he became so unpopular that iron shutters were erected to protect the gallery windows against the assaults of rioting Londoners – said to be one origin of his nickname, the Iron Duke.

The Waterseller is in plain view. The portrait of Nieto is just behind a door, and further guarded by the cautious label: 'A Spanish Gentleman, Probably José Nieto'. In the absence of written evidence, historians are reluctant to trust their own eyes.

For the man seen here, close and large as life, dressed in black and silhouetted in a rectangle of glowing light, reappears in miniature at the back of *Las Meninas* – he is the chamberlain in black, framed in another rectangle of glowing light in the doorway. Nieto is ten or maybe fifteen years older there, the face heavier and the hair now receding, this time portrayed in his last and most prestigious court role – standing on the threshold of this little life that we see, waiting to usher us into the next world.

Palomino identified Nieto – indeed all but one of the figures in Las Meninas – in his 1724 biography. He may have known Nieto personally, since they overlapped at the Spanish court, and he praises the tiny portrait as 'very life-like, despite the distance and the reduction of scale and the light in which he is placed'.

Just as Nieto is immediately recognisable to Palomino as a miniature silhouette in a distant doorway, so the king and queen are instantly recognisable to *us* as thumbnail reflections in that hazy mirror; recognisable from the larger portraits, and vice versa.

Las Meninas shows friends, colleagues, princess and dwarves like figures in a dream: the people around Velázquez by day who reappear in the mind's projections at night. And the chamberlain haunts the whole picture, with its revelation of their shared lives at court. The two friends are together, just as they were in reality, Nieto appearing alongside Velázquez in his most famous work.

Come close to A Spanish Gentleman in Apsley House and the painting discloses more of Nieto; it is not all there at first sight. The soft hair, the inner tension, the level-eyed look of tacit empathy: at a distance, every brushmark is quick with descriptive power until you draw near – and they lose their legibility. The upturned moustache ends in a whisker so fine you can scarcely see it, literally a hair's breadth; the hair itself fades away as imperceptibly as smoke. There is a star of reflective light on the forehead so tiny that its exact shape is only visible millimetres from the surface, though its point is large, as if marking the spot where the soul lives.

Brushing that surface is a sense of movement, of breathing impermanence. This is how Nieto looked in mid-thought, in mid-life, at this moment; there is no straining after the definitive. The man is here, supremely conjured in paint, but the picture does not give all of him because there is always more within him. He is allowed his privacy, his secrecy, his full mystery as a man, which is the respect Velázquez gives all of his sitters. Monarchs, chamberlains, watersellers, dwarves: they are all sovereign of themselves.

The expect of the response of the premium of the expectation of the ex

The Talk of London

If you write to anyone in London, recommend their going to see a magnificent portrait of Charles the First when Prince. There is so much spirit and youthfulness that it is quite free from the sadness of the Van Dycks . . . It is the finest picture I have ever seen.

Mary Russell Mitford, 1847

JOHN SNARE EVENTUALLY became sufficiently confident of his discovery to show the painting - and a tantalising fragment of evidence concerning its past - to the well-known novelist Mary Russell Mitford. Miss Mitford was to Reading what Jane Austen was to Bath, a profoundly shrewd observer of the public and private lives of men and women in the microcosm of provincial society. Her fictional Belford Regis was a portrait of Reading in deft sketches, its lawyers and doctors, colonels, parsons and landed gentry, its matchmaking, parlour games and election campaigns. all depicted with a spry eloquence that made her books popular throughout the country. In London her plays were performed at Covent Garden and her circle of admirers included the poet Elizabeth Barrett Browning, with whom she corresponded and to whom she confided her excitement on seeing Snare's picture. This portrait of Charles, she enthused, was not just the standard silken Cavalier, destiny inscribed in his every feature, repeated in grand houses all over Britain. One of her own stories features a hack copying just such a Van Dyck, until he too can pull off that look

of elegant melancholy with a hint of decadence to satisfy his credulous customers.

Not only did Miss Mitford know about painting, she was an expert on the man in the portrait. Her *Charles the First: An Historical Tragedy in Five Acts* premiered to acclaim in 1832, and she had studied images of the royal face at least as obsessively as Snare. She agreed that none of the existing pictures looked quite like this one; and none seemed to show him both newly bearded and young, as he was in Madrid. Miss Mitford had no doubt whatsoever that this was the desideratum of English historians as mentioned by Palomino – the long-lost Velázquez, the missing portrait of Prince Charles.

Snare took heart, and he had another reason for optimism. In the quest to uncover a past for the painting he had come across an antiquarian's account of London that made passing mention of an unusual portrait by Velázquez hanging in Fife House in Whitehall in 1794. Perhaps this would be the very same painting! (Snare permits himself only this one excited exclamation mark in his account of what followed.) But where could he find corroborating evidence – a print, maybe, a sale record or at the very least a written description? This is where the search forks in different directions.

I looked where he looked, searching through the pages of old newspapers and books, through auction house records and catalogues marked up with prices and blotted with ink, handled and creased where a person from the past has shoved it in his pocket at the end of a sale, triumphant or disenchanted. These are social documents and curiously intimate in their annotations – too high, only passable, surely not, a poor copy! They capture the moment when paintings surface in public, liberated from private houses, before disappearing once more, and they sometimes catch the reaction as well. But I had what Snare did not, a library with a computerised index, and could immediately find the vital document that he did not come across for half a year. An old bibliographer's

manual tipped him off to a catalogue of paintings at Fife House written and published in 1797 by the 2nd Earl Fife himself. And there, among the parade of kings, queens and aristocrats hanging in the corridors and galleries, was the unusual portrait by 'Valasky' (in the earl's Scottish brogue): 'Charles I when still a prince, painted in Madrid'.

The painting existed, the painting survived; and what's more, just to cancel one fear from Snare's anxious list, it had not been quietly abandoned in Spain after the disastrous campaign, but had returned with the prince to England. How it entered Fife House, or Radley Hall half a century later, remained so far unknown; but the worldly Miss Mitford had no concerns about the odd ways in which paintings changed hands. She urged Snare to be less hesitant in setting the picture – legitimately acquired, after all – before a larger public. And thus it came to be displayed, in the spring of 1847, at 21 Old Bond Street in London.

This Mayfair address was the very squeak of chic, then as now, a place to be seen and spend money. It already had a long career in satire, particularly in the acid-bitten etchings of the cartoonist James Gillray, who lived about twenty yards away from what is now Chanel, in the early 1800s. Gillray hardly had to step from his front door to witness every passing fashion in that most fashionable of streets: those towering quiffs and wasp waists, extruded sideburns and bulging breeches that became the early elements of his style. Sitting at his window, he drew directly from life: the king's mistress in rib-crushing corsets; Prime Minister Pitt with his woodpecker nose; James Duff, who would one day inherit the title to become the 4th Earl Fife, mincing along in dainty pumps tied with satin ribbons: 'All Bond-street Trembled as He Strode'.

Fortunes were made and lost on Old Bond Street. Art buyers (and sellers) were fooled. Some dealers showed phoney pictures that brought the newspapers out in ecstatic chorus, others displayed authentic masterpieces that died a death of indifference. For

anybody hoping to make a painting pay its way, the risk was as high as the rents.

In Mayfair, art was drama. A painting might be for sale, but it could also double as a spectacle that required publicity and tickets. John Wilson ran his European Museum as an ever-changing theatre of Old Masters, genuine Holbeins alongside blatantly fake Titians, taking enough money at the box-office to keep the cast of artists constantly refreshed. Stanley's Rooms in Old Bond Street specialised in sensational pictures; Rubens's bosomy Susanna Fourment, smiling beneath her famous straw hat, had its first London showing there. The two Englishmen who had purchased it in Belgium also tried and failed to sell it to George IV, but so many visitors paid half a crown to see the sultry beauty that the proprietors made their money back in two months.

Paintings had to compete with the wildest of attractions. At William Bullock's Egyptian Hall on Piccadilly, 220,000 visitors came to gaze at Napoleon's bulletproof carriage, an ingenious mobile home that could be configured as a kitchen, bathroom or study and still contained Boney's steel bed. Bullock bought the carriage from the king, who got it from the Prussian major who had captured it at Waterloo – an investment returned forty-fold, with a staggering £35,000 taken in tickets. But Bullock would just as

readily invite Géricault to display *The Raft of the Medusa* in the same venue, all expenses paid, after that devastating vision of shipwreck, starvation and drowning had failed to impress viewers at the Paris Salon. Presented in the right light, and at the right height – low down, so that the waves rose menacingly high – the immense painting electrified its British audience.

The Egyptian Hall was a sign of the times. Turner had shows there, and so did the highly respectable Society of Painters in Watercolour. A Victorian visitor could stand before a Leonardo saint, but he could also gawp at Captain Tom Thumb on his European 'Midget-Tour' in 1844. 'The greatest little man on earth', produced by P.T. Barnum, was a far bigger hit than Leonardo.

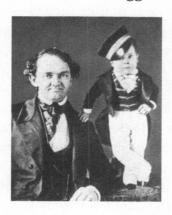

When John Snare rented the room on the first floor of 21 Old Bond Street in March 1847 he was in the right place at the right time with the right painting: a lost portrait of a lost monarch (as Charles seemed then to romantic Victorians) by an artist whose genius was still new to the British public. The staging was meticulous. After paying a shilling, visitors passed up a staircase muffled with carpets, through heavy drapes and into a cell-like space enclosed by carved wooden screens, where they came face to face with the masterpiece, illuminated by gas as the day faded into dusk. It was exactly as a modern curator might present a Velázquez: in silence, beautifully lit and without any visual distractions. If

Snare wanted people to be awestruck, these were ideal conditions. The press response was immediate.

The Times was powerfully impressed, describing the event as a 'superb encounter' with the incomparable Velázquez. The Morning Chronicle was enchanted. 'The flesh of the face is brilliantly executed . . . a warm and liquid transparency makes the countenance glow like magic.' The Illustrated London News hailed it as a splendid historical find. 'This single painting,' ran its editorial, with a sideswipe at Bullock and all, 'is worth a whole Exhibition of yesterday's novelties.'

Correspondents from newspapers all over Britain began to arrive and offer their praise. Snare kept every cutting. The eulogies would appear, like the press raves outside Broadway shows - astonishing, mesmerising, unique - on the handbills that promoted the portrait on its subsequent adventures. And with the press came the public, beginning with the figures of fashion, the lords and ladies and society hostesses of Mayfair, the peers of the realm and the members of the House of Commons who walked up from Westminster to take a look and then dine at the grand houses of St James's. The intelligentsia followed; the Brownings came from Wimpole Street, bringing their friends. Soho dealers arrived, and the professors, lawyers and classical scholars, the historians and antiquarians of the Camden Society, of which Snare was now a member, lending probity and gravitas to his case. And the Duke of Wellington, only just retired from political life, visited not once but twice, bringing a whole section of London society in his wake.

But of all the grandees who visited the show, the most gratifying to Snare was not the Iron Duke, but a Spaniard who had first-hand knowledge of Velázquez in the most intimate circumstances imaginable: the Count of Montemolin, claimant to the Spanish throne.

The count, who styled himself Carlos VI, was born in the Royal Palace in Madrid and had grown up with the portraits of Velázquez. But he was now a socialite in exile from a civil war so brief and

half-hearted that historians have wondered whether it amounted to a war at all, provoked in 1846 by a battle over whether women should succeed to the Spanish throne. The attempt to restore the (male) Carlist line failed; and the rest of Montemolin's short life was spent wandering aimlessly through Europe.

The count sent word that he would visit on Friday June 11th, red-letter day, and sure enough this dapper Spaniard arrived on cue with his entourage: the Velázquez expert coming to pronounce on the Velázquez.

Snare was so anxious not to interfere with the count's response, and so concerned to hear it spontaneously spoken, that he hid behind one of the screens. The reaction exceeded all hope. 'His Highness having attentively surveyed the portrait was pleased to express himself much gratified. He entertained no doubt whatsoever as to the author, whom he pronounced to be Velázquez.'

As if this was not enough, the count's chief equerry, Don Juan de Montenegro, also long familiar with the paintings in Madrid, saw Velázquez's hand everywhere in the painting. He drew Snare's particular attention to a close passage of impressionistic brushwork. 'He asked me if I saw anything extraordinary in the white collar about the Prince's neck, adding that the loose and feathery touches that somehow produce the effect of embroidery are characteristic.'

These two men – these two Spaniards who knew Velázquez's work from first to last, who had seen his portraits early and late – confirmed it as a true Velázquez.

To believe in a painting amounted to an act of faith in Snare's day. There was no visual proof to sustain an opinion other than the painting itself, no X-rays, no photographs, no chemical analysis of paints. One could not unmask a fake or demote a painting by showing that the canvas or the pigments were too modern. Experience and judgement were all; and even now this remains the case. When every other piece of evidence complies with one's

idea of what a painting might be, but there is no documentary support, experts must rely upon their eyes.

The London show was a test of the bookseller and the portrait alike. Snare held two beliefs about his picture that were infrangibly bound: that it showed Charles as a young prince, but with the beard grown in Spain; and that it was by Velázquez. Now his conviction that this was the lost portrait had the endorsement of two unrivalled Spanish experts.

The only snag was that their opinion came too late to protect him.

If the bookseller had not advertised the portrait as 'the Velázquez' it is possible that he might not have suffered what followed, but in April the *Fine Arts Journal* published an all-out attack. The writer's scorn seems to have built up like steam emitting through a spout, as a result of all the previous press praise. He took Snare's syllogism apart. The picture was not necessarily Charles, and therefore not by Velázquez; and if not Velázquez, then probably Van Dyck (not that any of this follows). Perhaps a studio assistant had been involved too, for there had been 'much injudicious tampering with the left hand'.

The scoffing continued in the letters page of the next edition:

A picture purchased in the neighbourhood of Oxford for some eight or nine pounds . . . is surrounded with decoration costing some fifty times the price given for the picture itself, and the field is taken at the commencement of the London season with an intention of selling the work for a sum that shall amply recompense the pains taken by the speculator. The undertaking has two points in its favour. First, the gullibility of the public; second, the influence of the press. But the press knows nothing.

The letter was signed: A LOOKER-ON.

The attacks were ad hominem: a little man from the provinces who doesn't know the price of proper pictures, who thinks he can

con the great city with his carpets and screens (on which, incidentally, Snare had spent nothing, having borrowed them from his landlord) with the aim of flogging the portrait when the circus is over. Who does he think he is?

Scenting class war, the press immediately weighed in against the *Fine Arts Journal* on behalf of the tradesman who had the gall to think he had chanced on a Velázquez. The *Morning Post*, Britain's bestselling daily paper, published its outrage first. 'Spanish it decidedly is, and there is no question as to the person for whom it was made. The treatment is so original . . . That it is the production of Velázquez is *not* to be disputed.' One publication after another came out strongly in favour of the Velázquez – fifty-one in all. Some went so far as to thank the bookseller in person. 'We wish Mr Snare every success . . . for had he not upheld the character of the painting it would have been buried in oblivion and the world deprived of this unique produce of so eminent an artist as Velázquez.'

What such a picture might look like, however, was a subject almost too nebulous to address. The first half of the nineteenth century was a virtual wasteland for anyone wishing to learn about the art of Velázquez in the press. Journalists mentioned him with reverence, but scarcely attempted to characterise his work in any way, and it was hard to form a coherent idea from the few works on public display.

The earliest outings were at the British Institution in Pall Mall. The Boar Hunt, that wide and washy panorama studded with minuscule figures – the king and Olivares immediately recognisable in Velázquez's deft shorthand – had been shown in 1819, followed by Baltasar Carlos in the Riding School two years later. Baltasar, the little prince who would die so young, before his seventeenth birthday, whose face does not look Spanish, whose little horse is not heroic and whose doting parents are miniaturised far away in the distance, must have been as unrepresentative a first encounter with Velázquez as The Boar Hunt. From these paintings the visitor might have imagined him to be an artist of the great outdoors, or of teeny

horses and hounds. It can hardly be coincidence that auctioneers of this period were trying to sell miniatures 'by' Velázquez.

Most of the genuine paintings were locked up in country houses – *The Toilet of Venus* at Rokeby Hall, *Juan de Pareja* at Longford Castle – or the mansions of the metropolis, such as Apsley House. But persistence and politesse sometimes opened closed doors. One of the world's first female art historians, Anna Brownell Jameson, wrote a companion guide to the private galleries of London in 1844, with tips on how to inveigle your way in (Snare stocked the book in his shop). The golden mile is Mayfair.

Jameson goes to see a Velázquez 'self-portrait' at Lansdowne House, procured for the Marquess of Lansdowne via a middleman during the Peninsular War. A dark-eyed Spaniard wearing a golilla, the portrait makes a strong eye-to-eye connection. But the sitter is round-cheeked, snub-nosed, with short puffs of baby hair; to anyone who had ever seen *Las Meninas* (practically nobody in England, of course), this was plainly not Velázquez.

At Bridgewater House, Lord Egerton has a Velázquez portrait of Philip IV of Spain (fake) and another of the bastard son of Olivarez (not the bastard, not Velázquez). In the Duke of Sutherland's collection at Stafford House, Jameson sees a landscape with figures that might just possibly be by Velázquez (but is in fact by the Dutchman Albert Cuyp). At Grosvenor House, which you could scarcely get into without knowing the Duke of Westminster in person, Jameson admires *Baltasar Carlos in the Riding School* and finds another Velázquez self-portrait: 'Himself, in a cap and feather, head only'. This will turn out to be Rembrandt.

One sharp-eyed visitor spotted the Rembrandt for what it was at the time, however – none other than Snare himself.

These confusions about how Velázquez's paintings should look, about who or what they represented, arose out of ignorance and inexperience. There were simply not enough works outside Spain. Painted copies were helpful, but how could one see that mysterious

hand at work if not in an actual Velázquez? Las Meninas was the transcendent example: there were no photographs to give a sense of its mysterious beauty and prints, beyond the ostensible subject, could communicate almost nothing of his style. Goya's attempt to make an etching of a painting that obsessed him fell so disastrously short that he wrecked the plate. More or less the only available print, made in the eighteenth century by a Frenchman who had never seen the original and was working from someone else's sketch, reduced the girls to puppets and the dwarves to boggle-eyed trolls.

Even in Spain Velázquez's masterpiece was scarcely seen. From 1656, when it was painted, to the nineteenth century, when it was set free, *Las Meninas* moved only through a few closed corridors, from the king's semi-subterranean offices to the queen's bedroom to the royal dining quarters. Diplomats, papal nuncios and foreign dignitaries occasionally saw it, but even quite senior Spanish noblemen only glimpsed it 'muy paso' – in passing. Until 1819, when the doors of the Prado opened to the public, the number of people outside court circles who had ever seen this greatest of all paintings must have been tiny.

So it was that a young Englishman visiting Madrid in 1814 came to believe he had bought Velázquez's first version of *Las Meninas*, somewhat smaller but no less magical — not that he had any idea of the original. The MP William Bankes was following in the footsteps of his friend Byron on a European journey that would last for eight years. He had inherited enough money to buy art wherever he went and managed to secure this prized Velázquez with huge difficulty in Spain, sending it back home to Kingston Lacy, the Dorset manor he was transforming, room by room and tile by tile, into an Italian palazzo. Bankes had dreamed up a scheme for a Spanish Room, and when he finally returned to England *Las Meninas* took its rightful position above the fireplace in this gallery lined with gold-blocked leather.

The little *Meninas* had once belonged to Gaspar Melchor de Jovellanos, a hero of the Spanish Enlightenment and minister in the late eighteenth-century government of Charles IV. He had seen the original more than once in the palace, so one might find it

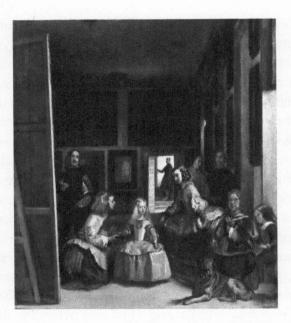

surprising that he was so certain he had a true Velázquez. It is not just that the picture is smaller, as preliminary versions often are – though of course Velázquez did not make any – or that it is tighter and brighter in some places, but slacker and coarser in others. The princess is smaller, there are not enough colours on the palette for the picture and, above all, the mirror – that glimmering surface in which the king and queen are reflected, and our presence too implied until the end of time – this quicksilver surface contains nothing and no one. It is blank. The picture is a copy.

Bankes did not know this. More piercingly, he does not seem to have known when he bought it that the original still existed and was hanging only a few streets from his lodgings in Madrid. He loved the picture he owned, and even when he learned that it was probably what the Velázquez expert Sir William Stirling Maxwell tactfully called 'a small repetition', his passion survived the judgement. The picture was no less real or potent for him because it was by another artist.

It still hangs above the fireplace at Kingston Lacy, next to the portrait of a shrewd but uneasy young cardinal dressed in blue velvet that Bankes bought in Rome. This picture, although he didn't know it, really was a Velázquez.

It might have gone on for who knows how long, this Old Bond Street show, but disaster struck towards the end of autumn 1847. While Snare was out, the freeholders of number 21 entered the premises and took away the portrait.

Snare had always paid his rent on time to the landlord, William Higgins. But Higgins was – or claimed to be – badly in debt to the freeholders, whose existence he had never once mentioned. The portrait was seized as an asset in lieu. Poor Snare, who owed nothing at all, lost his treasured possession.

If this happened nowadays, of course, there would be intensive press coverage and a flood of legal actions. The price of the painting would be relentlessly hyped. Dealers would emphasise its rarity; insurers would discuss liability; conservators would be consulted on television about the consequences for the canvas. And every time Snare is separated from his picture, one wonders about its safety as an object, men lugging it about, propping it against walls, tying it up with rope and brown paper as they did in Old Bond Street, particles of paint shedding like skin cells in transit. The disintegration of paintings far younger than this one was common: faces had been known to fall from Joshua Reynolds's portraits during the sitters' own lifetimes.

Snare wrote plaintive letters to the freeholders and even published a pamphlet in protest, but still they were intent on putting the kidnapped picture up for sale. The only way he could get it back was by settling Higgins's debts himself, to the tune of £400. He could no longer afford to keep the London show open and retreated, wounded, back to Reading with the painting.

Evidently he did not forget the injustice. Among the items up for debate in the House of Commons on February 18th 1848, I found a 'Petition for Exemption from Distraint as it Affects Works of Art' lodged by Mr John Snare. Its hopeless passage is recorded

in Hansard. Perhaps the politicians thought he was bothering them with a trivial matter, perhaps they were eager to move rapidly to the tabled discussion of the Revolution in France. At any rate, there was no response; his petition was left on the table.

But the newspapers took the side of the little man once more. The *Morning Post* ran an editorial deploring the 'virtual plundering of a deserving individual' and decrying a law that discriminated against art, as if it were no different from the carpets and screens. The Velázquez got another helpful push, and there were calls for the portrait to be purchased for the nation. But by now there was serious opposition too. The picture had acquired two powerful detractors in the art experts Sir Edmund Head and William Stirling Maxwell.

Head was the author of the life of Velázquez in the bestselling *Penny Cyclopedia*. In his gently expressed opinion, the prince looked a little too old to be courting the infanta, so that the portrait might not have been painted in Spain; he was not certain, moreover, that all parts were definitely by the same painter.

Stirling Maxwell was far less cautious.

A Scotsman of exceptional dynamism and intellect, Sir William Stirling Maxwell (his final title) was an MP, antiquarian, philanthropist, bibliographer, breeder of shorthorn cows and shire horses, Rector of the University of Glasgow and all-round polymath who spoke several languages and was the most knowledgeable and experienced commentator on Spanish art in the country. He was rich enough to travel widely, gathering his own collection of Spanish art, and had written three books on the subject before he was thirty. One of them changed the course of art writing for ever. In *Annals of the Artists of Spain*, Stirling Maxwell did something that had never been done before: he inserted reproductions into the text. Hazy grey talbotypes of six paintings by Velázquez appear alongside the words; it is the first photographically illustrated art book.

Published in 1848, the *Annals* is also a superbly eloquent work, in which Stirling Maxwell proposes – no doubt to their owners'

delight – more than seventy paintings supposedly by Velázquez in British collections. Since the Prado had opened with not even fifty, Britain would have been practically awash. The Earl of Elgin's poodle sniffing its bone is here, and the preposterous bagpipe player (with a question mark at least), but the portrait of Prince Charles is not. Stirling Maxwell cannot believe that this portrait could possibly have been done in such a short time, as it looks 'more than three parts finished'. He does not think that the prince looks twenty-three or that the artist is Velázquez.

Yet he acknowledges that opinions are only opinions. 'In artistic criticism, nothing is certain but vaguest uncertainty and irreconcilable difference. No position is so strong that it may not be assailed.' Edmund Head, for instance, had only recently given a public lecture announcing that *The Waterseller of Seville* was not by Velázquez at all.

Some of the claims in the *Annals* were risky even in 1848. Stirling Maxwell mentions Sir Robert Walpole, who believed he had the original portrait of Pope Innocent, when the real thing was where it had always been, in Rome. The 4th Earl of Carlisle had a portrait of Juan de Pareja that wasn't authentic, and a portrait of Baltasar that was (but which he thought was by Correggio). The real Juan de Pareja, now the pride of the Metropolitan Museum in New York, once belonged to the diplomat Sir William Hamilton, who brought it back from Naples along with his wife Emma and her lover, Lord Nelson. After its sale in 1801, a hundred more of the Spaniard's 'rare' creations would come on the market in the next ten years. Only two were by Velázquez.

Yet some of the least probable candidates appear in Stirling Maxwell's book nonetheless – scenes of Venice by candlelight, a head of John the Baptist on a dish and no fewer than five self-portraits in the southern counties of England alone, each showing a quite different dark-eyed gentleman. In this thicket of dreams, copies and outright delusions, how was one supposed to discover a true Velázquez? People resorted to Palomino's biography. If Palomino said Velázquez painted fish, or fruit, or still lifes of

vegetables, then such paintings would be found. If Palomino said Velázquez painted the Count-Duke Olivares more than once, then ten or twenty counts would turn up.

In the mists before the evolution of the modern art world, even such an authority as Stirling Maxwell can make some extraordinary claims. In his judgement, a painting by Velázquez's son-in-law, Mazo, showing the family quarters in the east wing of the Alcázar, which is now more valued for its documentary evidence of the contemporary life of the painter than for its erratic brushwork and inconsistent perspective, is a genuine Velázquez. And not just genuine, but quite possibly the best picture he ever painted: "The composition has never been surpassed and perhaps it excels even the *Meninas*" (this from one of the few British writers who had actually seen this painting in the Prado). This is because Velázquez, or rather Mazo, has cleared out the unsightly staff. "The dwarfs of the palace have not intruded in the privacy of the painter's home."

But the greatest anomaly in the whole book is the one that most shocks. Stirling Maxwell writes that Velázquez left a 'curious study of one of the women dwarfs, in the nude state, and in the character of Silenus . . . Captain Widdrington says he saw it.' Such was the state of knowledge in those days that a man who had travelled as widely in Spain as Stirling Maxwell was still forced back upon the partial glimpses of earlier travellers, unreliable memories and hearsay.

The female dwarf, nude and in the character of the Greek god of drunkenness, is such an offence against Velázquez, most dignified of all painters, that one wonders if Stirling Maxwell has actually looked at the paintings of dwarves in the Prado – whether he is even writing about the same painter at all. And yet he was a figure of such authority and experience, compared to the lowly bookseller who had never left England and whose portrait of Prince Charles he now so abruptly denied. It is all the more remarkable that John Snare would one day muster the courage to publish a counterblast.

A Man in Full

You have to look up to this little man on his rock; the picture raises him up. He is out in the open, high among the Spanish hills and far away from the gloomy prison of court, living in the sunshine of Velázquez's paint.

Francisco Lezcano is said to be his name, and he was hired to work as a playmate for Baltasar Carlos when the prince was four or five years old. At some stage in their years together, the dwarf and the little boy must have been the same height.

Lezcano was well liked for his gentle ways and is identified with this young man in green precisely because of the dreaminess conveyed in the portrait. The soft hair, the breathing mouth, the face tipping back to get a better look at the painter: the warmth of body and soul, and of mutual empathy, radiate from the canvas. The dwarf's face is attentive and so is Velázquez's brushwork. It is a portrait full of grace (Plate D).

In his little hands, like an attribute, Lezcano holds a tiny book or perhaps a pack of playing cards. These were seen as a symbol of idleness, but Lezcano is not idle so much as relaxed, settling back on this rock in the balmy outdoors. It ought to be a perilous position for such a small person, but he takes it in his stride, one leg casually slung over the rock, the other extended towards the viewer. He is free. This is his day off, a day away from the duties of companion and court entertainer. His face is bright against the forest-green of his clothes and the mountain surroundings, so that

the whole painting seems to focus on his sunlit half-smile. But the eyes are delicately veiled, one beneath its lid and the other in shadow. They are soft and still and what they register is seeing – seeing Velázquez, just as Velázquez looks calmly back at his companion. His way of painting, so fluent and gentle, gives Lezcano the utmost respect.

Yet this is not how some art historians have viewed the portrait at all. Instead, they have found vacancy in those eyes, declaring that Lezcano is evidently deformed in mind as well as body. The dwarf has been described as half-witted, weak-brained and, even in the twentieth century, as an abortion of Nature. His head is too big, his legs are too short, his eyes unfocused and his mouth half-open: obviously he must be retarded.

This has been the prevailing bias ever since the portrait first appeared before the public at the Prado in 1819 (where it was catalogued as 'A dim-witted girl') and yet everything goes against it, not least the facts. The length of Lezcano's arms and legs, the prominence of his nose and forehead are all features of achondroplasia, otherwise known as short-limb dwarfism. There is no evidence, and there never has been, that this condition affects intelligence in any way. And the same writers who see Lezcano as slow – or dangerously quick, in the eyes of one writer, who was able to imagine something homicidal in his face – would have to concede that the short-limbed dwarves of the Spanish court were famously employed for their wit, and not the lack of it.

Velázquez is remarkably accurate about Lezcano's achondroplasia; but the portrait is in no way prurient. It does not pretend to know his predicament so much as empathise with his experience as a man who has to live on his wits to survive. His clothes are theatrical: the big hat, the oversized cloak that must have dragged in after him when he entered a room; and perhaps he performed startling tricks with his cards. But Lezcano's expression has nothing to do with his guise, or his size, and whatever role he played in palace life, whether he was perceived as wondrous or comic, he is not playing it now with his eyes.

It is this watchful stillness — an almost conspiratorial exchange of understanding between them — that distinguishes the dwarves in Velázquez's paintings. These men and women had to be prodigiously talented to thrive at the court, they had to understand how to use their looks to hold and not repel people's attention. They had to learn how to turn the joke back on the joker, so that anyone who mocked them could be mocked in return, anyone who pitied them could be defied. There are many stories of dwarves at European courts who were allowed to say what others could not, by virtue of their size, and who enjoyed extraordinary freedoms of speech. They might sit on the floor at mealtimes keeping up a flow of caustic observations, or climb into the laps of courtiers and tease them to their faces; indeed, these same courtiers sometimes paid these same dwarves to say to their royal masters what they could not.

But the dwarves at the court of Philip IV were not necessarily there just to make people laugh, no matter that they might have the skills of a clown. Certainly they were hired for their appearance – little people contrasting with their noble overlords, low and high, quirks of Nature compared to Nature's supposed prodigies – but also for their special gifts. Historians traditionally lump them into the general category of court entertainers – dwarves, jesters, actors, sometimes grouped as buffoons – but there is a world of difference between them, and between their professions, and Velázquez singles them out.

That is his way of thinking about all human beings; everyone is unique. Singularity is all. And perhaps Velázquez sees this more than anywhere else among his colleagues, the dwarves.

Sebastián de Morra is a man of defiant intelligence, strikingly handsome and self-possessed (Plate E). He sends out such a questioning look as to root any viewer to the spot. There is that sense

of mutual consciousness that is such an aspect of Velázquez's revolutionary portraits, but in this case it is intensified by the personality of the sitter, who gives you a look of such compelling force it cuts straight through the centuries.

De Morra had a long career with the Spanish royal family, working first for Philip's younger brother in Flanders, and then in Madrid as a tutor to Baltasar Carlos, teaching the boy about horses, weapons and the principles of war in preparation for the time when he would be king. Except that this day never came. The little boy who grows up in Velázquez's art, from the tiny child on his charger to the blond teenager out hunting in the same forest-green clothes as Lezcano, vanishes quite suddenly from the paintings, carried off by smallpox at the age of sixteen. Philip IV was so traumatised he no longer knew, he wrote, whether life was real or a raging dream.

Baltasar left a will, and his feelings for de Morra are written there: to his dwarf he leaves nothing less than his best silver dagger. And in this portrait de Morra cuts a fighting figure, dressed like a soldier in red and gold. His legs extend straight towards us like a marionette, but the pose conceals their shortness by blocking the view with the shoe soles. He looks tightly boxed (though the picture was once bigger), but his force of personality breaks right out, feet first. He defies you to imagine him standing up, to pity or look down upon him, and the vantage point is dropped so that we must meet him eye to eye as equals. Is it possible he chose the pose himself?

For although he is on the floor, where dwarves often sat, de Morra is squaring up and tilting his head – willing you to look at him, waiting to be looked at with his unqualified stare. He is his own man first, before his job, before his physical proportions. The dark eyes hook you in: a powerful intelligence and a powerful pose, matched in this head-on confrontation.

De Morra appears more than once in Velázquez's pictured world. His distinctive look – which outlives office, clothes and role, which meets the artist's eyes, and ours, over time – is immediately recognisable in the direct gaze of the dwarf who stands a little way behind Baltasar Carlos at the riding school. He gets equal billing with Olivares on the other side of the child, and points at the prince with parental pride. In the distance the king and queen, high on a balcony, are now no bigger than a dwarf.

Not only was de Morra held in high respect by his royal masters, but in a decade when Velázquez is estimated to have painted very little at all, probably not more than a couple of pictures a year, this solo portrait was one of them. It was surely made in the spirit of solidarity. It is not the dwarf's size that makes the picture so profoundly moving, but the expression of the inner man, his condition as a human being. He was exceptional: Velázquez's portrait tells that truth.

Yet still people ask why Velázquez kept painting dwarves; why – of all the hundreds of aristocrats and courtiers who could have appeared in his art – these were the colleagues he so often chose to depict. The dwarves appear in close-up and at a distance; on their own, paired with a royal child or in larger palace gatherings. In *Las Meninas* they are as numerous as the maidservants after which the painting is named. The lady dwarf, María Bárbola, stands closer to the viewer than any other adult, an emphatically prominent position to match her formidable candour. Next to her the young dwarf nudging the dog with his foot is the only human being who moves (who is allowed to move), hair swaying in the rapt stillness of the painting.

Captain Widdrington, the Hispanophile naval officer who said he saw a nude dwarf, actually believed that she was María Bárbola herself. In fact the picture he came across in 1834 showed an unusually stout child and not a dwarf, and was painted by another artist altogether; *The Monster* is its sad title in the Prado. The idea that Velázquez could have painted a female dwarf stripped of her clothes is inconceivable; he left only one nude that we know

of and she is the goddess of love, the so-called 'Rokeby Venus', named after the country house in Yorkshire where the picture hung – another spoil of war – seen by almost no one in the late nineteenth century.

Velázquez has reaped scorn as well as admiration for giving such attention to the dwarves, just as Philip IV has been criticised for employing them. Stirling Maxwell writes that 'the Alcázar abounded with dwarfs in the days of Philip IV who collected curious specimens of the race, like other rarities. In Velázquez's paintings they are, for the most part, very ugly, displaying, sometimes in an extreme degree, the deformities peculiar to their stunted growth.' Richard Ford claims that 'the ugliest of these distorts of nature were most esteemed . . . like Scotch terriers'. They were spoken of as 'palace vermin'. In the catalogue for the 1986 Prado show 'Monsters, Dwarves and Buffoons', Alfonso Pérez Sánchez, then director of the museum, echoes the phrase: 'It might seem surprising, or even in bad taste, to dedicate an exhibition to the certainly disagreeable and painful world of the physically and psychologically deformed beings who swarmed around the European courts.' But the Prado had so many of these creatures, so often painted by Velázquez, that it seemed excusable to make a show of them.

If the dwarf was a freak, it followed that the portrait of a dwarf was freakish, too – unless of course the painting happened to be by some genius like Velázquez. In fact, Velázquez's portraits of dwarves make exactly the opposite case: that these people have the right to appear in paintings by virtue of their profound individuality. Each deserves a portrait to him or herself.

But still there must be something more, for historians, something beyond Velázquez's even-handed fascination with humanity, to explain the existence of these portraits – or explain them away – and that is to consider them purely as palace commissions. This way the dwarves do not have to be subjects voluntarily chosen by Velázquez, even though he paints some of them more than once.

Palomino says he saw several paintings of dwarves, actors and jesters grouped together in the queen's apartments in 1683. A palace inventory confirms this in 1701. But immense scholarly efforts have gone into proving that wherever they were then, they started out somewhere else – in a hunting lodge called the Torre de la Parada not far from Madrid.

The Torre was a miniature brick palace at the foot of the Pardo mountains. Many artists were commissioned to produce works for it, including Rubens, at that time the most famous painter in Europe. On its walls hung Velázquez's portraits of ancient philosophers – including his great *Aesop*, now in the Prado – and, some scholars believe, the solo portraits of dwarves.

So perhaps this was thematic art, the paintings made to measure and hung high on the walls, which would explain the audacity of propping a dwarf like a doll on the floor, his footwear so frankly exposed (quite unacceptable at eye-height). It would also explain why they were painted with such experimental freedom, these loose and gracious brushstrokes entirely acceptable because the pictures would be way up on the walls of a place where people collapse in heat and exhaustion below, after a hard day shooting wild boar. Not that anyone cares how the court painter depicts such people in any case, for there are no formalities to uphold and no likelihood of offending the sitter.

There is no thought in this scholarship that Velázquez might have been matching the art to the subject, or that he found the dwarves more interesting to paint, and therefore his conceits were more interesting; above all, that he might have been as (or more) inspired by a man who could hold his own in the palace despite being the butt of midget jokes as he was by a gloomy monarch.

The hunting-lodge narrative can only ever explain the circumstances of their making, in any case, not what occasions the depth of these portraits themselves. This comes – as always in Velázquez – from the live encounter between subject and artist more

markedly, almost, than with any other painter. Now that they have been brought down from the high walls on which they may have hung, we can witness this supposedly casual experimentalism up close – the soft and filmy paint, the amazing grace of the brush-strokes for Lezcano; the quick strokes, bravura dots and intense dabs for de Morra – and see that it is more like palpable feeling transmitted directly to paint.

Velázquez is generally thought to have been hemmed in by official commissions, perpetually unfree as a painter. But as long as there are no documents to tell us otherwise, the opposite might equally well be true. He often managed to delay or duck out of painting royal faces altogether, so why should he not sometimes have chosen who should appear in his paintings? Velázquez's dwarves are themselves, first and foremost, and they have something like the same freedom they had at court, humanising that strained and formal world. Nobody catches your eye on such equal terms as a dwarf, nobody has such a free smile or such an overt sorrow. The only person who reads a book anywhere in his art is a dwarf.

Don Diego de Acedo was a learned scholar and civil servant in charge of the Royal Seal. He travelled with the monarch on diplomatic missions, and is portrayed outdoors, like Lezcano, but in such a wintry world. Partly this is to do with the fading of paint, but the scene shows snow-laden hills beneath a heavy grey sky, and Diego's huge book looks like snowfall too, a vast heap of whiteness in the gloom.

Into this volume he presses a tiny hand, bearing the monumental weight of pages. Velázquez gives him the fullest respect in the posing alone – the way that Don Diego handles the burdens of seniority, the way his fingers are both at work and tactfully concealed by that work. He is not too small for high office; it's an image of exquisite tact.

The hat is jaunty, but there is suffering in that highly intelligent

face. Was ever an artist more able to convey minute degrees of extroversion or introversion than Velázquez? Maybe the painting was supposed to go above a door in the pleasure palace of the Torre de la Parada; if so, it could hardly have contributed to the general cheer. It is a grave and penetrating study of a pensive man, in a continuum with the portrait of Nieto.

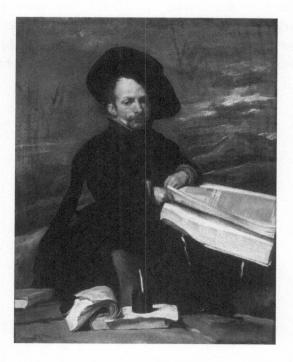

All people are equal in the art of Velázquez, whatever their size. His paintings make small people large, and large people tiny. He does not take sides. There are full-length portraits of dwarves just as there are full-length portraits of inbred kings, and he doesn't truckle to either. These paintings of small figures with short legs and large heads are just as respectful as the portraits of Philip and his brother with their dopey stance and enormous jaws, just as clear-eyed with fascination. Velázquez and his king became friends; and so it seems with the dwarves, in whose painted faces there is such deep connection.

Dwarves appear in other paintings of that era as a spectacle, shocking or novel. When Van Dyck was commissioned to paint Jeffrey Hudson – the English dwarf who became such a plaything to Charles I's eventual bride, Henrietta Maria, that she had him jump out of a pie at a royal banquet – the painter gave his subject a tiny dog to boost his height, but then cast Hudson in the dog's role to make the little queen look taller. Velázquez never uses a human being in this way. Nobody appears in his art as an ornament or device; nobody is high or low. People appear in his paintings simply to be their unique selves. Nothing human can ever be alien to him.

The Attack

To the high-minded critics who looked down on this little man from the provinces, the bookseller and his precious painting had something telling in common - both were entirely unknown, arriving out of nothing and nowhere. John Snare had no education, no social standing, no pedigree as a gentleman or an expert on painting. That might not have mattered if he had been some rogue adventurer like the Scottish captain who 'found' the Arnolfini portrait in Brussels, or one of those middlemen who dodged about the continent picking up Old Masters for aristocrats; these chancers were only trying to flog their wares. But Snare was carrying on like an earl, displaying his possession in Old Bond Street as if he too collected the unimaginably rare works of Velázquez. He was mocked as an amateur, in the worst sense of the word, accused of ignorance and 'silliness of supposition'; and he was habitually described as a country bookseller, as if he had strayed outside his class. Stirling Maxwell darkly implied that Snare might even be trying to raise his social standing by linking his name with that of the mighty Velázquez.

Perhaps Snare felt he had to work especially hard to establish a reputation for the portrait, having none of his own; the pamphlet he put out midway through the London show is even titled 'The History and Pedigree of the Portrait of Prince Charles'. But there is no question that he was driven by a powerful intellectual curiosity to read deeply, follow every trail and put all of

his knowledge into the cause. He goes to extraordinary lengths to solve the mystery with which he has become obsessed, a mystery that irresistibly presents itself to all who saw the painting then, and anyone who chances on Snare's story now: namely, how on earth he could possibly have laid hands on a lost Velázquez that others before him had longed to discover, yet of which there was – apparently – no recorded sighting since the day it was made in Madrid.

The first conundrum is how the portrait reached England (there is no reason to think it was left behind in Spain; Pacheco makes no further mention of the painting and nobody has ever suggested that it lingered on in that country). Snare believes it returned with Buckingham and Charles. 'It was not likely they would leave such a token behind, and though mention is made of some pictures promised to be sent to England by the King of Spain, I can find no evidence that the gifts were ever received, nor am I able to discover any reason to suppose that the Prince's portrait would have been entrusted to so hazardous a custody.' The high price of the painting also goes to that argument.

Snare's timeline is tight, at least to begin with. The royal party docks at Portsmouth in October 1623 and travels by carriage to London, arriving at one in the morning. They do not go straight to the palace, but stop at Buckingham's house by the Thames to rest until later that day. So far, so true; Snare has come across the diaries of the king's chaplain, John Hacket, from which he learns that all the baggage was unloaded at York House. He believes the Velázquez stopped there, passing without further ado into Buckingham's famous art collection.

He has at least two reasons to think so. There is no reference to a painting of Prince Charles by Velázquez anywhere in the royal collection. Snare works diligently through the inventories of Charles's pictures on becoming king in 1625, and those made after his execution in 1649, and can find not a hint of it among the

hundreds of portraits; although the main inventory was drawn up by a Belgian painter whose grasp of English – and perhaps even of the historic importance of his task – seems almost comically limited.

And why would Charles want to hang on to a memento of the Spanish Match in any case? The whole campaign had been a dismal charade, much satirised back home in England. Since anything connected with the trip might be distasteful to Charles, 'he would desire to get rid of the picture, and any friend who should take and keep it from his sight would perform a kindly service. Such a friend was at hand in Buckingham.'

The second reason, of which Snare had no knowledge, backs up his belief. Charles did indeed get rid of a masterpiece that reminded him of the Spanish Match, and had done so even before leaving Madrid. This was a parting gift from Philip that he passed straight on to Buckingham: an immense statue of Samson Slaying a Philistine by the Italian sculptor Giambologna, now in the Victoria and Albert Museum. Seven feet of stupendous anatomical torsion carved in white marble, commissioned by Francisco de' Medici for his Florentine palace in 1562, the sculpture had already doubled as a diplomatic gift more than once. It proved monstrously difficult to ship back to London, but became one of the city's vaunted spectacles almost as soon as it was installed in Buckingham's waterside garden.

York House, the duke's home off the Strand, was a magnificent white palace with a garden leading down to the banks of the Thames. In its many rooms were pictures by Holbein, Raphael, Titian and Durer, as well as images of the royal family. Buckingham specialised in portraits and had recently bought a hoard of Roman busts from Rubens, sometime guest at York House, who described the collection as one of the greatest he had ever seen. The Italian master Orazio Gentileschi frescoed first the ceilings, and then the walls, of this extravagant building over many long months;

Rubens made a deft sketch of him while they were staying there. The drawing survives, but York House does not. All that is left of it is the pillared water gate, built just after the return from Madrid, its steps disappearing romantically into the dark waters of the Thames.

The inventories of Buckingham's collection do not mention Velázquez (or any spelling thereof). But many paintings disappeared after Buckingham's dramatic death in any case. Five years after the Spanish Match, an English lieutenant with a grievance about the treatment of his comrades during disastrous French campaigns led by Buckingham stabbed the duke to death in the Greyhound Pub in Plymouth. Buckingham's widow spent several years trying to make some income from his estate and evict the lingering Gentileschi before she married again; and in the months leading up to the English Civil War in 1642, a loyal servant named Trayler managed to smuggle most of the remaining art collection out to the continent, where large parts of it were rapidly sold off. The facts of how – and which – paintings eventually returned to England are still emerging to this day.

But Buckingham's inventories do include several portraits of Charles, and two are unattributed, so it is possible that one of them might have been the Velázquez. Snare had no knowledge of these tantalising records, alas, as they only came to light in the twentieth century.

Indeed, his next conundrum is precisely this silence. He can find no mention of Velázquez's painting again before the Civil War, but offers an explanation that is persuasively rooted in truth. The twenty-four-year-old Spaniard was nobody outside Madrid, let alone Spain. He had no significance, no reputation to speak of; and if the painter had no name, then his painting was effectively nameless too, slipping from memory's grasp after Buckingham's death. In York House the Portrait remained a thing at which no man might look too closely. Little by little it sank gradually to be regarded as no more than the thousand and one pictures which

are at this day preserved simply because of the likeness they were intended and are supposed to represent.'

Anyone trying to discover the history of the portrait today might begin, as Snare could not, with the computer. But it is striking just how swiftly the trail goes cold. There is scarcely any trace of its adventures, ominously, between Pacheco and Palomino and the negligible references to the bookseller himself. I soon found myself back in the very libraries Snare haunted, searching through the same books and marvelling at how much he had managed to discover, nose deep in the past, without an index. For there are occasional sightings, here and there, though Snare could not find them all.

The first comes in the vivid book on London published in 1790 by Thomas Pennant, the Welsh naturalist and antiquarian. Pennant walked all the way from Wales to London to marvel at the sights of the city, the great river, the noble architecture, the wonders of London life. He gives a close account of every grand building on Whitehall, including the Banqueting House where Charles I was executed in 1649. At number 3 he admires the 2nd Earl Fife's handsome Georgian house with its red-brick façade, high windows and elegant ceilings designed by Robert Adam. The earl shows him round his picture collection, with its noted portraits of Mary, Queen of Scots and the Duke of Buckingham, its lush canvases by Gainsborough and Van Dyck. And it is here, on the wall of the large drawing room, that Pennant is introduced to the cherished portrait of Charles I when Prince of Wales, 'painted by the Spaniard Velasco'.

James Duff, 2nd Earl Fife, was an intellectual, a friend of Samuel Johnson and the Scottish philosopher David Hume, an ardent art collector and politician. Born in 1729, he represented Banffshire in the north-east of Scotland in the House of Commons for many decades and was an unusually dutiful MP at a time when many parliamentarians scarcely troubled to take their seat in the House.

A progressive figure in Scottish agriculture, he built model farms on his estates, reduced the rents when times were hard, and bought grain from France to distribute as seed corn when the crops failed, at considerable personal expense. He seems to have been the opposite of the Duke of Sutherland (owner of the Velázquez that turned out to be a Rembrandt), whose role in driving local people from the land during the Highland Clearances remains notorious. The correspondence between the 2nd Earl and his estate factor is a touching portrait of the developing friendship between the two Scotsmen over decades, James to Willie, on every kind of subject from the new Prime Minister to the unusually early snowdrops in Banff

After the earl's death in 1809, most of the paintings in Whitehall would end up in his country seat, Duff House in Banffshire.

A few years after Pennant's visit the 2nd Earl received a letter from another antiquarian, the Scottish cartographer, historian and numismatist John Pinkerton. Pinkerton has heard tell of the painting and writes to the earl in 1797 to ask if it is really true that he owns it. 'Your letter,' comes the reply from Duff House on December 1st 1797, 'was sent to me from London. I have a very large collection of portraits. And there is indeed a very curious portrait of Charles I, when Prince of Wales, painted by Valasky, at Madrid: it is in my house at Whitehall. You may see it when you please. I am making out a catalogue of my pictures. If you remind me, I shall certainly send you a copy. I shall be in town by Christmas.'

A copy of this catalogue survives in the Victoria and Albert Museum in London, its heavy pages mottled with mildew. Affectionately inscribed to a lady who has done him the honour of examining his pictures, it is a testament to that vanished time when earls took a personal pride in their art. Fife welcomed visitors to Whitehall with something close to gratitude, delightedly escorting them around the portraits. Even when he was in his seventies, stooped and blind, he still managed to accomplish this guided tour entirely by touch and devoted memory.

The earl had scarcely any pictures to start with, inheriting few from his parents other than their own portraits. But in the 1798 catalogue he writes that 'I have lately had the good fortune to purchase many curious Portraits and Pictures smuggled over from France, since the beginning of the Revolution there. The Royal portraits were bought from many different places; many of them are very rare, and in great preservation.'

The catalogue walks the reader through the collection, room by room. He has Van Dyck's great portrait of Sir Kenelm Digby, diplomat and member of the Spanish Match entourage, whose letters home describe some of the diciest moments. There are paintings by Holbein and Poussin, a spirited portrait of the actor David Garrick as Hamlet, Godfrey Kneller's *Alexander Pope* and numerous Tudors and Stuarts. And in the First Drawing Room is the portrait of Charles 'When Prince of Wales, 3 quarters. Painted at Madrid 1625 when his marriage with the infanta was proposed. This picture belonged to Buckingham.'

When he comes upon his own copy of the catalogue, Snare, ever the respectful reader, is polite about that mistaken date. The printer diagnoses a misprint.

But there are worse errors to come. In 1851, the historian

Mackenzie Walcott refers to the Velázquez in his *Memorials of Westminster* as a 'celebrated head of Charles I when Prince of Wales, supposed to be the work of Velasco.' By 1902, a later writer has converted this 'head' to marble: 'this statue was executed in Spain when his Royal Highness was there in 1625.' The confusions creep in down the years: 1625, by Valasky or Velasco, who has now become a sculptor.

John Snare had only two sources – Pennant and the 2nd Earl's catalogue – but was faced with a more teasing discrepancy than spellings. Pennant referred to the portrait as a head, while the 2nd Earl specified three-quarters: which was it?

A three-quarter portrait, though it seems to imply a three-quarter-length figure, is in fact a term in general use since the 1630s to refer to the *size* of a canvas, usually 29 or 30 inches by 24 or 25. (Three-quarters, historically, refers to three-quarters of a yard.) There are many instances of three-quarter portraits from the seventeenth century onwards; they tend to show a figure to the waist or just below. But a three-quarter portrait could also depict just the head and shoulders.

Although it is a stretch, the two different descriptions of the Velázquez could almost be made to agree, if this was a head-and-shoulders portrait painted on a three-quarters canvas. Snare has to square the descriptions because 'both are obviously referring to the same Picture, there being no other to which the after-description about Madrid in the collection would apply'. In this he is surely correct. But then, a few pages later, he notices that Pennant describes another painting as 'A Head of Charles the First' and decides that he has simply muddled the portraits in his account.

Now there is another nerve-racking complication. In his catalogue, the 2nd Earl says that the picture once belonged to the Duke of Buckingham. What if he is speaking of a more recent Buckingham? Snare cannot believe this. He rightly points out that the 2nd Earl's catalogue contains a large number of portraits of members of the Buckingham family painted in the 1620s, and

though it is entirely possible that they may have been bought as a job lot from the present duke (of which there is no evidence to this day), only one of them is singled out, only one of them is glossed with that special boast: 'belonged to Buckingham', meaning the famous (or infamous) George Villiers, 1st Duke.

Snare admits that he cannot prove the picture belonged to Villiers, and he cannot show how it got into the hands of the 2nd Earl Fife. He cannot absolutely, and securely, prove that Pennant and Fife are talking about the same painting. He concedes all these points in *The History and Pedigree*, and frets sorrowfully – and honestly – over the holes in his narrative.

But given all the documents available today, Snare's theories still remain plausible: that Charles no longer wants the painting and gives it to Buckingham, avid art collector, just as he gave him the enormous Giambologna statue; that the portrait probably vanished from York House after Buckingham's murder (when Velázquez's name still meant nothing in Britain) or after his successor's flight from the Civil War in 1642, or as the Civil War was drawing to a close four years later. Whereupon debt or embezzlement, mishap or war sees it either slip through the slats or vanish abroad. There are documents of four different sales relating to the Buckingham collection in a period of sixty years and many paintings disappeared into Europe in this time, where they might quite possibly have been bought by the 2nd Earl Fife from their present owners: 'smuggled over from France, since the beginning of the Revolution'. Thus the portrait disappears in the seventeenth century and reappears in the late eighteenth in Fife House - assuming that this is the same picture owned by the 2nd Earl. Snare realises his theory pivots upon this point and that he needs more proof than Fife's catalogue. That proof arrives quite without warning.

While the painting was on show in Minster Street in 1847, a servant working at nearby Mapledurham Manor asked to come and see it for personal reasons. Snare agreed, avid to know more in case it

shed any light on the picture's history. Once again he stood anxiously by as a stranger scrutinised his Velázquez; once again he was not disappointed. There was no talk of Van Dyck – quite the reverse. The servant wanted to see the portrait for sentimental reasons; his father had talked of the Velázquez from his time serving the 2nd Earl at Fife House. Could he remember how the earl came by the picture? The servant offered to write to his father, long since retired to Scotland, asking for any memories, however small.

Weeks of silence turned to nail-biting months before a response eventually arrived:

Dear Son, I have been too long in writing to you, but was always waiting to make more inquiries concerning that Picture. Mr Forteath the factor recollects it being at Fife House, but how it came there he cannot say. John Brown and his wife were two or three years working there, they both know the picture, but cannot say when nor from whom it was purchased . . . So there can be no evidence got here, and I am afraid there is none living at this day that can give any more. Your affectionate Father, Alex. Grant.

Grant regrets he can give no more information: how amazed he would have been to know how much joy his letter brought Snare. 'Independent of the writer,' he enthuses, 'four individuals are mentioned as recognising the Portrait to have been in Fife House. Five persons therefore speak positively to one fact . . . The Portrait is clearly recognised as having once belonged to the Earl Fife, and as having formerly adorned Fife House.'

Now it should be acknowledged that not one of these four individuals had seen the portrait in Minster Street; and the fifth, the Mapledurham servant, had never seen the portrait in Fife House. They are all going by written descriptions, and it is one of the oddest aspects of those days that these could possibly be thought to suffice. An envoy writes from Venice that he has a

landscape with three horses and a half-built haystack by a Florentine painter, and that is supposed to be enough for the distant buyer to part with his money, never mind that it might be anything from a forgery to a daub, that the painter may be Dutch, that the haystack may be something quite else, that there is no way of knowing what the picture really looks like.

Inventories run to little more than a line per painting, in those times. Auction catalogues scarcely manage anything more. Early historians frequently concern themselves only with the subject of a painting – not how it appeared, how it was painted, how it struck the viewer – even though every work of art is so much more than its content.

The servants who had dusted the portrait of Prince Charles in Whitehall, who knew its surface by the inch, might not have believed that it was the same picture as the one in Reading, had they only seen it themselves.

The strength of Snare's developing case comes from the fact that each piece of evidence is corroborated by another; they all become mutually reinforcing. That his picture once belonged to the 2nd Earl is supported by these people's testimony, but also by the notion that he eventually parted with it, the proof of which must come from finding the various dealers through whose hands it may have passed on its way to Radley Hall.

The last piece of the puzzle arrives quite suddenly by post, on July 28th 1847, in a letter received from a London restorer named Thomas Mesnard, to whom Snare had turned for help. Mesnard (who greatly admires it) announces that he has two colleagues who not only know of the picture, but have actually seen it with their own eyes, hanging in the premises of one dealer who did business with Earl Fife, and another dealer who is said to have sold it to Mr Kent at Radley Hall. Five Scottish servants, three London dealers, a peer of the realm and a Spanish monarch: for Snare, the circle is complete. This is the lost portrait.

But is it?

Snare published *The History and Pedigree* in August 1847, in response to the wounding hostility of the *Fine Arts Journal*. He must have written it in less than three months; indeed, he stopped the Minster Street presses at the last minute, he confides, to include the contents of Mesnard's letter. He opens with many apologies for being only a humble printer, liable to make many literary errors, but his writing is lucid, impassioned and eloquent, so much so that one almost comes to suspect his self-deprecating tone. Is he trying to wheedle the reader with false humility; conversely, is this an attempt to ingratiate himself with the public on the basis of class? One is always waiting for the clock to strike thirteen; it never does.

Newspapers throughout Britain thrilled to the pamphlet. 'The manner in which Mr Snare has, without leaving the shadow of a doubt, traced the pedigree of the picture is truly wonderful,' wrote the *Post*, 'as romantic in many of its incidents as the expedition of the princely original himself.' The publication 'has converted many unbelievers among the best judges', and so it seems. 'The proofs are irresistible.' 'Can scarcely fail to convince the most sceptical reader.' 'Mr Snare has settled the question!'

'That the picture is a work of high art is attested in the fact that it has been pretty generally attributed to Van Dyck,' writes *The Times* correspondent. 'But this point has been most learnedly and we think satisfactorily put out of court by the criticisms of Snare.' Sure enough, Snare's reasoning seems sound. Van Dyck came to England in 1620, very briefly, before *Prince* Charles had a beard, and did not work for him again until 1632, when *King* Charles looked different and much older. If the portrait was made in the 1620s in England, and not Spain, it would have to have been by one of the court painters, such as Cornelius Jonson or Daniel Mytens, who worked there through that decade. But since none of these artists had ever seen a picture by the unknown Velázquez, they could hardly have painted anything that so resembled the Spaniard's unique style. (Unless of course they had in fact seen, and tried to emulate or even copy, Velázquez's portrait of Prince

Charles; this is a step Snare does not take since he believes that the portrait is genuine).

One acute reviewer observes that Snare's passion for the portrait 'is as angling to Mr Isaac Walton, almost the only thing in this sublunary world worth caring for'. But *Jerrold's Weekly Newspaper* makes an even greater literary comparison. In its palpable sincerity, in its honest enquiry and truth of expression, *The History* 'ranks with the pamphlets of Daniel Defoe'.

Snare might at last have reached some peace of mind about his painting. How much more he could believe in it, after the universal endorsement of the pedigree he had set forth; how much more he could hope that others hereafter would see it as he did. He had been unfairly accused of speculation, of trying to hype the picture for sale when he hadn't the slightest desire to part with it; he had been accused of ignorance and, if not ignorance, then wilful 'knavery' in trying to forward a hoax. Now he could at least rest in the knowledge that he had done his best to provide a convincing history for this masterpiece. But then Sir William Stirling Maxwell came at him – and not once, but in two books.

In his Annals of the Artists of Spain Stirling Maxwell was not quite unkind: 'Mr Snare has shown great industry in collecting, and skill in arranging the presumptive evidence as to this point (authenticity), which I do not think, however, that he has proved.' The author does not believe Snare has shown that the painting definitely belonged to the 2nd Earl Fife; and, even if he had, that would establish nothing more than the earl's opinions about the painting. But much more significant is this second objection: 'I cannot agree with him in considering that this picture, more than three parts finished, can be the work spoken of by Pacheco as a "bosquexo" or sketch.' It is too complete.

Stirling Maxwell was one of those who interpreted Pacheco's vexed sentence to mean that Charles was on a hunting trip at the time, so Velázquez can only have made a very hasty sketch en route. But he does acknowledge the printer's contribution to know-

ledge. 'Mr Snare's book, however, is no less candid than curious, and deserves a place amongst works on Spanish art if only for its translation of Pacheco.'

Damned by a phrase, the picture is too complete to be a sketch. Yet Velázquez's haunting images of the Medici Gardens in Rome have long been known as sketches because they were made on the spot, and they are more than 'three parts complete'. Las Meninas was once described as the largest oil sketch ever painted. Who, beyond the artist himself, is ever to say when, or if, a work is finished in any case; in Velázquez's portraits, faces magically condense out of loose strokes and emptiness as nebulous as air, while bodies are barely touched in, yet these works were accepted in his lifetime as fit for the walls of the palace.

Even before Stirling Maxwell, Richard Ford wonders at Velázquez's miraculous way of working on the canvas as if making a sketch: 'He seems to have drawn straight on the canvas, for any sketches or previous studies on paper are never to be met with.'

The painting is the sketch.

Snare was so distressed that he wrote a rejoinder to Stirling Maxwell. Proofs of the Authenticity of the Portrait of Prince Charles, 1848, is a strange mixture of scrupulous argument and research, but also of anxiety bordering on despair. 'He who has something to say surely has a right to speak,' he begins, his voice ringing with anguish. Anyone who thinks that Snare was just an amateur impresario, trying to make money from his painting – he did, after all, charge for the London exhibition and the accompanying pamphlet – might read this defence of the painting, so hard-won and sad, so exhaustively detailed, as a lament for the damage inflicted not on the author but on the reputation of Velázquez.

Snare's pamphlet was an invitation that Stirling Maxwell could not resist. In *Velázquez and His Works*, 1855, he attacked not just the picture, but all of the printer's beliefs, from the idea that it showed Charles as a prince to the notion that it had ever belonged to the

and Earl, still less the Duke of Buckingham himself. Stirling Maxwell did go so far as to admit that he had completely misunderstood the term *bosquexo*, conceding that Snare's interpretation was correct, but still he dismissed the portrait.

Snare rightly feared that Stirling Maxwell's opinions would be repeated by his successors: they can be found, fossilised, in many books on Spanish art.

It is easy to understand how Snare might have felt after years of labour – with no grand library of his own, no money for travel, no chance of comparing one Spanish painting with another, none of Stirling Maxwell's advantages – to have his painting repeatedly swatted by this highly respected historian. But what upset him most was the fact that Stirling Maxwell never ventured anything more than his abrupt verdict. He never troubled to go into any detail about style, colour, subject or indeed any aspect of the picture as art, even though so many people believed it really was by Velázquez.

For Snare, 'the handling is free in the extreme. The brush appears to have swept across the canvas and never to have paused or hesitated. The touch of a master who knew his power and put forth his energy is at once recognised.' For Stirling Maxwell, it hardly matters what the brushwork is like because the prince looks older than he should, and the picture is more than what he understands by the term 'sketch'. Yet the same writer, of course, was prepared to believe that Velázquez painted bagpipers and poodles and, on the strength of hearsay, nude female dwarves.

The difference between the two writers is one that still exists in art writing today. Stirling Maxwell is intent on establishing the history and pedigree, so to speak, of all the paintings by Velázquez he can find, and ordering them in time and place like the pioneer art historian he was. Whereas Snare is looking at a single work of art with the power to affect the viewer as a person or a poem might. His pamphlet is a biography of the picture, but it is also a hymn of praise. He is an evangelist for his Velázquez: he wants to travel the world with it, he wants the world to see and love it as he does.

ad an arm meneng at territoria general fizik an da saman beneral penengan beneral penengan beneral penengan be Penengan pe Penengan pe

The granus is a second of the control of the contro

The Theatre of Life

ÉDOUARD MANET BOARDED the new direct train from Paris to Madrid one summer's evening in 1865. The uncomfortable journey took a day and a half. He stayed in the Grand Hotel de Paris, supposedly noted for its French cooking, though Manet found the food so inedible that he sent every dish back. We know he saw a matador gored in the ring and took an excursion out to Toledo to look at the paintings of El Greco. But the overwhelming reason for this hazardous pilgrimage, taken during an outbreak of cholera and without a single word of Spanish, was to set eyes on the art of Velázquez.

In the long galleries of the Prado, Manet found the painter of painters, 'worth all the misery and exhaustion of the trip'. But he also discovered what would become, for him, the painting to end all paintings: Velázquez's portrait of the court performer, Pablo de Valladolid (Plate F).

Pablo makes a momentous appearance – out of thin air. His dark figure flashes up in the glowing void of the picture, a burning black shape in an empty space, anchored by nothing but shadow. There is no floor, nothing to hold him there but his own commanding presence in this solo show. The sheer suddenness of the image amounts to an entrance.

The actor holds his pose, feet planted far apart, one hand across his body as if to contain all the energy inside him, just as Velázquez's contours hold him tight to the picture. He stands fast, but his

gestures speak for him. One hand hitched in the cloak signals to the other, which points down and away as if towards another time and place. It is a declamatory gesture; and this is the only portrait in which Velázquez depicts action. These communicative hands – the left leading to the right, and to the finger pointing to a thought in pure space – are performing a double act together.

There is no stage, no set, no costume or props, nothing that might limit him to a particular character or performance. Pablo is free to be simply and only himself. And just as the picture does not define him by role, so it does not confine him to any particular place. Behind him there is no wall, no architecture, not a speck of context, even the junction between the wall and the floor has gone. The space in which Pablo stands has become his element, a diaphanous void in which the performer appears monumental. The right foot drifts off into its own shadow, which trails away like smoke on water. Pablo is standing on – in – nothing but a painting.

Manet could scarcely believe what he saw. He wrote from Madrid to his fellow painter Henri Fantin-Latour: 'This is the most astonishing piece of painting that has ever been made. The background disappears. It is air that surrounds the fellow.'

Who is the man in the portrait? Anyone can see that he is some sort of performer, that gesture is his métier; he is not one of Velázquez's nameless courtiers; indeed, his identity has never been in doubt. Pablo de Valladolid worked at the Spanish court from around 1632 (nobody has a fixed date) until his death in 1648, and is probably in his late forties in this picture. He was an hombre de placer – man of pleasure – one of many servants hired, though not always regularly paid, to entertain their royal masters. He may not have come from Valladolid so much as Vallecas, a poor district on the outskirts of Madrid, and we do not know what characters he played, or what roles, either on- or off-stage at the court. But we have the picture and its staging of the man, the homage it pays his performance.

When Manet saw the painting in the Prado, it was called Portrait of a Famous Actor at the Time of Philip IV. In the slippery guesswork of titles, this feels exactly the right surmise: an actor, to be sure, and evidently acclaimed at the very least by Velázquez himself. But Pablo started his career in the records as a jester. He was described as a jester for centuries, in fact, until someone listed him as a buffoon, whereupon the nineteenth-century German scholar Carl Justi defines him as a Pantaloon and finds him killingly funny. 'The gesture of the mime cannot possibly be mistaken,' Justi writes in his influential study of Velázquez. 'His half-open right hand is extended a little downwards, as if he were retailing to the public some good joke, perhaps at the expense of some notable person in that direction. Pose, gesture, countenance, correspond nicely with the outburst of laughter doubtless provoked by the humorous quip drily uttered by apparently the most innocent of beings. This is a laughter-compelling head.'

Nothing is more subjective than humour, a comedian might argue. But nobody laughs at Pablo now, and one wonders if anyone ever did. If he had appeared as an actor in the palace inventory, would Carl Justi still have found him so hilarious? Taxonomy distorts interpretation. Get the naming of parts wrong from the start, and it seems that you can believe anything.

Pablo has had multiple identities over the years. He has been one of the 'palace vermin' and one of the licensed fools. In the twentieth century he was an improvisational actor, although he remains a 'buffoon' in the Prado to this day. Whatever he was – and as with the term *bosquexo*, the simple translation of Spanish nouns has caused endless discrepancy – he was nobody's fool to Velázquez.

The painting shows him in his professional moment, all his dramatic gifts supremely embodied. Some have seen fear and lone-liness there, others the vulnerability of a man putting on the performance of a lifetime each day. Far from being a comic turn – and it is doubtful that modern eyes see anything much to laugh

about now – the painting is both dazzling and poignant. Nor is this depth an illusion. It emerges from a strange ambivalence that becomes apparent to anyone standing where Manet once stood, in front of the painting in the Prado.

Pablo is all in black, except for the golilla collar, so the focus is thrown on the face and the knife-edge contours. This is where the mystery enters. The man has more power on the right-hand side – best foot forward, firmly holding his cloak about him, its feathery swags, and the knee ribbon, like uplifting wings – than he does on the left, where life is altogether less certain. The portrait is a balancing act. As you walk from one side to the other, the pose becomes ambivalent; one eye is no longer quite in accord with the other and a sense of sorrow complicates the face. The power of the portrait, and its subject, is immeasurably deepened.

Manet left Madrid as soon as he could, so miserable without his creature comforts that he lasted not much more than a fortnight. He wrote to Baudelaire that 'Velázquez was the greatest painter there ever was.' Back in Paris, he painted a picture based on the Velázquez and called it *The Tragic Actor*; he clearly didn't find Pablo funny, either.

Manet's picture shows the French actor Rouvière dressed in black, a sword discarded on the ground beside him. He is in the same no man's land as Pablo, but like so many of Manet's figures is conspicuously himself, the modern man in the shell of somebody else's clothing, playing a role – in fact, the role of Hamlet. The difference is that Velázquez's Pablo is purely himself; he is held there by nothing but the strength of his own presence and the painter's art. 'Simply the thing I am shall make me live.' It feels like Existentialism avant la lettre.

That portraits are like performances is a truth rarely in need of mention; the person in the picture is making an appearance, the picture is staging that appearance. Some portraits take this further than others, but Velázquez goes beyond any artist before him. He

positions Pablo in an expressive world of his own, surrounded by an atmosphere that might be the visual manifestation of his own charisma.

The air – the paint – around him is a combination of ochre, green and grey brushstrokes that vibrate with a glow that has something in common with sunshine, candle and limelight. It is oddly radiant, and nothing at all like the ambient light around you in the Prado, just as the nameless place in the picture lacks all definition; it is only the actor's feet that indicate the ground beneath him, that bring the scene down to earth.

But there is a palpable sense of brighter lighting in the spot where Pablo poses, ringed by shadows that also seem to indicate an off-stage world.

Even in Velázquez's lifetime, Spanish theatres had sophisticated lighting, elaborate sets and complex machinery to conjure illusions of moonlight and rain, flight and fire. Seville had four theatres by the time he was born, and another was built in his childhood. Drama was so fundamental to Spanish life that there were theatres everywhere, even in quite small towns, and plays were performed on travelling stages in market squares, during pageants, parades and outdoor festivals, in palaces, villas and gardens. When the new Buen Retiro palace was built in Madrid in the 1630s, there were even spectacular performances on the boating lake that is still there today in El Retiro Park.

Flaming torches, and their reflection in the rippling waters by night, created a spellbinding sense of danger for the production of Calderón's play about the sorceress Circe. Silver lamps brightened the sense of daylight and enormous candles were used to illuminate certain passages of painted scenery; they could be snuffed out, too, to powerful effect: sudden darkness, sudden death.

On a single spring night in 1632 Count-Duke Olivares laid on three productions for the king and queen on temporary stages in the bosky gardens of a villa outside Madrid. A few weeks later, on Midsummer's Eve, they returned for Francisco de Quevedo's crackling satire He Who Lies Most Prospers Most, and then progressed through to the gardens of the villa next door to watch Lope de Vega's Midsummer's Night. One imagines them moving about in the warm dusk like Titania and Oberon in Shakespeare's Dream.

Velázquez painted Quevedo, magnificently irascible in nosepinching specs; a copy exists that shows us something of this startling portrait – the asperity of the sitter's eyes ringed and redoubled through his large lenses – but the original has, alas, vanished.

Quevedo lived a life of constant drama: vicious fights with rival writers, banishment, exile, skirmishes with the Spanish Inquisition, defamation and ultimately prison. But he was for a brief few years one of Velázquez's colleagues at the court and it seems, moreover, from a poem that appears in his collection *Silvas*, that these two lights of Spain's Golden Age – the piercingly intelligent writer, the piercingly intelligent painter – had some deep understanding of one another. Quevedo wrote a famous praise of Velázquez's unique way of painting:

Through you the great Velázquez,
Skilful as he is inventive
Can bring beauty to life
And give feeling to flesh
With his distant blots.
When he paints
The result is not likeness but absolute truth . . .

'Distant blots' so perfectly captures the apparent chaos of marks made using long-handled brushes, Palomino says, in the manner of Titian. And who better to confirm the truth of a portrait by Velázquez than the one person with an intimate knowledge of the sitter, both within and without – the poet Quevedo himself.

It was sometimes said that Olivares's motive for dreaming up the new palace of the Buen Retiro was to distract Philip from daily politics so that he could get on with ruling Spain himself – the overbearing, resoundingly ambitious minister once more puppeting the hesitant and insecure king. Work began in 1629 on a building raised so fast it was nicknamed 'the chicken-coop', partly in reference to an old aviary that once stood on the spot, but also because the structure appeared so provisional and hasty. The new palace was to be an escape (retiro: retreat) from the gloomy old Alcázar, without the laborious slog to the country-side, for it is not fifteen minutes' walk between them; and an elegant park was created for the palace in the surrounding lands donated by Olivares himself, where pleasure boats could be rowed, puppet shows performed, masques and plays staged upon and around the lake.

The inaugural production took place on a massive platform erected seven feet above the water. Calderón's *Love, The Greatest Enchantment* lasted for six hours, finished at one in the morning and ran for several nights, including a free public performance watched by hundreds of Madrileños. In addition to the usual trapdoors and curtains, it featured a waterfall, a chariot drawn across the water and artificial lighting that would brighten or fade to create an illumination something like limelight.

The most important of all the rooms in the Buen Retiro was the Hall of Realms, built as central throne room and chamber of state, but initially used as a theatre. Velázquez painted a sequence of huge equestrian portraits for the Hall, images of monarchs he had never met – the last king, Philip III, and his wife – as well as those he saw every day in a great cycle of lineage: this queen's eyes, that king's chin, their pale complexions, handed down from one generation to the next in a spectacle of inbreeding so intensive that some of the figures in these paintings had aunts who were also their nieces. Like players on a stage, these paintings were meant to be viewed from a distance; and they have a double existence: up

close, a baffling semaphore of dots, dashes and blots that resolve, from further away, into monumental rearing figures.

The Hall of Realms was the size of a theatre in itself and fitted with high balconies all round so that spectators could watch the proceedings below, which often took the form of new plays and masques. Door shapes were later cut out of some canvases so that the professional actors (and the players of court life) could make their entrances and exits at exactly the right intervals around the room. Indeed, two of these portraits, now in the Prado, recently grew larger when conservators discovered flaps of canvas that had been folded back to make the pictures fit the space between windows and doors. These sections are bright and unfaded, like the turned-back cuffs of an old overcoat that have never been exposed to daylight.

When the Buen Retiro finally acquired an actual theatre, one of the first performances had thirteen scene changes – palace, forest, river, glade, lake – in little more than one hour, devised and created by the royal painters.

And the courtiers themselves were sometimes required to take part in palace productions, no doubt to the mirth of their colleagues. On one occasion Count-Duke Olivares even appeared on-stage himself in a representation of the world turned upside down – 'el pobre mundo al revés' – featuring a mock-wedding between the knight of the shining vegetable, the Marquis of Cauliflower, and the daughter of the good Count of Parsley. The Count-Duke slummed it as a porter. Velázquez, in drag, was elevated to the title of countess. He had only one line: 'Come on, marry them.' Was he cast according to character – a man of few words, too taciturn and watchful to be cajoled into farce? It is easier to imagine Velázquez listening than laughing.

The court itself was of course the grandest theatre of all. *El teatro de la grandeza*, as it was known – the theatre of greatness – had more than 1,200 dignitaries, and rituals as slow and deliberate as a masque in perpetual performance. Its leading actor was Philip IV. The king's progress down a corridor was a spectacle in its own

right - the chamberlain with the key opening each door in turn, as courtiers watched - and he would dine before a public audience once a week at the Alcázar. Philip was alternately hidden (literally. behind small latticed screens to overhear his advisers' conversations) or dramatically visible. When he went to mass at San Jeronimo's church in the east of Madrid, every courtier followed behind in a long procession. And when plays were performed, Philip's presence - his very person - might be ingeniously acknowledged in the staging. The king would be seated some twelve feet away from the stage, at the exact focal point for the perspective of each piece of painted scenery. Next to him sat the queen, and on either side of the room stood ranks of courtiers looking back and forth. watching both the play and the monarchs. That they were as much a spectacle as the performance itself was a point superbly made in one particular production, when the curtain rose to revealed a throne positioned at the centre of the stage, exactly opposite the seated monarchs. And propped upon this throne were two portraits of these same monarchs, so that the king and queen looked at their own images, which looked back, like mirror reflections - an act of staging that irresistibly invokes Las Meninas.

Velázquez, involved in these spectacular productions, in turn theatricalised the royal portraits. His painting of *Baltasar Carlos in the Riding School* shows a real place at a real time – it even offers a glimpse of the brand new Buen Retiro and the parkland beyond – but its figures are positioned in different phases, as it seems, almost in different planes of reality. They recede at intervals, the dramatis personae of a crowded performance in which everyone breathes the same air, is lit by the same fresh morning light; and yet none of it looks real, so much as a theatrical dream.

The young king on the balcony is barely more than a pale oval marked with two dots and a dash, but even a child can read this simple sign as a face. Velázquez makes Philip instantly recognisable simply by adding a hint of moustache and a wavelet of strawberry-blond fringe. The whole effect is pulled together with

body language, the king's stance and the impression of his long legs in their white stockings a miniature version of his pose in the bigger portraits. His first wife is summarised in no more than a hairline and cheek. And behind the royal couple – a vignette as small as the mirror in *Las Meninas* – are gathered some watchful servants, arranged like those in Velázquez's greatest masterpiece. We know these people through his painting, large and small, near and far, in a thousand brushstrokes or conjured in two or three: the members of the court, the people of that world – the characters of Velázquez's art.

Velázquez, as no other painter, moves people back and forth in space, showing them tiny or vast, gathered in crowds or in an isolation so profound that their surroundings have dissolved away. The blocking of figures is crucial to his vision: he shows his people as they appeared in the grand theatre of the Alcázar. Monarchs, courtiers, actors and dwarves passing through the maze of long corridors and wide chambers, framed in doorways, visible close up or silhouetted at extreme distance. Velázquez himself arranged the Hall of Mirrors so that to enter that vast room was to step into a concatenation of images: mirrors, portraits and their looking-glass reflections, people moving among them like figures freed from the pictures. What was real, and what was illusion?

Which artist of the baroque era, or since, depicts the same people on every scale, and in every part of the scene, down-stage, centre-stage, in and out of the wings, in light and shadow, from the soliloquising foreground to the chorus line and background exit? People who look at each other and us, who have such an acute sense of our presence, who seem conscious at all times of the edge of the stage, the proscenium arch, the borderline between watching and being watched – between the performance and the world?

If the palace is a theatre, it is also a gallery – a gallery of Velázquez's own pictures. He only has to walk along a corridor, up a staircase, through a grand apartment, into a Hall of Mirrors or a prince's

quarters to see his own paintings hanging in state. He only has to stand in his studio to see works from the past preserved alongside those in progress. He can see his own evolution flowing without interruption all the way round the building. He sees the results of his own experiments: how pictures look at a distance, how effects work in shadows, how he used to paint, how he might paint people in the future. All of that thinking lies deep in his work.

And the people Velázquez painted saw themselves too, of course, pictured on the walls of the palace: Pablo the performer and Francisco Lezcano the dreamy young dwarf; the jester Redbeard, who played a Turkish pirate of that name in court comedies (his portrait also described as a *bosquexo* in the palace inventory of 1701), and his opposite number Don John of Austria, who took the part of the Spanish hero who beat Redbeard in a famous victory at the Battle of Lepanto.

Don John in his plumed hat, cocked over a shrewd and handsome face, heavily worn by worry and weather, is as thinly painted as a fine watercolour. Even in its incomplete state, the portrait was displayed during Velázquez's lifetime and valued just as highly after his death as the portrait of Pablo. And there in the background is a little battle scene, too; if only John Snare had been able to see this painting.

The portrait of Don John has amused Velázquez scholars to the point of hilarity down the years. Armour lies ready on the floor while the naval battle rages outside, two ships about to clash. But of course the poor man can do nothing about it, for he is only a jester in worn clothes and an oversized hat who works at the court, eats with the farriers and probably doesn't often get his wages. The discrepancy is supposed to be comic, in theory at least. But is the painting actually funny? Again one sees something far deeper in this strange and tender portrait of the man with his broken nose and bony beauty, a performer working bravely to be mocked. Do we really see paintings so differently nowadays – hasn't there always been far more than mock-heroics to this scene? Perhaps we have

been too cautious in our responses to art, too little confident of the witness of our own eyes against the arguments of scholars. Art historians point out that Don John was a low-class jester playing a high-class hero, so the dissonance must have been comic. But that only relates to what we know about the entertainer's job and the role he was hired to perform. It does not relate to what we see: to the portrait and the way it is painted. What strikes here is not just the complex character of the man, but the matching character of the paint: gentle, grave, dissolving in veils, as if the man was hovering on the edge of a dream.

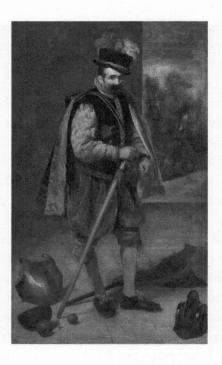

Don John and Pablo de Valladolid were not in a position to commission their own portraits, despite being the living inspiration for these pictures. They are performing for their royal masters once again, in a sense, when they pose for Velázquez. But on the royal walls, masters and servants became equal. Imagine what it must

have been like for Pablo to happen upon his own portrait down a palace corridor, this lightning strike of an image, this coup de théâtre. Himself! Velázquez surely chose to paint him thus as a form of salutation: the master painter recognising the master performer. The portrait rises in every respect to the level of the performance.

Pablo returns in a later painting that has been known variously as 'The Astronomer', 'The Geographer' and 'Democritus'. Here he acts the part of a merry man with one hand suspended above a globe, about to tickle the world into motion with his light finger. He's the very soul of mirth, with a smile that deserves a smile in return.

He didn't always have this globe. An X-ray shows that he was impersonating someone else, before Velázquez converted him into the figure we see today. A copy of that original exists, entitled *The Sense of Taste*, showing the same glowingly cheerful man holding up a large glass of wine. Perhaps *Taste* was on a palace wall for years, Velázquez contemplating its potential every time he passed, or perhaps he kept it in his studio – patient, critical, pensive. As Pablo works on his part, so Velázquez recasts the picture; the two artists collaborating on their performance.

Was Velázquez ever alone for long? We know that he had studio assistants, some of whom became properly renowned in their own right. Juan de Pareja, the black slave he made a public point of freeing, probably came all the way from Seville with Velázquez and never left his employment. Juan Bautisto del Mazo, whose paintings are such respectful imitations of the master, became Velázquez's son-in-law and a court painter himself. Juan de Alfaro, the apostle who grew up in his studio, drew Velázquez on his deathbed, eyes sunk, features as delicate as pencil lines in themselves; it was Alfaro who gave such deeply detailed knowledge to Palomino for his influential biography of Velázquez.

There are eight other people with the painter in *Las Meninas*, not counting the implied presence of the king and queen. The picture shows a chamber of the Alcázar on another floor and in another wing from the apartment where Velázquez lived with his wife Juana

and their daughter Francisca; if one followed Nieto through that door, up that staircase and on through the vast labyrinth of corridors, one would eventually come to the artist's home in the eastern flank. It was a long way; a courtier could walk miles criss-crossing the Alcázar in a working day.

That this was a tightly knit family is apparent from the paintings. Velázquez's wife Juana may be the woman in profile in the beautifully wistful vision of a sibyl. Francisca is thought to be the girl with her head intently lowered over her needlework, an image of absolute absorption. She may also have appeared as an infant with her mother in an earlier painting, of *The Adoration*, Juana as the Virgin and Francisca as the baby Jesus. Juana's father is there too, reverently witnessing the scene on his knees as one of the wise men. Francisco Pacheco, whose pompous tone, so apparent from his writings, might have jarred with his former pupil, nonetheless gets Velázquez's respect and a solo portrait too, now in the Prado, in which the intensely corrugated brows of this irritable intellectual are surrounded by a ruff so complex in its cranial folds that it seems to be the sartorial equivalent.

Yet Velázquez's art speaks of solitude, silence, prolonged contemplation, of watching and listening with matchless concentration, of unhurried thinking, exemplary clarity and fullness of response. No matter that the court goes on all around him like a gigantic machine-play, no matter that social and political negotiations are

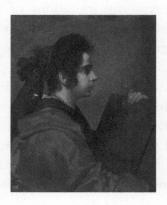

going on outside his windows at all times, that the shops on the ground floor are frantic with custom, that lawyers are receiving and rejecting pleas as they speed across the courtyard below, Velázquez is able to shut out the pressure of noise, friction, disturbance. Even when surrounded by dogs, dwarves and children, he is beyond distraction wherever he chooses to work.

For his paintings rarely show a specific place, so much as a space; there is never anything so concrete, or modern, as a studio (Las Meninas is perhaps the exception). That Velázquez could, and did, work in shifting conditions and different places is apparent from the portraits of dwarves made on trips to the Spanish countryside, the pictures painted outdoors in Rome or on the spot during royal missions. A late portrait of Philip IV in scarlet and silver, now in the Frick Collection, was created in extremely difficult circumstances in the town of Fraga in Catalonia while the Spanish army was defending the nearby garrison of Lérida against the French army. Contemporary bills show that the king had two windows cut into the wall of his makeshift lodging to let in the light, and hired a local carpenter to knock up an easel for his painter. The floor was unpaved, the walls were collapsing and the battlefront was only a few miles away, but still Velázquez managed to create this dazzling image - the king's face hovering between courage and sadness, the silver brocade twinkling with a virtually unreadable constellation of marks - in three rapid sittings.

He added the hat and baton later in his own hovel of a lodging, doorless, dark and in utter decay.

None of the paintings on the wall in *Las Meninas* are by Velázquez himself, modest man. Two are copies of pictures by Rubens, who came to the court from Flanders on a diplomatic mission in 1628, made several paintings while he was there and left with the very knighthood (so glibly given to him by the king) for which Velázquez would angle year after year. Velázquez was able to watch the older artist at work – Rubens was in his fifties – and vice versa; a connection grew out of deep mutual respect. Rubens visited him in his

rooms and remembered how much he prized the modesty of the Spaniard's work. Philip, too, was in the habit of dropping in on Velázquez to watch and talk, a distraction from the melancholy weariness of kingship. This intimacy is always evident: there is no social distance between them.

Velázquez's son-in-law Mazo made the Rubens copies that hang on that wall, and it is to Mazo that we owe that glimpse of the quarters where Velázquez spent the last years of his life. In The Family of the Artist, painted some four years after Velázquez's death, the rooms are high-ceilinged, chasmic and bare. (The rooms of the Alcázar so often were: a visiting French envoy remarked with horror on the absence of anything in these dark canyons except the occasional lonely chair.) A rose in a glass sheds its petals in front of a portrait of Philip, painted of course by Velázquez, whose posthumous presence is thus invoked. Down the corridor in an adjoining space is a tiny dark-haired painter, seen from behind, at work on yet another likeness of an infanta. It is an ungainly painting, its perspective skewed, its family line-up a very uneven series of portraits (though from Stirling Maxwell's point of view, of course, the dwarves have been satisfactorily cleansed). But what strikes is the sincerity of Mazo's emotion, his love of family and the touching

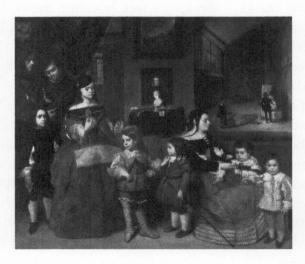

loyalty of his composition, which is surely conceived, at least in part, as a homely reprise of *Las Meninas*.

Mazo's painting gives us some hard facts about the interior of the Alcázar, the stony mass of the walls and floors, the oppressive gloom of the rooms – all of which become light as air in the art of Velázquez. This is one of his pictorial inventions, this ethereal atmosphere, not a place so much as a glowing void in which a person may appear free of the prison-house of palace life.

Palaces, wrote Quevedo, 'are the sepulchres of a living death'. Velázquez himself only managed to break free twice in forty years.

For Manet, and for so many artists before and since who have made the pilgrimage to see Velázquez in Madrid, his way of painting is unique. He rejects the conventional rules of painting, judging that the eye cannot focus on every part of a picture simultaneously, that the background may become a blur without any loss of veracity whatsoever. So it is with the portrait of Pablo, where the juncture between floor and wall has disappeared and the shadow drifting from his heel, up close, is barely visible. Yet Pablo does not float, or turn as flat as a playing card, so much as spark into life with startling directness.

The performer fills the void with his own personality; it becomes an expression of himself. And Velázquez extends this grace to so many of the men and women who lived in the palace and worked for the monarch, just like himself – in his art, these servants are free as air.

Manet said of Pablo that he was filled with life, and so he is. A sprung figure perpetually in his dramatic moment, not quite floating, but nor quite tethered to this humdrum world. His act is a performance, a virtuoso illusion, like the art of the painter who can make people appear on-stage, vivid as life, while also showing that these apparitions are conjured out of paint. This is the crucial paradox. The figures in Velázquez's art are superbly real and yet simultaneously revealed to be illusions. The actor stands firm, but he stands on nothing but painted air.

arean of the commentation with a comment of the com

atomical and the second second

The first of the control of the cont

entros. In the source of the s

The second secon

Seizure and Theft

Tait's New Royal Hotel in Edinburgh was an elegant establishment on the main thoroughfare of Princes Street, not long open when John Snare arrived in 1849, but already popular with advocates, journalists and well-heeled travellers. It had quite a reputation among English writers by the 1850s. Tennyson, the Poet Laureate, took a room with spectacular views of the castle rising high above the city on its sharp volcanic crag, and the novelist Wilkie Collins, writing home to London, praised the extraordinary lightness of Edinburgh's summer nights and the 'darkly deeply beautiful blue' of the Firth of Forth, visible at the bottom of the steep streets behind the hotel.

John Snare signed the register in the first week of January, when the Scottish wind bites and darkness descends by mid-afternoon. He took rooms for himself and his friend James West, and hired a large salon for 'The Lost Velázquez', as it was promoted in the newspapers and on the handbills the two men posted through the Georgian New Town doors. Edinburgh was the first stop on what was conceived as a theatrical tour of Britain with the portrait as solo performer – Glasgow, Liverpool and Birmingham would have been next, if not for a shocking turn of events – and Snare had chosen the time and place with care. January was a dispiriting month in Edinburgh, low on entertainment and ideal for setting a novel portrait before a winterweary public, especially one whose royal subject was born in Scotland, not England; and Tait's Hotel was perfectly positioned on the main

street, midway between the railway stations and opposite the Society of Antiquaries and the Royal Scottish Academy.

The show opened on January 15th. Snare, skilful publicist, had offered Scotland's oldest newspaper an exclusive preview and the *Caledonian Mercury* published its awed response that morning: 'Few pictures leave a more powerful impression of grandeur on the spectator's mind than Velázquez's Charles. The design is chaste to severity. There is life and youth; strength and majesty are stamped on the brow and beam from the eyes. Its beauties are at once manifest and striking.' 'Chaste to severity' is unusually apt for early Velázquez.

As soon as the doors opened, curious visitors began to arrive. The numbers built: four hundred in the first few days, several hundred more by the second week as the Scottish press warmed to its new Velázquez. Spanish painting was little known and virtually unseen in Scotland, which had yet to build a National Gallery for the display of Old Masters. The Earl of Elgin had a portrait (considered a Velázquez) of Count-Duke Olivares in Broomhall House on the other side of the Firth of Forth, enjoyed by nobody except his guests; and although one of Scotland's finest painters, Sir David Wilkie, had returned from a journey to Spain with an extraordinary purchase, the portrait of Archbishop Valdés that now hangs in the National Gallery in Trafalgar Square, he kept it in his London home. The Scottish public had not yet had the epiphany, as Wilkie put it, of setting eyes on a Velázquez.

At the beginning of the third week, James West was at his post in the hotel foyer ready to greet visitors. West was a cabinet-maker who happened to be lodging in Old Bond Street when the picture was on display there. He came to know Snare well and remained loyal to him through every crisis. But the most valuable service West ever performed for his friend was the calm and sober account he would later give under oath, at the Court of Session in Edinburgh, of what happened next at Tait's Hotel.

It was a little after lunch on January 31st. West was taking the ticket money (a shilling) and Snare was upstairs, hovering as always

by his masterpiece. A number of visitors were admiring the picture when a pair of sheriff-officers burst into the salon with a warrant to remove it there and then, by force if necessary. Somehow Snare kept cool enough to study this document, issued by the local sheriff's court. It stated that the Velázquez currently in his possession had been stolen 'at some time unknown' from the Trustees of the 2nd Earl Fife. It must be confiscated straight away because this Englishman, being a foreigner, and a tradesman to boot, 'might be very apt to run away with it'. Despite the bewilderment, and the affront, Snare remained composed, quietly sending West out to find a lawyer and entering into negotiations with these sheriff-officers for the next two hours. He told them about the auction at Radley Hall, about the show in London, about the pamphlets and all the press coverage, explaining that there must be some kind of mistake. He even suggested that if they would only keep the Velázquez safe themselves, at Tait's Hotel, he would go straight to the court in person and clear up any confusion about his ownership. But the sheriff-officers were out to get their 'stolen' goods and as twilight fell, the picture was taken down, removed from its frame (to Snare's wincing horror) and lugged on its stretcher through the dark and freezing streets up the Mound, across the Royal Mile that sloped down from the castle and down again to the courthouse in the Lawnmarket.

Snare and West struggled to keep up. When they eventually reached the Lawnmarket they found the officer in charge so uneasy about the legitimacy of the warrant that he had already suggested sending the picture straight back to Tait's Hotel. But two agents representing the Trustees – the mysterious Messrs Burns and Inglis – were sent to intimidate him. Reluctantly the officer had the painting boxed and sealed with his personal signet, on account of what he felt to be 'the dreadful responsibility of handling such a valuable work'. The portrait was taken down to the cellars beneath the court and there it stayed – seized, detained, kidnapped, as the press had it – through all the furore that followed.

Snare was devastated. He immediately lodged an appeal, imagining

that light would dawn and all would be well. It was rejected – his first experience of the baffling dramas to come. He tried everything he could, filing one application after another right up through the legal system, thwarted every time by counter-petitions from the powerful Trustees. This group numbered several scions of the Fife family, including the 4th and present earl, as well as William Souter, Writer to Her Majesty's Signet, a very senior lawyer in his own right.

The English tradesman now found himself on the wrong side of the Scottish establishment.

Snare certainly knew who these Trustees were, for he had dispatched West to call upon William Souter in his Edinburgh chambers only days before, hoping that he might have more information about the picture's history. Out of courtesy – or naivety – Snare had even sent along a free ticket for the show. He received a dusty answer. It is certainly no coincidence that the sheriff-officers descended two days later.

The warrant they served is a slippery document. It does not state that Snare has stolen the picture himself, only that he is in possession of stolen goods, with the dark implication that he knows this full well. As for the theft, it alleges that the picture was stolen from the 2nd Earl's possessions some time after his death in 1809, which could have been practically any time in the previous forty years. To sharpen up this risibly vague scenario, the Trustees further claim that the picture must have been 'effectually hidden' ever since.

Somebody had stolen it, somebody had hidden it, yet apparently not a soul had noticed when it disappeared and nobody ever raised the alarm. But now that it had turned up once more, the Trustees were having it back.

Two weeks after the picture was seized, a judge finally ruled in Snare's favour, noting that the picture had been honestly acquired. He did not conceal his disdain for the Trustees' case:

The petitioners admit that Mr Snare, the respondent, publicly exhibited the picture about a year ago in London. But nothing

is done until the foreign purchaser crosses the River Tweed. In Scotland, the petitioners, without any premonition whatever, attempt to deprive the respondent of his property, on the bare averment that it is stolen. And when stolen? The date of the theft is unknown – the locus of the theft is not stated – the manner of the theft is not stated – the thief is not even hinted at. The petitioners are at a loss when they describe the disappearance. The picture was 'stolen or surreptitiously abstracted.' If the latter expression means something different from theft, it is an alternative statement by the petitioners. But nothing *but* theft could support such a proceeding as that adopted by the petitioners whose treatment of the bona fide purchaser of the picture has been outrageous.

Succinct and conclusive: case closed, one might think. But still the picture remained beneath the ground in the Lawnmarket while the Trustees put in five more appeals, all laborious and expensive and all rejected as vexatious. Two months passed before Snare finally got his picture back.

What to do next? He printed another handbill – 'Seizure and Restoration' – to make the best of the story, and opened the show

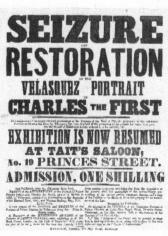

in Princes Street once more, complete with accompanying pamphlets. But the picture now had the taint of crime upon it and the citizens of Edinburgh in all their probity stayed away. The dwindling ticket sales could not begin to compensate for the losses he had already suffered, still less the legal fees or the mounting hotel bills. John Snare was running out of money.

He had been sinking into financial difficulty ever since the Old Bond Street freeholders forced him to part with £400. From 1845, when he bought the painting, to 1849 when the Trustees seized it, Snare had devoted himself to the Velázquez - to showing it, writing about it, obsessing over its history and authenticity, defending it against every kind of attack - all to the neglect of the Minster Street business. During his long absences, his wife Isabella had to deal with suppliers and creditors pressing for money. Bills apparently went unpaid. A more agonising worry came in 1848 with a lawsuit closer to home, when Snare was sued for failing in his duties as executor to two separate wills, including that of his uncle Robert. Snare's own sister pursued him for money owed. In all this chaos, with the business floundering and three children under the age of ten to support, perhaps all he could think of - perhaps all he ever wanted to think of - was the painting; it might be his salvation, if he took it on tour.

Perhaps Snare had this in mind when he bid for another painting in 1848. The British press was reeling with the news that the Duke of Buckingham and Chandos had so overspent his stupendous fortune – said to be the largest in the world – that the bailiffs were coming after his assets. These included Stowe House, set in a landscaped park of temples and follies and filled with magnificent paintings.

The auction of the duke's collection took place in August and was enthusiastically reported throughout Europe. The Morning Post ran four pages on the sale and there, among the details, is the purchase of 'one of the premiere paintings', The Confinement of John Duke of Cleves by Rembrandt, 'bought for 81 guineas by Mr Snare of Reading, the owner of the Velázquez'.

This painting is powerfully dramatic (though its subject is now recognised as *Samson Threatening His Father-in-law*). Samson appears behind bars in the feathered hat and velvet robes that Rembrandt himself wears in an early self-portrait. Snare sold it quite rapidly – the painting was much later bought by the Chrysler Museum in Virginia – perhaps to fund the Edinburgh exhibition; the money certainly didn't go to his creditors.

By the spring of 1849 Snare had a different reputation in the press. Newspapers all over Britain had covered the incident at Tait's Hotel – Seizure and Theft! Earl's Masterpiece Recovered! Stolen Velázquez in Scotland! But the local coverage was the most damaging for Snare. Even the Reading Mercury was aghast; the newspaper that had once been so proud of its local bookseller went from concern to confusion to outright doubt. Custom at Minster Street began to slow amid the shameful rumours, until one day it ceased altogether. Receivers prepared for the collapse of the business, which happened with drastic speed. By June, John Snare was bankrupt.

The kindly foreman of the print-works, William Webb, would one day be questioned at court in Edinburgh about the decline:

- Q. Did people in Reading hear of the seizure in Edinburgh?
- A. Oh yes, the news of the theft became the subject of conversation all over the town. It had a material effect on the business. The people said that Mr Snare was a ruined man.
- Q. Did the men in Mr Snare's employment ever say anything about their wages?
- A. They said they were almost ashamed to ask for their wages, there was so little business doing; they had a feeling of pity for Mr Snare. We came to have no work in the printing office that was my department; the business dropped off by degrees and in the course of one month we had nothing to do. We were there till the

- auctioneer commenced taking the inventory about six months after the intelligence reached Reading.
- Q. Did it appear to you to be a great sale, or an ordinary sale?
- A. It was a great sale, and a great sacrifice.

The sale of Snare's worldly goods began in August and continued, lot by lot, exhaustively described in an immense catalogue available at the price of one shilling – perhaps the only publication in his entire story *not* printed by Snare – for twelve full days.

It began with the beautiful stationery: several thousand blue-laid envelopes and quires of rose-tinted paper, quarts of scarlet ink, black ink by the gallon, wedding envelopes and sermon covers, silk purses and gold paper, sealing wax, quill pens and string.

There were drawing pencils, watercolour boxes and French pastels. There were violin strings and penny whistles, and those eccentric bundles – shuttlecocks and funnels, apple scoops and spoons – where the items have family relationships. At Minster Street you could buy children's necklaces and wax effigies of monarchs. The stock had its own exuberant largesse.

The books went on for days: Jane Austen, Mary Shelley, the Brontës, George Eliot; Chaucer and Shakespeare, Diderot and Goethe; philosophy from Aristotle to David Hume; all the great historians, Herodotus, Gibbon, Macaulay; atlases of the wide world and coloured maps of the local countryside. Three copies of Miss Mitford's bestselling memoir, *Our Village*, and Snare's own Berkshire guide with its picturesque engravings. There were several books on Spanish painting.

The twelfth and final day was the sale of 'sundry works of art'. The first items were touchingly modest: local landscapes, fruit, a girl in a bonnet. But what came next was the mirror in which one glimpses the bookseller. Snare had Jacques Callot's *The Miseries and Sufferings of War*, a terrifyingly brilliant set of etchings that inspired Goya, as well as Goya's own dark prints of mankind's follies

and sorrows. He had Rembrandt's complete etchings in folio. He had several Stuart portraits, including one by Cornelius Jansen from the reign of Charles I.

But as the lots came up for sale, one by one, there was no sign of the Velázquez.

By the end of the day, the auctioneers were selling off the blinds, the counters and even the bookshelves. The final item was the polished brass doorknob. The premises themselves were now sold and Snare's name was erased from the fanlight above the door. But a faint echo can still be seen in a drawing made a few years later for Swain the Ropemaker, the business that followed: Swain's W has not quite vanquished Snare's N.

It all went to ruin in such a short time. Once Snare was the toast of Reading, the talk of London, the brave provincial tradesman who had discovered the lost Velázquez, saluted in the press. He had welcomed the Duke of Wellington and conferred with the Count of Montemolin. He had awed Edinburgh with his chaste and mysterious Velázquez and might have continued to amaze the great cities of Britain, but now it was all over. He had gone from buying the treasures of a ruined

duke to seeing his own possessions auctioned; from the pinnacle of respectability to mistrust and disgrace. He had lost a business built up by two generations of Snares; he had lost his good name.

And how did the Snares feel about the intense humiliation in that little street at the very heart of Reading, right there among the town's shops and offices, doctors and clerics, only yards from the bank where her family were shareholders, beside the church where they worshipped, opposite his brother's thriving business; right there on the very premises where they lived, coming in and out of that door that lost its knob, in front of the entire town and the knackers themselves, the auctioneers from Haslams just around the corner bringing down the gavel on a barrel with the sale of every lot?

If Isabella Snare had any courage left, she must have needed it now. For there is no sign that Snare was there, present at the devastation she endured. She had already had to live with so much anxiety, from the build-up to the Radley Hall sale and the Old Bond Street exhibition to the seizure in Edinburgh, her husband writing furiously day and night and so often away, her shop crowded with gawping visitors, her house filled with obsessive conversation and then suddenly silent, shunned. And now, in full view of every single person she knew – all her husband's relations, and all of her own – she had to watch their belongings passing out of the building one by one, along with every iota of the family reputation.

Cruellest of all, as she watched her home being sold, Isabella Snare was heavily pregnant. Her fourth and last child was born a few days after the auction in September 1849. No name is given in the parish records. The child is anonymous, recorded without ceremony as another male infant.

There is no written evidence of Isabella's reactions to her husband's downfall, but it was the end of her own life in Minster Street. She lost her home and her livelihood and was forced to move with her children into the house of her father. There is no proof that Snare went with them. Perhaps she lost her husband,

too. His whereabouts in the next two years – and those of the painting – now become peculiarly uncertain.

Snare, once a most prominent son of Reading, supplier of its pencils, books and paper, printer of its maps and postal directories, who once knew everyone, through whose shop the citizens had passed for conversation and more for decades, and who had brought renown to the town, was becoming a ghost.

All that can be said for certain is that he did not submit to the Edinburgh injustice. In the autumn of 1849 John Snare's lawyer lodged a claim for damages against the Trustees and there began a case so convoluted that the Scottish press had some difficulty following its serpentine twists. Each time Snare's side succeeded in arguing for a proper hearing before a senior judge, the Trustees would appeal the ruling, bringing to bear every manoeuvre in the book so that the technicalities ramified over more than a year to the point where one of the presiding sheriffs described the variety and mass of the proceedings as unparalleled in his experience.

More than once over the coming months the Trustees tried to make out that Snare was an English fly-by-night who might flit across the Tweed before the case was decided, dodging any legal costs for which he could be liable, and this had been their exact line when serving the warrant to stop him running off with 'their' Velázquez in the first place. It is because of this accusation that one can momentarily pinpoint his whereabouts, in court testimony, when 'the claimant' (Snare) promises to reside at a temporary address of 41 Lothian Street, Edinburgh through the month of May 1850. But there is no hint that he remained in Scotland after that, and no evidence that he was in England with his family (he was not living with them in the 1851 census). Strangest of all, for a man so eager to speak on behalf of his painting, there is no sense that Snare was present in Edinburgh when he finally won the right to a full-scale trial.

The Trial

The trial that unfolded in Edinburgh in the summer of 1851 had only one issue at stake: whether there should be reparation for the damages caused by the picture's seizure. It might almost have been a matter of haggling over money. But by an unexpected turn of events it became something else: a battle between an English tradesman and the Scottish aristocracy, riven with prejudice, mockery, racism and class bias, and characterised by wild discrepancies of experience and judgement. The argument about how much John Snare had suffered was rapidly swept aside, moreover, by much larger questions: whether the picture showed Charles I as Prince of Wales, whether it belonged to the 2nd Earl Fife and above all – Stirling Maxwell's challenge – whether it really was by Velázquez.

The portrait itself was on trial.

The case was heard before Lord Cowan at the Court of Sessions, Scotland's supreme civil court. With true Scottish rigour, the court sat until 10.30 each night and all through Saturday. The jury comprised five farmers, two bootmakers, a coal merchant, a grocer and a blacksmith, a baker from the seaside town of Musselburgh and a saddler from Dalkeith, which was no small ride, especially in an uncharacteristically hot Lothian summer.

In Scotland, in those days, jurors were allowed to question the witnesses; and these witnesses included the servants who cleaned the picture and the typesetters who worked with Snare and testified to his depression and downfall, as well as experts summoned all the way from London – Soho dealers, English artists and European connoisseurs – testifying against the highest figures in the Edinburgh art establishment, then, as now, university professors and Royal Scottish Academicians. A portrait emerges of Edinburgh society, as well as the Victorian art world with all its fantastical confusions about Velázquez.

John Snare was represented on a pro bono basis by George Young QC, one of the sharpest young silks in Scotland, a future Lord Advocate and Member of Parliament, who would eventually become so famous for his rapid wit and rigour, and his severely logical cross-questioning of hostile witnesses, that he was retained as the senior counsel in almost every important case. His opponent was the much less ambitious Erskine Douglas Sandford QC, whose case for the Trustees is characterised by a complacent and conspiratorial hauteur as if he scarcely needed to defend them at all, so patently outrageous were the claims against them. Both lawyers show signs of genuine incredulity during the trial when these so-called expert witnesses cannot manage even one shared opinion about any aspect of the painting.

George Young opens for Snare with a tart recitation of the pertinent passage from the warrant that most exposes its full absurdity, so that the jury may be in no doubt.

'After the death of the 2nd Earl Fife, Fife House, in Whitehall, with everything therein contained, including the picture in question, was taken possession of by the Trustees in perpetuity. Fife House was thereafter sold by the Trustees. Before the sale, the picture in question, with the other pictures, plate, and wines, were packed up to be transmitted to Duff House in Banffshire, and other houses in Scotland, during or subsequent to the month of February 1809, and the picture has been since either stolen or surreptitiously abstracted. It remained effectually hidden and concealed ever since.'

Effectually hidden, asks Young? How can it conceivably be

The Trial

139

described as hidden in all the brilliant newspaper glare? 'Snare publishes first one pamphlet, then another, to establish the genuineness of the picture, and the consequence is that the whole Republic of Art, and all the critics, and all the periodicals, take up the question of its genuineness. Is it not strange the way the controversy should rage for years in London and yet the Trustees should never find out that the subject of the public controversy is a picture supposedly stolen from the Fife Gallery?'

And stolen or surreptitiously abstracted – which is it? 'There is no specification as to when or where this painting was lost. The Trustees admit themselves that they cannot tell how. It may be that it was never packed up at all. It may be that it was stolen from Duff House. We do not know that it might not have been given or sold by Earl Fife himself to someone in London.'

Having dispatched the warrant with relish, Young proceeds to his client's innocence. His first task is to establish that the picture was legitimately acquired at a public auction in front of numerous witnesses, and he summons none other than Mr Benjamin Kent, late of Radley Hall, now retired to Gravesend.

Did he sell a portrait of Charles I when Prince of Wales at an auction in October 1845? He did.

Has he seen that portrait since arriving in Edinburgh for the trial? He has.

Each witness is required to examine the picture before giving evidence to the court; it is on display in a private room at (of all places) Tait's Hotel.

Does he have any idea how long this portrait had been in Radley Hall before the sale? Mr Kent certainly does. It belonged to his father-in-law, Mr Archer, a picture dealer who worked in Oxford and retired to Radley, where the painting hung in the principal drawing room from 1821 to 1845, though he owned it long before that.

Where did he get it? It was acquired from a London dealer called Charles Spackman.

One of the jurors is astute enough to ask Kent whether his father-in-law ever mentioned the 2nd Earl Fife. The answer is a brisk and decisive no.

The name of Charles Spackman was well known to Snare, for back in 1846 he too had begun by applying straight to Kent for information about the painting.

'It came into my father-in-law's possession between 1806 and 1812.' Kent had written back:

and was purchased before that by Charles Spackman, who was in business with Mr Archer, sending him pictures to Oxford. Spackman resided for many years at Nos 34 and 39 Gerrard Street Soho, and being considered an excellent connoisseur in Pictures, I have no doubt would be well remembered in that vicinity. If he is now living, further information might be obtained from him. There was also Mr Foote, a celebrated Picture-cleaner, who was much employed by Spackman and I would recommend your making some inquiries of Mr Anthony of Lisle Street . . . My father-in-law believed that the painting was by Van Dyck.

Snare's response to this deflation was to ignore it. 'I had so thoroughly investigated the history and style of Vandyck my conviction had become proof against all opinion.' In the meantime he followed Kent's directions straight into a dead-end. Mr Anthony knew nothing, Mr Foote had recently departed this life and Charles Spackman had been dead for twenty years.

With this in mind, Snare had the desperate idea of pursuing the undertaker who had conducted the 2nd Earl's funeral in 1809, as if he would know anything, but unsurprisingly could not trace him after almost four decades. Snare grew despondent, until a brilliant notion struck: what about the company hired to remove the furniture from Fife House after the 2nd Earl's death? They might know what happened to the paintings. Snare worked his

The Trial

141

way through the narrow streets of Soho, knocking on doors, asking questions, pursuing every suggestion until he turned up the name of John Marshall, dealer and upholsterer of Gerrard Street – his premises only a couple of doors from Spackman's – who may have removed the 2nd Earl's goods. John Marshall, too, had just died.

Still Snare was resourceful. He managed to find an old lady in Soho Square who once worked for Marshall and recalled that he had some connection with Spackman. Better still, she even claimed to remember 'the removal of pictures and furniture of the Earl Fife, from Fife House, Whitehall to the premises of Mr Marshall in 1809'. The only trouble with her testimony was that she ceased working for Marshall in 1807, was illiterate and now in her dotage. She could only sign a statement X, her mark.

Snare realised that this fragile testimony was scarcely enough to establish a connection between his painting and the 2nd Earl Fife, but he now set off in pursuit of something even more ephemeral – John Marshall's old account books. Amazingly, some of the pages had survived, torn out of their original volumes and sold as serviceable paper; so expensive was paper in those days that even used sheets had commodity value. Tipped off by Mr Crisp the printseller of Newman Street that the pages may have been bought by Mr Portch the cheesemonger of Goodge Street, Snare rushed rapidly through Soho, across Oxford Street and up Tottenham Court Road in the hope that they had survived and had not been used for shop receipts or, worse, to wrap up a hunk of sweating Cheddar.

Luckily, Snare got there in time and managed to bargain with the puzzled Portch for the remaining portions of the account books, which by astounding fluke happened to include the relevant years. With these fragments Snare shored up his case. In one, dated 1816, he found this: 'Received this day from Hore's Wharf one close case, the property of the Earl of Fife.' Even better, in 1817, was this: 'Received from Lord Fife 15 Pictures, various sizes and subjects.' Marshall had dealt pictures with Fife! Snare was even

able to establish from another batch of wastepaper sold to Mr Painter the tobacconist that Spackman and Marshall had definitely done business in 1807.

Snare believed he had found clinching proof in this urban village of Soho, with its wonderfully named tradesmen. In his scenario the picture was removed from Fife House in 1809 by the dealer John Marshall, who sold it to Spackman, who passed it to Archer, who had it for decades before the Radley Hall auction in 1845.

But his theory was full of anomalies. If the 2nd Earl Fife died in 1809, then which Fife was doing business with John Marshall in 1816 and 1817? And since the Velázquez was definitely hanging on the wall of Fife House in 1807 – it appears in Fife's own catalogue, updated that year – then what was the value of that scrap of evidence indicating dealings between Marshall and Spackman in 1807? After all, the picture didn't vanish from Fife House until 1809, after the earl's death. Or so the Trustees insisted. This point would be raised at the trial.

George Young's next witness is Marshall's chief employee, John Brown, who was with the old man on his deathbed when he reminisced about some of his grand customers, including the late Earl Fife:

- Q. Did Marshall ever speak of having got pictures from the Earl?
- A. He did, and furniture besides.
- Q. Did he ever speak about the Earl being in difficulties?
- A. Yes, I heard him say that the late Earl had come to him several times, and he was obliged to find money for him.

Erskine Sandford, for the Trustees, objects with theatrical disbelief:

- Q. Which Earl Fife did he say had borrowed from him?
- A. The late Earl Fife.

- Q. Are you aware how many Earls Fife there have been within this century?
- A. I am not.

In fact there had been three: James Duff, the 2nd Earl, owner of the Velázquez; his brother Alexander, who survived him by only two years; and the 4th Earl, James Duff (a veteran of the Peninsular War), who is still alive and living in Duff House at the time of the trial. John Brown is asked again which earl is supposed to have had money troubles and he pinpoints the one before this one, who died as long ago as 1811.

The 2nd Earl Fife was rich enough to own Balmoral, as well as all his other estates, and the Trustees were even at this moment engaged in negotiating its sale to the royal family. The mocking implication of Sandford's question – that none of these earls could possibly be short of a shilling – is apparently lost on the London dealer.

But nothing at all is said, and nothing asked, about the finances of the 3rd Earl Fife, who had six children and was not a beneficiary of his brother's will, bypassed as he was by the Trust.

Another of Marshall's foremen, Jacob Wilson, testifies that he distinctly remembers seeing the painting hanging in the drawing room of Marshall's Gerrard Street premises in 1804. Perhaps it was being cleaned. He was much struck by it, he says, and remembered it well when he saw it again in the Old Bond Street exhibition.

Young thinks better than to remark on the enormous time lapse and has the witness address the picture instead:

- Q. Do you remember any part of it particularly?
- A. I remember the general features of the picture and particularly the background, and also a globe. The background is very striking and the face very beautifully painted. It is a wonderful picture.

Wilson gets a mauling from the Trustees' counsel, insinuating that this Soho tradesman cannot possibly be any judge of pictures, still less able to remember this one after so many years:

- Q. Were you frequently back at Marshall's after you left him?
- A. Sometimes.
- Q. Were you ever in the drawing-room after you left?
- A. I never was.
- Q. You cannot undertake to swear that this is even the same picture, can you?
- A. I say it is.
- Q. You have never dealt in paintings?
- A. No, but I have valued them.
- Q. So you consider yourself a good judge of paintings, then?

Poor Wilson retorts, in the time-honoured phrase, 'I know a good painting when I see one.'

Wilson is characterised as a low-life from Gerrard Street – 'where many people are not respectable' – though in fact he was based in elegant Wigmore Street in Marylebone. But Gerrard Street becomes a leitmotif for the Trustees' lawyers, who keep needling away at its supposed notoriety as a den of crooks and prostitutes to discredit the claimant's witnesses, many of whom carried on their business in Soho. The response from the London witnesses is surprise, and mounting outrage. Some of the most respected art dealers of the day were based in Soho, including William Seguier, who had identified the paintings from the Battle of Vitoria; and Henry Farrer of Wardour Street, from whom the National Gallery had purchased Velázquez's Boar Hunt. Nor was John Marshall some rag-and-bone man, as Sandford sneeringly insinuated, but a dealer in fine art whose estate on his death was valued at many millions of pounds in today's money.

Next it is the turn of James West to describe the events on that icy January day when the sheriff-officers burst into Tait's Hotel. He remembers Snare growing quiet with despair as the painting was sealed up in the policeman's box and removed from his sight:

- Q. You returned with Mr Snare to the hotel, and you saw that he was excited?
- A. Yes, he seemed to be very much cut up; seldom did I ever see any man giving such vent to his feelings as he did on that occasion.
- Q. Did he weep?
- A. He did, sir. He fell off in his diet. He could no longer do anything.

What happened to the painting after Snare got it back from the Trustees: was it shown anywhere else, here or abroad? Young asks this crucial question almost in passing. West explains that it was shown for a few more days in Edinburgh and was meant to go to Glasgow and Liverpool and other cities, but as far as he knows was never exhibited again. Between March 1849 and the present month of July 1851 he has no idea what became of it. He himself has only just seen it again in Tait's Hotel.

James Tait himself is called to give the financial particulars. The picture took something close to £60, at a shilling a time, before it was seized, he thinks; Snare's final bill was a punishing £102. Tait is somewhat tight-lipped, since no part of the story advances his commercial interests, but he does volunteer the startling disclosure that Burns and Inglis, agents of the Trustees, approached him personally with a devious offer to buy up Snare's hotel debts, thus acquiring further leverage over their victim.

Tait flatly refuses to accept the defence suggestion that this was only a joke; indeed, he repeats the allegation quite emphatically, a brave stance considering the social standing of the Trustees and their lawyers in Edinburgh circles.

One of these Trustees was General the Honourable Sir Alexander

Duff, brother of the present Earl Fife, and an old warhorse who had served in India, Egypt and South America and who, as an MP, was vigorously opposed to any kind of military reform. Some sense of his character comes across in a strange anecdote that haunts the case.

It seems that when Snare was delving into the history of the Velázquez, he sought an expert of sufficiently high repute to guarantee a meeting with General Duff; this was the London dealer Thomas Mesnard. Mesnard's task was to find out how the 2nd Earl got hold of his Velázquez in the first place and, if possible, how it came to leave the collection. The general sent him off with a stinging remark: 'Mr Snare has got a fine picture and should keep quiet and not interfere in family matters.' What could this mean? That it was or wasn't the Fife picture? That there was some dark business afoot, that family matters were complex? And what would happen if Snare didn't keep his mouth shut?

Thomas Mesnard has died in the intervening years, but his son William appears for Snare.

William Mesnard was a gifted painter and restorer, who had worked on pictures for the National Gallery. His opinion of the painting is detailed in its appreciation, from the light in the eyes to the virtuosity of the brushwork. He believes the painting to be a Velázquez without any doubt, most likely the long-lost portrait of Charles, and worth somewhere between £5,000 and a colossal £10,000.

Mesnard's testimony marks a turning point in the trial. He sets the bar for a stand-off between the witnesses on the value and authenticity of the painting. Anyone who now praises it as a Velázquez inevitably confirms its value, and thus the scale of Snare's loss when it was taken from him; the Trustees must therefore discredit such a witness. So Erskine Sandford immediately comes in with a trick question to challenge Mesnard's expertise:

- Q. Have you much experience as to pictures by Velázquez?
- A. I cannot have much, there being so few in this country.
- Q. How many pictures of Velázquez are in the National Gallery?
- A. I think possibly two, a hunting picture and a portrait; and two at the Dulwich Picture Gallery, one a portrait of Philip IV.

All the experts are asked this last question by Sandford; only Mesnard gives the right answer.

Why does he think that the picture is by Velázquez? Because it is different from the work of any other artist of the period. It is not a Van Dyck and not a Rubens, and he cannot think who else could have the power to paint such a portrait in the early 1620s, so it follows that the artist is Velázquez.

Mesnard might be speaking today. Even in the age of X-rays, dendrochronology and DNA testing, when the identity of a picture cannot be scientifically established and specialists have only their eyes and experience on which to rely, this remains the logical approach.

George Young comes in for Snare:

- Q. Laying all these things together, that it is unlike the styles of other artists of the period, that it must have been painted by a great artist, and that it is like the style of Velázquez, you conclude that it is a Velázquez?
- A. Yes, and more than that, from the face being unfinished.
- Q. Is it known and spoken of among artists that Charles only gave Velázquez one sitting?
- A. I have always heard so.
- Q. And are you satisfied that the face was painted at one sitting?
- A. I am, perfectly so. I believe the rest was painted in later. It is from the marvellous touch of the face, like hand-writing, that one can detect the mark of Velázquez.

A London dealer who has travelled all over Europe now takes the stand. Louis Herrmann has seen paintings by Velázquez in public galleries and private houses in England, Germany, Italy and Spain. He is the most experienced of the witnesses and he has no doubt whatsoever that the portrait is by Velázquez.

Does he believe the face was painted at one sitting? He cannot say, but the face is very beautifully done, and Velázquez is reputed to have been a rapid painter. Herrmann makes a fine observation. 'He was that kind of painter that he could as beautifully depict a portrait in one hour as perhaps he might have done in three or four days. His idea was immediately conveyed to the canvas.'

Herrmann is repeatedly asked to put a price on the picture and repeatedly says that Velázquez is beyond price. But in the event he comes in at £6,000. He is much focused upon the unusual combination of Spanish style and English sitter. The defence lawyers have no questions for Herrmann, who is worryingly authoritative and cannot be tarred with the Soho brush since his business is in Great Russell Street, Bloomsbury, in the irreproachable purlieus of the British Museum.

The final witness for the claimant is the eminent engraver Henry Robinson, invited by Snare to make a print of the portrait. The testimony of a man who inches his way across a painting, to imitate it as precisely as possible with a burin on copper, is particularly telling; and, like Mesnard, he is dazzled by the face. He is also certain that the portrait is by Velázquez.

Robinson would have earned a sizeable 1,000 guineas if it hadn't been for the Old Bond Street troubles, which interrupted the commission, followed by the seizure in Edinburgh. At which point he became leery. 'I understood that the picture had been taken from Mr Snare by certain parties as having been stolen; and had he offered me the engraving of it at twice the amount I would not have taken it . . . I would have required *proof* that it was not stolen goods before I would have gone on with such an important

engraving.' A huge source of income – engravings were exceptionally popular – was thus lost to both Snare and Robinson.

Robinson made no print of the painting, and neither did anyone else. No reproduction ever existed. With the exception of those who had actually laid eyes on it, all that anyone knew of the Velázquez was expressed in words – in the recollections, and misrecollections, of fallible people, in their exaggerations, understatements and subjective emphases, in the strength or weakness of their spoken reports. And in the fragile memories and haphazard descriptions of a picture that lived only in the mind's eye, the Velázquez was different to each and all. It was becoming a picture in words.

It now falls to the defence to argue a case based upon a grotesque contradiction. The Trustees must somehow prove that the picture they were once so determined to wrest from Snare, because it was a priceless Velázquez, they now despise. The worth of the picture correlates directly with the scale of the damages, so they must establish that it is in fact worthless. Their behaviour (and their argument) is two-faced: now that they have looked twice, so to speak, they have come to realise that the portrait is nothing but rubbish.

The Trustees' star witness is Sir John Watson Gordon, an extremely successful Edinburgh portrait painter and President of the Royal Scottish Academy. He is so grand, in fact, that the trial has had to be rearranged to accommodate his congested schedule. But Sir John has managed to view the picture that morning and is distinctly unimpressed. 'The armour is tolerably well painted, and the figures in the background are skilfully introduced, but the head and hands are not like Velázquez; they have neither his decision nor his force.' He thinks it is a finished portrait, nobody else involved and no touching-up later, probably by a Flemish painter.

His fellow Academician William Bonnar is more critical. 'The colouring of the hands is remarkably bad.' He believes it has been retouched. 'It is laboured with great care . . . it would appear that

the artist had been working at it over a very long time.' Bonnar cannot remember seeing any globe, though he too saw the portrait only that morning, and when asked to characterise the art of Velázquez comes up with three adjectives that would not be high on many people's lists: 'firm, forceful, determined'.

Has he seen many paintings by Velázquez? Yes, four in Dulwich and several at the National Gallery. He has no recollection of *The Boar Hunt*; in fact he can't remember what any of these pictures showed, even though he claims to be a devotee of the Spaniard's manner. Young is incredulous:

- Q. You cannot recall whether that manner was in the depiction of a dog or a tree, let us say?
- A. No I cannot.

George Harvey, historical painter and Royal Academician, is well acquainted with the works of Velázquez. He has seen them in Naples. He doesn't think much of the Spaniard's portraits, vastly preferring his 'landscapes'. He has been to the National Gallery in London, of course he has, but he can't recall any works there by the Spaniard except for a close-up head of the old general. Young points out that this is by Van Dyck. No further questions.

An Edinburgh dealer, John Donaldson, then argues that the background is by a Dutchman, but the canvas is English, which he cannot quite explain. The face is too red for the ashen Charles. The drapery is the best thing in it. It turns out that Donaldson can't remember what else is in the painting – possibly a field; certainly no globe. It has barely been four hours since he stood in front of the portrait.

William Donaldson, partner of the aforementioned John, thinks the picture was made in the eighteenth century. His reasons? The colours. He mockingly values the frame almost as highly as the picture: £25 with, £15 without.

Lastly, Charles Galli, an optician-turned-dealer, gives his opinion

The Trial

that the painting may be a copy of a Van Dyck, or perhaps a copy of a print by Van Dyck or some painter of the sixteenth century. Sandford asks his opinion of the value. 'No idea, but I do not want it!'

The painting is finished; it is not. It is Velázquez; it is not. It is Charles; it may not be him at all. It is Spanish, Flemish, Dutch or English, or English with a touch of Flemish. It is sixteenth-, seventeenth- or even eighteenth-century. The face is done once only in a virtuoso performance; no, the face is laboured with great care, perhaps retouched by more than one hand. The experts eventually begin to wonder whether Velázquez was really any good at all. He may have had force and breadth, sneers William Bonnar, but he was incapable of making anything up.

Just as the London dealers and the Edinburgh advocates do not understand each other, so there is a gulf between the lawyers and the painters. Is the picture finished? Is the face sketchy? Is the painting 'solid' or is it not? What *should* it look like? All these questions are of course peculiarly relevant to the art of Velázquez, but the painters are so various in their replies that the lawyers become exasperated. How are they to trust these experts who can't come up with any useful words for Velázquez and don't even seem to be using their eyes?

The paradox of the trial is that both sides need the picture to have belonged to the 2nd Earl, but one side has to show it belonged to the earl and is valuable, while the other has to show it belonged to the earl and is worthless. The only way to do this is to focus upon that most volatile and subjective of issues: personal reactions to the painting itself.

By deriding the picture, the Trustees seek to minimise their exposure to damages. But they still have to prove that the painting really did once belong to the 2nd Earl, otherwise they are guilty of wrongful seizure. And here they run into two difficulties. The first is that this insistence upon Fife's proud ownership of the Velázquez

is hardly compatible with decrying it as Flemish, or English, or copied or 'a miserable daub'. The second is that the sole witness to its being in Fife House is now dead.

Mr Forteath, sometime factor to the 2nd Earl, has only recently departed this life. But the Trustees believe they have overcome this apparently insuperable problem. Forteath is able to speak from beyond the grave through his son-in-law, and the doctor who attended him, to the effect that this picture definitely belonged to the 2nd Earl and was in Fife House at the time of his death.

It seems that Forteath was brought down to Edinburgh especially by the Trustees to examine the painting at Tait's Hotel in 1849. It was forty years since he had last been in Fife House, but he noticed a special mark on the canvas by which he thought he could identify the picture – not by the actual image itself, one notes. What was this mark? As a perfect climax to some almost comically incompetent testimony, the doctor says that they really have no idea, except that it wasn't a brushmark.

As the trial proceeds, the lawyers are progressively grander for each side. It now falls to a very senior advocate, Sir George Deas, Solicitor-General of Scotland, to present a closing argument on behalf of the Trustees. He opens with haughty disgust at the very suggestion that any of the earls – still less the spotless Trustees – might have flogged the picture to some London *upholsterer*. Perhaps it has taken rather a long time for the Trustees to notice that the picture was missing, but they are busy men who do not make it their business to count the pictures, any more than the teaspoons. As for their slowness to respond to the painting's reappearance in London, and then Edinburgh, well, they do not trouble themselves with newspaper reports, even those in *The Times*, still less the screeds of a self-publishing printer.

Deas sneers at the tradesman's ridiculous claim that he has a Velázquez in this daub, apparently without noticing that he is thereby damning the 2nd Earl as well. 'Snare had a hobby for old portraits

The Trial

and pictures, and on purchasing this picture, he thought he had got the "Long Lost Velázquez", and he set off, riding on this hobby of his, between that period and this; and I am not surprised that, from the whole of his time being taken up with this hobby, he had ridden it to death; and I am not surprised at the result which has occurred, the ruin of his business.' What Deas blatantly sidesteps is the damage the Trustees inflicted on the reputation of the painting and the bookseller, quite apart from the collapse of the tour – the effect of disgrace on the Minster Street business.

The outrageous idea of sending West to Mr Souter with a ticket to see what is effectively the Fife Trustees' own painting appals Deas – 'well, I have heard of men putting their heads into the lion's mouth and I can compare Snare's conduct in this to nothing else'. As for the warrant, 'My learned friend gave you an account of the seizure of the picture, and he did lay on the colouring with as free a hand, and as broad a brush as' – wait for it – 'Velázquez himself!' The Trustees were entitled to repossess the painting, since they had Snare's own evidence that it belonged to them. Deas concludes with a description of the picture from the book that he now flourishes triumphantly at the Edinburgh jury: The History and Pedigree of the Portrait of Prince Charles by Mr John Snare!

The last word goes to John Inglis QC, future Lord Justice General of Scotland, the most senior lawyer in the land. He makes the closing argument for Snare and appeals directly to the common sense of the jury.

'What is the history of this matter, gentlemen? It is simple. Mr Snare comes from the other side of the Tweed, a foreigner in a foreign land and meets with this treatment at the hands of Scotch noblemen. The picture is torn down from the wall, and carried away through the streets and succeeded by petition after petition. I shall be surprised if you can recollect any instance of such an accumulation of oppressive legal proceedings by the trustees of an Earl against a humble tradesman.'

As for the picture's history, the witnesses with the longest memories contradict each other directly. Jacob Wilson says he saw it in Marshall's drawing room in 1804; Forteath says it was always in Whitehall. Not that he left any statement.

'It is a most remarkable circumstance, if true, that he was the only human being that could speak to the fact of that picture having been in the Earl's house at the time of his death; and yet this man was allowed to go down to his grave without his deposition being taken. Is there no man alive,' Inglis asks, 'who could speak to that picture being in Fife House?'

The Trustees never stir themselves to show that the painting was ever stolen, because they simply do not know that it was. Inglis takes General Sir Alexander Duff's strange behaviour as evidence.

"The General says "it is a very fine picture, but it is all humbug – Snare had better keep quiet." This is mysterious enough, and might puzzle the most acute critic. But I find one fact here – worth a whole apparatus criticus, for the mere purpose of discovering Sir Alexander's meaning – Snare says, I have got the Velázquez that once belonged to the Earl of Fife, tell me all about it. One would think that the first thing Sir Alexander would do, if it were a stolen picture, would be to send for a policeman. He does not even warn Snare that he is dealing in stolen goods."

The evidence of each witness turns the case like a kaleidoscope. Perhaps the 2nd Earl sold the picture to Marshall, in which case how can it be in his 1807 catalogue; indeed, why would he ever sell the pride of his collection? And if the dead Forteath is right and the picture was with his employer until his death in 1809, how then did it vanish? Is it possible that another Fife disposed of it? Perhaps General Duff knew the picture had been sold and wanted Snare to stop rummaging through the family business. Perhaps he had sold or surreptitiously abstracted it himself, without consulting the Trustees, to pay off his debts in London?

But then again, what if the Velázquez never left the earl's collection and everyone is as confused about the painting as they are about The Trial

the painter. Perhaps poor Snare – terrible thought, given his passionate faith – has a different picture altogether? He needs the earl's belief in the painting to strengthen his own, otherwise the evidence weighs entirely upon his own humble opinion. But at least he now has the comfort of knowing two things for sure: that Forteath also believed the picture was in Fife House, and that even the experts cannot begin to agree on what is, or is not, a Velázquez.

'We had some gentlemen examined,' says Inglis, 'of whose perfect respectability, and whose good taste, it would be presumptuous to say anything derogatory. I do not think that Mr Bonnar's evidence is quite so intelligent as that of Sir John Watson Gordon; and I think some of them never saw a Velázquez till they saw mine. But take Sir John Watson Gordon. I do not think that he puts you in a position to find against our case. Do you think that this great strife could have been raging for years if there had been no doubt about the authenticity of this picture? While you put one set of gentlemen in the witness-box who tell you it is not a Velázquez, you will find others who give their evidence, as clearly and decidedly that it is.

'But gentlemen, fortunately this is not one of those cases in which the disagreeable duty is cast upon the jury of deciding on conflicting evidence. So long as any important section of the world of the fine arts speak of the picture as being a genuine Velázquez, so long will it continue to be a valuable acquisition for exhibition or for sale. There is a romance too attending this picture, the mystery of its origin, the peculiar history with which it is connected, the manner in which it found its way into the Fife Gallery, and the manner in which it found its way out, all these throw around this picture a certain charm . . . But be the picture better or worse, good or bad, it can make no difference to the case of the Trustees. If the subject is worthless, so much the more malignant and unjustifiable have been their proceedings.

'The Trustees say that the value of the picture is greatly enhanced by the defenders' proceedings, that these prove, beyond doubt, the fact of the picture having been in the gallery of their predecessor, thirty-eight years before. Is this, then, the Velázquez? Is this the picture described in the Earl of Fife's catalogue, painted by the greatest of all Spanish masters or is it not? In the defences to this action we are told that it is, and that these proceedings have proved it. Why, then, have the Trustees themselves been at such pains to prove that it is not the picture? One of their witnesses said "it is a miserable daub, and no more a Velázquez than I am." It is worth no more than £15, says Galli the picture dealer. What do these Trustees mean? They blow hot and cold alternately. But I take them at their word. Let it be that it is a delusion of the fifty-one periodicals that supported Mr Snare; let it be that the painters and picture-dealers in London are all wrong; that James Earl of Fife was a mooning idiot; and his Trustees out of their senses when struggling for the possession of such a piece of trash. What is the result? What do you think of the conduct of parties who, for a picture they try to prove not worth £15 would subject Snare to such persecution as they have done? How will they answer now for bearing down on this poor man with an unprecedented mass of oppressive litigation, and ultimately driving him into a state of insolvency, if the price for which they sacrificed Snare's credit, and their own reputation, was a daub, worth no more than £15?

'I do not care,' continues Inglis, with remarkable daring, given the terrible tightness of Edinburgh's professional circles, 'I do not care for all the witnesses they have in the box. The main ground of damage is the injury done to Snare in his credit and reputation, and it is for this clear injury that I ask your verdict.'

The jury was out for less than half an hour. It found unanimously in favour of Snare, who was immediately awarded £1,000 in damages. But if he had ever been at the Edinburgh trial – and there is not the slightest hint of his presence in the court, or anywhere else in the city – the claimant was no longer there. John Snare had vanished.

The Escape

WE LOOK AT the world, wondering if we see what our forebears saw in the unreachable past, whether the colours remain the same, whether anything looks exactly as it once did beyond the trees, the clouds and the seas, whether anything of our world is just as they saw it.

In Madrid, nothing remains of the Alcázar where Velázquez lived and worked through his whole adult life, and very little is left of the Buen Retiro. There is a ballroom and one staircase, and the walls of the Hall of Realms where his huge equestrian portraits of the Hapsburgs, young and old, once hung. Everything else was destroyed by French troops occupying the building as a barracks during the Peninsular War. What survives of this palace life, this self-contained society, is in Velázquez's paintings.

But the Retiro Park is still there at the heart of the city, with its maze of sandy-gold avenues radiating out beneath the cedars and limes. This was the view from the palace windows. This is where the summer masques took place in the scented air, where mock sea battles were performed on the lake. A tree planted in Velázquez's day still thrives, a Mexican cypress brought back from the Spanish conquest of the Americas. Rowing boats still pull across the waters below the same colonnaded terraces. This is where Velázquez walked, as men in black still stride out summer and winter, suddenly visible at the end of long vistas, citizens of Madrid granted the freedom of the Park when the monarchy

collapsed. This is where Velázquez walked in the sun and air, but it does not appear in his art.

It is almost always indoors in Velázquez. His is a world of interiors, of shuttered rooms at the end of long corridors away from the bustle. He goes out with the royal hunt and on diplomatic missions; he paints Baltasar Carlos posing below an oak in leafgreen clothes. But these are exceptions. His is an inner world, pictured behind closed doors. Until one day the world opens up to him and he finally escapes the palace.

Velázquez got away from court only twice in his life, both times to Rome. Italy alters his art forever.

It is said that when Rubens visited the Spanish court in 1628, industriously copying the royal pictures as if he was still learning how to paint at the age of fifty-one, and then producing thirty pictures of his own for Philip IV, it was not his prodigious work but his wise words that affected Velázquez. Rubens urged the younger painter to go to Rome as soon as he could, to see the home of art. Two months after Rubens's departure, in the summer of 1629, Philip IV gave in and allowed Velázquez to travel.

On the voyage out from Barcelona he spends the days at sea in close conversation with the Genoese general Ambrogio Spinola, whose portrait appears in the middle of the military throng in *The Surrender of Breda*, accepting the keys to that city from his beaten Dutch enemy with empathetic compassion. Velázquez began the picture six years after meeting Spinola, yet the portrait is quick with character and life. No human encounter is lost, with Velázquez, no conversation wasted.

They dock in Venice, where he wants to walk the city alone to look at every painting, but the Spanish ambassador insists on a bodyguard as the alleys are too rough. Still, Velázquez manages to spend long hours before Titian, Veronese and Tintoretto, whose paintings he copies. In Ferrara, the papal nuncio invites him to dinner, but is delicately spurned as Velázquez, claiming that he eats at odd hours,

prefers to keep to his rooms. The painter always goes his own way.

In Rome, Velázquez is treated like a prince. Cardinal Barberini finds him an apartment in the Vatican, in what is now the Etruscan Museum. We know that he was allowed to visit the Sistine Chapel any time of day or night to look at Michelangelo – he was even trusted with a key – and that the Spanish ambassador sent his personal doctor to tend Velázquez when he was ill. We know that he managed to remain in Rome for more than a year, despite appeals from Philip IV to come home, because in the summer heatwave of 1630 he was offered cooler rooms above the city in the grand Villa Medici, where the shady gardens spread out below his window. This is where he stopped for a while, and something extraordinary happened. Velázquez went outdoors, gazed at the view and painted a picture without precedent.

The scene is a drowsy corner of the Medici gardens surrounded by cypresses (Plate G). A white cloth hangs over the edge of a balconied terrace above a classical archway boarded up with wooden slats. Two colleagues stand chatting, perhaps builders, perhaps gardeners, one distractedly holding the end of a rope that dangles down from those slats, criss-crossing the picture with a silvery line as imperceptible as a spider's thread.

The picture is so casual and yet so intensely captivating; this paradox is part of its mystery. The shadow of the statue in its alcove looks half-alive; the figure of Hermes rising above the hedge might be eavesdropping on the conversation. The immense cypresses, holding the day's heat within their darkness, rise like a screen to the world beyond, concealing everything but a glimpse of the pink-tinged sky. And at the centre of the scene, as it seems, are those open gaps between the slats, which so entice the mind and eye. If only one could slip between them and find out what lies behind that door. If only one could enter the painting.

We could go to the real gardens now, for they still exist. But this corner could never be as Velázquez sees and depicts it. What haunts this silvery scene is not just the white cloth, somewhere between

festive bunting and flag of surrender, and not just the murmuring figures or the theatrical archway, but what surrounds it: the wonderful stucco wall.

That pictures are like walls – flat, upright, impermeable – is a point often made by modernist painters. But this is a different kind of resemblance, a gorgeous analogy between pigment on canvas and plaster on walls. The paint lies smooth and creamy in certain places, thinner in others; sometimes it is scraped back so that one sees the bare weave of the cloth, its tiny grid exposed like brickwork beneath plaster. The painting mimics the very thing it represents.

Velázquez's picture is small, not twice the size of the page before you. The figures standing with their backs to us are tiny, the servant draping the cloth over the balcony barely visible: the vista is real, yet distanced as a dream. A small canvas is easily carried outside, of course, but perhaps he chose the scale for another reason, too: the weave of the cloth is exactly the right size to imitate the pattern of bricks at that distance.

This is one of Velázquez's unimaginably subtle calculations. How could he guess in advance, or did it come to him as he painted? This is a great question with his art: what grows out of what, how it all evolves at leisure, or at speed, by chance or design. But what one sees here is something akin to precision engineering, in terms of vision and judgement: each brick finds its tiny outline in the grid of threads.

This painting is a miniature revolution in art for more than one reason, not just the extraordinary way in which it was painted, but that it seems to have no pretext, no definitive narrative or focus. A fragmentary glimpse, strikingly modern in its random observations, it is simply itself – the momentary scene. It is as remote as possible from the classic Roman landscapes infested with nymphs and temples that buyers craved in those days. The two great exponents of the ideal landscape were also living in Rome, Velázquez's French contemporaries Claude Lorrain and Nicolas Poussin. Their prized pictures were circulating through the same villas and palaces and

among exactly the same patrons. There is no doubt that Velázquez knew their work, and Palomino says he knew the artists, too; he shared a friend with Poussin, and he painted a portrait of Claude's chief patron. But his landscape is nothing like theirs.

What is so singular about this little canvas is that Velázquez is actually out there in the still gardens of the Villa Medici. He is recording what he sees with a loaded brush and an extreme sensitivity to the place, its atmosphere and warmth, and to the mellow light of a Roman summer. It is painted on the spot, with the eye's observations transmitting directly through the hand to the brush – an impression, literally and, of all his works, the one that most prefigures Impressionism two centuries later.

Did nobody paint outdoors before the nineteenth century? It is bizarre to think of artists trudging back from the fresh air, drawings in hand, to work up the big picture in a stuffy studio. But landscape was so often an excuse for allegory. To depict nature purely for itself, live and unadorned – in its natural state, as it were – was very much the innovation of Velázquez.

Even Corot, whose silvery landscapes with their secretive air have a genetic link back to Velázquez, has the odd ruin or viaduct in his scenes of the Roman Campagna, and his late works – those elegiac willow-and-wanderer scenes of the 1860s – descend more directly from Claude. Corot was prolific and his paintings were available to the French Impressionists as Velázquez's were not, so the Spaniard's influence came indirectly through him. His landscapes were so popular that copies flooded the market; of the 3,000 Corots in existence, the old joke ran, 10,000 were owned by Americans.

View of the Gardens of the Villa Medici is one of the smallest paintings in the Prado and one of the greatest. It is a painting that insists upon nothing, that appreciates something as mean as a wall, that makes a wall as beautiful as a painting. Perhaps because it has so many of his crowning characteristics – it is so advanced, so radical and original – specialists have argued that it must have been made during the second trip to Rome in 1649, when Velázquez was fifty,

otherwise he would have reached an evolutionary peak when he was barely out of his twenties. But he had already done so; and he was right there, after all, living in the Villa Medici.

It is during the second trip to Rome that Velázquez becomes more visible. Although the walls of the Alcázar were covered with paintings by Leonardo, Titian, Veronese and now Rubens, Philip still aimed to enrich his collection despite the absolute poverty of his treasury. He sent Velázquez on a mission to collect art, and it is typical of the early biographies that we know more about precisely which paintings Velázquez purchased and which classical sculptures he had copied in bronze, and what became of them, than about his exact movements during the two years he was away. But the journey materialises in other documents, some only recently discovered.

Velázquez set off from Malaga in 1648, accompanied by his black assistant Juan de Pareja, just as the king was about to marry again after the death of his first wife Elisabeth. They were part of a group sent to meet Philip's future bride (and niece), Mariana, in the city of Milan. Velázquez was supposed to paint a likeness of the fourteen-year-old princess who looked so like her cousin (Philip's daughter) that their portraits were confused for centuries. But Velázquez somehow managed to duck the task so that he could see Leonardo's Last Supper and other masterpieces in Milan. He was single-minded about art on both legs of the Italian trip, breaking away to visit Giotto's frescoes in Padua and revisit Titian and Tintoretto in Venice; travelling to Bologna to look at Raphael and Michelangelo and to meet two Bolognese fresco painters; to Parma for Correggio and to Naples to meet his old friend, the Spanish painter Jusepe de Ribera.

There is a purported interview, in baroque rhyming couplets, in which Velázquez gives his famously pithy opinion of Titian as a genius compared to the overrated Raphael. The Italian author describes the Spaniard in a phrase that could also stand for his art: 'A Cavalier breathing dignity'.

No matter how self-contained his art, and how aloof he has often seemed to scholars, it is clear that Velázquez kept good company with artists and that his loyalty was true and enduring. When they were out of work, Velázquez managed to find commissions for both of his Bolognese colleagues in Madrid. He was the first Spanish artist to connect with his Italian peers – Velázquez tried, and failed, to persuade Pietro di Cortona to come and work for Philip – and in Rome he evidently had friendships with women artists as well as men. He is known to have portrayed an Italian woman named Flaminia Trionfi who was herself a painter. Nothing more is known of her, or the connection between them; the portrait, alas, is lost.

Just at the moment when the Spanish court wanted portraits of the newly-wed monarchs in Madrid, Velázquez somehow found time, among his many duties as the king's art collector, to paint some of his most personal pictures and to become the great portraitist of another court in another country – the papal court in Rome.

Stories about Velázquez's portraits being mistaken for real people were legion in Spain. Philip IV is supposed to have rebuked one of his pictures – 'What, are you still here?' – confusing it at dusk with a courtier who had annoyed him. But they reach their apogee at the Vatican when Velázquez is working on the portrait of Pope Innocent X and a passing aide, convinced he had seen the pontiff, and not the picture, through a doorway warns everyone in the vicinity to keep the noise down. It is a tedious old strain of art praise – why, it's the living (speaking, breathing) likeness of the sitter! – and Innocent's own comment about the portrait is far more revealing. Of this devastating icon of ferocity and power he simply conceded '*Troppo vero!*'

Too true to character, as well as to life: the image seems intensively both, flashing back at you like a sudden face at the window. The sense of its awful animation is emphasised by the theatrical presentation at the Doria Pamphilj Gallery in Rome, where the

first glimpse of Velázquez's deathless portrait is not the canvas itself, but Innocent's frightening face looming round the corner in a specially angled mirror. It is a sight to make anyone flinch, the Pope's merciless intelligence glaring right back at you – and who hasn't been momentarily deceived? Obviously one's continuous eye movements and the mirror's slippery volatility double the illusion of animation; it is an ingenious stage effect to make one start. But it turns out to be no more sensational, in fact, than the actual experience of entering the room and coming face to face with the Pope.

Innocent by name, runs the adage, but not by nature. The first truth the painting declares is that the pontiff enthroned before you is formidably astute, wily enough to have reached the top of an infinitely complex political structure and equally capable of maintaining that position. It is not just that the portrait is powerful—though it is, abundantly so—but that its subject possesses that power. This has its pictorial expression, above all, in the eyes.

It is commonly said by people who have stood before the picture in Rome that Innocent seems to regard you with piercing clarity; or worse, that he sees through you. This is more than just a variation on the cliché about the eyes in portraits following you around the room. Innocent's look is drilling, pertinacious – it is an active look, he appears to be keeping a close eye on you – and this intensity is abetted by other aspects of the image: the turning to look, the sharpening expression of those eyebrows, the hand that holds the letter in relation to the one that waits, fingers restlessly curling as if about to clench with irritable impatience. And because Velázquez gives the eyes such a light and glancing touch – almost unbelievably so, just darkness tinged with a scarcely perceptible white blur – they have an open-ended vitality. Innocent looks, and he keeps on looking, with a fixity so intense that one may imagine it contributed to his authority in real life.

Innocent was notoriously ugly, or so people said. In fact he looks like the handsome film star Gene Hackman in all the contemporary

portraits. But no matter what anyone else thought of his appearance, the Pope himself respected the portrait so much that he displayed it before his visitors in the waiting room outside his office. It shows him with a written plea in his hand, so that one senses his temporal as well as his spiritual power; and it seems as if Velázquez himself has been granted an audience with God's representative. But in truth – and it is the same truth, once again – this is not the image of an almighty stranger so much as a person known to Velázquez.

Innocent X, formerly known as Giovanni Pamphilj, had been the apostolic nuncio in Madrid from 1626 to the end of that decade. He moved through the city and its churches, was a frequent visitor to the royal palace and, indeed, had a sufficiently strong connection with Spain to worry the French when they were fielding their own candidate during the election campaign that eventually crowned him Pope. Artist and sitter are known to each other.

If a portrait can be said to have a human trait, this portrait has inexhaustible charisma.

When Innocent died, the picture (by Velasco, as the Italians had it) went to his adopted nephew, Camillo Astalli Pamphilj. Camillo had a short but spectacular career at the Vatican, becoming a cardinal in 1650. He was given the family name and the family palace in the Piazza Navona in the hope that he would prove to be a brilliant administrator, and then stripped of everything on the grounds of incompetence – and leaking state secrets to Philip IV, continuing the family bias towards Spain – three years later.

Velázquez also painted this vain and feckless man, who wears his red biretta at a slightly rakish angle (or is made to wear it at that angle: X-rays show that it was level at first, and later tilted by the painter) with a certain spare understatement. There is the faintest trace of a smile, or a sneer, about the lips, and Camillo looks about to dissolve like a hologram, so thin and fine is the diaphanous paint. Velázquez heard word of Camillo's dramatic downfall back home in Spain, far away from the events, far away from the political ups and downs, the disasters,

assassinations and executions of kings, watching the world turn like Lear in his jail.

There is evidence of other people's reactions to the way Velázquez saw them. Cardinal Barberini, who got him those first Vatican lodgings, so disliked the character Velázquez gave him, believing the portrait made him less vivacious and too melancholy, that he destroyed it and commissioned another from a rival. Philip IV ceased to sit for his painter from his mid-fifties, saying that he no longer wished to see the truth of himself in Velázquez's mirror. What is plausible about Innocent's remark, what takes it beyond the reflex compliment paid to practically any half-decent portrait at that time, is just one word, the simple adjective 'troppo'.

Perhaps the young Charles in Madrid in 1623 had seen someone he did not care for when he looked at himself through Velázquez's eyes, someone pale and callow, too frail inside his stiff outer shell, a small man alone in a painting.

Palomino says that Velázquez would not take any payment from the Pope, 'and could only be prevailed upon to accept a gold chain as a personal mark of esteem from the Holy Father'. The Pope's whole entourage now insisted on having their portraits painted in turn: his sister-in-law Olimpia; his chamberlain, his barber and his major-domo; Ferdinando Brandani, banker and chief officer of the secretariat; and in addition 'a Roman gentleman called Girolamo Bibaldo, and the excellent Roman painter Flaminia Trionfi . . . All these portraits were painted with long-handled brushes in the spirited manner of the great Titian.' And all these portraits have been thought irretrievably lost.

But in 2003 a portrait of a man emerged from a private collection into the Prado Museum. He was nameless, but it seemed that he might qualify for the role of the barber who looked after Innocent's health and appearance. He was depicted on a piece of canvas cut from the same cloth used for the Pope; how fitting that he might have cut the Pope's locks.

With his wavy hair, girlish eyelashes and breezy moustache, this man looks as if he might well be a barber. The image isn't formal – there is no distance between sitter and painter – and yet there is something strange going on. This man is not responding to Velázquez; there is no engagement in his eyes. He is sly. You go closer in the Prado, as so often, to see how this mystery is achieved and it all comes down to a mark about the size of this little letter i.

The ambiguity of the face depends upon one faint grey scintilla on the left eyelid, so subtle and small it scarcely seems possible that the whole portrait is inflected by it. But something in that mark suggests recoil; Velázquez doesn't trust his sitter.

In the 1920s August Mayer, the German art historian whose studies of Velázquez influenced scholarship for the better part of a century, saw this portrait in the gloom of Chilham Castle in Kent (its adventures between Italy and England are unknown). He was struck by the informality. No pomp, no props, a casual sitting: Mayer had the man pegged as another buffoon. But then the buffoon turned out to be Italian, not Spanish, because the beard and moustache were identified as Roman fashion; and then he became a barber, because his collar was too modest for the

chamberlain or the major-domo; and then, in the twenty-first century, the barber turned into a banker.

A scholar who had trawled the Roman state archives for decades hit upon the final identification. The banker Ferdinando Brandani kept careful accounts, in the manner of his profession, and among them was a receipt for a portrait of precisely these dimensions. The scholar then discovered that Brandani owned another picture of himself by a different artist; she found it: the two likenesses matched.

The fact that Mayer thought the man was a buffoon and not a papal grandee confirms just how intimate the portrait appeared, how close it was (and is) to those profound images of colleagues, actors and dwarves. Many historians have concluded that the ten or so Roman portraits must show the influence of Italian painting, the fluent manner of Bernini, and of Titian before him. But it could as well come from the liberty of Velázquez's life in the Eternal City, the intensity of the Italian experience, the close companionship he had with the people around him, with intellectuals and fellow painters. Rome was his freedom. We know that he fathered a baby called Antonio, born after his departure, because a record of payment to the baby's nurse has come to light. Nobody knows who the mother was, or if the infant survived, though there is the romantic hope that she might have been the painter Flaminia Trionfi.

Perhaps Trionfi kept the portrait to herself. There is no trace of it now, and no trace of her work, either. Unlike the paintings of little and large princesses with their rouged cheeks and obsolete clothes, held in place by the great barred cages of their underdresses, never moving from the palace where they were made, Flaminia's portrait was not tethered to a single place; lacking signature and identity, it could drift free, move among other houses. Many of the paintings Velázquez made in Rome remained there; but some came back with him to Madrid. View of the Gardens of the Villa Medici is one such, a souvenir of the world seen through

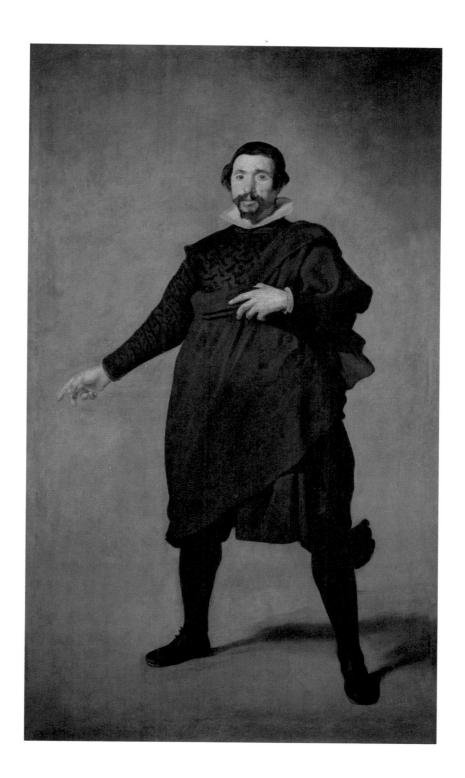

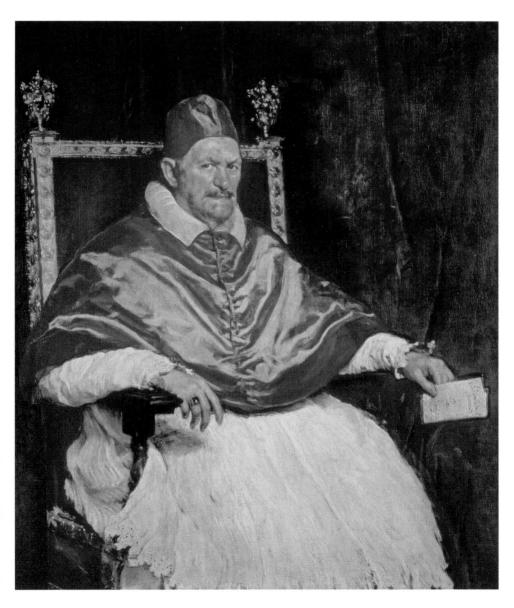

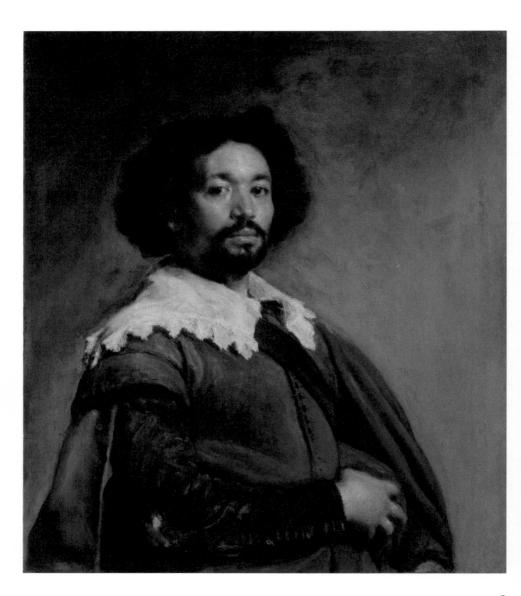

his eyes, as it was when he was present on that summer's day; a vision of the world as it looked before we were there.

One last Roman story. On that second visit Velázquez painted the great portrait of Juan de Pareja, a slave of Moorish descent who worked with him from the 1630s, grinding pigments, priming canvases and making studio copies. Perhaps Pareja prepared the very pigment used to make his own portrait, or painted one of the persuasive copies once mistaken for originals. For he was a gifted painter in his own right, judged as worthy of an entry in Palomino's Lives and Works of the Most Eminent Spanish Artists as Velázquez himself.

Pareja is poised, magnificent, proud (Plate I). He holds himself with all the dignity of a hero who has accomplished recent marvels on land or sea; not for nothing has he been cast as the face of Othello. A man of action keeping still for his portrait, he has one hand at the ready, as if resting on the hilt of a sword. But there is no sword and the hand is scarcely more substantial than the fabric around it, just a hint of fingers, almost notational, and the ear is nothing but an irregular red dab. Velázquez holds these outlying elements in abeyance, indistinct, because this is how they appear to our eyes in peripheral vision. The true focus is the face.

That face is strong, beautiful and profoundly expressive. Some have seen vulnerability there, perhaps extrapolating from the notion of a slave required to sit for his portrait, a man without power striving to find it within himself when exposed to his master's gaze; others have seen coolness, disdain or the hint of a militant temperament. The portrait holds so many nuances that one senses the human complexity of this man before all else; and this is enhanced by the frisson of recognisability. For no matter when he lived, this is a man one might see in the streets of New York today: he looks like one of us, as the people in the portraits around him in the Metropolitan Museum do not.

This vitality, this veracity, was something noticed by the very

first commentators when the picture was displayed outside, beneath the portico of the Pantheon, for an international artists' festival on March 19th 1650. 'It received such universal acclaim,' wrote a Flemish painter who saw it that day, 'that in the opinion of all the painters of different nations everything else looked like painting, this alone like truth.' This is exactly Manet's feeling in that letter sent to Fantin-Latour from Madrid. The other painters in the Prado are just making it up, he writes, they are nothing but fakers by comparison. Velázquez's sitters are real, present, true. Take away the collar, and Juan is our contemporary.

This collar is dazzling, a brilliant white expanse of fabric painted on fabric. The cloth of the picture becomes the cloth of the collar, as it seems, in both real and representational ways. Velázquez is able to construe the warp and weft of canvas as a distant brick wall or as the weave of expensive Flemish cloth. Again one wonders how could he know where to put these dabs of lead white and Venetian grey to conjure this luxurious item, a collar that was banned under Spanish laws as too sumptuous. Why is Pareja wearing one? Perhaps it is a political gesture. The slave is portrayed as Velázquez's colleague – one might say friend – and since both men have temporarily escaped Madrid and its punitive dress codes, the collar becomes a sign of freedom twice over. But it is also part of the aesthetic manifesto.

Velázquez paints the nap of grey velvet with a few gliding marks, and where the clothing wears thin, so does the paint. He doesn't trouble to number the buttons, which simply tail off like elliptical dots (etc. . . .) He doesn't define the cloak or even the mouth, 'one of the great orifices in art,' in the American painter Chuck Close's celebratory remark, 'out of focus yet you still know just how soft the lips would be to kiss'. The collar is rich, creamy, all scumbles and swags, as heavily worked as the stitched lace itself, yet never doggedly representational; a sumptuous accessory given sumptuous treatment.

The collar was made to amaze, and not simply as a luxury item. Anyone looking closely at it now, as at Pareja's face or the rest of his clothes, will see an unreadable scramble of marks. That they resolve into the man in the collar is as astonishing now as it must have been then. Velázquez draws them to your attention, as it were; you are not meant to see through them, as if they were part of some transparent illusion of reality. The veracity arrives out of incomprehensible chaos: it is vital that his people *should* look like paintings.

Velázquez sent Pareja around Rome with his portrait to dramatise the surprise. 'He drew Pareja with such similitude and liveliness,' writes Palomino, 'that the Romans stood a while looking sometimes on the picture and sometimes on the original, with amazement and even a sort of terror.' This was not the usual response, but something closer to awe at the fact that a living man and an inanimate object could look so alike, even though one of them was so conspicuously conjured from paint.

How staggering this experience must have been to those first viewers: a black servant at the door carrying his own portrait. And since continuity was everything, one can only assume that Pareja was not only wearing the collar, but manifested the regal bearing of the man in the picture. It is therefore too easy to say, as people have, that Pareja was ennobled by this portrait; he did not need to be raised.

'You know his [Velázquez's] phlegmatic nature,' Philip IV wrote to his Roman ambassador after many months. 'See that he does not take advantage of it to protract his sojourn at that court.' But Velázquez was not to be rushed. The king wrote again, and again, in the hope of drawing him home. Two years after he had left Madrid, Velázquez sailed back by way of Barcelona. He painted more portraits in that one Roman holiday than he would in the whole of the next decade at court. He was never granted leave of absence again.

Pareja received his freedom in Rome in the autumn of 1650. But he did not leave, choosing to work alongside Velázquez until his death ten years later. And he lives on in our eyes through Velázquez, who gives him the utmost esteem; they are bound together in this stupendous painting. Juan de Pareja, via Diego Velázquez, became the most expensive portrait in history when it left an English country castle in 1971 to embark on a new life in America.

Velázquez on Broadway

There is something intensely romantic in the fact that while walking up Broadway in the midst of a busy noonday crowd — made up of Bulls and Bears, rattling omnibuses, express wagons, Fifth-avenue carriages, railroad ticket offices, big hotels, big coaches hurrying passengers to steam on water or land — in a few moments, and by passing through a rather slim and dusty hall, you may shut yourself out from the present. In this silent place . . . may be seen a magnificent painting, a portrait of Charles I painted by the great Velázquez. This is truly superb.

On a March morning in 1860 the *New York Times* urged its readers to make their way through the noise and haste of Broadway to the grand public building at 659, where they would see a genuine masterpiece by the Spanish artist Velázquez in the hush of the Stuyvesant Institute. This portrait would introduce them to a dazzling artist whose reputation had reached America long before any of his paintings, and it would place a famous figure before them, too: a young man, bearded, dark-eyed, solitary, a prince destined to die beneath the axe – the future Charles I.

The *Times* writer was amazed by what he saw: 'The warmth and life of the flesh, the breathing in the nostrils, the wonderful depth of expression in the eyes could be given by none but a master.' For the price of a dime, he had come face to face with the fabled genius of Velázquez.

It would be another thirty years and more before the steel and railroad barons of the Upper East Side began to vie for Velázquez's deathless portraits of princesses in shimmering gowns, of dwarves and servants, boy princes and grave courtiers, all ruled over by a sad-eyed monarch in the silvery shadows of the Spanish palace. The Metropolitan Museum had yet to open, although the picture of Prince Charles would one day appear on its walls. The Frick Collection, with its magnificent portrait of Philip in scarlet silk, had not yet been imagined, for Henry Frick was still a boy. Jules Bache, who gave the Metropolitan Museum two paintings that would eventually turn out to be by Velázquez, was not even born. If the owner of the portrait at 659 was right, this could be the first American Velázquez.

For a few cents more, the man from the *Times* might have bought a curious pamphlet quite unlike the usual hyperbolic handbills to these shows, telling how the portrait came to be painted in Madrid in 1623 and by what luck it came into the possession of a humble tradesman, as the owner described himself, two centuries later in England. Indeed, visitors to the public rooms at the Stuyvesant Institute might actually have set eyes on this solitary man, haunting the corridors in a tarnished black suit. For he spent every day there, solicitously tending the ancient relics of Dr Abbott's famous Egyptian Museum on the ground floor. Some visitors would recall his habit of talking about the picture to anyone who would listen.

A modern journalist might have wondered how this man now came to be showing the Velázquez in New York, why he had left his own country behind, indeed why he had not already sold this masterpiece for enough money to buy himself at least a new suit. But a modern journalist would have known so much more than his predecessor ever could – how rare such a portrait might be, how precious; above all, what a Velázquez might actually look like.

There were no explanations in the pamphlet, no hint that John Snare might have brought the Velázquez to America in haste or

desperation. Nothing in it suggested how long the picture had been in New York, or that it had in fact already made several appearances on Broadway, proceeding sporadically up that great thoroughfare from one address to another over the years. It would emerge into the light for a month or two, perhaps as long as three, and then just as randomly vanish from view. The writer from the *New York Times* was by no means the first to undergo this epiphany.

Precisely when Snare arrived in New York is a mystery. His name does not seem to be on any of the available passenger manifests of ships sailing out of Britain before 1860. Perhaps there are missing documents or clerical errors; perhaps Snare travelled under another name. For there were times in his life when he might not wish to have drawn attention to himself, or his picture, passing through a British port.

Sailing out of England – or was it Scotland? – he left behind a wife, four children and the whole little society of friends and relatives in which he had lived for more than forty years, attending their weddings, mourning their deaths, employing their neighbours and children, listening to their news over the Minster Street counter, praising their town in his writings and raising its name by association with Velázquez. He had been a man of substance, a figure of fame; and then he disappeared.

In Edinburgh, during the 1851 trial, he does not take the stand despite the dramatic opportunity to talk up his painting. Perhaps his lawyers advised against it. But there are no glimpses of him in the Scottish newspapers either, as there had been when the painting was seized. He gives no interviews, sends no letters, prints nothing, responds in no way to the triumphant verdict. There is no background noise, as always with Snare, only a ringing silence. If the painting appears nowhere in public after the Edinburgh disaster in 1849, then neither, apparently, does its owner.

So it is surprising to find a notice in the *Caledonian Mercury* as late as 1852 implying that Snare may have set sail from Britain that summer. Where was he in those intervening years?

The Scottish newspaper was reporting the latest legal news of the Velázquez. It had been running regular reports ever since the trial ended in 1851, for that was by no means the end of the torment. George Young, Snare's barrister, was prophetic when he diagnosed something between acute litigiousness and outright malice on the Trustees' part; they appealed time and again, while pursuing nearly incomprehensible counterclaims of their own, until they had exhausted both sides and whittled the damages all the way down to £550. Dickens's Bleak House, with its case of Jarndyce and Jarndyce, was coming out in instalments in 1852. If ever John Snare missed a trick, it was in failing to draw the comparison in any future pamphlet.

The damages, now reduced almost by half, came too late for him in any case. His business had collapsed, his worldly goods had long since been sold. As soon as the trial had ended, and the verdict in favour of Snare was announced in the press, his own brotherin-law took out a suit against him for £500. It hardly seems likely that he would have - could have - lingered in Edinburgh for another whole year after the trial. He must have left Scotland long before, with his painting.

Everything was for sale at the 1849 auction - everything except the Velázquez. The one possession that might have kept the family afloat was not there, not even mentioned in the hoopla surrounding the auction. Since every Reading citizen must have known of it - the London triumph, the Edinburgh disaster, the fact that aristocrats were prepared to wage legal war over this treasure - the painting's absence must have been noticed. The auction was repeatedly featured in the press, and the Chancery bailiffs would naturally have seized upon the painting if its whereabouts had been known. So where was it?

Snare promises to remain at 41 Lothian Street in Edinburgh in May 1850. But before and after that he is increasingly elusive, shuffling the cards, slipping between addresses, dodging the bailiffs, his debts. If he lingers in Edinburgh while they are selling off his assets in Reading, the Velázquez will be safe in Scotland with its separate

laws. In Edinburgh the picture cannot be distrained by English bailiffs from across the border.

On the other hand, he might have left Britain already. Perhaps he sails for New York in 1849 before the painting can be seized for auction. Why stay around when he could be showing the painting elsewhere? Why stay in this miserable country?

There is a clue to the picture's whereabouts, at least, in the trial itself. George Young makes that cryptic reference that the other side completely fails to pick up. He asks James West, very much in passing, whether he ever heard tell of the picture being on show in another country, to which the loyal West replies that he has not.

Yet the picture may already have reached New York. Public records suggest that the Velázquez made its first appearance on Broadway in October 1850, whether West knew it or not.

By now Snare had nothing to lose, having lost everything in Reading except his picture; and perhaps the picture was the only means of support he could think of to provide for his family. He would make it work for its living, he would put it on show in America and send back the ticket money and the takings from selling pamphlets. This was not just any painting, after all, but the rare phenomenon of an actual Velázquez.

Or perhaps Snare could not bear to be parted from his picture? He had received an offer for it early in 1849, and yet he still refused to sell it, convinced that he possessed the artistic treasure of the age if only he could make people see it, and in as many places as possible. His life's work – his reputation, his credibility, his faith – had become the painting.

Sometime between the summer of 1849 and the autumn of 1850, or so it seems, Snare left his wife and children behind and spirited the picture off to a better life in the New World. It is possible that he left before the last baby was born.

Perhaps Isabella Snare was grief-stricken, devastated, broken; perhaps she was released from an unbearable oppression, and from the picture that had wrecked her life. She did not make the voyage out to New York and he did not return. They never saw one another again.

When Snare set sail for America he was going to the right place at exactly the right time. It was the next most advantageous port of call. He did not speak French, so there was no point in trying Paris, and he could hardly spread the missionary word about Velázquez in Spain. Besides which, part of the attraction was the subject of the portrait: this was the King of England, after all, still of some significance to Americans, and to the British arriving in New York in increasing numbers. Nor was he going off to prospect in some uncharted territory, for New York already had a thriving art scene and Broadway, in terms of galleries, was the equivalent of Old Bond Street.

On that longest and most crowded of streets there were dozens of dealers, auction houses, restorers and copyists, art suppliers, exhibition halls and galleries. Broadway had, or would soon have, the most reputable dealers in Manhattan – Goupil, Knoedler, Paffs, Henry Leeds, where Old Masters were regularly sold. It had the National Academy of Design, mounting shows by living artists, and the Chinese Assembly rooms for grand panoramas; the American Art Union for American painters, the National Academy of Fine Art for European Masters and the picture galleries of the Stuyvesant Institute. Almost every single novelty and succès d'estime, almost every great name (or painting) was made on Broadway in these years. There was nothing hick or amateur about Snare's choice. But he did not find his footing easily in all the rush.

Broadway was so busy with comings and goings that early daguerreotypes show the midday crowds as a speeding white blur. With its jungle of cables and wires, its carriages, horses, omnibuses, messengers and pedestrians, just getting from one side to the other was perilous and people were swept off their feet in the confusion. The throng on the sidewalks was worse. William Bobo's book *Glimpses of New York* (1852) describes a stream of

beings in bonnets, caps and tall hats as 'one grand kaleidoscope in perpetual motion'. But without this din, this squeezing and jamming and bargaining, 'this exhilarating music which charms the multitude and draws thousands within its whirl', the beauty of Broadway would be gone.

Every second building (literally) had pictures on show: Jacques-Louis David's Coronation of Napoleon aptly displayed in a social hall – a hundred portraits crammed into a canvas thirty feet wide; Americans queuing more than once round the block to view the dizzying white vortex of Frederic Church's Niagara in all its cinemascope grandeur, swagged with velvet curtains and viewed in spotlit darkness at the auctioneers' Williams, Stevens and Williams. In 1859 Church made \$3,000 showing one canvas alone, a magnificent ten-foot panorama of the Andes so dense with botanical detail that visitors were offered opera glasses to view each exotic blossom and bird. Considering that he charged only a quarter a head (exactly what it cost to see 'The Velázquez', as it had been definitively renamed for the American market), this was sensational box-office.

In 1850 you could see Benjamin West's ever-popular vision of the apocalypse, *Death on a Pale Horse*, riding melodramatically back into view on Broadway for the fourth time in as many years; and a gallery of Rembrandts at Niblo's Theatre, where Charles Blondin once walked a tightrope. John Martin's *Last Judgement* sailed across the Atlantic to number 353, a three-part apocalypse to rival anything by West, with civilisations toppling into blazing canyons and rocks bursting like popcorn as the sun went out. For those with more refined tastes, Titian's sumptuous *Venus* was on display at 449 the same month.

'Genuine Velázquez At 430 Broadway' announced the *New York Times* in 1853, in a column on evening entertainments on Broadway that included a performance by the ubiquitous Captain Tom Thumb at one end of the thoroughfare and a production of *Hamlet* at the other. The Velázquez appeared at a dealer's gallery and in a print shop, but its most frequent, and prestigious, address in the early years of Snare's second life in New York was the Stuyvesant Institute.

STUYVESANT INSTITUTE

A grand white building with a pillared neoclassical façade that would become the first home of the New York Historical Society, the Stuyvesant had three floors of rooms for all kinds of public events. European paintings and sculptures were regularly presented. Whole museums of artefacts from the ancient world were displayed. Music was performed, politicians gave speeches, clergymen preached sermons and Henry James Senior, father of the novelist, gave a celebrated series of lectures on 'The Universality of Art' in 1851. In his volume of autobiographical essays, A Small Boy and Others, Henry James remembers the Broadway of his youth, where he first saw paintings: 'Ineffable, unsurpassable, those hours of initiation which the Broadway of the 1850s had been. If one wanted pictures there were pictures, as large, I seem to remember, as the side of a house, and of a beauty of colour and lustre of surface that I was never afterward to see surpassed.'

James saw Chinese relics and Egyptian mummies at the Stuyvesant Institute, paintings by Watteau and Poussin, West's Death and Emanuel Leutze's gigantic image of Washington Crossing

the Delaware. Every month there was some new spectacle. 'We were shown, without doubt, everything there was.'

Perhaps he saw 'The Lost Velázquez' too, as the newspapers tended to describe the painting whenever it was shown (there was never, alas, a single illustration in these early papers). The doomed history of the prince was always emphasised, along with the adventures of the picture in Spain and England, before praise of Velázquez. The *New York Post* spoke of its beauty and solemnity, its uniqueness, its quasi-mystical glow.

The Stuyvesant was not just a venue for Snare to show the picture. It would become his home and refuge in Manhattan. It was here that he met a young compatriot named Dr Henry Abbott, a physician who had gone to work in Cairo in the 1830s, where he had become a devoted Egyptologist.

In Cairo, Abbott amassed more than two thousand artefacts, including mummified bodies and pharaonic headdresses, papyrus scrolls and funeral portraits, all of which were on display at the Stuyvesant Institute in 1853 at the same time as the Velázquez. The two men became friends, and something approximate to colleagues. Snare was described in a newspaper article after his death as having once been the curator of Dr Abbott's Famous Egyptian Museum on Broadway.

The museum was filled with captivating objects – hieroglyphic tablets, cat gods, golden helmets – disinterred from an ancient culture. The poet Walt Whitman was haunted by these visions of another world. He returned again and again; his name appears twenty times in the visitors' book, and in 1855 he wrote an article for *Life Illustrated* declaring that 'there is nothing in New York now more interesting than this museum'. He had long talks with Dr Abbott, and in the article mentions Abbott's disappointment at the American response to the show – which was modest compared to the excitable crowds Tom Thumb could muster along the street – and his fading hope that the city might one day buy the collection to keep it united.

The newspapers took up the cause, maintaining such a steady pressure over the years that by 1860 several plutocrats were persuaded to club together to raise funds for the New York Historical Society to buy the collection. It now belongs, in its entirety, to the Brooklyn Museum.

But Henry Abbott did not live to hear this news. He had given up hope and returned to Cairo in 1856, where he died in his forties, a disappointed man, barely three years later.

It does seem that Abbott left Snare in charge of the museum for all or part of the time, for he is described as a curator more than once in the New York City Register in the 1850s, his address given as 659 Broadway. Indeed, he took the responsibility so seriously, people said, that he rarely left the Institute and slept in one of the attics. But this diligence had a double purpose, of course, for it also allowed him to guard his own treasure night and day: the Velázquez that meant the world to him, and which he had rescued from danger back home. Now they lived together in a house full of mummies and gods.

Velázquez, until this time, was by no means the best-known Spanish painter in America. That title still belonged to Murillo, his contemporary from Seville, whose pictures of sweet-faced saints and unfeasibly cheerful urchins had captured nineteenth-century hearts across two continents. But, as the century progressed, Velázquez gradually became more popular as prints of his paintings emerged from the newly rolling presses of Fifth Avenue and Broadway. American writers began to praise his unaffected approach to his subjects, whether they were monarchs or slaves, and his palpable independence as a painter. All those years in Rome, yet no bowing down to Italian art; all those years in the shadow of Rubens, but no sign of influence. Velázquez stood free of tradition, free of academic rules, free of the royal court that might so easily have enslaved him with its absurd hierarchies and incessant commissions. Velázquez was an honorary American, an Old Master for the New World.

This feeling was mainly based on hearsay and prints; hardly anyone could claim to have seen Velázquez's art at first hand. There are fleeting mentions in handbills and catalogues for New York auctions: a copy, they say; or School of Velázquez, thought to be Velázquez, possibly Velázquez; Americans were more scrupulous about their sales talk in those days than the English. There had already been alarming scandals, including the notorious exhibition of Richard Abraham's collection of European Masters at the American Academy of Fine Arts in 1830. The catalogue promised Leonardo's Virgin of the Rocks, Titian's Penitent Magdalene in the Wilderness, Raphael's Adoration and paintings by Velázquez, Watteau, Tiepolo and many more - a dream show, in the truest sense. It is now known that almost every painting was a copy. The theatre producer and painter William Dunlap hailed them in his elephantine three-part history of art in the New World as 'the best pictures from Old Masters which America had seen'. And sure enough most had been copied directly from Old Masters on behalf of English aristocrats who had developed a taste for art on the Grand Tour

Abraham himself was a will-o'-the-wisp, a London dealer who had acquired these pictures by duping their English owners; he was arrested on his arrival in New York. But still the exhibition went ahead. Thousands of people paid fifty cents for the privilege, and the correspondent from the *Morning Courier* was lost for words at what he imagined to be original masterpieces: 'Language would convey but a faint idea of the effect which is produced upon the mind in examining the pictures.' As soon as the show closed, auctioneers sold the lot. The victims in England pressed charges, but eventually settled for selling their family treasures in New York.

Abraham's phoney Velázquez was listed as 'A Portrait of a Man'. What else?

Americans in the second half of the nineteenth century often received news of Spanish art through the conduit of British magazines. In 1855 two New Yorkers founded *The Crayon*, 'a journal

devoted to the graphic arts and the literature related to them', which soon became the most respected art journal in America. A few issues along, the editors splashed out on some substantial extracts from Stirling Maxwell's *Annals of the Artists of Spain*, specifically those about Velázquez. These homed in on what Pacheco had written about his son-in-law, 'that he very early resolved neither to sketch nor to colour any object without having the thing itself before him'. No fantasies, only Nature, an artist's best teacher: it could have been a motto for Frederic Church, lugging his easel all the way to Niagara.

But here, too, was Velázquez's devotion to the common man. 'Velázquez had extensive knowledge of the other masters, but still he remained constant in his preference of the common and the actual to the elevated and ideal.' He painted the servants. Stirling Maxwell had a perfect image for this Washingtonian truthfulness, this refusal to be swayed by foreign artists or outside influences: 'The oak had shot up with too vigorous a growth to be trained in a new direction.'

Mercifully for Snare, *The Crayon* did not publish Stirling Maxwell's remarks on his picture. Nor did it run a single word on *Las Meninas*. That marvel was still waiting for an American audience.

Snare was ahead of his time in New York. Henry Marquand had not yet bought the Velázquez self-portrait he would give to the Metropolitan Museum in 1889. It would be more than a century before the portrait of Juan de Pareja entered the museum. These were the dry pioneer days when nobody owned anything and there was practically a gold rush.

When the writer from the *New York Times* described Snare's painting as a marvel in 1860, urging his readers to make their way as fast as possible to Broadway, he did not ask himself why Snare had never sold the painting, and the accompanying pamphlet offered no direct answers to this question. Rather, it gave a dramatic account of not one but *ten* legal actions by the executors of some long-dead Scottish aristocrat against the owner, which had dragged

on through more than two years in the city of Edinburgh. So one might conclude that he had simply had enough of all this strife, packed the picture in its crate and quit Britain for a fresh start in the New World like so many of his compatriots.

And now here he was, John Snare, installed in a neoclassical building on the best-known thoroughfare in Manhattan with his Velázquez and receiving the same enthusiastic response from the fourth estate as he had, over a decade before, in Mayfair. Perhaps life was good, and he was free; or perhaps he was desperately trying to make ends meet, sending whatever money he could make home to England.

New York already had an extraordinarily dynamic press – five newspapers published each morning, two more in the evening – and journalists would come to look at the Velázquez on many occasions over the years, each time with a sense of revelation. In 1859 Robert Shelton Mackenzie, literary editor of the *New York Times* and a fellow immigrant from the United Kingdom, wrote about the picture with an unusual slant on the vexed issue of the sketch: 'Velázquez was commanded to make a sketch of Charles Stuart, Prince of Wales, then on his love-visit to Madrid . . . from which sketch, there is every reason to believe Velázquez painted the portrait of Charles, formerly in the Earl of Fife's collection, and now in possession of Mr. John Snare, Egyptian Museum New York.'

Mackenzie's awed judgement became the general opinion. 'It is one of the finest portraits in the world.'

The term of the contract of the property of the contract of th

The property of the control of the c

of the company of some self-transmitted services of the services of the self-transmitted services o

The Escape Artist

We are Hesitant with Velázquez's name in English, wondering whether we have lisped it correctly. El Greco is easy to pronounce. Goya sounds as it looks. Van Gogh we have arrived at as something quite other than the Dutch pronunciation, a sort of harsh anglicisation that has long since settled into consensus. But Velázquez is uneasy in any version, properly Hispanicised or not. We do not mention him too often, for all his transcendent genius. His is not a name on most people's lips.

It was evidently so in the past as well. Anxiety about the name of this elusive Spaniard whose works were so hard to come by left its trace in the flux of spellings. He was Velasco, Valasky, Valasca, Valasques, like the conjugations of an irregular verb. In Spain, in his lifetime, he was generally Velásquez or Velázquez. The artist signs his name both ways in the few documents that survive, but he scarcely ever signed a painting; and when they do appear, what is more, these are no ordinary signatures. They are never just functional, only there to put a name to the work; but neither are they flamboyantly expressive. Consider Rembrandt's intricate jewellery of fine letters; Courbet's name, left-leaning and revolutionary red; Picasso's upwardly swooping declaration. Velázquez's signature, by comparison, is steady and precise and it does not give anything away.

Signatures point out that a picture is an illusion. They allude to their own whereabouts on the flat surface of the canvas. They ought to get in the way (and sometimes do, in the case of Oskar Kokoschka's initials, OK, scrawled like a teacher's terse mark of approval across his own handiwork). But from the Renaissance onwards we have grown so used to words in paintings and particularly portraits – names, ages, dedications, assorted boasts and assertions – that even when a signature has nothing whatsoever to do with the scene, does not share in its composition or even its colours, we do not let it disrupt the illusion. Nobody ceases to find Monet's visions of waterlilies dreamily persuasive, to take an example, because his backward-leaning name is laboriously lettered across them. But Velázquez goes his own way, as always; he makes the signature part of the illusion.

One of these rare signatures appears elegantly inscribed on a letter in a most conspicuous place: the gloved hand of Philip IV. The letter is at an angle, as if the king was taking it with him somewhere, or at the very least holding it as part of whatever occasion the painting commemorates, which seems to be more ceremonial than usual since he is not dressed in his customary black clothes, but in a fabulous brown costume embroidered with twinkling silver thread.

Diego Vela z

The exact spelling disappears in a flurry of marks, so we shall never know whether it would have been an s or a z.

And what is this letter – is it from Velázquez or to Velázquez? It continues 'Painter to His Majesty'. This seems to imply that it's on its way from king to courtier, rather than the other way round; although some have speculated that it is the reverse, and that this is a petition from the painter to his monarch.

Does it resemble Velázquez's own signature? It certainly resembles the signature on another letter held in another hand, that of the pink-faced Archbishop Fernando de Valdés, a portrait that cannot be seen all at once, for the strange reason that it has been cut into pieces.

The part of the picture that hangs in the National Gallery in London shows a tense, wary, highly intelligent man experienced in worldly ways, but with an anxiety bordering on sadness. This is the face of a patriarch – Archbishop of Granada, President of the Council of Castile, a political post equivalent to Lord Chancellor – but a face is pretty much all that we have, for the rest of Valdés is invisible. He sits in front of one of Velázquez's rose-pink curtains, against which his black hat takes the arresting shape of a pair of crab's claws; but the form of his own body is completely concealed by the voluminous robes of office.

This is one of those paintings that has the aspect of its missing parts, like the glove-puppet above the stage that implies the unseen hand below, or the piece of jigsaw that invokes its missing neighbour. One sees Valdés and knows there must have been more of him; and sure enough, the upper torso is here, but the arms and hands are somewhere else: the patriarch has been dismembered.

How did Valdés lose his hands? We know they once existed because a version of the complete picture survives. Most of Valdés is in London – brought back from Madrid by the Scottish painter Sir David Wilkie – but the hands remained in Spain and perhaps there is a reason why they were separated from the body.

Valdés was holding a letter in his right hand, and on this letter Velázquez had painted his signature. A hand holding a handwritten

note, painted by the hand of Velázquez to imitate his own hand-writing – it matches the compressed flurry on a rare surviving document: one may easily imagine why this section might have been cut from the canvas as a special trophy.

The hand was last seen in the Royal Collection in Madrid in the 1980s. Nobody knows when it disappeared. Perhaps somebody has it even now, a fetish for a secret collector.

In the portrait of *Philip IV of Spain in Brown and Silver*, Velázquez's name is incorporated as a piece of documentary evidence. The king has written to him (or vice versa); he carries the letter; the letter is part of the story. Perhaps the two men corresponded during the first Roman trip, though no letters survive; it is thought this portrait was painted not long after Velázquez's return. During the second visit he also set his own name before the eyes of Italians unfamiliar with his art, in the letter held by Pope Innocent X.

But there are precious few signatures. Indeed, Velázquez goes all the way in the opposite direction from everyone else. Just as he can unpaint that equestrian portait of Philip – Diego Velázquez, Painter to the King, Unpainted This – so he effectively un-signs certain paintings.

There is a sheet of white paper lying casually in a corner of his huge horseback portraits of Philip and Olivares, and another in *The Surrender of Breda*. Known as *cartellini*, these are illusionistic pages or scrolls on which artists may leave their names as if written on paper. Philip IV's court painters all signed their names; but not Velázquez. In each case his sheet of paper is blank. He omits his signature in the very place where others would have spelled it out, having no interest in embellishing his reputation. It is such a fine rhetorical device, a sort of pictorial shrug. Who else could have painted this picture? No name necessary.

If only that had turned out to be true. Velázquez seems profoundly self-contained still, a figure in another room. His paintings have no titles, no inscriptions, rarely a date or a signature; he kept no

record of their sequence, as far as we know, and the questions of when they were made and why (and if, indeed, they are by him) drive scholars, as one has written, 'into a world of pain'.

The pictures issue from his mind, to his brush, and out into life to represent themselves; his way of painting remains exceptionally elusive. And for Americans fascinated by reports of his art, and half a world away from seeing it in person in the nineteenth century, there was nothing to look at but prints.

Murillo, by comparison, was practically a household name, his heartfelt pictures having reached the New World long before those of Velázquez; New Yorkers could even see one of his largest paintings, *The Immaculate Conception*, with its seventeen-strong crew of cherubs transporting the Virgin upwards on a rosy cloud, for free any day in the Tenth Street home of the shipping tycoon William Henry Aspinwall by 1859. But Velázquez was unseen, intangible, remote. Even thirty years later Walt Whitman writes to a friend that he has been trying to visualise the Spaniard's way of painting by studying a little black-and-white print in the November 1889 edition of the magazine *Century*. 'Wonderfully good, I looked at it for ten minutes. By what the fellows (experts) tell me who have travl'd in Spain I guess there is no portrait painting existing any better than V's.'

The painting was *Aesop*, the ancient Greek fabulist made modern in the person of a strewel-haired old tramp, shabby, at ease and incorruptible. He has no pockets to warm his hands, nothing but the sagging folds of his coat, beneath which he is evidently naked. One of his boots is broken down from limping, and around his poor feet is a litter of rags and a wooden bucket, perhaps to remind us that this great writer was also a slave (Plate L).

Whitman calls it a portrait, and so it is – not some imaginary Greek, but a real human being dressed for the part. Velázquez finds an Aesop in the living people around him. Some scholars have insisted that the face is made up or, worse, that it is based on 'the bovine type' in a contemporary iconography manual; one

has even proposed that Velázquez is punishing Aesop for satirising human beings as beasts. But in fact Aesop has the face of an actual person – he looks exactly like the English actor Albert Finney – just as the portrait has the force of a true human presence. It goes to that idea we all must have at some stage, that the legendary figures of the past must still have had ordinary bodies; and as we walk through the world, certain faces strikes us as fit for particular heroes. Aesop's is an exemplary face – level-eyed, dignified, unillusioned after a lifetime's hardship – but it is also a real one. Perhaps there is something of Velázquez's own character in that watchful gaze, so wise and undeceived.

When Hans Christian Andersen saw the portrait, he declared he had found his ancient counterpart and could never picture Aesop any other way.

The print in *Century* magazine was based on a dim photograph of the painting far away in Madrid; and yet, even at such a remove, Whitman still had a sense of the marvellous original.

That same year of 1889 the Metropolitan Museum was given the gift of its first supposed Velázquez. The painting that entered the new museum on the Upper East Side was not just any Velázquez, what is more, but a portrait of the artist by his own hand. That is to say it had that intensity about the eyes, that piercing look of recognition that comes from staring long and hard in the mirror, which seemed to single it out as a self-portrait.

It was the very painting the art writer Mrs Jameson had admired forty years earlier in Mayfair, which had now passed from the Marquess of Lansdowne through an Old Bond Street dealer to the American railroad magnate, Henry Marquand.

Marquand was so famous for never being able to say no to a dealer that the entrance hall of his Fifth Avenue mansion was chronically jammed with deliveries of antiques, carpets, paintings and sculptures; there was no room, he lamented, for a humble working clock. He was equally famous for his largesse, a generosity

so deep that works of art bought on his behalf in Europe sometimes passed straight into the public museums of America without spending a single night in his house.

This particular purchase once belonged to a Spanish Prime Minister, who bought it as a self-portrait; nineteenth-century writers from Mrs Jameson onwards were equally convinced, and so it appears in the Metropolitan Museum's own catalogue until well into the twentieth century. But August Mayer was not so sure, and the doyen of Spanish Velázquez scholars, José López-Rey, whose catalogue raisonné was published in 1963, thought it was possibly a fine work by a student. As the century passed, that student was identified as the painter's son-in-law, Mazo. Certainly the brushwork strives to imitate, in slow and calculated strokes, what Velázquez achieves apparently without effort – the hazy air, the enigmatic eyes, the transparent glow of flesh. Look at the back view of the painter working at the easel in Mazo's *The Family of the Artist* and surely this is the same man: the round head, the bushy puffs of soft dark hair: Mazo's own self-portrait.

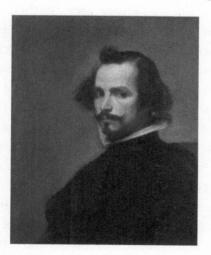

But each time someone said it was by Mazo, somebody else reverted to Velázquez. There were no two identical opinions. The assertion that it was by Velázquez split the specialists just as much as the claim that it was a self-portrait – absurd to anyone who has ever seen *Las Meninas*, for it looks nothing like the painter.

Jonathan Brown, the great American Velázquez scholar, once formulated what he called the five-second rule to deal with the perils of using one portrait to identify the sitter in another. If the resemblance is not apparent within five seconds, it is almost certainly not the same person. Apply the rule in this case and it undoubtedly works.

In the late nineteenth century other pictures by Velázquez gradually began to reach America. Arabella Huntington, wife (and aunt) of Henry Huntington, who made his fortune laying rail-tracks through Tennessee and Kentucky, bought the immense horseback portrait of Olivares that hangs in the Hispanic Society of America. At the turn of the century her husband bought the exquisite portrait of a little girl, dark-eyed, innocent, aged around seven and so tenderly close to the artist as he works that one might conjecture a family relationship, perhaps grandfather and granddaughter. He takes his time to paint her grave face, bathed in pearly light. Between them, the Huntingtons also bought Velázquez's portrait of the cashiered Cardinal Astalli, nephew of Innocent X. His identity was unknown in those days and the documents describe him – with a vagueness that would have outraged the cardinal – as 'A Young Ecclesiastical'.

In time, some of Velázquez's least-privileged sitters arrived in the land of the free: the seering image of the lyric poet and satirist Luis de Góngora, in exile from royal favour – though not from Velázquez's respect – which is now in Boston; the cross-eyed jester Calabazas, holding his paper windmill and beaming so cheerfully at the artist, in Cleveland. The beautiful painting of a sibyl, thought to be Velázquez's wife Juana, bought in the Sixties by the oil millionaire Algur Meadows for his eponymous museum in Dallas, one of three paintings by Velázquez in this little Prado in the desert. If this is Juana, it is almost all we know of his loyal wife.

In New York there were no fewer than nine paintings, including the Metropolitan's portrait of Juan de Pareja – or so it seemed until 2010. And then, in the same museum, a Scottish conservator who had been cleaning a portrait of an anonymous gentleman, a picture so murky that it was, he said, like looking into the bottom of a dank pond, began to realise that he was staring into the eyes of a lost Velázquez (Plate J).

The picture shows a thin man with a high forehead and long, narrow face. He is still and secretive as a heron. His brow is slightly moist as if affected by self-consciousness or heat, his hair as fine as the glassy halations that surround him. The eyes are dark discs, one hidden in shadow, the other edged with light and becoming more visible, though still he is reserved; there is a hint of sleeplessness in the sag beneath that eye. The moustache turns up in a single live wire.

He is fractionally turned towards the painter, but the two men are held together by what feels like only the most minimal pressure, nothing so strong as a formal sitting with a concerted pose and special clothes, nothing so routine as a commission. Perhaps this man – this friend, colleague – was a reluctant sitter, but Velázquez has been gently persuasive. The picture won't take long to make, although it will last for ever.

It is an electrifying sight: radiant, fugitive, volatile. The paint is as fluid as a watercolour and so thin as to be almost transparent. The brushlines crackle. Around the head the atmosphere of silver, grey and greenish-silver resembles nothing so much as mist. The underlying canvas is everywhere visible, so that the paint seems to have materialised on the surface like condensation on a mirror.

If portraits had souls, this one would surely complain that nobody had ever understood it. The first we hear of it is in the nineteenth century, when it was bought – despite its pensive restraint – as a work by the garrulous and sociable Van Dyck. The buyer was the illegitimate son of King George II of Britain, a Hanoverian aristocrat who kept it in his eccentric castle on the

Rhine. It passed to a German dealer who bizarrely included it in his collection of Dutch paintings from the circle of Rembrandt, which is where August Mayer saw it, identifying it as a Velázquez in 1917, most probably as a self-portrait. This was partly because of its powerful resemblance to a man in another painting by Velázquez, the figure in the plumed hat positioned on the edge – and thus in the traditional onlooking role of the artist – of the immense crowd of troops in *The Surrender of Breda*.

He does look exactly like the man in the plumed hat, and vice versa: they pass the five-second test. And each likeness seemed to corroborate Mayer's theory that both showed Velázquez around the age of thirty-five, when *The Surrender of Breda* was painted.

It is a truth seldom acknowledged that historians change their mind, sometimes quite radically. This happened to Mayer. A few years after his declaration that the picture was by Velázquez he began to feel that it might be by Mazo instead. Nobody now would imagine that Mazo had the ability to carry off that collar in one astounding line, or to catch the faint moisture on the forehead and the way the light bounces off it as Velázquez does. Nobody now would imagine that Mazo could even begin to paint that scintillating air, but nobody now sees the picture as Mayer saw it – uncleaned.

And yet he changed his mind, once more. How this came about is one of the low stories of art.

The picture was sold in 1925 to a German dealer named Blumenreich, and as it changed hands attracted the attention of another dealer, the notoriously slippery Joseph Duveen. Duveen wanted to buy the painting from Blumenreich as a middling Mazo and sell it as a great Velázquez. He pursued his course like the sly predator he was, quietly negotiating with Blumenreich until he had caught his prey, but at the same time relentlessly pressurising Mayer to come and look at the picture again in Paris. Mayer resisted at first, reluctant to appear so changeable in his views. But Duveen wheedled and coaxed and increased the enticements until eventu-

ally, at the end of 1925, Mayer relented and came to France. A cable from Duveen, now in the Metropolitan Museum, says that he has 'cleaned up a little' as he thinks 'it would give a much clearer effect for discussion with Dr Mayer'. Sure enough, a few days later another cable triumphantly announces: 'Mayer passes Velázquez'.

Art historians ever since have been uneasy or downright critical about Mayer's volte-face, since he was — as is customary — paid for this final verdict. But the surface of the picture had changed since he last saw it in 1917 and there were no colour reproductions to prepare him for the way it now looked. It was, he wrote, 'one of the most delightful surprises which I have ever had . . . The modelling is simply marvellous, the painting is like a flowing water colour, the tints of the face look like mother-of-pearl. It has come out most splendidly. The picture lost all the dimness and shows now the characteristic silver-grey tone of the works of these years.'

If only the painting had been left in this state, its future would have been different.

But Duveen wanted to sell it to an American collector and he believed, correctly as it turned out, that he would get bigger money if the picture looked more like an Old Master; or rather, an Old Master as imagined by an American unfamiliar with Velázquez. Having cleaned it once, he now effectively uncleaned it. Duveen sent the picture to a restorer for transformation. The picture was darkened, the beautiful silver-grey tone dimmed once more. The features were given more emphasis, the head a rigid contour, the hair a heavier do. One could not say that the essential subject changed - it was still the portrait of a man, probably Spanish - so much as that it was solidified, weighed down, coarsened. It was traduced, extra-Hispanicised, 'improved' or 'consolidated', as you will, and then heavily varnished on top of all this cosmetic surgery. And this is how it came into the collection of Jules Bache, sold to him as a Velázquez self-portrait for a gigantic \$1.25 million a few months later in 1926.

Bache was a German immigrant who arrived in New York as a teenager, some twenty years after Snare, to work his way up the stockbroking company founded by his uncle. By the age of thirty he had taken over; by the age of forty he had made the firm so successful its only rival was Merrill Lynch.

Bache bought paintings with a passion and opened his large house at 814 Fifth Avenue to the public free of charge, four days a week, with the idea that it might eventually become a private museum. The painting appears in a photograph, hanging on the wall of the drawing room among the Rembrandts, the Titians and the ormolu clocks. But Bache later decided that his collection needed a more reliable home and bequeathed most of it to the Metropolitan Museum.

The portrait that entered the museum in 1949 in the Bache bequest was not a Velázquez for very much longer. It was revarnished in 1953 and then again in 1965, by which stage it no longer convinced the specialists and was demoted to that dispiriting category 'workshop of Velázquez'. By 1979 it was relegated to the store. What had begun as a possible Van Dyck, become a definite Velázquez, then a Mazo, then a Velázquez all over again now turned into nothing very much: any old portrait of any old Spaniard; anonymous sitter, anonymous painter.

How easy it would be to draw a contrast between garrulity and silence, between Van Dyck's incontinent output, over-talking, cease-lessly communicating, never-ending until interrupted by his premature death, with all these sittings like salons where he conversed with his sitters while painting their portraits, non-stop and more and more of it all the time, and Velázquez: taciturn, pensive, watchful, restrained, his output slim and the antipodes of glib.

And yet it is Van Dyck with whom Velázquez is so often confused – that is to say, at a certain point all sorts of paintings by Velázquez were thought to be by Van Dyck, whose name was better known. Perhaps there was even a stage at which it would

have been useful for some poor, ill-considered canvas by this greatest of painters to have been mistaken for a Van Dyck so that it would be set before the public instead of buried in the stacks.

The Velázquez that had been a Van Dyck ceased to be mentioned after a while. In 1972 the talk centred entirely on the new Velázquez, the portrait of Juan de Pareja painted in Rome. Not until the twenty-first century did a curator return to the painting, at a time when the Frick's magnificent portrait of Philip IV – produced in desperately reduced circumstances outside Fraga in wartime – was in the museum's studios for restoration. The anonymous man was brought alongside it; to the restorer, it appeared dull to the point of dead. Gingerly he cleaned a tiny area and the silvery tones instantly became visible, just as they had for Mayer a century before; just as they had for John Snare.

What became evident was that this was not a highly finished portrait so much as a life study made with startling rapidity, the collar revealed to be no more than a couple of darting strokes, the moustache a fantastical line swept upwards in seconds. The colours, all the way from buff-pink to silver, green and many different greys, are exceptionally dilute, and so softly and subtly applied as to appear diaphanous.

Why would Velázquez make this portrait and then incorporate it into *The Surrender of Breda?* Perhaps because this man had actually been there when the Spanish overcame the Dutch after a year-long siege and Velázquez's old friend Spinola accepted the keys to the city. When people say that the man in the hat and the man in the Met must be self-portraits there is the obvious and significant fact, for such a truthful artist, that Velázquez was never at Breda; and he never did anything so predictable as to sign himself as an eyeballing self-portrait on the edge of a crowd.

The Surrender of Breda teems with unique portraits, and this is surely one of them: a vital painting of a man who was actually there, outside Breda, and is really here now with Velázquez.

Has he come to the same part of the palace to be painted as the chamberlain Nieto, in the Apsley House portrait? The light falls from the same angle. Again, the courtier and the artist talk and then fall silent as one poses and the other paints. Perhaps we will one day discover who he was, this tense colleague; but he will still be mysterious because Velázquez allows him his full depth of character. The picture is rapidly achieved, finished in its own terms, but what it shows is a man in mid-thought, mid-breath – like all of us, a work in progress.

Velázquez's self-portraits are sighted everywhere and nowhere. He is a man of many faces: with a beard or no beard, a long chin or cheerfully plump cheeks, a nose like a nib or a button mushroom. In Munich he is the dark-eyed man with Hasidic locks and no moustache. In Dresden he has a moustache and a skullcap. He has been Mazo, he has been Nieto and now this thin-faced gentleman. The need to find him in such various faces seems to reflect some sense that he is protean, a chameleon whose colours are never fixed. But it is also a need to bring him closer, to find him among the paintings that have emerged out of Spain into the Old and New Worlds, to discover a face for his character.

But perhaps there is another reason, too. What all these paintings have in common is that intensity about the eyes that is the familiar sign of a self-portrait – that look of looking, that frisson of recognition, that suggests a particular intent, actively seeking out the viewer. This is one of Velázquez's extraordinary gifts, that he is able to give portraits of other people the freedom and force of self-portraits, as if they were their own creations, *sui generis*. They appear as if through their own eyes, with their own insight. It corresponds, too, with the old idea that Velázquez could see the truth of each person, that he was a walking mirror.

The oddest aspect of this longing for another face is that he left that definitive image of himself, the very index of the five-second

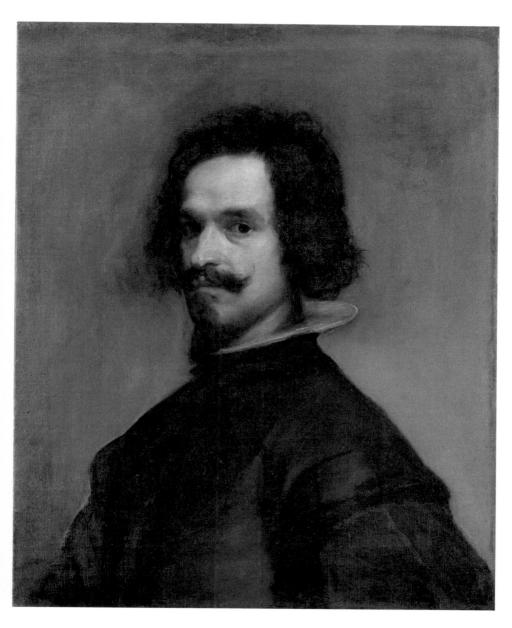

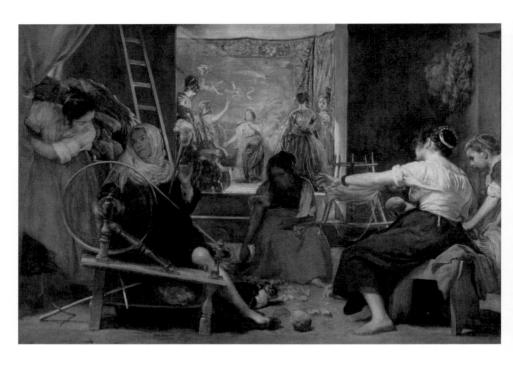

K

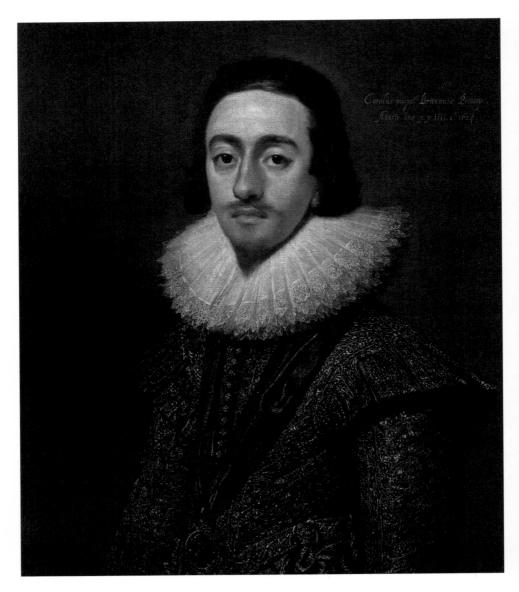

rule: the tall, dark figure behind the canvas, his brush held like the wand with which he has magically summoned everything and everybody in *Las Meninas*.

How could anyone fail to notice a Velázquez on a wall, in a museum, at an auction? – that is the irresistible question. Is there something in this art that makes it so hard to identify as his? Why does it seem to defy ordinary analysis? Surely the signature of the artist is there in every brushstroke of the Metropolitan portrait – in the astonishing indistinction where the forehead meets the hair, which simply disappears; in the pearly light that touches the face; in the small irregular dabs that describe the bump in the nose; in the darting marks that pulse through the face and hair. It is that characteristic Velázquez feat: every wild and random stroke falling exactly into place. He did not need to sign his pictures. Or did he?

The mystery of Velázquez's way of painting – how could he know how little, how thin, what colour, what force, what weight and place and point of mark it would take for the eye to see tension, softness, silkiness or breath – has made it almost equally possible for his art to be unrecognised. His paintings appear and disappear in these confusions, vanishing in all their subtlety beneath the burden of varnish, dirt and bewilderment.

In 2011 a Velázquez portrait was discovered in a seaside town in Kent by an auctioneer valuing some paintings for the descendants of a Victorian artist called Matthew Shepperson. Shepperson was a modest painter, mainly known for copying other people's works and painting quiet portraits of his own. He was also a modest collector, and had picked up this portrait for around seven shillings in the 1820s (less than one-twentieth of the price paid by Snare). The family believed that Shepperson had no idea what he had bought; and neither had they, it seems, for every generation since had assumed that the man with the fine shrewdness in his face and a certain dignity of bearing and costume was in fact Shepperson

himself. This was in spite of the golilla collar, the black satin doublet and the Spanish goatee that suggested a quite different country and era.

Perhaps Shepperson thought he had bought a copy of a Van Dyck, cheap at the price; in Victorian times so little was known about the details of seventeenth-century Spanish costume that an Englishman's falling collar could easily be confused with a Spaniard's ruff, and vice versa. The gentleman in the portrait has white hair, what is more, so perhaps he was not quite so obviously the Spanish courtier he appears to modern eyes.

Still, it is strange to think that nobody saw the Velázquez for what it was, in all that time; that nobody looked at this work of quicksilver insight and thought it had nothing in common with Shepperson's country parsons. The painting eventually sold to a New York dealer in 2013; no museum was prepared to bid the highest price. Everyone involved in that sale believes that it is a Velázquez, yet when it was ferried between London, New York and Madrid for appraisal there were specialists who refused to commit themselves because the painting was not in a public collection. It could become a Velázquez only when it had emerged from the wilderness and been sanctified by a museum.

The picture has no other name than *Portrait of a Man*, though he is evidently a man of judgement and intelligence, a courtier like Nieto or the Metropolitan man, a colleague and perhaps even a friend. Some specialists have identified him as the Master of the Royal Hunt. But one way of discovering more about who painted the picture is through X-rays, which have so extended our knowledge of art. X-rays can put an end to aggravated caution, tell us whose hand is at work, reveal the origins, errors and changes in a painting.

How much better (or worse) Snare's life might have been had he lived in the age of Röntgen.

When this portrait was X-rayed, however, something astonishing came to light – namely, nothing at all. You cannot see any under-

painting, correcting, outlining or retouching, you cannot see a beginning or end. There is no trace of the brush at work, only a misty grey blank. And this is the proof, paradoxically, that the painting is his. Even as he was making the man appear, so Velázquez himself was disappearing; the X-ray shows his vanishing act.

The Vanishing

I have looked at this portrait till my sight has become dazzled. I have thought of it till my mind has grown confused. My life has been spent trying to discover the proofs of its originality to the neglect of all other pursuits.

'The History and Pedigree of the Portrait of Prince Charles', 1847

JOHN SNARE IS a man without a face. No image of him survives. This person who spent most of his life transfixed by a picture of someone else, who lived out his days with that painted face, simply disappears behind it.

He is present in his words, of course, which ran to many thousands, from the first pamphlet in London to the last in New York, the petitions and protests and all the letters he must have written, year upon year, campaigning for his painting, pleading its cause, raising its name in the newspapers of two continents. If ever a man left an expression of his private feelings in the form of public proclamations it was John Snare.

But inside all these words he remains invisible, a blank to anyone who has been following in his footsteps and longs to know what he looked like; and who wouldn't want to know – to be interested in other people's faces is almost a test of human solidarity. Would he look like an English version of Brandani the distracted banker, not quite trusted, or quite trustworthy, a showman talking up his picture, slipping off to New York; or would he be more like Don

John of Austria, with his gaunt stoop and actor's energy, living on his nerves? The bookseller of Reading must have had his portrait painted by somebody somewhere, given his love of art, but if this ephemeral image survives, one among millions, it is lost in the tide of time. Perhaps he is destined to remain forever in the shadows, like the watchful retainer on the edge of *Las Meninas*, his features a hazy blur.

An awkward watercolour exists of Snare's father, pot-bellied in those high-waisted early-Victorian trousers that must have been worse for a man than any miniskirt for a woman, revealing so much of what he has, or has not, showing his leg and stomach so unforgivingly. One sees this man, and from his faint face one might deduce something of the son, pale-skinned, dark-browed and busy. It is easy to imagine Snare with Victorian sideburns and beard, to picture him in waistcoat and shirt sleeves, his printer's hands nimbly manipulating the tiny metal blocks, changing the font once, twice, sometimes six times for an eye-catching handbill. He must have been remarkably quick-witted too, for he researched and wrote *The History and Pedigree* in less than four months, with all its tireless, not to say fanatical research and its deep reading on Velázquez.

In Reading, Snare is a gentleman: and proud to describe himself thus in the local census as his business grows. Perhaps he writes an elegant script with the Indian ink he stocks in the shop; perhaps he takes the snuff he sells; perhaps he paints watercolours for the society of which he is a member. I see him leaning on the counter that will later be sold, reading the works of Richard Ford and Mrs Jameson, homing in on the mentions of Velázquez and teaching himself respectable beginner's Spanish. Perhaps he is in checked trousers, a bit of a dandy, or all in black with a diamond-pinned cravat. In the Reading Museum is a portrait of his fellow bookseller, George Lovejoy, in a black silk suit, heavily whiskered and genial, on the verge of a smile. Perhaps he is more like this?

Anyone can picture Snare's obsessive zeal and driving energy (how they must have oppressed the life of his wife). He is always talking of the future, compulsively expanding the business, urging the picture onwards, learning more like the avid antiquarian he is. And yet Snare steps free of this picture. With his Dickensian name he irresistibly turns into a Dickensian figure, drawing anyone who seeks him into his snare. He is elusive, perhaps even fugitive, vanishing off to America in silence, never to return; to find him there is to spot a glint of gold in the dust. You can sieve the newspapers and the census forms, the tenancy agreements and the city directories, the stories of shops and shows and pictures on Broadway, the memoirs and letters - did Walt Whitman see the Velázquez, did Mark Twain, did Henry Marquand take an interest? - and all the surviving anecdotes of those who lived and worked on that great boulevard, without finding this wraith in the crowd.

But in the end he is the one snared, caught up by his Velázquez, bound to it, taking it everywhere and never-endingly pressing its virtues home, driving its value through the republic of art.

When Dr Abbott returned to Egypt and Snare became his soi-disant curator at the Stuyvesant Institute, the Velázquez found its place in the world again for a few more years. It was on show there, with full advertising, four times between 1850 and 1860. Here was the Englishman in the attic, shrewdly keeping a presence about the building, working for Abbott, helping out with the other shows – Frederick Church, Benjamin West, Paul Delaroche – while protecting the interests of his own picture at all times. He even turned himself into an agent for the premises.

In 1855 he advertises the Lecture Room in the newspapers: commodious, thoroughly lit by gas, with cushioned seats and a stage suitable for exhibitions, concerts, readings and Sunday worship. For terms, apply to John Snare, room no. 22. No political meetings allowed; the Stuyvesant is for artistic and literary

purposes only. He lets the second- and third-floor rooms for clubs, religious societies, literary associations and business purposes, but is scrupulous about these too, they must be first-class businesses, not frauds or fly-by-night salesmen. This is a reputable neighbourhood.

In 1856 he opens up the possibility of displaying a new kind of portrait at the Stuyvesant, now that the spacious Gallery 'has been admirably adapted for the new Daguerre-ian profession'. Photographs are to be shown, though let us never forget the Old Masters; the lighting is good for both.

Snare is still hanging on there as late as 1862, still living above the shop, as it were. It is remarkable that he has managed to remain so long after Abbott's departure in 1855, especially as the Egyptian collection is no longer on show there, since its purchase by the city. And, sure enough, by 1868 Snare loses his foothold.

Now he shifts the remains of his worldly goods a few doors up Broadway to number 678, floor upon floor of rentable rooms that will soon be demolished to make way for the new Brooks Brothers store. He still refers to himself as J. Snare, Stuyvesant Real Estate, in the City Directory. But soon that title vanishes and he is forced to uplift once again, to number 701 and a bedsit under the eaves high above a music shop. Fractional moves, a little further from the grand Institute every time, yet always on the street where art thrives.

But New York moves at speed and the picture palaces need new paintings every month. He cannot keep showing the Velázquez at a quarter a time, trading on its waning novelty. The painting is not paying its way; and yet still he does not part with it. He survives the Civil War in some poverty, adapting fast, then briefly reinvents himself as a dealer in 'objets d'art'. There is no evidence that he managed to buy or sell anything at all.

And then, at some unknown date in the early 1870s, John Snare returns to his first profession. He becomes a buyer and seller of books, working between the publisher Charles Scribner's Sons on Broadway and Brentano's bookshop at Union Square.

Scribner's, future publishers of Edith Wharton, F. Scott Fitzgerald and Ernest Hemingway, was already publishing fiction, along with children's books, religion and philosophy, with huge success. And the pioneering publisher had its pioneering bookseller close at hand in August Brentano. An Austrian immigrant who had once sold newspapers outside the New York Hotel on Broadway, Brentano's great entrepreneurial leap was to gamble all his money on bulk-buying a single issue of the London Times at the docks, for its report of the boxing match between John Heenan of San Francisco and Tom Sayers of England, the first 'world title' and the match that changed boxing history. With the proceeds made from this single page of prose, he set up a bigger stall and eventually his own bookshop, Brentano's Literary Emporium, which blossomed into a chain of shops with an outpost in Paris. The Emporium turned into an empire, eventually merging with Borders Books.

Snare bought from Scribner's on behalf of Brentano. The narrow passage of Broadway he now walked grew by a few more feet as he negotiated back and forth between the two. Many years later, in 1903, when the *New York Times* was trying to work out what had become of John Snare and his mysterious Velázquez, a retired member of Scribner's staff wrote to the paper remembering regular encounters with Snare in the 1870s. 'I can call him distinctly to mind, especially as he looked during the winter, because he used to wear a heavy Scottish plaid thrown over his shoulder, and always wore kid gloves and a tall hat.' He stood out, this Englishman in exile, his first life lost, always trying to keep up appearances.

August Brentano's nephew Arthur, who inherited the business, also recalled Snare from those long-ago days. He was old by now, but still working part-time, toiling back and forth to Scribner's. And he had one more role, too, as the bookshop's 'versificatory advertiser'. Snare, once compared to Daniel Defoe, was now reduced to rhyming copy.

Arthur Brentano was invited to come and visit the Velázquez up several flights of stairs in Snare's room at 701 Broadway, but was too young at the time to remember anything about it. By the 1880s he had lost sight of the Englishman altogether.

By now Snare was in his seventies and still labouring up and down the stairs at 701, still living at the top, with Schirmer's music store at the bottom, a large family of Prussians on the floor below him and, by touching coincidence, a young printer newly arrived from England. This part of Broadway was beginning to lose its theatres and restaurants as they migrated north towards 14th Street, and the NoHo buildings were either converted into warehouses or demolished. 701, Snare's last perch on Broadway, was gone by the end of the nineteenth century.

In 1880, in the New York City Directory, his profession has dwindled all the way to a single syllable: Books. It is as if his life no longer has any definition at all. But some part of him must have rallied for the Census that took place that same year. He could not go down in history so meanly: in that document, among the dressmakers, violinists and house cleaners, he appears with a better phrase, and some small claim to truth after all, as 'John Snare, Dealer in Works of Art'.

There is a passage in *The History and Pedigree* where Snare talks of humble people falling in love with portraits. 'They often treasure and even love an old likeness without desiring to know whom it was designed to personate. They grow familiar with it, and in a short time become fond of it. They talk to it and address it by some name, as if it were a living being.' He might have been describing himself.

But by the time of that census Snare had lived with his portrait for more than thirty years. He had saved it twice from kidnap; carried it the length of Britain by trap and train; and all the way across the Atlantic, cut from its frame and rolled up in a tarpaulin, or a tin box, or under Mrs Snare's petticoats (there were increasingly high-coloured theories, though there seems no reason to discredit the crate made by the Radley carpenter). They had shared a town house in Reading, a hotel in Edinburgh, a ship, the Stuyvesant Institute and now a cold-water tenement on Broadway. He had devoted most of his professional life to its cause. He lived with it – eye to eye, face to face – unable to part with it for any money, and yet he never seems to have grown tired of it, or angry with it for bringing his family to ruin; he only loved the picture more. *Amour fou*, love unto madness.

Everyone who left a written memory of Snare in Manhattan spoke of his habitual talk of the painting, of his infatuation with it. But the testimony always takes the form of indirect speech until one spring day in 1860, when a journalist from out of town happens to pay a visit to Broadway.

'We saw, a few days since, two very remarkable sights at the Stuyvesant Institute. One was the picture by Velázquez and the other,' he writes, 'was the present possessor Mr. Snare.'

'A Letter from New York', signed only by 'G', was the jewel of the *Buffalo Courier*, a weekly column that brought pictures of the metropolis to the people of Buffalo, forty miles upstate on the shores of Lake Erie. Its portrait of city life was so eloquent and acute that one can't help wondering about G's identity; it is well known that Mark Twain wrote for the paper.

G is sending back news of the craze for art in Manhattan, particularly this spring, when the rest of America is looking at real live blossoms outdoors, but New Yorkers have to make do with painted flowers instead, which of course they believe to be infinitely superior:

New York is glowing with new pictures just now, and everybody who can see a 'brown spot' will talk of light and shade, neutral tints, perspective, Chiaro-O-scuro, and the schools of design, and style, and locate every brush to suit their know-nothingness, and impress their hearers – not listeners - with their effete decisions. They will be egotists in their criticisms and egotists in their praise. Titian, Raphael, Correggio, Vandyck, and a host of others will rest uneasily in their dusty sleep, if they were not mummified with lint in their ears.

Everybody will claim for the pictures of their painted friends, beauties and virtues which could make Michael Angelo blush in his grave to hear, if they were bestowed upon his name and these same everybodies will insist that true merit is never rewarded in this world. We wonder if there will not be a good picture gallery in the next dominion, where deserving and rejected sketches will be properly appreciated and praised? Personal interest so blinds all our eyes that we can't tell a gallot from a galleon, if it sail down the stream by our shallop.

In this vanity fair, where every painting is a Raphael, and every gallery-goer an expert, it is hard to find a true picture or a teller of truth. But G believes he has come across one, or possibly both, he is not quite sure, at the Institute.

He stands before the Velázquez with some awe. That it is the picture painted in Madrid he feels sure, but it is so much more than its subject:

It is, certainly, in many respects the most remarkable picture when viewed through a glass that we ever beheld. There is a blending of colours, and a finish that resembles porcelain. The eye when magnified has the appearance of the purest Mother of Pearl. Before this work of Art Mr Snare stands day after day, and month after month, with the gas light falling upon his darling possession – as if to do honor to the poor dead King, whose semblance is so precious only through the gifted hand that fixed his features upon canvas.

Snare tells G the story of the auction, and how terrified he was at the 'assemblage of connoisseurs, and how disgusted when it was struck down to him for the paltry sum of eight pounds sterling. He felt as if the painting had been insulted.' He tells of tracing its whereabouts from servants with very vague memories all the way to Fife House in Whitehall and the puzzle of how it found its way out of there, which 'nobody knows, and Mr Snare cares most as it is dearer to him than home'. G relates the adventures of the picture up to the Edinburgh trial, and how Snare managed to turn the tables on the Trustees. And now he has come to America, 'where he strays with his beloved Velázquez – as if it were a thing of life, and returned his devotion'.

'To see his eyes sparkle when one appreciates it, and to see them glow with indignation at a failure to satisfy with its history is worth a visit to its hiding place. A doubt as to its genuineness he receives as a personal insult, and he would defend it with his life.'

Nor will he ever sell it.

'Said Snare: "If England wants this picture, she shall possess it, but no man shall ever own it while I live. I would expire before it first."

Those who own Old Masters are keenly aware of their frailty, of the painful truth that they must be handled and transported and treated like objects, no matter how magical they may be as works of art. That responsibility does not burden the rest of us. We are free to admire without a care, to believe or disbelieve, love or loathe what we see without thinking about its flaking pigment and damp patches, the alarmingly threadbare state of the canvas or the heavy question of who painted it. We do not have to live with it, look after it or stake our reputation on its authenticity. The ownership of art in the days before more exacting forms of authentication existed than the proverbial practised eye (and even in the present, when paintings are blue-chip investments, ruinously expensive to insure) carried its evident risks, and John Snare fell prey to so many of them.

When the portrait appeared in Charles Curtis's definitive 1883 catalogue of Spanish paintings by Murillo and Velázquez, it was with the author's comment that Snare could not bear to show it in public any more since it had brought him so much trouble.

Curtis was an American scholar, a devotee of Spanish art and an avid buyer of prints after paintings by Velázquez and Murillo – the 'working collection', as he called it, on which his enormous inventory of their works was based. He gives a faithful description of the portrait of Prince Charles, so faithful in fact that one realises he has extracted it from Snare's own account in the Stuyvesant pamphlet. It is hard to believe that Curtis ever saw the painting himself. It is admitted to his catalogue, it is true, although he notes that not all connoisseurs are persuaded of its authenticity. But his own testimony takes the reader no closer to the truth of the picture.

A picture that is gradually receding from view, to the extent that nobody seems to see it – or write about seeing it – during the remaining years of Snare's life. It is not shown in public, perhaps it is scarcely seen in private by anyone but the young Arthur Brentano in the late 1870s. It is fading out as other stars are being born: the new pictures by Velázquez that are beginning to arrive in America through the auspices of dealers such as Wildenstein, Duveen and Christie.

But at least one more person saw it on Broadway before John Snare's death, and that person was his youngest child Edward.

The nameless male infant born in Reading the summer of the bankruptcy sale grew up and came to visit the father he had perhaps never met. He is there in the passenger manifests: Edward Snare, Engineer, disembarking from the *Lydian Monarch* on April 20th 1882.

If one imagines John Snare simply vanishing without a care, leaving his family in the lurch, sidestepping all duty and debt to escape, Edward's arrival argues against this. Perhaps whatever money Snare could save in New York had been going back to Berkshire after all. Arthur Brentano, in the *New York Times* article of 1903, says that some of the older colleagues at the bookshop

could remember nothing about the Velázquez, which they never saw, but they did recall Snare talking about his family back home, the sons and daughters he had not seen for decades. The kaleidoscope shifts. Perhaps it was a great sacrifice to be parted from his family; perhaps Mrs Snare asked him to leave; perhaps he was dragging the family down. One sees the intrepid son taking the long passage to the New World to find his long-lost father, determined to make his acquaintance. What did he find? Heartbreak, if nothing else: an old man in an attic with a painting he once could have sold so that he never had to work again; an old man fixated and yet faltering, who cannot quite recall his own age on the census but retains every detail of the painting.

Edward's visit prompted a singular and telling event. In early 1883 John Snare made his way to the immigration offices at Washington Square, a few city blocks down Broadway, and applied for American citizenship. He had been living in America for more than thirty years.

Perhaps there was a sense of mortality now that he was in his seventies. His children would have been liable for death duties in England if they had inherited the painting while Snare was still a British citizen; here was a legal loophole. Or perhaps Edward's visit brought dismal reminders from home, the memory of what had happened in Britain, the sense that he hadn't quite been believed and the realisation that he would never see the rest of his family again. There was nothing left to tie him to England and he had made the best he could of his life in New York, so he might as well sign up for good.

But John Snare was an American citizen only for a mayfly moment. He signed the papers in March 1883. All trace of him dies out that year.

It seems possible that Curtis never spoke to Snare at all, never actually met him in time for his hugely influential book on Velázquez and Murillo, that he was working from the pamphlet and perhaps a letter; that the picture 'withdrawn from public view' had in fact already vanished with Snare's death, disappearing along with his effects.

Except that there is one last sighting in America, and it is in the grandest possible location.

'A large picture in the west end of the Metropolitan Museum of Art is attracting a great deal of attention,' reports the *New York Tribune* of June 9th 1885. 'It is loaned by Edward Snare, the son of the late John Snare, of Reading, England, the discoverer of the picture. The face is handsome and the fingers and hands eminently aristocratic. It is evidently an old masterpiece, though connoisseurs are divided.'

In its early years, from its first Fifth Avenue home to the later building on the Upper East Side, the Metropolitan Museum had numerous exhibitions of art loaned by collectors and dealers. The museum had not yet amassed its permanent collection, but displayed Old and New Masters at these temporary shows. The Rembrandt that Snare bought at Stowe appeared at just such an event, and now here was the Velázquez.

Edward Snare had achieved something remarkable by loaning the painting to the museum, flying the flag in memory of his father. The picture had at last ascended to its rightful position in America's great pantheon of art.

If only John Snare had lived to see the day. The last person to describe seeing him alive, in the 1880s, is his former Scribner's colleague who visits him at 701 Broadway. Of the Velázquez, this man says only that it was so precious Snare refused to let it out of his sight. Of the living quarters, however, he remembers the darkness and the bleak redolence of onions; the poor man's food – fried onions on Broadway.

I searched for the physical traces of Snare's passage through life and found them nowhere. His birth certificate is gone. Perhaps he was born in 1808, for there is a baptismal record from that year; but Snare seems confused about the matter himself, giving two different ages to successive editions of the New York census. By 1880 he says he may be 'about 70', but clearly doesn't know or can no longer remember.

What did his handwriting look like? For half a second I thought I saw his signature on a copy of *Proofs of the Authenticity* in the Victoria and Albert Museum, but the names were the wrong way round: Snare John, inscribed in fading copperplate, the mark of a Victorian librarian.

Looking for the history of the lost Velázquez, I searched in the same places as John Snare, perhaps touching the same objects, looking through the same editions of rare books, certainly reading the same documents, sales guides and catalogues. But it never brought him any closer as a once-living presence. He slips through the ordinary documents – births, marriages, deaths, leaving no last will and testament. There is no record of his death, how or when he died, whether he was alone, where his body is buried. Perhaps he was given an unmarked grave on Hart Island along with New York's paupers and John Does, the city's anonymous dead.

I want to know what he looked like, but it might be too much. There could be something there to dismay. We are not our faces, or so we say, but Snare's face might carry a nuance of suffering or mania. His character is there in pamphlet after pamphlet, cause after cause, a man walking the same few streets of his neighbourhood in Reading, then London, then New York, tirelessly active; chronically striving. He is poor by the end, but still hard at it, still working.

Perhaps a face exists somewhere, a daguerreotype taken at one of the new booths on Broadway in the 1860s, or in that Gallery in the Stuyvesant Institute. Perhaps there is a *carte de visite* somewhere in New York; or perhaps it long ago ended up with all the other unidentified faces in those boxes at flea-market stalls. The Englishman vanishes into the speeding white blur of Broadway.

It may be a mercy to have no likeness of Snare, for a photograph might be too momentary or partial, too disappointing or disturbing. Faces do not always fit. Let him remain a fine mystery in this respect. Whatever he was, the totality of the man himself can never be portrayed in one image.

In 1888 Scribner's published the ninth edition of the *Encyclopedia Britannica*. Its entry on Velázquez mentions the portrait of Prince Charles. Although the painting's exact whereabouts are apparently unknown, three years after the show at the Metropolitan Museum, 'it is said to be still in America'.

The New York Times took up the pursuit in 1903. After interviewing a few surviving members of the staff at Brentano and Scribner's to no avail, the article comes to its conclusion about the painting and its owner: 'Snare was comparatively well known in this city from 1854 to 1883, but careful inquiry has failed to establish that he survived into 1884 and the fate of "The Lost Velázquez", which was certainly in his possession at the close of the civil war, and said to have been held by him in 1881, has not been learned.'

Some weeks later, a letter in response to the article arrived from one of Snare's former Minster Street employees, then a teenage apprentice, now retired to the county of Suffolk:

I never quite lost touch with his family, and I heard that he had found employment in some institution in New York. In 1883, I was in New York myself for a short time. So one day I went into a bookseller's and asked to be allowed the use of a directory. I found my gentleman's address, at the top of a lofty building on Broadway, but when I got there the bird was flown. I lost all further trace. But the question remains still: Where is the Velázquez? There is a nut to crack.

Seeing Is Believing

Where are all the paintings from the last ten years of Velázquez's life? This is an abiding mystery of his professional career. It is true that he was hardly prolific, painting perhaps only as many as half a dozen pictures a year while accomplishing all his duties as a courtier, but on his return from the second trip to Rome he seems to have painted less and less. Some paintings were lost in a fire at the Alcázar palace and it is possible that others, of which we know nothing, were once made. But the numbers dwindle until he seems to be painting only one or two pictures in the final decade, and then perhaps no paintings at all.

When Velázquez sailed reluctantly home from Rome in 1650, it was to the court of a terminally disappointed monarch. Philip's sister had died; his beloved son Baltasar Carlos had died; a plague had reduced Seville's population by almost half. The king had a new wife, and babies were beginning to arrive, but one son did not live long and another was so damaged by inbreeding that he would die, prematurely senile, in his thirties; he was the last of Spain's Hapsburg rulers. Portugal and Catalonia were rising up against Spanish rule, partly over the devastating war with France that had never let up for twelve years, destroying many thousands of lives and emptying the state coffers. By 1654, to the horror of a visiting emissary, there were days when the royal household could no longer pay for bread. And yet it is in this country, at this time, and for this court, that Velázquez would paint Las Meninas.

Royal likenesses were still required, as always, although the king was no longer inclined to sit for his portrait. Philip wrote to his confessor that he did not wish to see himself growing old through the eyes of Velázquez. The portraits, now, were all of girls in blue and silver, coral and gold, blonde hair softly waved and fixed with rosettes, or weighed down with wide wigs, rosy young faces unaffected by time and care. Vast areas of these canvases, made to promote European alliances, were devoted to shimmering silk costumes heavy with lace and brocade. They were among the very few works to leave Spain during Velázquez's own lifetime. He tried to get away again himself, in 1657, but his request was refused 'on account of the dilatoriness of the previous journey'.

Gradually he vanishes from view into his life as a courtier; and perhaps this life removes him from art. Palomino wrote, with intense regret, that when Velázquez was promoted to the position of chief chamberlain in 1652, this highest of honours was more like a punishment. 'The position is so onerous it needs a whole man to fill it and although we painters take so much pride in Velázquez's elevation, we also grieve to have missed so many more proofs of his genius.'

What we do not know, of course, is whether Velázquez regretted it himself. Some writers have suggested that he was now more concerned with the pictures in the royal collection, of which he had charge, than with any of his own. The Spanish philosopher José Ortega y Gasset even asked whether Velázquez really could be bothered to paint any more. Others have wondered if he had no choice – the administrative duties weighed upon him so terribly – or if he simply preferred the life of a courtier, by now, to that of a painter who had achieved everything he could. But in all the debates that have raged over the years, what so often goes unmentioned is that Velázquez did paint, and the few pictures he painted were among his greatest

achievements, the late fables and *Las Meninas* itself, pinnacle of a lifetime's work.

Quantity here means nothing; and just because some of these images appear to have arrived on the canvas like morning mist does not mean they were done with ease, simplicity or dispatch. The profundity of these paintings argues for the most prolonged contemplation. It is not that Velázquez disappears into the bureaucracy so much as that he disappears into extreme thought.

In his biography, Palomino quotes one parting remark as proof of the painter's rapid wit. 'His Majesty said to him one day that there are many people who declared that his skill was limited to knowing how to paint heads. To which he replied, "Sire, they compliment me greatly, for I do not know that there is anyone who can paint a head." What a remarkable reaction to jealousy in a man who had proved his *universal* command of art.' Palomino is referring to the fact that although Velázquez was employed to paint portraits, he made many other kinds of image too – tavern scenes and history paintings like *Breda*, pictures of Aesop and Mars, fables and even nudes. All of these pictures, however, are also a form of portraiture by other means. Velázquez never loses sight of the human beings in the close world around him. Real people stand in for mythical people without ever losing their essential selves.

'The Rokeby Venus', which hung for so much of the nineteenth century in a dark Yorkshire house, is Velázquez's only surviving nude: a pearly girl basking in a silvery light before a mirror that reveals her hazy face — although technically it shouldn't. Had Velázquez followed the laws of light and optics, the mirror would have shown her waist, rather than her features, but instead he presents the whole of her back, inching with infinite softness over her curves, while also giving us her unidealised face. And what is she looking at in her mirror, this goddess made mortal? Venus seems to be looking at herself, and yet also at us — it is an

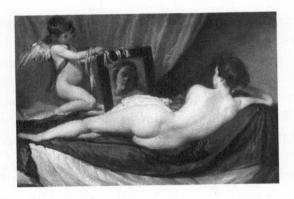

astonishingly subtle painting. You cannot find the exact focus of her eyes in the spectral mirror, and yet Venus is no mirage, but a real living woman.

It is well said that everyone will find something different in that indistinct face; perhaps she is welcoming, perhaps she is forbidding, perhaps she is waiting to find us in her looking glass. Like Las Meninas, the painting is open to all. And what further connects these images is Velázquez's acute and unprecedented sensitivity to us, to the presence and imagination of every single person who comes before the picture. It is that same open-ended connection with the viewer that one sees all the way back to the sad-eyed servant in the House of Mary and Martha at the very beginning of Velázquez's painting life.

But by now, thirty years later, his art has become nearly evanescent. The painting of Venus's body is virtually imperceptible; Cupid's back foot is barely there: and yet somehow we see it. With 'The Rokeby Venus', Velázquez has reached the point where his way of painting – close up or at a distance – is uniquely mysterious. And just as you cannot make out the all-seeing eyes of Venus, so in the work generally held to be his last, known as *The Fable of Arachne* or *The Spinners*, the image itself seems to be dissolving into an optical blur. How perfectly this corresponds with the subject of the fable, which is the creation of images themselves.

Arachne, in Ovid's Metamorphoses, is a young country weaver

whose gifts were so great they enraged the goddess Athena, the more so because she had taught the girl herself. Athena challenges her to a weaving contest. When Arachne's tapestry appeared more beautiful in the eyes of others – and Arachne shows no sign of debt to her teacher – Athena turns her into a spider.

Velázquez shows tapestry weavers in the real world of a dark but sun-warmed interior, carding, spinning and winding the woollen threads, as the foreground to a brilliant illusion viewed through a curtain in which the two protagonists of the fable are shown (Plate K). But are Athena and Arachne in the same reality, or are they figures in a tapestry themselves? The whole image, from dark to shining light, is as close as possible to a dream.

And yet this strange and spectacular painting in which Velázquez might be intimating something about himself – no teacher, no debt – is also powerfully real in its effects. The softly vaporous light, the fluttering threads, the impression of movement all through the scene, climaxing in the whirring blur of the spinning wheel: everything contributes to such a presentiment of flickering light and life, of partial glimpses and barely grasped images, that the picture seems above all to portray the restless ever-changing experience of seeing – a vision of seeing, itself.

How does the illusion appear so nebulous and yet so real? The art historian Kenneth Clark tried to identify the precise moment where the chaos of brushmarks in a Velázquez somehow coalesces into an image. He had been looking hard at *Las Meninas*. 'I would start from as far away as I could, when the illusion was complete, and come gradually nearer until suddenly what had been a hand, a ribbon and a piece of velvet, dissolved into a salad of beautiful brush-strokes. I thought I might learn something if I could catch the moment at which this transformation took place, but it proved to be as elusive as the moment between waking and sleeping.' Somewhere between waking and sleeping, between consciousness and dream: that is the effect of these final works.

Did Velázquez paint The Spinners for the king or himself? Nobody knows, but it is not to be supposed that he only made paintings on other people's orders. Velázquez had a freedom no other artist enjoyed at court; he went his own way, and was both respected and envied for it. Palomino speaks of jealous courtiers, of 'malevolent people trying to deprive Velázquez of his sovereign's grace' because there was such a palpable bond between them. Even as Velázquez was working on Las Meninas in the late 1650s, bureaucrats were vindictively attempting to thwart his attempts to become a Knight of Santiago, the noble Catholic order he had long hoped to join. Philip himself had gone to some lengths to get Velázquez in, including direct appeals to the Pope, but not without anxious prompting from the painter, who spent years espaliering the family tree to prove he had enough class to join the aristocrats. Legend has it that the king personally added the red cross, emblem of the Order, to Velázquez's breast in Las Meninas when the painter was finally elected in 1659. But X-rays do not show another hand at work. How apt that Velázquez, ennobled by his paintings far above any worldly title, should speak his quiet vindication in the silence of art.

People have argued for centuries about the meaning of this masterpiece. Some have insisted that the mirror on the back wall does not reflect the king and queen *outside* the painting so much as the portrait on which Velázquez is currently working, so that this magnificent painting of the blank back of a huge canvas is in fact nothing but the humdrum reverse of yet another royal commission, a double portrait of Philip and Mariana. The picture carries no secrets, no marvels, and makes nothing of the viewer. These commentators cannot have looked at Velázquez's art, at 'The Rokeby Venus' or *Mary and Martha*. They cannot be looking at the same painting. Pictures are their own form of evidence.

To argue that this whole scene has been conjured to show nothing more than the objective reality of the artist at work – close to the infanta and painting the king's portrait, once again, as if Velázquez was awfully keen to appear in royal company – is to go against pretty

much all the evidence of his genius. Velázquez, who was so deeply acquainted with *The Arnolfini Portrait*, who knew its ingenious use of a mirror to draw the room outside the scene, including Jan Van Eyck himself, into its depiction: it is not credible that this most intelligent of painters would have conceived of anything less remarkable. And if the mirror reflects the presence of the king and queen, so it also implies that you now stand where the monarchs once stood; that you, like they, are the watchers and the watched. Time telescopes, and you too are contained in the artist's vision.

Las Meninas is nothing without him, what is more. He is the crux of the whole painting. If Velázquez had not included himself, the picture would still be exceptional, but its emphasis would be thrown. A princess, some servants, two parents in a mirror – 'The Family of King Philip IV' (how overlooked was Velázquez even then) – but an end to that unique cycle of connections, and reversals, between viewers and viewed. Our participation, the sense in which we complete the picture, would no longer be required and the never-ending transmission between us would cease. Since this is central to the painting's complexity – and Velázquez must surely have meant to make his masterpiece as complex as he could, this meditation on art in which he finally reveals himself as an artist and a courtier, a poet and a philosopher of the human condition – the self-portrait, no matter how taciturn, how remote, is none-theless the lynchpin.

Velázquez, stepping momentarily free of the shadows with his brush, visibly declares that this world is all his, that he can make a king and queen appear and yet disappear, that he can paint both in and out of focus, so to speak, knowing that the eye shifts continually, seeing sharply only what it focuses upon for a second, and that it cannot take in the entire scene at once. So *Las Meninas* runs all the way from solid description – the floor, the walls, the coffered door beside Nieto – to the little dwarf's flurried movement on the right, not much more than a brushy blur, even to the nearly imperceptible frisson of air. The execution is a marvel, conveying

the actual movement of our eyes, while casting each one of us as part of this spectacle.

Perhaps there is a hint of the conjuror in Velázquez's self-portrait, making the world materialise and yet vanish with this wand of a brush, but to modern eyes the black-clad artist, set apart, rising watchfully above it all, sombre in his knowledge, has more affinity with Prospero, the dramatist-magician who brings the action of *The Tempest* into being and then breaks his wand at the end, revealing the secrets of his art. The secrets of Velázquez's art are all on show in *Las Meninas*, yet their mystery does not melt into thin air.

Velázquez wore the red cross of the Order of Santiago in the summer of 1660 during his last creative act (and his ultimate achievement as a courtier). This was the theatrical staging of a French-Spanish truce sealed by the betrothal of the Infanta Maria Teresa to Louis XIV of France on the Isle of Pheasants in a river between the two countries.

Velázquez was still working with José Nieto, his fellow chamberlain; Nieto organised the infanta's lodgings along the route to the French border, Velázquez prepared the way for Philip – and perhaps for the whole betrothal in a deeper sense, for his portraits of the blonde princess were said to have aroused Louis's interest in the first place. The two chamberlains were present at the betrothal, which lasted four days and for which Velázquez designed an elegant mise-en-scène inside a sequence of tents. The return journey was just as elaborate and Palomino says that the whole enterprise left him weary and low.

A few days later, on July 31st, 'a burning sensation obliged him to retire to his apartments'. Velázquez became feverish, then sick with pains in the stomach and heart. The king sent his doctor. The Archbishop of Tyre delivered a long valedictory sermon. On August 6th, at two o'clock in the afternoon, the painter died in his bed at the age of sixty-one. Palomino wrote the best epitaph: 'God created him for the wonder of the world.'

The Ghost of a Picture

It is surprising how often curious old portraits are found in places where nobody would ever think of looking for them. They are found thrown out of many houses for lumber, the name of the Artist and the Person represented being unknown; or are sold to pay debts, or to make way for the modern fashion for papering rooms. I know many houses where very fine portraits are put up to garrets, and neglected, while their places are supplied with an eight-penny paper. 2nd Earl Fife, 1798

PORTRAITS DISAPPEAR ALL through time in their untold numbers. As the people they represent leave this world, so their portraits also depart to make way for the next generation. No matter how precious they are, or once were, they cannot all be preserved in air-conditioned pantheons for the rest of time. Our museums are full to bursting, their directors protest, on being offered another donation, as if they were talking of cemeteries.

Perhaps we think it an outrage against art to abandon or cremate a portrait, and yet it is done. An English artist once installed a vast skip in a London gallery for 'the humane disposal of unwanted art' and people all over the capital came to be relieved of their guilt, their quandary and their paintings. For what are we to do with our portraits if there is not enough space in our homes, our museums, our public buildings; if the people in these portraits – and the portraits themselves – mean nothing to us any more, the

identities of the artists and their sitters lost in the tidal drift of amnesia? What if a portrait has been handed down from one generation to the next but nobody knows where it came from in the first place, why it mattered, who this pallid oval at the centre of the filthy black square might supposedly represent?

Paintings can disappear as dramatically as the people they show, vanishing into the elements by just such acts of man, God and fate. A Velázquez was lost at sea in the eighteenth century, nobody quite knows when, on a voyage to Italy from Spain. Another may have been destroyed in transit simply because it was next to a canister of mercury that shattered on a ship, ravaging the picture surface. A third, The Disciples at Emmaus, suffered not one but two catastrophes. First a fire broke out at the museum where it was hanging in 1907, destroying the Velázquez, to the grief of its owner, one Baron de Quinto. But when the galleries were sifted for evidence of arson and not a trace of scorched canvas was found. Quinto correctly surmised that the fire was a cover for theft. Several clues led directly to a Spanish shipping line to America, and the New York Sun reported that the baron had written to police there appealing for help. But he was too late. 'The vessel docked here long before the arrival of Quinto's letter, and even started on its return trip to Spain on February 7, but it sank in the East River, where it now lies.' The stolen Velázquez went down with the ship, if it was still on board; or was simply spirited away into America. Its whereabouts are unknown. But it did suffer one final fate, which the baron did not live to learn. The picture, it was later established, was only a copy.

Ships go down, carriages are plundered, railway trains crash. A Vermeer was crushed on a train between Germany and Paris. Somewhere in the English Channel lies Carpaccio's Virgin and Child. Several paintings on the way to Paris with Joseph Bonaparte were never seen again after the battle at Vitoria.

Transport companies lose track of works or accidentally dispose of them; insurers muddle them; banks mislay them. Artworks go missing when efficient records are not kept. During the Second World War records across Europe were trashed; thousands of artworks were moved, kept in salt mines, bunkers or damp cellars, burned or damaged by bombs. Some of these paintings were atomised in air strikes – a Vermeer in Dresden, a Caravaggio in Berlin – but many are still missing today.

The English Civil War, the Reformation, the French Revolution, the Paris Commune: innumerable works were punished, purged or suppressed, all verbs used at the time, and all manifesting the violence intended upon real people and here enacted upon surrogates – the kings, aristocrats, bishops or politicians who had commissioned these portraits.

Even without war or natural catastrophe, it is surprisingly difficult to discover the whereabouts of works that disappear from public view into private houses. Even at the eleventh hour, curators sometimes hear of an Old Master that hasn't seen daylight for decades and can now be included in a show. Specialists may pursue lost artworks through Interpol or the Lost Art Register, only to turn up nothing because the painting, which still exists, is in a house (or a garret) so far off the beaten track as to be beyond the sphere of the questing dealer. 'Location unknown' is the customary phrase, with the hope that this will one day be reversed.

The history of art is largely the history of the works that have survived, that people have bothered to protect. For pictures are not only lost by chance, and error, they are also deliberately discarded. Artists – and their descendants – destroy works they don't think sufficiently important because they have no money for storage and no other place to keep them. Canvases are reused out of perfectionism, experiment, thrift, or all three, in the case of Velázquez, who once transformed a portrait of Philip IV into a portrait of his niece Mariana. X-rays show the shocking ease of this transition between the grown man and the young girl with their lugubrious Hapsburg features; so do pictures disappear beneath other pictures.

The loss of a painting may be devastatingly final by water or fire. But it may be nothing so sudden or conclusive, more like a gradual fading away. Portraits lose face when their subjects are discredited, their names forgotten or their status relegated by history. Or they just become the victims of oblivion and ordinary neglect, waiting on a wall, in the stacks of a museum, forgotten among the other white elephants in the loft. We press on with our lives; and then they outlive us. One day they may turn up by accident, design or chance, their rediscovery as random or mysterious as the circumstances in which they were originally lost.

There is now on view in the Reading Art Museum a picture which possesses a remarkable history, and which will revive in the minds of older inhabitants of the town recollections of persons and events that together constituted a curious and marked sensation. The picture in question is a portrait of Prince Charles by the celebrated Spanish painter Velázquez, and it forms part of a collection of seventeen works of art, including several that are valuable, which have been kindly lent to the Reading Museum Committee by Mrs Snare, widow of Mr John Snare, who for many years in the early part of the century carried on business at 16 Minster-street, Reading.

It is the last week of December 1888. John Snare and his Velázquez have been gone from England for almost forty years and the writer of the article in the *Reading Observer* realises that his younger readers may know nothing of the picture, which he does not describe, despite the fact that the *Observer*'s offices are just across the road from the museum. The appeal of his story lies entirely with the bookseller, his extraordinary purchase at Radley Hall and their subsequent adventures together. The writer is too humble to give an opinion of the portrait and, in deference to Mrs Snare and the museum, not to mention the status of his own story, makes no mention of the auction, either.

What else was in that memorial show, as Mrs Snare might have conceived of it in respect to her late husband? No other records survive. Perhaps some of the other works were unsold relics of that auction, which had been with her (or with Snare) ever since. The writer says nothing about them, but he offers a tiny portrait of his own.

'Mr Snare possessed qualifications and characteristics that made his shop the resort of many besides the ordinary run of mankind, who often came as much out of curiosity and for friendly intercourse as to make purchases . . . He gratified a taste for high art until he came to be regarded as a local connoisseur and to possess paintings that made his shop a sort of semi-art exhibition.'

This is the nearest thing to an obituary Snare ever received.

One marvels at the loyalty – or the continuing resourcefulness – of Isabella Snare, a woman forced to fend for herself and her children for decades without a husband, lumbered with his paintings, including the portrait of young Charles that she might have hoped never to see again. What was she to do with them? Like the widows of artists and collectors throughout history, she finds herself burdened, with nowhere to hang them, nowhere to store them. So she lends them to the local museum, conscious of their worth, and gives the local paper some words about Radley Hall and the Edinburgh trial, plus one of Snare's pamphlets to fillet for tips on Velázquez. These appear almost verbatim in the article, which concludes with an odd abruptness: 'Mr Snare carried his picture across the Atlantic and exhibited it in America, where, we believe, he continued to reside.'

'We believe' seems such a strangely qualifying remark.

Isabella's tale is one of bravery and sorrow. She was in her early thirties when Snare sailed for America, leaving her to raise four children alone, one of them perhaps no more than a baby. After the 1849 auction, with every last fitting sold off in full view of her entire social world, she moved from one Reading address to another, relying on the kindness of her side of the family. In 1861 she found a perch

with her father Thomas, a retired banker, at Southcote Lane; perhaps it was he who found work for both of Isabella's sons. Howard worked as a clerk, Edward spent three years at Simonds' Bank, a few yards from the old Minster Street shop. He also lived on and off with Isabella's brother, Bossom Williams, a London clerk whose several short-lived enterprises included importing cigars from Havana.

The family moved one last time, to a detached house in the village of Hurst outside Reading in the 1870s, but by then Isabella's eldest daughter Margaret had died, and her youngest daughter Jessie passed away in 1880; both were carried off by nameless illnesses in their thirties. Edward had to carry this sadness to his father when he sailed away to New York.

The final history of the Snares in England emerges in fragmentary details. Howard was taken ill during a visit to Norwich in 1891 and died after 'a very few hours', according to the inquest. He was in his fifties. A few months later exactly the same thing happened to Isabella Snare on a visit to her niece in London in 1891. She was gone within a day, having endured the deaths of all of her children except Edward.

Edward Snare's life was one of infinite trouble. His exact career is uncertain, except that he did not last long at Simonds' Bank, or in his next job with the Civil Service. In the 1881 Census, he is lodging with his uncle in Deptford, describing himself as a 'Colonial Engineer', but the following spring he has set sail for New York. He cannot have stayed long (it is not clear how the painting came to be in the Metropolitan Museum, or how it returned to England) for he is soon off to Africa to find work as an engineer. On his return Edward seems to have lost himself to drink. Although he inherited money from Howard, he must have gone swiftly through those funds and whatever Isabella bequeathed him in 1891, for he was reduced to selling off the Hurst furniture soon after her death.

Edward remained rootless and restless, wandering between Hurst and Reading. And it was in Reading that he was charged, more than once, with being drunk and disorderly and failing to turn up at court for the proceedings.

On a January afternoon of 1897 Edward was drinking his way between Minster Street and Castle Hill. The inquest tells a desperate tale of a falling-down drunk, his eye black from hitting the pavement, rambling on about the kindness of the folks at the alehouses, rescued from the freezing night by a passing stranger who somehow persuades a local landlady to take him in. A bowl of mutton broth, a blanket, and then death must have occurred sometime between 7 and 10 p.m., when the landlady went up to check on him again. Edward Snare was forty-eight. The good woman weeps: 'poor soul, he did not take care of himself'.

Bossom Williams, at the inquest, is very sure that his nephew was of 'ample means'. But this man who had once lent a painting to the Metropolitan Museum left only a modest sum. Edward's executors were the Hurst neighbours – one of them a printer, as if for old times' sake.

There is no mention of the Velázquez in Edward's will, and neither he nor any of his siblings married or had children. Bossom Williams does not seem to have inherited the portrait; he died two years later in London, leaving only £60 to divide between his spinster daughters. So where was the painting?

In 1890 Isabella Snare put some of the pictures from the Reading Museum exhibition up for sale. But the Velázquez was not among them. It passed to Edward, who did not sell it either, even in his hour of need, flogging off the furniture at Hurst. That it was in his possession when he died is borne out by a story in *The Times* of July 1901, which says that 'the Velázquez' had been offered for sale in 1898 'by the order of the executors of the late Mr Edward Snare'. How it came into their hands is not clear, since it was not in his will; it seems that the picture did not sell.

There is one last mention of John Snare in the press. *The Times* was running the story about the Velázquez to advertise a final sale, 'A Collection of Pictures By Old and Modern Masters formerly belonging to the late Mr John Snare of Reading shortly to take place at Willis's Rooms in St James's Square in Mayfair'.

In the list of works going under the hammer are some old friends from the Minster Street auction in 1849, including the girl in the bonnet. But Velázquez's portrait of Prince Charles is not there.

16 Minster Street is gone, pulled down in the 1930s to make way for new shops. So are the tall buildings on Broadway where John Snare once lived, every single one gone; and all of the places in New York where he worked. There is no grave. There were no direct descendants to pass on the tale of his life, no grandchildren to inherit the portrait.

The last, unconfirmed sighting is the 1898 auction when the painting remains unsold; and surely returns to the place where it has been sleeping for a decade already: the vault of a bank, the bank where Edward once worked, where Isabella perhaps kept whatever money they had left – Simonds' Bank in Reading.

The portrait is turned to the wall and left to decline. Perhaps it lies there for years, from the time of its return to England to the late days of Edward's ruin, his mother's death and then his own in the harshness of winter. It is casually forgotten, at first; and then one by one they are all gone. There is nobody left to remember.

Woodworm chew their way through the frame, moths lay their lethal eggs on the picture. Mildew creeps slowly across the image, while the paint gradually changes colour. Damp clouds those mother-of-pearl eyes. The canvas sags. The portrait decays.

Simonds' Bank was sold to Barclays in 1908. The lingering contents of the vaults may have been disposed of, it is true, or they may have remained exactly where they were as the owners changed hands. Barclays simply swept up the business, and the customers, and kept on going for another century, until the King Street doors finally closed in 2008. There is no record of the picture.

Unless it escaped this fate and is still out there on a wall somewhere in the world, handed down through some other family, its name decoupled from that of John Snare. Perhaps someone is walking past it even now, without noticing it at all. Or maybe

nothing remains of it except the tantalising trace of its long-ago existence in words. This dream of a picture that cannot be seen, what was it after all?

The loyalty of the Snares may prevent us from knowing. For nobody ever let the painting go. Every successive member of the family to whom it passed, from Howard to Isabella to Edward, faithfully honoured Snare's own words in *Proofs of the Authenticity of the Portrait of Prince Charles* all those decades ago:

The picture is not for sale, and the reader will excuse me if I take this opportunity of publicly announcing my intention to retain it. It has to me a value that to no other person it could possibly possess. The manner in which I procured it was extraordinary – the means that enabled me to establish it are no less curious. I have laboured hard and suffered something to make the world appreciate its worth. My feelings and my pride render the object dear to me. Could I part with this, it is not in the fortune of a life to discover such another. Humble as I am, I cannot help acknowledging a sense of triumph when I look back upon the history of this work.

The position of the feath of the position of t

The person of companies and a contract of the contract of the

An Infinite Number of Charleses

Some months after I first came across John Snare's pamphlet in the library, the dust shimmering and shaking on its desiccated pages, I went to visit the only other person, to my knowledge, who had ever written anything about him. Diana Mackarill is a historian in the Centre for Ephemera Studies at the University of Reading. She specialises in typography and had published a brief but elegant pamphlet about this local man, illustrated with fine examples of his printing. But she warned me against pursuing Snare any further. Too much of her time, she darkly observed, had been lost trying to unravel the tangled threads of his story.

We sat drinking coffee a few yards from Minster Street, pondering Mrs Snare's humiliation in the face of the family lawsuits and the bankruptcy auction. Neither of us had discovered what happened to the printing presses, unmentioned in the catalogue, and she too believed that Snare had spirited the painting to America to escape the auctioneers.

Of its current status Mrs Mackarill was certain: the painting was gone, and the publication of her pamphlet in 2007 had prompted no further news of it. No relatives had come forward; nobody claimed to have seen it. I asked whether she had ever wanted to see it herself. 'Oh, but I have,' she said, causing my heart to turn over at the thought of some long-ago sighting. 'It is all described in that big American book by Charles Curtis. I don't need anything more.'

But I needed more. In those days I wanted to see the painting all the time and not just out of native curiosity or the chance, however small, of setting eyes on another Velázquez. I didn't know what to think about Snare himself. Every new discovery tilted the balance: did he really know what he had, and what *did* he have? The questions were fused. To believe in Snare meant believing in his portrait, too, or so it seemed to me at the beginning; and later, as more of his struggles emerged, it seemed just as important to see what had caused so much suffering. The painting would carry the truth.

In all the time of searching for Snare I was looking for the painting too, of course, and always in a state of ready hope. It would be just around some corner, its location revealed any day now; and when I could not find the actual canvas, I naturally assumed there would be a print; and if not a print, then surely a catalogue reproduction; and if not a catalogue, then surely a photograph in a newspaper or book. Only when nothing turned up did I make an appointment to go to the very place where I might find a ghostly trace of the painting, and perhaps even of John Snare. But I went in a state closer to dread than hope. What if there was nothing – or something far worse?

In a back alley in the heart of London is a library of faces. Discreet and hushed, with old-fashioned index cards and heavy box files, it is not much visited except by the staff of the National Portrait Gallery to which it belongs. The purpose of this place is to keep a photographic record of all the portraits of notable Britons ever painted from the life – every one of them, if possible, from the masterpieces in public museums to the portraits in private houses, people's attics and even their caravans. Everyone who matters, by anyone who ever painted their portrait: it is a valiant, if never-ending enterprise.

Battalions of green boxes, A–Z, hold more than a million photographs stretching back to the dawn of the camera age. Each represents more than a face, and more than just a painting, for time's passage is also measured in these photographic images. Here is a daguerreotype

of Holbein's *Thomas More* as the portrait used to look in 1860, that acute face dimmed by three hundred years of grime. Here is Joshua Reynolds's *Dr Johnson*, once robust, but already disintegrating when the photographer stood before it a century later. Calotypes, talbotypes and sepia photographs made using enormous box cameras show how works of art once looked, uncleaned, to the people of the past. And in some cases they are relics of lost paintings, too, images of works that have long since disappeared.

It is a black-and-white world – "This mechanical souvenir cannot do justice to my painting's *brilliant* hues," writes one frustrated collector on the back of the Edwardian photograph he has submitted – although there are occasional forays into colour. A Seventies snap of William Shakespeare shows the Bard in a flaring orange Polaroid; not that the subject looks anything like the portly egghead of the First Folio engraving in any case. No, this is a far better Shakespeare, a suave and handsome adventurer with luxurious hair: not William Shakespeare, but Walter Raleigh.

The guesses of hopeful owners - and the terse corrections of curators - are inscribed on the back. These identifications are a combination of aspiration, scholarship and comical error. For every photograph taken by a specialist, and meticulously attributed, there is another by an owner who believes that his or her heirloom deserves a place in the library, even though the subject is not really Shakespeare, Raleigh or any other British notable, but some anonymous woodenfaced ancestor. The library rules are rigorously democratic. If you believe you have a contemporary portrait of Elizabeth I, then your photograph goes into one of the boxes devoted to Gloriana, no matter how poor the painting or how far-fetched the guess, if there is no other candidate for identity. An exasperated curator may be quite sure this is some other redhead in a farthingale, but must still file it under E I if no other name comes to mind. The library is a tremendous assembly of portraits, but it is also a portrait in itself, of people's dreams and delusions as much as our affinity for painted faces.

In this great repository of photographs, Shakespeare to Cromwell,

Charlie Chaplin to Tony Blair, the hardest subject to bring into focus is also the one who turns out to require the largest number of boxes in British history: King Charles I.

Charles is filed first as a boy with big eyes and an unformed face, easily confused with his older brother Henry, who would have been king had he not died at sixteen; so easily confused, in fact, that several photographs actually show portraits of Henry. Here's the young Henry with a candy-striped stick, or is it Charles? Here's the young Charles in a perky hat, or is it Henry?

With Henry's death in 1621, that confusion ends, but still there are so many portraits of the future king they have to be classified by facial hair. The boxes are labelled 'Charles Without Moustache' and naturally 'Charles With Moustache' (but only from the age of nineteen to twenty-four).

Sometimes this moustache is so puny it looks more like a trick of the light, particularly in shadowy old photographs, so this seems an unreliable criterion. But facial hair has a secondary function, which is precisely to divide his princely life in two, for the next file heralds the dawn of the figure we know and recognise: 'Prince Charles With Beard'. He went to Spain without a hair on his chin and came home, one contemporary writer noted with surprise, or perhaps affront, given the expense of the adventure, 'full of gaiety and now bearded'. This beard is a proper Spanish beard, what is more, elegant, pointed and dark. It is exactly like the beards in Velázquez.

Here is the first place where Snare's picture might be filed. But not a single photograph in 'Charles With Moustache (19–24)' shows a portrait that looks anything like his account of the Velázquez.

After the Spanish Match, the images run wild. There are tens, twenties, hundreds of different portraits of the king in silk with his pearl-drop earring, with his wife, with his children, at Whitehall Palace or Hampton Court, on horseback or out on some Civil War battlefield. There are novelty portraits in stained glass, wax and porcelain. There is an anamorphic head, and a sketch made inches

from the king during his final trial; there are even paintings of the execution – anti-portraits, you might say – and one showing the head ghoulishly stitched back onto the body. There is even a drawing made on the spot as the corpse was exhumed 165 years later, the skull still patched with a wisp of that famous beard.

What did Charles I really look like? He has the face of a B-movie actor—almost handsome, strangely anonymous. As a beardless young man, his appearance is so amorphous that some of these large-eyed youths could be almost anyone—a point irritably noted by several curators. The Spanish beard was the making of him as a prince; and later on, in a more literal sense, so was the arrival at court of Van Dyck. For all these different Charleses eventually converge into one consolidated image: the long-faced, sad-eyed, silken-haired sovereign created by the Flemish artist.

If ever a painter could be said to have invented a look, and not just a style, it was Van Dyck. This look was his lasting gift to English art and perhaps to English people as well. For you can still see it everywhere, that particular air of nonchalant self-assurance, somewhere between detachment and languor, which protects and glamorises the bearer: the essence of cool. You see it in the soaring portraits of Cavaliers leaning carelessly against classical columns in their golden jackets, or throwing a glance of penetrating indifference in our direction. You see it in those aristocrats effortlessly calming their nervous dogs and, above all, in Charles sitting back in his chair, finger to pensive temple as if he were not just a king but a philosopher, too, urbane, profound, contemplative.

Van Dyck knew how to flatter. But he can't seem to stop himself from subverting all this glamour with strange, contradictory details. It might be a faint sheen of sweat, a flaccid glove or a sharp thorn tucked into a swelling bodice. Oddest of all is the famous triple portrait of Charles. On the right, in three-quarters, the king is a suave Cavalier with an earring. Front on, he is the highbrow scholar-soldier he wished to be. But on the left, he has the weak profile of a vain dilettante. This portrait was sent to Rome so that Bernini

could carve a bust from the likeness. Even he, the biggest flatterer of all, couldn't quite eliminate that note of decadence.

Like Bernini, Van Dyck was a workaholic. He painted in every genre, made thousands of etchings, produced portraits of entire families within days. His London studio was like a Harley Street waiting room, the rich and famous queuing for a session with the cosmetic surgeon. But what is so often missing in his portraits is a sense of anything beyond the present. They have no moral dimension, no deep empathy with the sitter, with his or her unique character, or sense of life, ticking away towards death. Van Dyck cannot compare with Velázquez for spiritual or emotional depth. His gift is for speed and motion, for sure-fire acuity, for catching the moment on a wing. He died at forty-two, most probably from overwork, just before the glittering society he portrayed was obliterated by war. The proof of that workload is there in these boxes of photographs: portrait after portrait of Charles.

I opened each box devoted to Van Dyck and his many followers with increasing ambivalence. Snare's painting appeared in the Radley Hall catalogue as a supposed Van Dyck, and some elements of his description made it sound like a Van Dyck, too – the armour, the baton, the battle in the background (although there is also one in Velázquez's *Don John*). Snare believed the portrait was too early for the Flemish painter, but he might well have been wrong. And Velázquez only painted Charles once, whereas Van Dyck had painted so many portraits, and had so many imitators, that the likenesses multiplied towards infinity. They are still turning up. Snare hadn't just hit upon the commonest of royal subjects, so to speak; he had hit upon the most prolific and imitated of royal painters. The odds were against Velázquez.

They were also against Van Dyck, to an almost farcical degree, for the owners of the paintings in the files. Time and again the curators correct some optimist who believes he or she has a genuine Van Dyck when in fact it is a Honthorst, a Mytens, a copy by one of those Stuart painters of whom we know so little, or not a portrait of the king at all. If Van Dyck had actually painted all the portraits of Charles attributed to him he would have died much sooner.

Miss Daniell has one at 2 Poplar Avenue, Hull in the 1920s. There is one in haunted Glamis Castle. Lord Grantham has one (the real Lord Grantham, though his *Downton Abbey* counterpart also has one in the dining room). Major Spearman in the German Section of the Foreign Office acquires one at the end of the Second World War (one wonders how), just as Herr Wilhelm Kraushaar is sending his implausible submission all the way from Berlin. Two ladies from Surrey turn up in the Sixties with a photograph of their family treasure and are most politely, if sadly, undeceived. It is only a copy of a Honthorst.

Van Dyck's majestic coronation portrait of Charles in velvet and ermine crops up time and again. There are not half a dozen copies, but a stupendous sixty-three. The image breeds. After this muddy torrent, you long to see the clear original, but it was lost (along with Bernini's bust) in the fire that destroyed Whitehall Palace in 1697, all except for the Banqueting Hall outside which Charles was executed.

Sifting through all these images for Snare's portrait is like looking for a missing person in the police files. Not this, not that; too dark, too old, too ginger, too young, too Spanish; no beard, nothing like Velázquez, nothing like Charles. Despondency (and relief) sets in. There are many hundreds of photographs and not a single one of them matches Snare's description. There is no trace of his painting, or any other candidate for the lost Velázquez.

But there is something else. One of the green boxes bears an enticing label. 'Charles I – Miscellaneous, Wrongly Named, Made Up'.

'Made Up' can mean entirely fantastical – the king out hunting for a unicorn – or just worked up from the imagination. The painter has never set eyes on his subject and is either trying to conjure a portrait out of an etching – putting flesh, as it were, on the bones of a drawing – or extrapolating from some earlier image. But there is a third, and more intriguing way, of making things up.

Van Dyck once painted a portrait of Charles I dictating dispatches to his secretary on the battlefield. The secretary is using a military drum for a desk, while the king is receiving a pen from his son. There is a photograph in the library boxes. And then there is another that looks exactly like the original, except that the drum is missing; and then another, now minus the secretary. The portrait is copied again and again by anonymous artists and each time something else changes: the pen becomes a pair of scissors, the scissors become a knife, which shrinks to a penknife and eventually disappears. There is even a version that omits the son, so that Charles is reaching pointlessly into thin air.

These copies were made to order. The proof is on the back of the photographs. 'This portrait was made up for Sir H Grimston, based upon a head by Van Dyck.' 'This painting' – of Charles with orb and sceptre, a madly popular format – 'is a combination of two full-length portraits, made specially for the owner of Kingston Lacy.'

Such fabrications are taken to a violent extreme when existing portraits are tailored to the buyer's taste, an unlovely backdrop cut out, an extraneous hanger-on edited from the scene. Some portraits are even botched together out of more than one canvas: the stylish figure from a Mytens (master of textiles) topped with a Honthorst head. Most bizarre, and hilarious, is a hybrid in which a head based on a Van Dyck has been superimposed on a portrait of Charles's nephew, Carl Ludwig, the Elector of Palatine. The point of this project is not immediately obvious, although it does give the uncle some swanky new blue velvet clothes. Presumably it was made for an ardent royalist who wanted to recycle a serviceable Carl into a romantic new Charles, but the effect is perverse: the head doesn't fit on the neck and, like Frankenstein, all the joins show.

Countless portraits have been customised down the centuries to satisfy their owner's whims. Legs are cut off, faces – or hands, in the case of Archbishop Valdés – hacked out and framed by themselves. It happens to Velázquez as well as Van Dyck; those generational

portraits of Philip IV, his parents, wife and son in the Buen Retiro were pruned and bent to fit the architecture of the main hall: a family tree, as it were, ruthlessly espaliered in the artist's own lifetime. His late portraits of the king's daughters have grown larger – extra strips of canvas added so that the girls stood in grander royal spaces – just as they have shrunk, trimmed to give a greater focus to the face or figure to entice a potential suitor.

Snare's portrait might have changed size or shape, like so many others. It might have acquired new elements or details. For there is another way to make up a painting, to fictionalise its appearance, and that is simply to take a brush and adapt the original.

The witnesses at the Edinburgh trial could not agree about whether the whole portrait had been painted at once, or whether some areas had been added later. Perhaps its style or identity was altered. We already know that this has happened to at least one Velázquez, the portrait in the Metropolitan Museum.

There may be no exact candidates for Velázquez's Prince Charles in the library and there are none on the Web, that true infinity of faces, but there are two boxes of portraits by Van Dyck showing Charles I in armour. They are divided thus: 'With baton in hand and the other or opposite elbow resting on a helmet'; and, more saliently, 'With baton in hand, and the other or opposite elbow resting on a globe'.

This globe makes the world of difference, for it is extremely rare among the prolific portraits of Charles I. It is not a geographic globe, but a glass sphere, a mysterious and spectral object that has the appearance of a mirage or shadow. Van Dyck's original was destroyed long ago, but a contemporary copy made in his studio exists, suggesting that it was in demand even at the time, so perhaps there were several others out there in the world. What if one of these was customised later on – the curtains, the distant scene?

Or what if some other portrait altogether had been overpainted with a ghostly sphere?

How cruel it seems even to suggest that the picture might have

been a Van Dyck (or worse, a copy of a Van Dyck) adapted for someone's private purposes; yet Snare thought along these lines himself. Writing about the red and yellow curtain that he believed to be emblematic of Spain's national colours, he remarked that "The drapery can in one place be made out to have been laid on after the arm, which its folds partially conceal, was finished. These accessories were therefore an addition, introduced in compliance with some suggestion thrown out after the work had been in a great measure completed.'

This drapery is there for a reason, according to his self-fulfilling logic. The Spanish colours were irrelevant before Charles went to Spain, and irrelevant after the failed Match, *ipso facto* they must have been painted in Spain. (Perhaps they were added by one of the studio assistants, even Juan de Pareja.) Why else would there be Spanish colours?

One obvious answer is that the canvas might have been doctored to look like the great desideratum itself – the lost Charles by Velázquez. Another might be that the painting was actually Spanish, and showed a Spanish nobleman until someone gave him a new face and transformed him into an English prince.

The awful possibilities begin to ramify. It was a doctored copy of a Spanish portrait; it was a doctored copy of Van Dyck's Charles with baton and sphere; it was something else altogether – the scarred and degraded relic of Snare's dream, the Velázquez that never was.

I left the library downcast, and yet relieved. To see the portrait would have been to see Snare himself, to know the truth of them both. Now one part of his story could remain open.

For all those nineteenth-century people who *did* see the painting, and in some cases actually met the man too, could not agree about the nature of either. To those who found it easy to sneer at this 'amateur of pictures', in Stirling Maxwell's words, Snare was quite likely a shyster, relying upon the fact that nobody could prove, once and for all, that his picture was not a Velázquez.

A silver-tongued tradesman with a gift for publicity, as the *Fine Arts Journal* has it, he hustles for money, touring the Velázquez wherever he can, betting the business without a care for his family or staff. He is too pushy, talking up his picture at every opportunity, the printer forever printing the latest news of his treasure. He is obsessive, riding his hobby horse, as the Edinburgh lawyer had it, to the point of destruction. He can no longer see anything except his Velázquez, he loses all sense of the world. He is blind; he is mad.

For only a madman would refuse to sell the picture when the going was good. He could have taken Colonel Blagrave's offer of £1,000 in 1847 and never found himself in trouble in Mayfair; in Mayfair, he could have accepted an offer from the Duke of Norfolk of £3,000 in 1849. What hubris it was to refuse, so says that former Minster Street employee in his letter to the *New York Times* in 1903; but it was only hubris if a bookseller was not allowed to own such a painting. Why would he – why would anyone – want to part with a Velázquez? Is there no conceivable world where art might come before money?

And then again, so many people believed that the portrait was by Velázquez during its brief visibility, from Miss Mitford to the collectors who tried to buy it in Reading and London; from the Conde de Montemolin, who had grown up in the Spanish palaces surrounded by Velázquez's works, to the painters, dealers and restorers at the Edinburgh trial; and the scores of writers and editors in the British and American press. It is a marvel to them all, the finest picture ever beheld, with its mother-of-pearl eyes and its wondrously spectral paint. There are the greys, greens and silvers of Velázquez's paintings; there are the tones that seem to glow, mysteriously; there are the airy transitions and, above all, the old mystery of Velázquez's art: how on earth has it been made?

Is it possible that the portrait had some genetic trace of Velázquez – that the miraculously fluent likeness so quickly made in Spain was brought home to England and laboriously overworked by other hands? Or was it another instance of that curious nineteenth-century

phenomenon, a painting that has been altered, made up, transformed into some other painting?

If only there was a photograph of Snare's portrait, we could see whether it carried something of Velázquez, or nothing at all. It would allow us to see what he saw, what he revered, above all what he truly loved – I believe in his sincerity – this work of art that wrecked his life. If Snare had lived in another time, he would undoubtedly have sent a photograph and a copy of each of his pamphlets to the National Portrait Gallery library. But the library, in all its vastness, is necessarily limited. It opened its doors too late for John Snare.

The last thing I ever discovered about him was a tiny mention in a New York magazine in the late 1870s. He is to receive a diploma for drawing on glass. In his final years, Snare is studying to become an artist.

About the painting, the last thing I discovered was this. In all of his searches through the old documents and books, his fanatical investigations around Soho, his appeals to anyone ever likely to have encountered the painting, handled, cleaned or owned it, it never occurred to John Snare – or to anybody else in this tale – to look anywhere else for the lost portrait of Prince Charles. Snare did not do so, of course, because he believed he had it. But it turns out that others, especially those involved in the Edinburgh trial, had no such excuse.

Everyone believed that the portrait had once belonged to the 2nd Earl Fife – this was central to Snare's theories – so it was vital to establish the truth of the case. But the more I searched, the less likely it seemed; until one day I came upon a book by a Victorian poet that brought a bitter conclusion to one part of Snare's story. For it turns out that the painting he bought that autumn day so long ago was not the curious portrait that once hung in Fife House in Whitehall. It never was the 2nd Earl Fife's Velázquez, which is neither lost nor destroyed. That portrait still exists.

Lost and Found

DUFF HOUSE STANDS by the shores of the cold North Sea near Banff, solitary, remote and magnificently out of place, a Georgian palace beached in a seaside landscape. Bright waves are visible from the uppermost windows. It is the most isolated of all the grand designs dreamed up by the great Scottish architect William Adam, and might have been grander still if he hadn't fallen out with his client, the 1st Earl Fife, over the cost of cutting limestone for two further wings.

This is where the 2nd Earl Fife was raised as a child, and where he later married unhappily – so unhappily that he and his wife Dorothy separated as soon as they could, though not before she had tried to kill him with a rifle in the Long Gallery. After the shooting, the building was partitioned so that husband and wife would no longer have to meet.

Duff House is where the earl kept good company with his guests, Edinburgh intellectuals and London politicians, and with the people who worked for him too, the grieves and factors, foresters and ploughmen who farmed the estate, the cooks and maids who ran the household during his long absences in London. The building was open to all-comers even while the earl was away, a tradition maintained long after his death. Which is how a Scottish poet on a walking tour of the neighbourhood in the summer of 1843, happening to knock at the servants' entrance, found himself warmly welcomed into Duff House.

Alexander Harper was following the River Deveron from its source to the sea, in the manner of Wordsworth and Coleridge walking the Lakes. He had the cunning idea of selling his romantic ballad – 'Summer Excursions in the Neighbourhood of Banff, by a Deveronside Poet' – as a tourist handbook by other means, combining this long and elaborately rhetorical poem, which celebrates every species of flower and bird along the way, and practically every blade of grass, with a useful guide to the local monuments and, in particular, the paintings in Duff House. The volume is humbly dedicated to the current owner, the 4th Earl Fife.

The housekeeper takes Harper's coat and gives him a tour of the rooms. He sees paintings by Brueghel and Holbein, is moved by a Murillo saint, seduced by Joshua Reynolds's flirtatious portrait of the beautiful actress Mrs Abington, charmed by some cows drinking by a river, possibly Dutch. He is shown a head of Charles I, 'exhibiting an indescribable look of majesty combined with melancholy'. It is the classic Van Dyck formula, and sure enough this is a genuine Van Dyck.

Here are all the Tudor and Stuart portraits, here are the paintings of the Duke of Buckingham and his family, of Sir Kenelm Digby back from the Spanish Match, of the actor David Garrick in the role of Hamlet. At the top of the stairs Harper even encounters the portrait of Mary, Queen of Scots admired by Thomas Pennant. In short, he sees the 2nd Earl's collection of paintings

just as he listed them, one by one, in his 1807 catalogue and just as they were sent up to Duff House after his death.

And it is here, in a room off the vestibule, in the year 1843, that the poet comes face to face with the Fife Velázquez.

The old housekeeper, who has been in charge since the turn of the century and has taken many a visitor round these crowded walls, has trouble with these Spanish names, pronouncing Murillo as Molière, but she tells the tale of Velázquez painting the prince's portrait on the farcical trip to Madrid. Harper makes a note: 'The portrait of Charles when a prince, said to have been made when he was in Spain, a suitor for the hand of the Infanta'.

What he sees is a portrait of compelling intensity. There is no armour, no baton, no vague background scene, nothing to distract from the prince himself, dressed in brownish-black, with 'a singular look'. This is the painting mentioned in the letter to Pinkerton, the 'curious portrait of Charles I, when Prince of Wales, painted by Valasky, at Madrid' (Plate M).

It is exactly the right size, what is more: the three-quarters canvas of the 1807 catalogue. This is not John Snare's painting at all; this is the 2nd Earl's Velázquez, a painting not lost or stolen or surreptitiously abstracted, but hanging right here in Duff House, visible to wandering poets as late as 1843 when Harper published his book.

It is just as well that Harper was so meticulous – his own catalogue of the paintings runs to reverential length – because his account of each painting and its exact position in Duff House precisely matches those of two writers who visited sixty years later. Both encountered the portrait of Charles when Prince, painted by Velázquez, in the very same room off the vestibule. It had remained in exactly the same place in Duff House in the far north of Scotland from the 2nd Earl's death all the way through the nineteenth century – long after the story of John Snare – right into the twentieth century.

The writer K. Warren Clouston is visiting Duff House for *The Connoisseur* magazine in 1904. She gives a strong account of the architecture, as well as the famous visitors who have stayed here,

including Dr Johnson, James Boswell and Robert Burns, but her true interest is the art, in particular the Velázquez. She runs through the Spanish Match and Pacheco's account of the picture and fervently agrees with the 2nd Earl's belief that this is indeed the missing portrait:

It represents him as fuller faced and more voluptuous looking than in his later pictures, when his vacillation and vicissitudes had left him thin and melancholy. However unfortunate he was in other respects, he was most fortunate in the artists whom he chose as his portrait painters, and whether we see him in the flush of youth, as in this stately portrait, or worn out by trouble, as he is represented by Van Dyck's head in the Ante Drawing-Room, we shall be of this opinion.

Katherine Warren Clouston died before completing her article. Her sister, M. Crosby Smith, revised the work and then published her own account of Duff House the following year. She describes the Velázquez as 'the jewel of the collection' and 'worth a king's ransom'. It sounds like another strain of old art praise (albeit now informed by a sense of Velázquez's market value) that tells us nothing about the portrait. But what makes these articles so significant is that there are not just words on the page, but reproductions too.

Here, at last, is the portrait.

Charles is very close: so near his painter that one can easily imagine them breathing the same air. The picture is startlingly intimate. It shows a young man with girlish eyelashes and narrow shoulders, not quite at ease inside the stiff husk of his lavishly embroidered doublet, which seems slightly too large for his body.

The same light that ignites this embroidery, twinkling across the golden threads, exposes the feint sheen of his high forehead. The nose is rounder than the elegant nib Van Dyck would give him, and his eyes have none of that melancholy, although they are heavily lidded. His beard is new, a fledgling growth that doesn't quite obscure the roundness of his chin, and his features are not

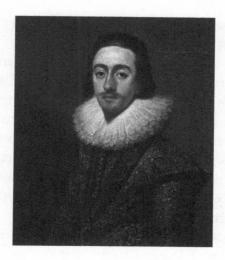

fully formed, either. He is recognisably Charles, but you can still see traces of his father's hollow eyes and his mother's long face, as if he had not quite overcome his parents to become his own man. He appears in indeterminate space.

The portrait is as precise as a snapshot, capturing the exact moment in the prince's life between acquiring a beard and growing into the heir who will one day be king. Mrs Clouston is right that he is fuller-faced, that he does not have the air of vicissitude one sees in the later paintings, or the hauteur of a king who believed in his divine right to rule, his royal prerogative to bypass Parliament whenever he wished, to levy taxes without anyone's consent, to account for himself to God alone, in his notorious phrase, and who went to war with his own country.

He is far nearer, here, to the young prince with the Scottish accent who was gauche and irresolute, according to those who knew him, and who would have to work hard to transform himself into the Cavalier with which his name and those of his supporters are associated. But nor is he quite the awkward boy with the downy upper lip who had set off for Spain with his father's favourite courtier under a false name, poorly disguised, imagining that he might come back with a Spanish bride. The portrait shows the

exact mid-point between these two periods, as if it might well have been painted in Spain; and there is more.

Charles has a Spanish beard. He wears a Spanish collar. His brownish-black dress is Spanish, remarkably like the dark doublets embroidered with metallic thread worn by the king in Velázquez's portraits; indeed, it is almost identical to the costume in *Philip IV* in *Brown and Silver* in the National Gallery. It would be perfectly reasonable to imagine – to believe – that this portrait of Charles in Spanish costume, with Spanish beard, might have been painted in Madrid; and if so, who else could have painted it, and with such penetrating insight, if not Velázquez himself?

It is not at all surprising that the 2nd Earl Fife believed he had Velázquez's portrait of Prince Charles, nor that all the writers who saw it later thought the same thing. It is a tremendously sensitive and subtle painting, and it narrows the psychological distance between Charles and the viewer to such an extent that one feels his human presence before his royal status; the painting has profundity as a trait.

But there was one more reason for these people to think the painting might be a Velázquez. The portrait they saw did not look as it does in this book. In those days it looked like this:

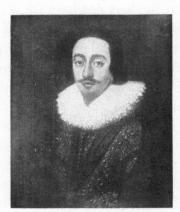

This is the photograph that accompanies Mrs Clouston's article. There is no golden light, no background space; the painting is dark, the features are heavy and the hair is black as tar. Murkier still is the portrait in the photograph that illustrates her sister's article, which presents an even more degraded Charles.

This image shows a canvas that has been almost poorly overpainted by some duffer with a brush, the hair a rigid black helmet, the beard sharpened and darkened, the eyebrows shaped as if plucked. The face is now a pale egg, defined by the dirty hair. Just like the man in the Metropolitan Museum, 'improved' by order of Joseph Duveen, the portrait has been made to look more like someone's idea of a Velázquez back in the eighteenth century. Charles has been Hispanicised.

Mrs Warren Clouston and Mrs Crosby Smith were only just in time to see the portrait in Duff House. Its last owner, now styled the Duke of Fife, was running into financial difficulties and had to sell off as much property as he could. Many of the paintings were auctioned in 1907, and Duff House itself was sold. It became a palm-court hotel, which failed, then a sanitarium, which also failed. In the Second World War it was a billet for Polish soldiers and was unlucky enough to be bombarded by the Germans despite its extreme remoteness. And then it stood empty, its great roof derelict and its high windows shattered so that the sea air moved through the rooms where the paintings once hung. Nobody visited; there were no further sightings of the Velázquez.

In 1963, after half a century of seclusion, it reappeared at a London auction, where it was sold to an anonymous collector. The portrait was cleaned, the layers of overpainting were removed and out of the darkness came the picture of today, far more penetrating and beautiful than it ever looked in the 2nd Earl's time, but also bearing several marks that he was never able to see. One was the date, 1624; the other was a signature – that of the court painter Daniel Mytens.

The earl loved this portrait, was fascinated by its strangeness and enthusiastically brought his visitors to see it; Thomas Pennant calls it curious, too. And so it is, with all its immediacy and insight, so clearly and closely painted from the life, unlike a thousand other portraits of Charles. It stands alone in the crowd, a close-up, painted eye to eye and knee to knee almost; it shows the man before the

prince. The earl did not stake his reputation on the painting. Would it have mattered so profoundly to him, as it did to John Snare, that his portrait was or was not a Velázquez?

The earl was right in one surmise, however. The painting almost certainly belonged to the Duke of Buckingham, and was made especially for him. It has the intimate character of a friendship portrait and, sure enough, Mytens painted another of Buckingham for Charles in just the same pose (the royal accounts record the payment). And then he painted a third, of the diplomat Sir Endymion Porter, who was with them on the trip to Madrid – as if working up a Spanish Match series.

Daniel Mytens is an elusive painter, mysterious in his diversity. He was born in Delft, or The Hague, around 1590, nephew of one painter, brother of another, uncle of a third. No paintings survive before 1618, when he arrives in England and is hired by King James I. He is awarded an annual pension in 1624, and becomes 'one of our picture-drawers for life' when Charles is crowned the following year (although that is not how his future turns out). He is also given the lease on a house with a walled garden in St Martin's Lane, just off Trafalgar Square, from which he can walk to Whitehall Palace or York House in a matter of minutes.

Mytens painted so many full-length portraits of Charles that he must have needed assistants. He gets a pattern going, a look plus a stylish pose: curtain, window, pillar, hand on hip, king turning suavely to viewer in fabulous clothes. Charles in dove-grey velvet and taupe suede, in aubergine and gold stripes, in slashed scarlet with a watered silk sash; Mytens is a most perfect portrayer of garments, of laces and toggles, stomachers and collars, complex inner and outer sleeves. Two of his greatest portraits are of the same man, the Earl of Arran, in black silk with vermilion stockings at the age of seventeen and then again in a stupendous suit of silver six years later. Arran went to Madrid with Charles, another witness to the Spanish farce.

But Mytens is a diffident painter, hesitant, gentle, perhaps lacking

in a strong or resistant personality. He gives a soft grace to his people, and seems to find their hesitance, too. There is no sense of an equal tension between artist and sitter, as there is with Velázquez and Van Dyck. He cannot quite rise to the challenge of Charles in the big formal pictures, cannot project enough character anywhere but here, in this unique friendship portrait.

Mytens sees clearly, paints gracefully, is patient and forgiving, but also anxious. All of these traits are present in his own self-portrait, which hangs in a long crepuscular corridor in the Queen's private apartments at Windsor Castle. There he is among the swaggering Van Dycks, making eye contact without wishing to appear too forward, his starched collar beginning to flag, a shy man in alien surroundings. There is a truthfulness here, a freedom and an understanding of the inner man that makes his self-portrait – as so often in art – one of his strongest paintings.

Many foreign artists worked at the court of Charles I, from Mytens and Honthorst to Jonson and Gentileschi and eventually, from 1632, Van Dyck. What these painters have in common is their internationalism, their knowledge of elsewhere and of other styles of art; but they have their isolation and vulnerability, too. It only takes someone better to arrive from somewhere else and a painter's days may be numbered.

Van Dyck included Mytens in a series of court portraits, but this doesn't make them friends. And Mytens was very soon sidelined. His tasks were reduced and in the final humiliation he was required to repaint one of his own royal portraits in the manner of the new Flemish star.

Sometime between 1633 and 1634 he left London for The Hague and never returned. Nobody knows when he died or where he is buried. Mytens is not the subject of a monograph; his paintings are not reproduced as postcards; his name is all but extinguished. But the friendship portrait of Prince Charles is an exceptional work: the young prince so close and alone, surrounded by nothing but glowing air. Mytens had never painted anything like it before.

Earlier in 1623 Mytens was commissioned to paint a portrait of Prince Charles as an act of pictorial diplomacy with Spain. It was dispatched to the Alcázar, where Velázquez must have seen it. It is at least conceivable that the same thing happened in London: that Mytens saw Velázquez's portrait too, before it vanished. Could he – could this portrait – have absorbed something from Velázquez?

The 2nd Earl Fife did not live to learn that his Velázquez was in fact a Mytens; John Snare did not live to learn that his Velázquez never belonged to the earl. This is a mercy in both cases, but the aristocrat was luckier than the tradesman because he lost nothing by his portrait, whereas Snare's life was set towards disaster at Radley Hall. He spent his life trying to establish a definitive history and pedigree for the painting based upon a false premise. Stirling Maxwell said that Snare had proved very little except that the portrait might once have belonged to the 2nd Earl Fife. And now this possibility is cancelled too, simply because we are able to see what they never could; because we can look at photographs, compare colour reproductions and magnify them down to the last whisker; because we can search through letters, inventories and memoirs in libraries all over the world, or shake the internet until it bears fruit. We do not know better than these people of the past, we just know more than they could.

Alexander Harper's book was published in a tiny local edition two years before Snare ever went to Radley Hall. If he had heard of it, if he had read it, his life might have taken a better course. 'Summer Excursions' is the letter that slipped beneath the carpet.

But that is to blame everything on chance or coincidence. If Snare had heard of Harper, if Harper had ever achieved the popular reach he hoped for, then everything might have been different. Whereas the onus is surely upon several other people: the executors of the 2nd Earl Fife, who might have taken the trouble to check the whereabouts of his paintings, who might have sent enquiries to Duff House, who might at the very least have consulted the 4th Earl before they brought so much grief to Snare (and how about the earl himself?). They simply decided to take Snare at his word, to believe he had the painting and casually – or maliciously – accuse him of handling stolen goods.

What the Trustees had, and what still exists, is of course the 1807 catalogue. They might have matched it to the paintings in Duff House. One of them might have made the journey and looked with his own eyes; one of them might have troubled to consult the staff. For the housekeeper of that Georgian house by the sea knew which portrait was which, enough to guide Alexander Harper straight to the Velázquez.

As for the old retainers from Fife House in Whitehall who thought that John Snare's painting had once hung there, there is a possible explanation for their belief. Among the paintings sold by the Duke of Fife in 1907 were several works by Van Dyck that had once been in Fife House. Three are portraits of Charles I. One of them is described as a painting of the king in armour, standing, with a lace collar and a baton. Now imagine it veiled with dirt.

The 2nd Earl Fife's collection is entirely dispersed. Mytens's portraits of Charles, many of which were made for foreign courts in the first place, for diplomats, aristocrats and monarchs, have

wandered all over the world, to Denmark and Canada, Majorca and Spain and the Czech Republic. The beautiful portrait of Prince Charles with his new Spanish beard has gone abroad too, from Duff House to England, then Italy, where it was cleaned. It is now in a private collection in America. But in this great flux of paintings moving around the world, tumbling in the tide of history, where is the picture the 2nd Earl Fife believed he owned, the picture John Snare thought he had bought, the picture first mentioned by Pacheco nearly four centuries ago – where is the lost portrait of Charles by Velázquez?

Rubens came to London not long after his time in Madrid, where he spent whole days with Velázquez; yet, if he saw it at all, he says nothing about it. There is no mention in the collections of Buckingham or Charles. Could it have been buried beneath another painting? Could there be a trace of it – if not literally, then aesthetically – in the Mytens? Or was it too dispatched overseas on a diplomatic mission, sent off to someone in Portugal or Poland long ago; has the portrait found its haphazard way out into the vastness of the world?

Historians often mention the lost Velázquez and, when they do, it is with decision. They say it is permanently lost, or irrevocably lost, as if some statute of limitations had expired and nobody need look for it any more. But it could go the other way. The condition of the portrait is simply that it has not yet been found, that – like the other paintings by Velázquez that have returned from oblivion – it too will come back one day.

Saved

PALACES ARE NO less perishable than the people who live and die within them. They only take longer to decline into the ruins that lie above and below the earth. But the fire that dispatched the Alcázar in 1734 was so mortally abrupt that most of the hulking stone fortress that had dominated the city's edge for hundreds of years passed into rubble and ash in a matter of hours. What was upright on Christmas Eve was gone by the end of Christmas Day.

The Alcázar was unusually deserted that night. Almost everyone was at midnight mass or staying in another royal palace, so the few servants left behind had to fight the fire on their own. Their first instinct, perhaps fearful of their masters' wrath, was to barricade the outer doors against looting. Rushing along passageways between cavernous state rooms and remote private apartments, they somehow managed to gather up paintings by Leonardo, Titian and Rubens, chests of coins and boxes of jewellery, including the outsize Pilgrim Pearl worn by Spanish queens, which would one day belong to Elizabeth Taylor. But when fireballs began to hurtle down the corridors, the only option was to open the windows and throw whatever could be salvaged as quickly as possible out into the freezing night air.

The fire raged uncontrollably all through Christmas Day, destroying walls and floors, consuming tapestries, melting silver and glass; the larger the treasure, the more dangerous the attempt to save it. Of the thousand and more paintings in the royal collection, many

were too big, too high on the walls or too far-flung to be rescued. The Alcázar had four floors, and the windows pierced through its thick medieval walls were often so obstructively narrow that the size and shape of the canvas came to matter as much as the image itself. As many as five hundred paintings burned in the flames.

On the palace walls that Christmas were two large works by Velázquez. One was a famous early triumph, *The Expulsion of the Moors from Spain*, a subject set by Philip IV for that competition between his court painters won by Velázquez at the start of his career. This masterpiece burned. The other was *Las Meninas*, greatest of all paintings, saved only by the speed and dexterity of exactly the humble people Velázquez depicts – the servants of the palace, who managed to free the canvas from its frame and push it out into the wintry courtyard below before the smoke overwhelmed them.

Only the cheek of the little princess was scorched that Christmas. If the rest of the picture had gone up in flames, the whole of art would have been diminished. One masterpiece was lost to fate, but the other was saved by the servants; and with it the revelation of all these children and courtiers held in a bright spot of time, their lives rescued from oblivion, in turn, by Velázquez's transcendent genius as a painter.

This is the end. There can never be anything better than this, so said Manet on seeing Velázquez in the Prado. He wondered why anyone would ever bother trying to paint any more – himself included – because this art could not be surpassed. Velázquez had taken the comparatively new medium of oil paint and done everything with it; he had taken it as far as it could go.

This has been the response of fellow painters from Velázquez's day to ours. What Velázquez painted was the truth; everyone else was just making it up: that was the reaction of the artists in Rome when the portrait of Juan de Pareja was shown outside the Pantheon in 1650. Here was the theology of painting, declared the awed painter Luca Giordano on seeing *Las Meninas* a century later, meaning that

Saved 263

it told the truth about life, as theology told the truth about God. Picasso, obsessed, went in and out of that painted room for years trying to understand its enigma, isolating the elements – the weight of darkness, the activity of light, the solitary figures standing like chess pieces in their different planes of reality – in more than forty prints, which are Disney cartoons by comparison with *Las Meninas*; and still he could not fathom its art.

Velázquez's way of painting was thought miraculous, magical, above all mysterious. Even now one wonders how he could know where to place that speck of white that ignites a string of flashing glints across pale silk, how to convey the stiff transparency of gauze with a single dab of blue on grey, how to paint eyes that see us, but are themselves indecipherable? How could he lay paint on canvas so that it is as impalpable as breath, or create a haze that seems to emit from a painting like scent, or place a single dab of red on the side of a head so that it perfectly reads as an ear?

These marks are conspicious. These brushstrokes can be counted. The methods are all laid out before you, openly declared as special effects, and yet you cannot break free of the illusion of life.

For some writers, the illusion is all there is. Velázquez can only be understood or appreciated as a virtuoso master. The Spanish philosopher Ortega y Gasset set the tone in the 1950s, damning Velázquez even as he praised him: 'All that matters to him are the fleeting images his retina receives in the blink of an eyelid. And each painting of this genius is like an immense retina . . . turning the world into pure visuality.' Out of chaos, he creates these visual phantasms. It is an extension of what Palomino says in that early biography – 'up close the painting was not intelligible. But from a distance it was a miracle.' And it is true that, in some way we may not understand, these paintings mimic the experience of seeing in itself.

But Velázquez's genius is not in this invention alone. He is not just striving for 'pure visuality', not painting for the sake of illusion alone. He puts his art to the deepest human purpose.

The mystery of his work is not just that his paintings are both

dazzling and profoundly moving all at once, but that these apparent opposites coincide to the extent that one feels neither can exist without the other. The truth of life, the mortal truth of our brief walk in the sun, has to be set down in a flash of brilliant brush-strokes that are themselves on the verge of dissolution. The picture, the person, the life: all are here now, but on the edge of disappearing. It is the very definition of the human condition.

And if the art of Velázquez teaches us anything at all it is the depth and complexity of our fellow human beings. Respect for the servants and the dwarves, the jesters and the bodyguards, the old woman frying eggs and the young boy with his melon, for the princess and the palace weavers, for the seller of water and the seller of books: that is what his art transmits. To respect these portraits is to respect these people. And this depth is not an illusion, not something merely in the surface of the work, but there in every nuanced observation. If we acknowledge the greatness of Velázquez, then we shouldn't scorn anyone; let alone this Englishman who cherished a supposed fragment of his art.

Velázquez gives every person he paints such individual presence, such unparalleled dignity. His figures are always portraits, never just types. Even when the subject is legend or myth, reality just keeps breaking through. His Aesop isn't some anonymous ancient, but a strewel-haired intellectual with a broken nose and no cash to patch his clothes. His Mars is a slumped old prizefighter, his occupation gone, muscles losing tone. Perhaps the picture was made to amuse the court, as scholars say – a drooping moustache, an oversized helmet – but Velázquez gives his veteran tragic status, a portrait of redundancy and loss.

He understands the harsh demands upon the dwarf, and the curiosity of the little princess surprised by the arrival of whoever we are in *Las Meninas*; he understands the resistance of the stoic dog and the tensions of the chamberlain, waiting on the step, one leg in and one leg out, his job this kind of exacting hesitation, trying to gauge the speed of the royal passage through court; he understands

Saved 265

the extraordinary skill required to become, and remain, a pope.

There is nothing sentimental in his pictures, or his thinking. They do not tug at your heart strings, or make you feel smaller by comparison with their style and flamboyance, like Van Dyck. They put you eye to eye with the sitter; this is the democracy of his art.

And it goes both ways. It is sometimes said that Velázquez reserved his compassion for the court outsiders, but the untruth of this is everywhere apparent. All men are born equal to him. A late portrait of Philip as a sunken old lion shows the full grief of his life's experience. Ineffably sad, it is also as near to a ghost as anything Velázquez ever produced, the paint so spectrally thin one can hardly believe it could register as a human face. And a late portrait of Olivares, who is about to lose his position – ruined in an instant and banished from Madrid for ever – shows that scheming politician, kiss-curl now a little dishevelled, jowls dangling heavy in a kind of haze of bewilderment, as if burled in all directions. His eyes show confusion, muddle, the onset of dementia. He is said to have died in utter madness.

What Velázquez emphasises is the dignity of all people. It would not be hard, after all, to hold Philip IV in contempt if one looked at the record of his reign, his womanising and his wastefulness, his ill-advised campaigns, his stupid squandering of Spain's wealth and power, his marrying of his own son's fiancé, his licentiousness – many bastards, no sons, as they used to say – his irresolute and craven character, susceptible to persuasion, flattery and above all to Olivares, who led him by the nose. But Velázquez is neither awed nor repelled; he is fascinated.

There are more than twenty portraits of Philip, a time-lapse biography in paint, from the early face with its ruddy lower lip, moist, protuberant and dangling – one can hear the wet lisp with which he surely must have spoken – to the splendour of the midlife monarch, supposedly mitigated by the golilla that says onward with our sober thrift, that does him no favours: a head on a plate,

a head dished. Twenty years into his reign he still has that straw-berry-blond hair and nearly invisible eyebrows, but the eyes are sunken and the lids drag heavily downwards, revealing the white inner rims. Velázquez sees him as fallible, mortal. The king has come closer again, as close as he was in the first portrait made on that summer's day in 1623, but now he is a man careworn and aware of his sins, and his sorrows, but keeping going, still here. Seek inside yourself for the flaws; pray that you will be understood.

Soon Philip will withdraw from his painter's gaze, and his truthful brush. Yet each painting gives him the fullest mercy – that human understanding that is the very soul of Velázquez's art.

Velázquez is able to see the whole world before him in the microcosm of the court, in the faces of servants on the stairs, in the behaviour of children, in the conversation and attitudes of actors and dwarves. He finds a Venus and a Mars in the humble people around him, sees a king as compellingly ordinary and is able to make an old man selling water seem like an ancient prophet. There is an extraordinary equality to his empathetic gaze.

The friends of his youth appear in middle age. Nieto is there at the beginning and he is there at the end. The dwarves come in and out of the entire life's work. Velázquez's loyalty is fixed. He does not pretend he never knew Olivares when it is all over for Saved 267

him. Nobody is too high or low for his art. He painted the jester who played a matador in palace comedies; he painted the palace gatekeeper. Like the long-dead people they represented, these portraits are gone too, thought destroyed by the Alcázar fire.

Ars longa, vita brevis. You only have to look at all the amulets dangling from the belt of the last of the royal children portrayed by Velázquez to sense the desperate fear of death at the Spanish court; the boy was dead at the age of four. Philip IV's first wife died young. His two sons and youngest daughter all predeceased him. His second wife would have been the bride of Baltasar Carlos, the son for whom she was intended, if the boy hadn't died before the wedding. And soon after bidding farewell to his eldest daughter at the Isle of Pheasants in 1660, in the betrothal to Louis XIV, Philip lost his painter, too. Velázquez was buried in the church of San Juan Bautista in the clothes we see him wearing in Las Meninas. His body has since vanished. The church was destroyed by French troops during the Peninsular War, on the orders of Joseph Bonaparte.

The greatest achievement of Philip's life was to have employed Velázquez.

The king's face in *Las Meninas* is a hazy blur; this was the last time Velázquez ever painted him. These are the twilight years of his reign, the high summer of the Spanish empire is over and war with France is bankrupting the government. By 1657 Philip will not be able to get credit even for food. A few years later he will be dead, followed far too soon, before she was even twenty-one, by the little princess.

Of course it is thanks to Velázquez that Margarita's youth and charm survive her. But *Las Meninas* is more than an arrangement of beautiful portraits; more than the sum of all its interpretations and more than a meditation on painting.

It is well said that Velázquez's brushstrokes reveal a true freedom of spirit. In this masterpiece they also release something equivalent in the people he portrays, so alive and unique, and in every viewer who comes before the picture. Las Meninas is piercingly sad in its representation of these lost children in their obsolete clothes, dead and gone for centuries, and the painting makes its elegy for what must come in miniature at the back of the room, where Nieto waits to lead us onwards into that other light, hovering between this world and the next.

But he does not go and they do not fade, kept here by our presence and Velázquez's art. The golden haze remains bright against the sepulchral darkness above. The figures of the past keep looking into our moment – as long as we keep looking back at them. Everything in *Las Meninas* is designed to keep this connection alive forever. The dead are with us, and so are the living consoled. We live in each other's eyes and our stories need not end.

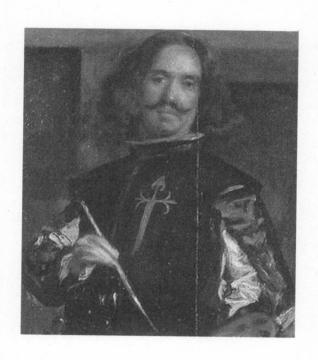

Acknowledgements

The first Velázquez I ever saw was An Old Woman Cooking Eggs at the Scottish National Gallery in Edinburgh. I was eight and my parents thought I ought to be old enough to appreciate it. For their confidence, their lifelong encouragement and the constant inspiration of their thought and work down the decades, I am intensely grateful to my beloved artists, James and Elizabeth Cumming.

How and where we come to see paintings is in part the subject of this book. The gallery of the Prado where Las Meninas hangs is a prospect of limitless excitement to me and I would never have been there after hours without the hospitality of Gabriele Finaldi, then at the Prado, now director of the National Gallery in London. I thank him for his wisdom and generosity. I am greatly indebted to the work of many other Velázquez scholars too, but most particularly Xavier Bray, Jonathan Brown, Dawson Carr and Javier Portus at the Prado.

Anna Reynolds took me behind the scenes at the Royal Collection and to the Queen's private corridor at Windsor Castle to see the Mytens self-portrait. Hilary Macartney and Laurence Grove of the Stirling Maxwell Research Project at Glasgow University were extraordinarily helpful about Sir W, as they call him. Lesley Miller, Senior Curator of Textiles at the V&A, was a reassuring authority on the subject of Charles I's clothes. Andrew McKenzie, Head of Old Master Paintings at Bonhams, showed me the X-ray of the Shepperson Velázquez and gave me many hours of conversation. I warmly thank them all.

I would never have come across John Snare if not for the existence of the National Art Library, where I have so often sat in draughty seat number 33 (occupied a century before me by a fellow art critic, C. Lewis Hind, whose *Days with Velasquez* all but bursts with love: may he find new readers today). My thanks are due to all the NAL librarians; also to Paul Cox at the National Portrait Gallery Library; Sarah Jeffcott at the Scottish National Portrait Gallery Library; Miriam Palfrey at Reading Library; and Maurita Baldock at the New York Historical Society. For answering all sorts of peculiar questions, I am grateful to David Allen Green, the Ross Herald Charles Burnett, Jo Edwards at Duff House, Bendor Grosvenor, Carrie Hunnicutt at the Meadows Museum, Diana Mackarill, Catherine Macleod at the National Portrait Gallery, Molly Marder at the Chrysler Museum, Virginia Napoleone at the National Gallery, Clive Stafford Smith, Mark Weiss and Florence Evans of the Weiss Gallery.

Clara Farmer is a superb editor – exacting, acute and imaginative. I am also grateful to Susannah Otter and Charlotte Humphery for all their kindness at Chatto and to Mandy Greenfield, meticulous copy-editor, and Alex Milner, eagle-eyed proof-reader. At Scribner's, Nan Graham sent the book in new directions with her strong insights and encouragement. Thanks also to Daniel Loedel for his warm editorial support. In Patrick Walsh of Conville and Walsh, my friend

and champion, I have simply the best of all agents.

Parts of this book were written in hard and fearful times and I can never be thankful enough to Sarah Baxter, Louise Cattrell, Jill Chisholm, Kate Colquhoun, Timothy Cumming and Kate Kellaway for their exceptional solidarity: bravehearts, all. I should also like to thank Sarah Donaldson, Carol McDaid, Susannah Clapp, Luke Jennings, Fiona Maddocks and John Mulholland at the *Observer*, Josephine Oxley, Sir John Leighton, Frank Cottrell-Boyce, David Edgar and Tom Lubbock, with whom I had the most exhilarating conversations about art when he was alive and I was privileged to know him.

My daughters Hilla and Thea never knew their grandfather James, who more than slightly resembled Velázquez in mind as well as appearance; but they have grown up loving the works of both and never resented all the time I have spent on the Spaniard. Their father, my husband Dennis Sewell, has helped me in every conceivable way, from the first clue to the last discovery, day by day, never losing faith in me (or Snare), never ceasing in his generosity. This book is his as much as mine, with boundless love and gratitude.

List of Illustrations

Text Images

- 16 Radley Hall, c. 1819-1844, W. Waite
- 27 An Old Woman Cooking Eggs, c. 1618, Diego Velázquez (Scottish National Gallery)
- 27 Detail, An Old Woman Cooking Eggs, c. 1618, Diego Velázquez (Scottish National Gallery)
- 28 Christ in the House of Mary and Martha, c. 1618, Diego Velázquez (National Gallery, London /Bridgeman Images)
- 31 Philip IV, 1623–24, Diego Velázquez (Meadows Museum, SMU Dallas, Algur Meadows Collection)
- 37 Minster Street, c. 1845, Reading
- 57 Philip IV, c. 1623, Diego Velázquez, (Prado National Museum)
- 59 Count-Duke Olivares, c. 1636, Diego Velázquez (Prado National Museum)
- 60 Baltasar Carlos in the Riding School, c. 1636, Diego Velázquez (Duke of Westminster)
- 4th Earl Fife, 'All Bond Street Trembled as he Strode', 1802, James Gillray (© Courtesy of the Warden and Scholars of New College, Oxford/Bridgeman Images)
- 69 P. T. Barnum and Charles Sherwood Stratton ('Tom Thumb'), c. 1850, Samuel Root
- 76 Las Meninas (after Velázquez), c. 1656–77, Juan Bautista Martínez del Mazo (Kingston Lacy, Dorset, National Trust Photographic Library/John Hammond/Bridgeman Images)
- 89 Don Diego de Acedo, c. 1636-8, Diego Velázquez (Prado National Museum)
- 97 2nd Earl Fife, 1805, Robert Dunkarton after Arthur William Devis
- 118 Don John of Austria, c. 1632, Diego Velázquez (Prado National Museum)
- 120 Sibyl, c. 1632, Diego Velázquez (Prado National Museum)
- 122 The Artist's Family, c. 1664–65, Juan Bautista Martínez del Mazo (Kunsthistorisches Museum, Vienna, Austria/Bridgeman Images)
- 129 Advertisement for an exhibition at Tait's Saloon, Princes Street, Edinburgh, 1849
- 133 Front door of 16 Minster Street, Reading
- 167 Ferdinando Brandani, c. 1650, Diego Velázquez (Prado National Museum)
- 180 Stuyvesant Institute, New York
- 189 Detail, *Philip IV in Brown and Silver, c.* 1631–2, Diego Velázquez (National Gallery, London/Bridgeman Images)
- 189 Detail, Archbishop Fernando de Valdés, c. 1640–5, Diego Velázquez (formerly Palacio Real, Madrid)
- 193 Portrait of a Man, 1660, Workshop of Velázquez (Metropolitan Museum of Art, New

- York, Marquand Collection, Gift of Henry G. Marquand, 1889, © 2015. Image © The Metropolitan Museum of Art/Art Resource/Scala, Florence)
- 222 The Toilet of Venus ('The Rokeby Venus'), c. 1647–51, Diego Velázquez (National Gallery, London/Bridgeman Images)
- 249 Duff House, Banff
- 253 Charles I, c. 1623-4, Daniel Mytens (© Mark Weiss, Weiss Gallery)
- 254 Charles I, c. 1623–4, Daniel Mytens, reproduced in The Connoisseur, Vol. X, September– December 1904
- 257 Portrait of the Artist, c. 1630, Daniel Mytens (Royal Collection Trust, © Her Majesty Queen Elizabeth II, 2015)
- 266 Philip IV, c. 1653-6, Diego Velázquez (Prado National Museum)
- 269 Detail, Las Meninas, c. 1656, Diego Velázquez (Prado National Museum)

First plate section

- A Las Meninas, c. 1656, Diego Velázquez (Prado National Museum)
- B The Waterseller of Seville, c. 1618, Diego Velázquez (© English Heritage, The Wellington Collection at Apsley House)
- C Portrait of a Man, possibly Nieto, c. 1635–45, Diego Velázquez (© English Heritage, The Wellington Collection at Apsley House)
- D Francisco Lezcano, c. 1636-8, Diego Velázquez (Prado National Museum)
- E Sebastián de Morra, c. 1643-9, Diego Velázquez (Prado National Museum)

Second plate section

- F Pablo de Valladolid, c. 1635, Diego Velázquez (Prado National Museum)
- G View of the Gardens of the Villa Medici, c. 1630, Diego Velázquez (Prado National Museum)
- H Pope Innocent X, c. 1650, Diego Velázquez (Galleria Doria Pamphilj, Rome/Bridgeman Images)
- Juan de Pareja, c. 1650, Diego Velázquez (Metropolitan Museum of Art, New York. Purchase, Fletcher and Rogers Funds, and bequest of Miss Adelaide Milton de Groot, by exchange, supplemented by gifts from friends of the Museum, 1971. Inv. 1971.86 © 2015. Image © The Metropolitan Museum of Art/Art Resource/Scala, Florence)

Third plate section

- J Portrait of a Man, c. 1630–5, Diego Velázquez (Metropolitan Museum of Art, New York, The Jules Bache Collection, 1949, © 2015. Image © The Metropolitan Museum of Art/ Art Resource/Scala, Florence)
- K The Spinners, c. 1655-60, Diego Velázquez (Prado National Museum)
- L Aesop, c. 1638, Diego Velázquez (Prado National Museum)
- M Charles I, c. 1623–4, Daniel Mytens (© Mark Weiss, Weiss Gallery)

Notes on Sources

1 A Discovery

Velasquez or Velázquez? The reader will immediately notice two different spellings, and there are comic variations to come (see Chapter 14). I abide by Velázquez, as generally accepted in modern times, but have honoured all the spellings in the sources. The same applies to Van Dyck/Van Dyke, Mytens/Mittens and so on.

John Snare's A Brief Description of the Portrait of Prince Charles, Afterwards Charles the First, Painted in 1623, by Velasquez: Now Exhibiting at No. 21 Old Bond-Street London, came out in April 1847. A much longer pamphlet, The History and Pedigree of the Portrait of Prince Charles (etc.), was published only weeks later. Snare would produce a further pamphlet in 1848, in response to his critics, Proofs of the Authenticity of the Portrait of Prince Charles (afterwards Charles the First), painted at Madrid in 1623, by Velasquez. By now his case was sufficiently well known for the publication to be distributed by the prestigious London book company Whittaker and Co.

2 The Painting

- Snare's recollections of the auction are taken from *The History and Pedigree*, unless specified.
- 13 'A Half-Length of Charles the First (supposed Van-dyke)' would be no small picture. In the seventeenth century, half-length implied a portrait to below the waist; but it also related to size, which might be as much as forty inches by thirty-three inches for Van Dyck's portraits of Charles. However the issue is vexed and the term unstable, as Snare would soon discover.
- The Reading postal directory, Belcher and Harris's sale catalogue and all nineteenth-century Reading newspapers are in the local studies department of Reading Central Library.
- 16 For the early prices of Velázquez's works in Britain, see Xavier Bray's 'Velázquez in Britain' in Velázquez, ed. Dawson W. Carr.

3 The Painter

- 25 All quotations from Pacheco and Palomino are taken from Michael Jacobs's indispensable *Lives of Velázquez*.
- 29 The carpenter's bill is cited in Velázquez, ed. Carr, p. 124.
- 32 The latest anthology of Velázquez documents is Corpus Velazqueño, ed. Aterido.
- On the illegitimate son, see Jennifer Montagu's 'Velázquez Marginalia', Burlington Magazine, CXXV, 1983.
- 33 Alfaro's sketch of Velázquez on his deathbed can be viewed by appointment at the Collection F. Lugt, Institut Neerlandais, Paris.

4 Minster Street

- The foreman's account of Blagrave's visit is in the transcript of the Edinburgh trial, published as *The Velázquez Cause* (see below).
- Two of the best recent studies of the Spanish Match are *The Prince and the Infanta*, by Glynn Redworth, and *The Spanish Match*, ed. Alexander Samson.
- 46 Mytens's portrait of Henry (private collection) was shown in the National Portrait Gallery's 2013 exhibition 'The Lost Prince' and appears in the catalogue, ed. Catherine Macleod.
- Pacheco's account is corroborated by an entry in Sir Francis Cottington's account-book for 8th September (National Library of Scotland, NLS, 1879) which reads 'Paid unto a Painter for drawing the Princes picture. Signified by Mr Porter from the Prince, 1,100 reales'. Cottington's accounts are analysed by Redworth, and also by Jonathan Brown and John Elliott in *The Sale of the Century*.

5 Man in Black

- 51 The watercolour is by Joseph Nash (1809–79).
- Benjamin West is quoted in Peter Young and Paul Joannides's 'Giulio Romano's Madonna at Apsley House', Burlington Magazine, CXII, 1995.
- 53 See Carola Hicks, Girl in a Green Gown.
- The correspondence between Wellington and Maryborough is in Catalogue of Paintings in the Wellington, Apsley House, p. 11.
- 55 On the golilla, R. M. Anderson, 'The Gollilla, a Spanish Collar of the Seventeenth Century', Waffen: und Kostumkunde XI, 1969, pp. 1–19. Also Janet Arnold's Patterns of Fashion.
- 56 J. H. Elliott gives a superb account of palace life in Spain and Its World 1500-1700.
- 56 The French visitor is Antoine Brunel, Voyage d'Antoine Brunel, p. 144.
- 56 Philip's frozen demeanour is from Marcelin Defourneaux's Daily Life in Spain in the Golden Age, p. 49.

6 The Talk of London

- 65 Life of Mary Russell Mitford, p. 204.
- 68 For Bullock and the Egyptian Hall, see Richard Altick's The Shows of London.
- 69 The Life of P. T. Barnum, Written by Himself recounts the midget tour.
- 70 Snare reports the Count's visit in The History and Pedigree.

7 A Man in Full

- 82 Moragas describes Lezcano as 'a cretin . . . of doglike faithfulness'. Gallego states that his costume 'has a dishevelled appearance in keeping with the disordered mind of the dwarf.' Brown describes him as 'a creature seemingly as deformed in mind as body'.
- 82 Two classic accounts of court dwarves are Beatrice K. Otto's Fools are Everywhere: The Court Jester Around the World (Chicago University Press, 2001) and E. Tietze-Conrat's Dwarfs and Jesters in Art (Garden City Books, New York, 1957).
- 86 Richard Ford on the dwarves, p. 751.
- 86 Alfonso Pérez Sánchez, Monsters, Dwarves and Buffoons, p. 9.

8 The Attack

- 93 On Buckingham's collection, see Randall Davies, 'An Inventory of the Duke of Buckingham's Pictures at York House in 1635'; Philip McEvansoneya, 'An Unpublished Inventory of the Hamilton Collection in the 1620s and the Duke of Buckingham's Pictures'; and I. G. Philip, 'Balthazar Gerbier and the Duke of Buckingham's Pictures'.
- 95 Thomas Pennant, Some Account of London p. 146.
- 96 The papers of James Duff, 2nd Earl Fife are in the Special Collections Library, University of Aberdeen.
- 96 John Pinkerton, Literary Correspondence in Two Volumes, Vol. 2, p. 14.
- 97 Walcott's Memorial of Westminster, p. 152; Edgar Sheppard in The Old Royal Palace of Westminster, p. 52.
- 98 On portrait sizes see the essay 'Three-quarters, kit-cats and half-lengths: British portrait painters and their canvas sizes 1625–1850' published online by the National Portrait Gallery in London.
- 103 Stirling Maxwell, Annals, 1848, p. 1368.
- 104 Stirling Maxwell, Velázquez and His Works, p. 82.

9 The Theatre of Life

- Manet's rejection of the food is from a letter by the art critic Theodore Duret, a fellow diner. Duret, Histoire de Édouard Manet, Paris, 1902, p. 45.
- 108 Manet's letter is in Brown and Garrido, Velázquez: The Technique of Genius, p. 45.
- 109 Carl Justi, Diego Velázquez and His Times, p. 442.

- The staging of Calderón's play is described in Brown and Elliott's *A Palace for a King*, p. 205.
- On court theatre, see Laura Bass's The Drama of the Portrait: Theater and Visual Culture in Early Modern Spain and Melveena McEndrick's Theatre in Spain.
- For the tailoring of canvases to fit the space, see J. Portus, J. Garcia-Maiquez and Y. R. Davila, in *Boletín del Museo del Prado*, XXIX, 47, 2011.
- The one line in the masque is given by Angel Aterido in *Velázquez's Fables*, ed. Portus, p. 83.
- 114 For the staging of plays before Philip IV, see J. Varey, 'The Audience and the Play at Court Spectacles: the role of the King', Bulletin of Hispanic Studies, 61, 1984.
- The French visitor is Marechal de Gramont, in Collections des mémoires relatifs à l'histoire de France, p. 78.

10 Seizure and Theft

- 125 Wilkie Collins, writing to his mother in 1842, from Palgrave's online Wilkie Collins Chronology.
- The judge's ruling is quoted in the trial proceedings, see below.
- 130 The lawsuit closer to home is reported by Diana R. Mackarill in The Snares of Minster Street, p. 19.
- 131 Samson Threatening His Father-in-law hung in the Chrysler Museum in Virginia for many years until the Rembrandt Research Project, whose enduring task it is to decide which Rembrandts are fakes and which painted by the artist, or one of his assistants, or some combination of both, decided in 2011 that it fell into the latter category. But John Snare's name is there in the history and pedigree of that picture, the bookseller among the magnates and aristocrats.
- 132 Stevenson, ibid.

II The Trial

All quotations from the trial are taken from 'The Velasquez Cause: report of the trial by jury in the action of damages at the instance of John Snare, bookseller in Reading, against the Trustees of the late Earl of Fife: for the wrongful seizure and detention of the celebrated portrait of Charles the First by Velasquez'. The trial transcript was published by Thomas George Stevenson, whose office was only doors away from Tait's Hotel.

12 The Escape

- 158 Pacheco and Palomino both give details of the trips to Rome.
- 163 Velázquez's opinions appear in Marco Boschini's Carta del Navegar pittoresco, published in Venice in 1660.
- 168 Francesca Curti's identification of Ferdinando Brandani is in Boletín del Museo del Prado, XXIX, 47, 2011.

- 170 Chuck Close's remark is from Michael Kimmelman 'At the Met with Chuck Close', New York Times, July 25th, 1997.
- 13 Velázquez on Broadway
- The pamphlet was 'The Velázquez: A description of the Celebrated Historical Picture of Charles the First, By the Great Velázquez, now on Exhibition at the Stuyvesant Institute, 659 Broadway' (undated, though the New York City Library edition suggests 1850).
- 177 Art and the Empire City, p. 78.
- 178 Glimpses of New York City, p. 11.
- 180 A Small Boy and Others, p. 266.

14 The Escape Artist

- 191 'A world of pain' is from Jonathan Brown's In the Shadow of Velázquez: A Life in Art History.
- 192 Walt Whitman writing to Dr Bucke, 11.1.1889, from The Correspondence, p. 393.
- 194 See Velázquez Rediscovered, by Keith Christiansen, Jonathan Brown and Michael Gallagher.

15 The Vanishing

- 206 The watercolour is in The Snares of Minster Street.
- 211 Buffalo Courier, April 21, 1860.
- 218 New York Times, November 15, 1903.

16 Seeing Is Believing

223 Kenneth Clark, Looking at Pictures, p. 36.

19 Lost and Found

- 253 The right size: the picture is 26 1/4 inches by 23 1/4 inches, three-quarters (of a kit-cat canvas) according to Fife's catalogue.
- 254 K. Warren Clouston, 'The Duke of Fife's Collecton at Duff House', The Connoisseur, X, 1904.
- M. Crosby Smith, 'Duff House: the ancestral home of the Duke and Duchess of Fife', *The Lady*, 1905.
- 261 There is one other painting in the Christie's catalogue that might have left a ghostly trace in the servants' memory. Lot 129 of the Fife sale is 'Velasquez: A portrait of a count . . . in lace collar, holding a stick in his left hand and resting his right arm upon his hip'. A curator has written 'No but very good' on the copy in the National Portrait Gallery library.

on the same of the contract of the same of

Alle of the following of the following people of the constitution of the constitution of the first section of the constitution of the constitution

34 94 34

man and the contract of the co

n de la companya de la co La companya de la companya del companya de la companya de la companya del companya de la companya del la companya de la compa

was to the second before the second second second

material and the second

Talkenaren erak erren 1. 200 arran eta erren 1800. Burralen erren erre

Andrew Commence of the Commenc

Alaba proprieta en la compositión de substituent e entre a como a como propertir antició em ATC de la april conserver en magneta en la color de la compositión de la color de magnete consequente en la color de la april transcribito por la color de la color

Select Bibliography

Alpers, Svetlana, The Vexations of Art: Velázquez and Others, Yale, New Haven, 2005 Altick, Richard Daniel, The Shows of London, Harvard University Press, 1978 Armstrong, W., Velázquez: A Study of His Life and Art, Seeley and Co., London, 1897

Arnold, Janet, Patterns of Fashion: The cut and construction of clothes for men and women c. 1560–1620, Macmillan, London, 1985

Aterido, Angel, 'The First Owner of the Rokeby Venus', Burlington Magazine, CXLIII, 91-94, 2001

Aterido, Angel, Corpus Velazqueño, Ministerio de Educación, Cultura y Deporte, Madrid, 2000

Bailey, Anthony, Velázquez and The Surrender of Breda, Henry Holt, New York, 2011 Barnes, Susan J., De Poorter, Nora, Millar, Oliver, Vey, Horst, Van Dyck: A Complete Catalogue of the Paintings, Yale, New Haven, 2004

Bass, Laura, The Drama of the Portrait: Theater and Visual Culture in Early Modern Spain, Pennsylvania State University Press, 2008

Baxendall, Michael, Patterns of Invention, Yale, London, 1987

Bazin, Germain, The Museum Age, University of Michigan Press, 1967

Beruete, Aureliano de, Velázquez, Methuen, London, 1906

Bindman, David, The History of British Art, Tate Publishing, London, 2008

Bobo, William M., Glimpses of New York City, J. J. McCarter, Charleston, 1852

Bomford, David and Leonard, Mark, Issues in the Conservation of Paintings, Getty Conservation Institute, 2005

Braham, Allan, El Greco to Goya, National Gallery, London, 1981

Braham, Allan, The Rokeby Venus, National Gallery, London, 1976

Berger, John, Velázquez Aesop: Erzählungen zur spanischen Malerei, S. Fischer Verlag, Frankfurt am Maim, 1991

Brewer, John, The American Leonardo: A Tale of Obsession, Art and Money, OUP, Oxford, 2009

Briggs, Martin, Men of Taste, Scribner's, New York, 1947

Brilliant, Richard, Portraiture, Reaktion Books, London, 1991

Brookner, Anita, Jacques-Louis David, Chatto, London, 1980

Brotton, Jerry, The Sale of the Late King's Goods, Macmillan, London, 2006

Brown, Christopher and Vlieghe, Hans, Van Dyck, Royal Academy, London, 1999

Brown, Jonathan, Collected Writings on Velázquez, Yale, New Haven, 2009

Brown, Jonathan, In the Shadow of Velázquez, Yale, New Haven, 2014

Brown, Jonathan, The Golden Age of Painting in Spain, Yale, New Haven, 1991

Brown, Jonathan, Velázquez: Painter and Courtier, Yale, New Haven, 1986

Brown, Jonathan and Elliott, John, A Palace for a King: The Buen Retiro and the Court of Philip IV, Yale, New Haven, 1980

Brown, Jonathan and Elliott, John, Kings and Connoisseurs: Collecting Art in Seventeenth-Century Europe, Yale, 1995

Brown, Jonathan and Elliott, John, The Sale of the Century: Artistic Relations Between Spain and Great Britain, 1604–1655, Yale, New Haven, 2002

Brown, Jonathan and Garrido, Carmen, Velázquez: The Technique of Genius, Yale, New Haven, 1998

Bryson, Norman, Looking at the Overlooked, Reaktion Books, London, 1990

Brunel, Antoine, Voyages en Espagne d'Antoine Brunel, Cologne, 1666

Buchanan, William, Memoirs of Painting, R. Ackerman, London, 1824

Burke, Peter, The Fortunes of the Courtier, Pennysylvania University Press, 1995

Burke, Marcus and Cherry, Peter, Collections of Paintings in Madrid 1601–1735, Getty Information Institute, Los Angeles,1997

Cammell, Charles, The Great Duke of Buckingham, Collins, London, 1939

Carr, Dawson (with Xavier Bray, John H. Elliott, Larry Keith, Javier Portús), Velázquez, National Gallery, London, 2006

Cherry, Peter, et al., In the Presence of Things: Four Centuries of European Still-Life Painting, Calouste Gulbenkian Museum, Lisbon, 2010

Cherry, Peter, 'Face to face with a new Velázquez portrait', Ars Magazine, Madrid, 2011 Christiansen, Keith, Brown, Jonathan and Gallagher, Michael, Velázquez Rediscovered, Metropolitan Museum Publications, New York, 2009

Clark, Kenneth, Looking at Pictures, Beacon, New York, 1960

Colomer, José Luis and Reist, Inge (ed.), Collecting Spanish Art: Spain's Golden Age and America's Gilded Age, Frick Publications, New York, 2012

Cook, Herbert Frederick, 'A Re-Discovered Velázquez', Burlington Magazine, Vol. 10, No. 45, London, 1906

Corns, Thomas (ed.), *The Royal Image*, Cambridge University Press, Cambridge, 1999 Cottington, Sir Francis, "The Account Book of Sir Francis Cottington, Madrid, 1623', National Library of Scotland, MS 1879

Cumberland, Richard, An Accurate and Descriptive Catalogue of the Several Paintings in the King of Spain's Palace at Madrid, C. Diller and J. Walter, London, 1787

Cumberland, Richard, Anecdotes of Eminent Painters in Spain, J. Walter, London, 1782 Curtis, Charles B., Velázquez and Murillo, Sampson Low, London, 1883 Danto, Arthur C. Encounters and Reflections, University of California Press, Berkeley, 1997

Davies, Randall, 'An Inventory of the Duke of Buckingham's Pictures at York House in 1635', Burlington Magazine, Vol. 10, London, 1906

Davies, D. and Harris, E., Velázquez in Seville, National Galleries of Scotland, Edinburgh, 1996

Defourneaux, Marcelin, Daily Life in Spain in the Golden Age, Stanford University Press, 1970

Dickens, A. G. (ed.), The Courts of Europe, Thames and Hudson, London, 1977 Donovan, Fiona, Rubens and England, Yale, New Haven, 2004

Elkins, James, Why Are Our Pictures Puzzles?, Routledge, New York, 1999

Elliott, J. H., Spain and Its World 1500-1700, Yale, London, 1990

Elliott, J. H., Imperial Spain 1469-1716, Penguin, London, 2002

Elliott, J. H., The Count-Duke of Olivares, Yale, London, 1989

Finaldi, Gabriele, Orazio Gentileschi at the Court of Charles I, Yale, London, 2000 Finaldi, Gabriele, Velázquez: Las Meninas, Scala, 2006 Ford, Richard, A Hand-book for Travellers in Spain, John Murray, London, 1845 Foucault, Michel, Les Mots et Les Choses, Routledge, London, 2001 Freedberg, David, The Power of Images, Chicago University Press, 1989

Gallego, Julian, Velázquez en Sevilla, Diputación Provincial, Seville, 1974 Gallego, Julian (ed.), Velázquez, Yale, New Haven, 2003

Gamboni, Dario, The Destruction of Art, Reaktion Books, London, 1997

Gardiner, S. R., *Prince Charles and The Spanish Marriage*, Hurst and Blackett, London, 1869 Glendinning, Nigel and Macartney, Hilary (eds), *Spanish Art in Britain and Ireland*, 1750–1920, Tamesis Books, Suffolk, 2010

Glendinning, Nigel et al., 'Lord Grantham and the Taste for Velázquez: The Electrical Eel of the Day', *Burlington Magazine*, Vol. 141, London, 1999

Goldberg, Edward L., 'Velázquez in Italy: Painters, Spies and Low Spaniards', *The Art Bulletin*, LXXIV, 1992

Góngora, Luis de, Sonetos Completos, Editorial Castalia, Madrid, 1990

Harper, Alexander, Summer Excursions in the Neighbourhood of Banff, by a Deveronside Poet, J. Imlach, Banff, 1843

Harris, Enriqueta, Complete Studies on Velázquez, CEEH, Madrid, 2006

Harris, Enriqueta, Velázquez, Akal, Madrid, 2003

Harris, Enriqueta, 'Velázquez and the Villa Medici', Burlington Magazine, CXXII, 941, London, 1981

Harris, Enriqueta, 'Velázquez's Apsley House Portrait: An identification', Burlington Magazine, CXX, London, 1978

Haskell, Francis, The Ephemeral Museum, Yale, London, 2000

Haskell, Francis, The King's Pictures: The Formation and Dispersal of the Collections of Charles I and His Courtiers, Yale, London, 2013

Haskell, Francis, Past and Present in Art and Taste, Yale, London, 1987

Haskell, Francis, Rediscoveries in Art, Phaidon, London, 1990

Hayes, John, Van Dyck in England, National Portrait Gallery, London, 1982

Head, Edmund, Handbook of the History of the Spanish and French Schools of Painting, John Murray, London, 1854

Hearn, Karen (ed.), Van Dyke and Britain, Tate Publishing, London, 2009

Hibbert, Christopher, Charles I, Weidenfeld, London, 1968

Hicks, Carola, Girl in Green Gown: The History and Mystery of the Arnolfini Portrait, Chatto & Windus, London, 2011

Hind, C. Lewis, Adventures Among Pictures, A and C Black, London, 1904

Hind, C. Lewis, Days with Velasquez, A and C Black, London, 1906

Hoff, Ursula, Charles I: Patron of Artists, Collins, London, 1942

Houpt, Simon, Museum of the Missing, Sterling Publishing, New York, 2006

Homberger, Eric, The Historical Atlas of New York City, Owl Books, New York, 2005

Howarth, David, Images of Rule: Art and Politics in the English Renaissance, University of California Press, Berkeley, 1997

Howe, Edwin, Life of Velázquez, London, 1881

Howe, Winifred, A History of the Metropolitan Museum of Art, Metropolitan Museum, New York, 1913

Hume, Martin, The Court of Philip IV, G. P. Putnam, London, 1907

Huxley, G., Endymion Porter: The Life of a Courtier, University of Michigan Press, 1959

Jacobs, Michael (ed.), Lives of Velázquez, Pallas Athene, London, 2007

James, Henry, A Small Boy and Others, Charles Scribner's & Sons, New York, 1913

Jameson, Mrs, Companion to the Most Celebrated Private Galleries of Art in London, Saunders and Otley, London, 1844

Justi, Carl, Diego Velázquez and His Times. H. Grevel, London, 1889

Kahr, Madeleine Milner, Velázquez: The Art of Painting, Harper and Rowe, New York, 1976

Kauffmann, C. M. and Jenkins, Susan, Catalogue of Paintings in the Wellington Museum, Apsley House, English Heritage, 2009

Kelly, F. M., 'Mytens and His Portraits of Charles I', Burlington Magazine, XXXVII, 209, London, 1920

L'Estrange, A. G. (ed.), The Life of Mary Russell Mitford: Related in a Selection From Her Letters to Her Friends, Richard Bentley, London, 1870

Lafuente Ferrari, Enrique, Velázquez, Skira, New York, 1955

Law, Ernest, The Royal Gallery of Hampton Court, George Bell, London, 1898

Lockyer, Roger, Buckingham: The Life and Political Career of George Villiers, First Duke of Buckingham, Longman, London and New York, 1981

López-Rey, José, Velázquez: A Catalogue Raisonné of his Oeuvre, Faber, London, 1963

López-Rey, José, Velázquez: La Obra Completa, Taschen, Cologne, 1996

MacGregor, Arthur, The Late King's Goods, OUP, Oxford, 1989

Mackarill, Diana, The Snares of Minster Street, Reading, 2007

Macleod, Catherine, Smuts, Malcolm and Wilks, Timothy, *The Lost Prince*, National Portrait Gallery, London, 2012

Magurn, Ruth Saunders, (ed.), The Letters of Peter Paul Rubens, Northwestern, Illinois, 1991

Manuel Barbeito, José, El Alcázar de Madrid, Madrid 1992

Marqués, Mena (ed.), Monsters, Dwarves and Buffoons, Prado, Madrid, 1986

Mayer, August, Velázquez: A Catalogue Raisonné, Faber, London, 1936

McEndrick, Melveena, Theatre in Spain, Cambridge University Press, 1992

McEvansoneya, Philip, 'An Unpublished Inventory of the Hamilton Collection in the 1620s and the Duke of Buckingham's Pictures', Burlington Magazine, Vol. 134, London, 1992

McIntyre, Ian, Joshua Reynolds, Allen Lane, London, 2003

McKim-Smith, Gridley et al., Examining Velázquez, Yale, New Haven, 1988

Millar, Oliver, The Age of Charles I: Painting in England 1620-49, Tate Gallery, London, 1972

Millar, Oliver (ed.), Abraham Van Der Doort's Catalogue of the Collection of Charles I, The Walpole Society, 37, 1958–60

Mould, Philip, The Trail of Lot 163, Fourth Estate, London, 1997

Montagu, Jennifer, 'Velázquez Marginalia: His Slave Juan de Pareja and his Illegitimate Son Antonio', *Burlington Magazine*, CXXV, London, 1983

Moragas, Jerónimo de, Los Bufones de Velázquez, Medicina e Historia, Madrid, 1964

Orso, Steven N., Philip IV and the Decoration of the Alcázar of Madrid, Princeton University Press, 1986

Orso, Steven N., Velázquez, Los Borrachos, and Painting at the Court of Philip IV, Cambridge University Press, London, 1993

Ortega y Gasset, José, Velázquez, Espasa Calpe, Madrid, 1999

Ortiz, Antonio Domínguez et al., Velázquez, Metropolitan Museum, New York, 1990

Pantorba, Bernardino de, *La Vida y Obra de Velázquez*, Sociedad General de Publicactiones, Madrid, 1955

Paul, Carole (ed.), The First Modern Museums of Art, Getty Publications, Los Angeles, 2012

Pennant, Thomas, Some Account of London, Longman, London, 1813

Petitot, A. and Monmerque, L. J. (eds), Collections des mémoires relatifs à l'histoire de France, 77 Vols, Paris, 1820–9

Philip, I. G., 'Balthazar Gerbier and the Duke of Buckingham's Pictures', Burlington Magazine, 99, London, 1957

Pinkerton, John, Literary Correspondence in Two Volumes, Colburn and Bentley, London, 1830 Portús, Javier, Diego Velázquez: The Early Court Portraits, Meadows Museum, Dallas, 2013 Portús, Javier, Entre dos centenarios. Bibliografía crítica y antológica de Velázquez, 1962–99,

Junta de Andalucía, Seville, 2000

Portús, Javier (ed.), Las Meninas and the Late Royal Portraits, Thames and Hudson, London, 2014

Portús, Javier, Pinturas mitológicas de Velázquez, Edilupa, Madrid, 2002

Portús, Javier, 'Las Hilanderas como fabula artistica', *Boletín del Museo del Prado*, XIII, Madrid, 2005

Portús, Javier (ed.), Velázquez's Fables, Prado Museum, Madrid, 2007

Quevedo, Francisco de, Poesia Original Completa, Planeta, Barcelona, 1981

Redworth, Glyn, The Prince and the Infanta: The Cultural Politics of the Spanish Match, Yale, London, 2003

Roberts, Jane, The King's Head, Royal Collection, London, 1999

Samson, Alexander (ed.), The Spanish Match: Prince Charles's Journey to Madrid, 1623, Ashgate, London, 2006

Sánchez Cantón, Francisco Javier, Escritos sobre Velázquez, Museo de Pontevedra, 2000 Schama, Simon, Rembrandt's Eyes, Penguin Press, London, 1999

Sharpe, Kevin (ed.), Culture and Politics in Early Stuart England, Stanford University Press, Stanford, 1993

Sheppard, J. Edgar, The Old Royal Palace of Whitehall, Longman, London, 1902

Southworth, John, Fools and Jesters and the English Court, Phoenix Mill, London, 1998

Starkey, David and Grosvenor, Bendor, Lost Faces, Philip Mould, London, 2007

Stevenson, R. A. M., Peter Paul Rubens, London, 1939

Stevenson, R. A. M., Velásquez, G. Bell, London, 1899

Stirling, William (Sir William Stirling Maxwell), Annals of the Artists of Spain, J. Ollivier, London, 1848

Stirling, William (Sir William Stirling Maxwell), Velázquez and His Works, John W. Parker and Son, London, 1855

Stopes, Charlotte, 'Daniel Mytens in England, Burlington Magazine, XVII, London,

Stratton-Pruitt, S. L. (ed.), *The Cambridge Companion to Velázquez*, Cambridge University Press, Cambridge, 2002

Stratton-Pruitt, Suzanne L. (ed.), *Velázquez's Last Meninas*, Cambridge University Press, Cambridge, 2003

Stourton, James, and Sebag-Montefiore, Charles, *The British as Art Collectors*, Scala, Milan, 2015

Strong, Roy, Van Dyck: Charles I on Horseback, Allen Lane, London, 1972

Tayler, Alistair and Tayler, Henrietta (eds), Lord Fife and His Factor, University Press of the Pacific, Hawaii, 2001

Taylor, Francis Henry, The Taste of Angels: A History of Art Collecting From Rameses to Napoleon, Little Brown, Boston, 1948

Ter Kuile, O., 'Daniel Mijtens: His Majesties Picture-Drawer', Nederlands Kunsthistoric Jaarboek, 1970

Tiffany, Tanya J., Diego Velázquez's Early Paintings and the Culture of Seventeenth-Century Seville, Pennysylvania State University Press, 2012

Tinterow, Gary and Lacambre, Genevieve (eds), Manet/Velázquez: The French Taste for Spanish Painting, Metropolitan Museum, New York, 2002

Trapier, Elizabeth du Gue, Velázquez, The Hispanic Society of America, New York, 1948

Vertue, George, Catalogue of the Collections of Charles I, 1757, James II and Queen Caroline, 1758, Privately printed for W. Bathoe, London

Voorsanger, Catherine and Howat, John K. (eds.), Art and the Empire City, Yale, New York, 2000

Waagen, Gustav Friedrich, Treasures of Art in Great Britain, John Murray, London, 1854 Walcott, Mackenzie, Memorials of Westminster, Francis and John Rivington, London, 1851 Wallace, Mike and Burrows, Edwin, Gotham: A History of New York City to 1898, OUP, New York, 1999

Walpole, Horace, Anecdotes of Painting in England, London, 1862

Walpole, Horace, A Catalogue of the Curious Collection of Pictures of George Villiers, Duke of Buckingham, Privately printed for W. Bathoe, London, 1758

Waterhouse, Ellis, Painting in Britain 1530-1790, Penguin, London, 1978

Whitman, Walt, *The Correspondence: Volume 5*, ed. Edwin Haviland Miller, New York University, 1969

Wollheim, Richard, Painting as an Art, Princeton University Press, 1990

egane i sugri eganego, i gili su esta esta presión de Espechio en esta de actividad esta esta esta esta esta e

The state of the s

To we have been all the second and t

without Parace Pillerin. Name and continue and a continue and

lan Kiruta, in the Politica and the American and the American and Amer

gregories and anti-composition of the second second

KARI AMBILI PERMUSAN P

Manadana da Tribada da Tribada da Tribada da Santa da Sa Manada da Santa da S Manada da Santa da S

ele angli angli angli angli angli

Index

Abbott, Henry 174, 181, 182, 207 Abraham, Richard 183 Acedo, Diego de 88-9, 89 achondroplasia 82 Adam, Robert 95 Adam, William 249 Alcázar Palace, Madrid 3, 24, 30, 32, 34, 44, 48, 56, 57, 80, 86, 113, 115, 119–20, 122–3, 157, 162, 219, 258, 261, 267 Alfaro, Juan de 33, 119 American Academy of Fine Arts, New York 183 American Art Union, New York 178 American Civil War (1861-65) 208 Andersen, Hans Christian 192 Apsley House, London 52, 54, 61-3, 74, 200 Arran, Earl of see Hamilton, James Aspinwall, William Henry 191

Bache, Jules 174, 197-8 Balmoral Castle, Aberdeenshire 143 Baltasar Charles, Prince of Asturias 59-60, 60, 73, 79, 81, 84, 85, 115, 158, 219, 267 Bankes, William 10, 75-7 Banqueting House, Whitehall 95, 243 Barberini, Francesco 159, 166 Bárbola, María 85 Barnum, Phineas Taylor 'P. T.' 69 Baudelaire, Charles 110 Bergman, Ingmar 27 Bernini, Gian Lorenzo 241-2, 243 Bibaldo, Girolamo 166 Blagrave, Colonel 42, 247 Blondin, Charles 179 Bobo, William 178-9 Glimpses of New York 178-9 Bodleian Library, Oxford 43, 46 Bonaparte, Joseph-Napoléon 48, 52, 54, 228, 267

Bonnar, William 149-50, 151, 155 Borders Books 200 bosquexo 47-8, 103, 105, 109, 117 Boswell, James 252 Brandani, Ferdinando 166-8, 167, 205 Breda, Siege of (1624) 199 Brentano, Arthur 209-10, 214 Brentano, August 209 Brentano's Literary Emporium, Union Square 208, 209, 218 Bridgewater House, Westminster 74 'Brief Description of the Portrait of Prince Charles' (Snare) 6-7, 17-18 British Institution, Pall Mall 72 British Museum, Bloomsbury 148 Broadway, New York 70, 173, 177-85, 207-11, 214, 215, 217, 218, 234 Brooklyn Museum, New York 182 Broomhall House, Fife 126 Brown, Capability 16 Brown, John 100, 142-3 Brown, Jonathan 194 Browning, Elizabeth Barrett 65, 70 Browning, Robert 70 Bruce, Thomas, 7th Earl of Elgin 10, 79, Bruegel the Elder, Pieter 250 Buckingham, Duke of see Villiers, George Buckingham and Chandos, Duke of 130 Buen Retiro Palace, Madrid III-I4, 157, 245 Buffalo Courier 211 buffoons 83, 86, 109 Bullock, William 68-9, 70 Burns, Robert 252 Byron, George Gordon, 6th Baron Byron 75

Calderón, Pedro 55, 58, 111, 113

Love, The Greatest Enchantment 111, 113

Caledonian Mercury 126, 175 Callot, Jacques 132 The Miseries and Sufferings of War 132 calotypes 239 Camden Society 70 Cano, Alonso 55 Canova, Antonio 61 Napoleon as Mars the Peacemaker 61 Captain Tom Thumb 69, 69, 179, 181 Caravaggio, Michelangelo Merisi da 33, 53, 229 Carl I Ludwig, Elector of Palatine 244 Carlisle, Earl of see Howard, Henry Carlos, Count of Montemolín 70-1, 133, 247 Carpaccio, Vittore 228 Virgin and Child 228 Carreño de Miranda, Juan 85 Eugenia Martínez Vallejo, naked 85, 105 Castiglione, Baldassare 14 Century 191, 192 Chaplin, Charlie 240 Charles I, King of England, Scotland and Ireland 7, 11, 13, 16-22, 30, 38-50, 61, 65-7, 69-73, 77-8, 90, 91-105, 125-30, 133-5, 137-56, 166, 173-81, 184-5, 205, 207-8, 209-18, 230-5, 237-48, 249-60, 253, 254 Charles IV, King of Spain 75 Charles Scribner's Sons, Broadway 208-9, 216, 218 Chilham Castle, Kent 167 Chinese Assembly Rooms, New York 178 cholera 48, 107 Chrysler Museum, Virginia 131 Church, Frederic 179, 184, 207 Niagara 179, 184 Cincinato, Romulo 30 Clark, Kenneth 223 Close, Chuck 170 Clouston, Katherine Warren 251-5 Coleridge, Samuel Taylor 250 Collins, Wilkie 125 Connoisseur. The 251 Corot, Jean-Baptiste-Camille 161 Correggio, Antonio da 53, 79, 162, 212 Cortona, Pietro di 163 Courbet, Gustave 187 Court of Sessions, Edinburgh 126, 137-8

daguerreotypes 178, 208, 217, 238 Dalí, Salvador 57 David, Jacques-Louis 14, 43, 179

Curtis, Charles 214, 215-16, 237

Crayon, The 183-4 Cromwell, Oliver 239

Cuyp, Albert 74

Coronation of Napoleon 179 Marie Antoinette on the Way to the Guillotine The Death of Marat 14 Deas, George 152-3 Defoe, Daniel 103, 209 Delaroche, Paul 207 Dickens, Charles 34, 176, 207 Bleak House 176 Diderot, Denis 132 Digby, Kenelm 97, 250 Donaldson, John 150 Doria Pamphili Gallery, Rome 163 Downton Abbey 243 Duff, General Alexander 145-6, 154 Duff, Alexander, 3rd Earl Fife 143 Duff, Alexander William George, 6th Earl Fife 255, 259 Duff, Dorothy 249 Duff, James, 2nd Earl Fife 67, 95-7, 97, 98, 99, 100, 101, 103, 105, 127, 128, 137, 138, 140-3, 146, 151-2, 154, 155, 185, 227, 248, 249, 250, 252, 254, 255, 258, 259, 260 Duff, James, 4th Earl Fife 67, 68, 128, 143 Duff, William, 1st Earl Fife 249 Duff House, Banffshire 96, 249-56, 249, 259, 260 Dulwich Picture Gallery, London 147, 150 Dunlap, William 183 Dürer, Albrecht 47, 93 Duveen, Joseph, 1st Baron Duveen 196-7, 214, 255 dwarves 2, 3, 59, 62, 75, 80, 81-90, 105, 121, 122, 225, 264, 266 Edinburgh, Scotland 8, 125-30, 131, 133, 135, 137-8, 139, 144-6, 149, 150, 151, 152, 156, 175-7, 185, 211, 213, 231, 245, 247, 248, 250 Egerton, Francis, 1st Earl of Ellesmere 74 Egyptian Hall, Piccadilly 9, 68-9 Egyptian Museum, Stuyvesant Institute 174, 181-2, 185, 208 El Greco 1, 107, 187 Elgin, Earl of see Bruce, James Eliot, George 132 Elisabeth of France, Queen consort of Spain 162, Elizabeth I, Queen of England and Ireland 239 Emma, Lady Hamilton 79 English Civil War (1642-51) 94, 99, 229, 240

Fantin-Latour, Henri 108, 170

Etruscan Museum, Rome 159 European Museum, Mayfair 68

265, 266

Farrer, Henry 144 Ferdinand of Austria, Cardinal-Infante 84 Fife House, Whitehall 66-7, 99, 100, 138, 141, 142, 152, 154, 155, 213, 248, 259 Fife, Earl ıst Earl Fife - William Duff 249 2nd Earl Fife - James Duff 67, 95-7, 97, 98, 99, 100, 101, 103, 105, 127, 128, 137, 138, 140-3, 146, 151-2, 154, 155, 185, 227, 248, 249, 250, 252, 254, 255, 258, 259, 260 3rd Earl Fife - Alexander Duff 143 4th Earl Fife - James Duff 67, 68, 128, 143 6th Earl Fife/1st Duke of Fife - Alexander William George Duff 255, 259 Fine Arts Journal 72, 102, 247 Fonseca, Juan de 30, 35, 36, 48, 61 Ford, Richard 18, 20, 25, 26, 43, 48, 86, 104, 206 Handbook for Travellers in Spain, A 18, 26, 43 Foucault, Michel 5 Les mots et les choses 5 Fourment, Susanna see Lunden, Susanna Frick, Henry 174 Frick Collection 121, 174, 199 Gainsborough, Thomas 95 Galli, Charles 150, 156 Garrick, David 97, 250 Gentileschi, Orazio 93, 94, 257 George II, King of Great Britain and Ireland 195 George IV, King of the United Kingdom 53, 68 George Hotel, Reading 37 Géricault, Théodore 69 The Raft of the Medusa 69 Giambologna 93, 99 Samson Slaying a Philistine 93, 99 Gibbon, Edward 132 Gillray, James 67 All Bond Street Trembled as he Strode 68 Giordano, Luca 262 Giotto 162 golilla 55, 58, 74, 110, 202, 265 Góngora, Luis de 194 Gordon, John Watson 149, 155 Goupil, Broadway 178 Goya, Francisco 43, 55, 75, 132-3, 187 Portrait of the Duke of Wellington 43 Grand Hotel de Paris, Madrid 107 Grantham, Lord 243 Gregory XV, Pope 45 Grosvenor, Robert, 1st Marquess of Westminster Grosvenor House, Mayfair 74 Guzmán, Gaspar de, Count-Duke of Olivares 45,

Hacket, John 92 Hall of Mirrors, Alcázar Palace 116 Hall of Realms, Buen Retiro Palace 113-14, 157 Hals, Frans 54 The Laughing Cavalier 54 Hamilton, James, Earl of Arran, 1st Duke of Hamilton 256 Hamilton, William 79 Hampton Court Palace, London 50, 240 Harper, Alexander 250-1, 259 Harvey, George 150 Hay, James 53 Head, Edmund 78, 79 Heenan, John 209 Hemingway, Ernest 209 Henrietta Maria, Queen consort of England, Scotland and Ireland 90 Henry Frederick, Prince of Wales 45, 46, 240 Henry Leeds, Broadway 178 Herodotus 32, 132 Herrmann, Louis 148 Higgins, William 77 Hilliard, Nicholas 46 Hispanic Society of America 194 History and Pedigree of the Portrait of Prince Charles, The (Snare) 48, 91, 99, 102-3, 153, 205, 206, 210 Holbein the Younger, Hans 46, 68, 93, 97, 239, 250 Thomas More 239 Honthorst, Gerard van 50, 242, 243, 244, 257 House of Commons 70, 77, 95 Howard, Henry, 4th Earl of Carlisle 79 Howard, Henry Charles, 13th Duke of Norfolk 247 Hudson, Jeffrey 90 Hume, David 95, 132 Huntington, Arabella and Henry 194 Illustrated London News, The 70 Inglis, John 153, 154, 155 Innocent X, Pope 34, 79, 163-5, 166, 194, 265 Isle of Pheasants 226, 267

James I and VI, King of England, Scotland and

Ireland 43, 44, 256

A Small Boy and Others 180

Jameson, Anna Brownell 74, 192, 206

James, Henry 180

James Sr, Henry 180

Jansen, Cornelius 133, 257

58, 59, 73, 74, 80, 85, 111, 113, 114, 126, 190, 194,

Ierrold's Weekly Newspaper 103 John of Austria 117-18, 118, 206, 242 John the Baptist 79 Johnson, Samuel 95, 239, 252 Jonson, Cornelius 102 Jovellanos, Gaspar Melchor de 75 Justi, Carl 109

Kent, Benjamin 13, 101, 139-40 Kingston Lacy, Dorset 75-7, 244 Kneller, Godfrey 97 Knights of Santiago 24, 61, 224, 226 Knoedler, Broadway 178 Kokoschka, Oskar 187-8

Lansdowne House, Berkeley Square 74 Lansdowne, Marquess of see Petty-Fitzmaurice, Leonardo da Vinci 20, 45, 52, 69, 162, 183,

Last Supper 162 Salvator Mundi 20 Virgin of the Rocks 183 Lepanto, Battle of (1571) 117 'Letter from New York, A' 211-13 Leutze, Emanuel 180-1

Washington Crossing the Delaware 180-1 Leveson-Gower, George, 1st Duke of Sutherland Lezcano, Francisco 81-3, 88, 117

Life Illustrated 181 London, England 7, 8, 9, 11, 19, 20, 26, 37, 41, 46, 50, 53, 54, 62, 65, 66-74, 77, 91, 92, 93, 95, 96,

138, 140-2, 143-4, 148, 151, 152, 155, 189, 205, 209, 217, 227, 232, 233, 238, 242, 247, 250, 255, 258 López-Rey, José 193 Lorrain, Claude 160-1 Louis XIV, King of France 226, 267

Lovejoy, George 206 Lunden, Susanna 68

Lydian Monarch 214

Macaulay, Thomas Babington, 1st Baron Macaulay 132 Mackarill, Diana 237 Mackenzie, Robert Shelton 185 Madrid, Spain I, 18, 23, 24, 26, 29, 34, 35, 39, 48,

54, 70, 71, 75, 76, 84, 92, 93, 94, 108, 111-17, 157-8, 163, 165, 192, 254, 258, 265

Maidalchini, Olimpia 166 Málaga, Andalusia 162

Manet, Édouard 48, 107-10, 123, 170, 262

The Tragic Actor 110

Mapledurham Manor, Oxfordshire 99, 100 Marat, Jean-Paul 14 Margarita Theresa of Spain 2, 3, 264, 267 Maria Anna, Infanta of Spain 7, 44, 45, 219 Maria Theresa of Spain, Queen consort of France 162, 226, 267

Mariana of Austria, Queen consort of Spain 162,

Marie-Antoinette, Queen consort of the French

Marquand, Henry 184, 192, 207 Marshall, John 141-4, 154 Martin, John 179 Last Judgement 179

Mary, Queen of Scots 95, 250 Mayer, August 167-8, 193, 196-7, 199 Mazo, Juan Bautista Martínez del 33, 80, 119,

122-3, 193-4, 196, 198 Portrait of a Man - 1660 184, 192-4, 193

The Artist's Family 80, 122-3, 122, 193 Meadows, Algur 194

Medici, Francisco de' 93 Medici Gardens, Rome 104, 159-61 Mesnard, Thomas 101-2, 146-7, 148

Metropolitan Museum of Art, New York 10, 79, 169, 174, 184, 192-3, 195, 197, 198, 216, 232, 233, 245, 255

Michelangelo 162, 212

Minster Street, Reading 7, 14-15, 18, 21, 42, 43, 49, 99, 102, 131-5, 175, 176, 218, 230, 232-4, 237, 247 Mitford, Mary Russell 65-7, 132, 247

Charles the First: An Historical Tragedy in Five Acts 66

Our Village 132 Monet, Claude 188

Montenegro, Juan de 71

Morning Chronicle 70 Morning Courier 183

Morning Post 72, 78, 102, 130

Morra, Sebastián de 83-5, 88

Murillo, Bartolomé 26, 182, 191, 214, 215, 250, 251 The Immaculate Conception 191

Mytens, Daniel 46, 50, 102, 242, 244, 255-60 Charles I 249-59, 253, 254

Portrait of James Hamilton, Earl of Arran 256 Self-Portrait 257, 257

Napoleon I, Emperor of the French 61, 68 National Academy of Fine Art, New York 178 National Gallery, London 20, 53, 126, 144, 146, 147, 150, 189, 254

National Portrait Gallery, London 238, 248 Nelson, Horatio, 1st Viscount Nelson 79

New York, United States 9, 10, 11, 79, 169, 173-85, 191-9, 202, 205, 207-18, 227, 232, 233, 234, 248 New York City Directory 208, 210 New York Historical Society 180, 182 New York Post 181 New York Times 173, 174, 175, 179, 184, 185, 209, 214, 218, 247 New York Tribune 216

Niblo's Theatre, New York 179 Nieto Velázquez, José 56, 60-3, 89, 120, 200, 225,

Norfolk, Duke of see Howard, Henry Charles

Olivares, Count-Duke of see Guzmán, Gaspar Order of Santiago 24, 61, 224, 226 Ortega y Gasset, José 220, 263 Ovid 222

Metamorphoses 222

Pacheco, Francisco de 23, 28, 29-30, 32, 46-7, 48, 57, 92, 95, 103-4, 120, 252, 260 Pacheco, Juana de 24, 119, 120, 120, 194 Lives of the Painters 30, 32, 46-7 Packe, Henry 29 Paffs, Broadway 178

paintings deterioration of 38-9, 213, 234 disappearance of 227-30 inner structure of 40-1; see also X-rays insuring of 213 restoration of 9, 29, 41, 255 signatures 187-90

Pall Mall, London 72

Palomino, Antonio 25-6, 29, 33, 34, 39, 60, 62, 79-80, 87, 95, 112, 119, 161, 166, 169, 171, 220, 221, 224, 226, 263

Lives and Works of the Most Eminent Spanish Painters 25-6, 169

Pamphili, Camillo Astalli 165 Pamphilj, Giovanni see Innocent X Pantheon, New York 9 Pantheon, Rome 34, 170, 262 Pareja, Juan de 33, 34, 79, 119, 162, 169-72, 184, 195, 199, 246, 262 Paris Commune 229 Paris Salon 69 Paris, France 26, 44, 110, 178, 196, 228 Peach, Samuel 26 Peninsular War (1808–14) 9, 29, 48, 52, 143, 157,

Pennant, Thomas 95, 96, 98, 250, 255 Penny Cyclopedia 78 Pérez, Antonio 55

Petty-Fitzmaurice, Henry, 3rd Marquess of Lansdowne 74, 192 Philip III, King of Spain 113 Philip IV, King of Spain 5, 8, 24, 30-I, 31, 33, 34, 44-5, 47, 52, 56-8, 57, 73, 83-4, 86, 92-3, 111, 113-15, 121-2, 158-9, 162-3, 165-6, 171, 174, 188-90, 199, 219-20, 221, 224, 229, 245, 254, 262, 265-7, 266 Philip Prospero, Prince of Asturias 267 Piazza Navona, Rome 165 Picasso, Pablo 187, 263 Pilgrim Pearl 261 Pinkerton, John 96, 251 Pitt the Younger, William 67 Porter, Endymion 256 Poussin, Nicolas 33, 97, 160-1, 180 Prado Museum, Madrid 1, 2, 4, 8, 18, 26, 43, 48, 55, 75, 79, 80, 82, 86, 87, 107–10, 111, 114, 120, 161, 166, 167, 262 Prince's Cabala; Or, Mysteries of State, The 44

Proofs of the Authenticity of the Portrait of Prince Charles (Snare) 104, 217, 235

Quevedo, Francisco de 112, 123 He Who Lies Most Prospers Most 112 Silvas 112 Quinto, Baron de 228

Radley Hall, Berkshire 13, 16-21, 16, 67, 101, 127, 134, 139, 142, 211, 230, 231, 242, 258 Raleigh, Walter 239 Raphael 14, 52, 93, 162, 183, 212 The Adoration of the Magi 183 Reading, Berkshire 7, 8, 14, 15, 18, 21, 26, 37, 37, 42, 65, 77, 99, 102, 131-5, 175, 176, 206, 211, 216, 217, 230, 231-5, 247 Reading Mercury 13, 14, 15, 131

Reading Observer 230 Rembrandt 14, 33, 54, 74, 96, 133, 179, 187, 196, 198, 216

Samson Threatening His Father-in-law 130-1 The Night Watch 54 Retiro Park, Madrid III, 157 Reynolds, Joshua 77, 239, 250

Dr Johnson 239 Ribera, Jusepe de 162 Robinson, Henry 148-9 Rokeby Hall, Yorkshire 74, 86, 221 Romano, Giulio 53

Rome, Italy 24, 32, 34, 77, 79, 104, 158, 159-61, 163-72, 182, 190, 199, 219, 241 Röntgen, Wilhelm 202 Royal Academy 53, 150

Royal Collection, Madrid 190 Royal Palace, Madrid 70 Royal Scottish Academy, Edinburgh 125, 138, 149 Rubens, Peter Paul 31, 33, 41, 68, 87, 93, 121–2, 147, 158, 162, 182, 260, 261

Portrait of Susanna Lunden 68 The Apotheosis of the Duke of Buckingham 93

San Jeronimo's Church, Madrid 115 San Juan Bautista Church, Madrid 267 Sánchez, Alfonso Pérez 86 Sandford, Erskine Douglas 138, 142, 143, 146, 147, 151 Sayers, Tom 209 Schirmer's music store, Broadway 210

Scribner, Charles 208–9 Seguier, William 53–4, 144

Seville, Andalusia 23, 26, 28, 29, 33, 35, 48, 56, 58, III, II9, I82, 2I9

Shakespeare, William 6, 34, 37, 132, 239 Hamlet 97, 110, 179, 250

King Lear 166

Midsummer Night's Dream, A 112 Othello 169

Tempest, The 226

Shelley, Mary 132

Shepperson, Matthew 201-2

signatures 187-90

Silenus 80

Silva, João Rodrigues da 23 Simonds' Bank, Reading 37, 232, 234

Sistine Chapel, Vatican 159

sketches 47-8, 103-4, 105; see also bosquexo

slavery 33, 119, 169-70, 191 Smith, M. Crosby 252, 255

Snare, Edward 134, 214–16, 232–5

Snare, Howard 232

Snare, Isabella 15, 22, 39, 130, 134-5, 177-8, 207, 210, 230-3, 235

Snare, Jessie 232

Snare, John 7–8, II, I3–22, 25–6, 34, 37–43, 46, 48–50, 51–2, 61, 65–7, 69–73, 74, 77–8, 91–2, 94, 97, 98–105, II7, I25–35, I37–56, I74–82, I84–5, I99, 201, 202, 205–18, 230–I, 233, 234, 237–8, 245,

246-8, 258-9 Snare, Margaret 232

Society of Antiquaries, Edinburgh 125

Society of Painters in Watercolour 69

Souter, William 128, 153

Spackman, Charles 139-41, 142

Spearman, Major 243

Spencer, George John, 2nd Earl Spencer 9

Spinola, Ambrogio 158, 199

Stafford House, Bloomsbury 74
Stanley's Rooms, Mayfair 68
Stirling Maxwell, William 76, 78–80, 86, 91, 103, 104–5, 122, 137, 184, 246, 258
Annals of the Artists of Spain 78–80, 86, 103, 184

Velázquez and His Works 104–5
Stowe House, Buckinghamshire 130, 216
Stuyvesant Institute, New York 173, 174, 178, 179–82, 180, 184–5, 207–8, 211, 214, 217
Sutherland, Duke of see Leveson-Gower, George

Tait, James 145 Tait's New Royal Hotel, Edinburgh 125-7, 130, 131, 139, 144-5, 152 talbotypes 78, 239 Taylor, Elizabeth 261 Tennyson, Alfred, 1st Baron Tennyson 125 Tiepolo, Giovanni Battista 183 Times, The 70, 102, 152, 209, 233 Tintoretto 45, 158, 162 Titian 30, 45, 68, 93, 112, 158, 162, 166, 179, 183, 198, 212, 261 Penitent Magdalene in the Wilderness 183 Venus 179 Tom Thumb 69, 69, 179, 181 Torre de la Parada, Fuencarral-El Pardo 87, 89 Trionfi, Flaminia 163, 166, 168 Turner, Joseph Mallord William 69 Twain, Mark 207, 211 Twyford Hall, Norfolk 29 typography 237 Tyre, Archbishop of 226

Urban VIII, Pope 31, 45

Valdés, Fernando de 126, 188–90, 189, 244
Valladolid, Pablo de 107–10, 117, 118–19, 123
Vallecas, Madrid 108
Van der Helst, Bartholomeus 50
Van Dyck, Anthony 13, 15, 16, 17, 18, 19, 22, 39, 41, 42, 49–50, 65, 72, 90, 95, 96, 100, 102, 140, 147, 150, 151, 195, 198–9, 202, 212, 241–6, 252, 257, 258, 265

Charles I of England 243 Queen Henrietta Maria with Sir Jeffrey Hudson 90

Triple portrait of Charles I 241–2
Van Eyck, Jan 53, 91, 225
Arnolfini Portrait, The 53, 91, 225
Van Gogh, Vincent 187
Vega, Lope de 60, 112
Midsummer's Night 112

Velazquez, Antonio 32, 168 Velázquez, Diego

> birth and baptism 23; begins studies under Francisco de Pacheco 23; marries Juana de Pacheco 24, 32-3; birth of Francisca 32; birth and death of Ignacia 32; given royal salary 30-1, 266; unpaints portrait of Philip IV after criticism 31, 34-5, 190; hired as royal painter to Philip IV 24: wins painting contest set by Philip IV with The Expulsion of the Moors from Spain 31-2, 262; death of Fonseca; buys back The Waterseller of Seville 36, 61: first trip to Italy 24, 158-61, 190; meets Ambrogio Spinola on voyage to Venice 158; attends royal bullfight 61; second trip to Italy 24, 32, 161, 162-72; frees Juan de Pareja 119, 171-2; birth of Antonio 32, 168; appointed King's High Chamberlain 24. 60, 220; refused permission to travel abroad 220; death of Francisca 32; elected Knight of Santiago 224; appears in theatrical staging of Franco-Spanish truce 226; death 226, 267

Works:

Adoration of the Magi, The 120 Aesop 87, 191-2, 221, 264 Archbishop Fernando de Valdés 126, 188-90, 189,

244 Astronomer, The see Democritus

Baltasar Carlos as a Hunter 158 Baltasar Carlos in the Riding School 59-60, 60, 73, 74, 85, 115-16

Baltasar Carlos with a Dwarf 79 Boar Hunt, The 73, 144, 150

Christ in the House of Mary and Martha 20, 28-9, 28, 222, 224

Count-Duke Olivares 58, 265

Democritus 110

Disciples at Emmaus, The 228 Don Diego de Acedo, The 88-9, 89

Don John of Austria, The 117-18, 118, 242 Equestrian Portrait of Count-Duke of Olivares

58, 59, 190, 194 Equestrian Portrait of Philip III 113

Equestrian Portrait of Philip IV - 1623 31, 34-5 Equestrian Portrait of Philip IV – 1635 190 Expulsion of the Moors from Spain, The 31-2,

Fable of Arachne, The see Spinners, The Ferdinando Brandani 166-8, 167 Francesco Barberini 166 Francisco Lezcano 81-3, 88, 117

Francisco de Quevedo 112 Geographer, The see Democritus Jester Calabazas, The 194 Juan de Pareja 34, 74, 79, 184, 195, 199, 262 Luis de Góngora 194 Mariana of Austria 229 Mars Resting 221, 264, 266 Meninas, Las (Velázquez) 1-6, 10, 11, 24-5, 29,

34, 40-1, 43, 48, 51, 54-5, 60, 61, 62, 74, 75-6, 80, 85, 104, 115, 116, 119, 121, 123, 184, 201, 206, 219, 221, 222, 223, 224-6, 262-3, 264, 267-8

Old Woman Frying Eggs, An 26-7, 27, 264 Pablo de Valladolid 107–11, 117, 118–19, 123

Philip IV in Fraga 121, 174, 199

Philip IV of Spain - 1623-24 30-1, 31 Philip IV of Spain - c. 1623 57

Philip IV of Spain – c. 1653–56 265–6, 266

Philip IV in Brown and Silver 188, 189, 190, 254 Pope's Barber, The 166-8

Pope Innocent X 34, 79, 163-5, 265

Portrait of a Man - c. 1630-35 195-200, 201, 202, 245, 255

Portrait of a Man - c. 1631-34 201-3

Portrait of a Man, possibly Nieto 51-6, 62-3, 89

Portrait of Camillo Astalli 165, 194 Portrait of Camillo Massimi 76-7

Portrait of Flaminia Trionfi 163, 166

Portrait of Girolamo Bibaldo 166 Portrait of Juan de Fonseca 30

Portrait of Olimpia Maidalchini 166

Portrait of Prince Charles 7-8, 11, 13, 16-22, 30,

38-50, 65-7, 69-73, 77-8, 91-105, 125-30, 137-56, 173-81, 184-5, 205, 207-8, 209-18,

230-5, 237-48, 249-60

Portrait of the Buffoon 'Redbeard' 117

Rokeby Venus, The 74, 86, 221-2, 222, 224, 266

Sebastián de Morra 83-5, 88

Sense of Taste, The 119

Spinners, The 222-4

Surrender of Breda, The 158, 190, 196, 199, 221

Sibyl, A 120, 194

Toilet of Venus, The see Rokeby Venus View of the Gardens of the Villa Medici 104,

159-62, 168

Waterseller of Seville, The 30, 35-6, 48, 53, 58, 61, 62, 79

Velázquez, Jerónima 23

Velazquez y Pacheco, Francisca 32, 120

Velazquez y Pacheco, Ignacia 32

Vermeer, Johannes 228, 229

Veronese, Paolo 158, 162

Victoria and Albert Museum, London 93, 96, 217

296 Index

Villa Medici, Rome 104, 159–61 Villiers, George, 1st Duke of Buckingham 43–4, 92, 93–4, 95, 98–9, 105, 250, 256, Villiers, Katherine, Duchess of Buckingham 94 Vitoria, Battle of (1813) 48, 52–3, 61, 144, 228

Walcott, Mackenzie 98

Memorials of Westminster 98

Walpole, Robert 79

Walton, Isaac 103

Waterloo Gallery, Apsley House 52, 61–3

Waterloo, Battle of (1815) 53, 54, 61, 68

Watteau, Jean-Antoine 180, 183

Webb, William 42, 131–2

Wellesley, Arthur, 1st Duke of Wellington 43, 48, 52–3, 61–2, 70, 133

West, Benjamin 53–4, 179, 207

Death on a Pale Horse 179, 180

West, James 125–8, 144–5, 177

Westminster, Marquess of see Grosvenor, Robert Wharton, Edith 209
Whitman, Walt 181, 191, 192, 207
Widdrington, Samuel Edward 80, 85
Wildenstein, Daniel 214
Wilkie, David 126, 189
Williams, Bossom 232, 233
Williams, Isabella see Snare, Isabella
Williams, Thomas 232
Williams, Thomas 232
Williams, Jacob 143-4, 154
Wilson, John 68
Windsor Castle, Berkshire 257
Wordsworth, William 250

X-rays 40-1, 119, 147, 165, 202-3, 224, 229

York House, Strand 92, 93–4, 99, 256 Young, George 138–9, 142, 147, 150, 176